The Kingdoms of Edward Hicks

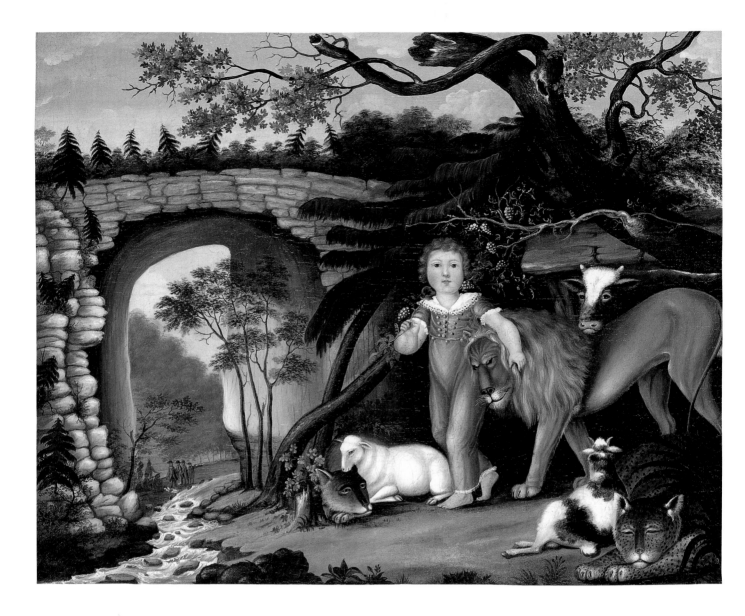

The Kingdoms of Edward Hicks

By Carolyn J. Weekley

WITH THE ASSISTANCE OF

Laura Pass Barry

Abby Aldrich Rockefeller Folk Art Center

The Colonial Williamsburg Foundation, Williamsburg, Virginia

IN ASSOCIATION WITH

Harry N. Abrams, Inc., Publishers

Library of Congress Cataloging-in-Publication Data

Weekley, Carolyn J.
 The kingdoms of Edward Hicks / by Carolyn J. Weekley ;
with the assistance of Laura Pass Barry.
 p. cm.
 "In association with Harry N. Abrams, Inc. Publishers."
 Includes bibliographical references and index.
 ISBN 0-87935-205-1 (CWF : alk. paper). — ISBN 0-8109-1234-1
(Abrams : alk. paper)
 1. Hicks, Edward, 1780–1849—Criticism and interpretation.
I. Barry, Laura Pass. II. Title.
ND237.H58W44 1999
759.13–dc21 98-33231

Published in 1999 by The Colonial Williamsburg Foundation
and Harry N. Abrams, Incorporated, New York

PRINTED AND BOUND IN SINGAPORE

ABRAMS
Harry N. Abrams, Inc.
100 Fifth Avenue
New York, N.Y. 10011
www.abramsbooks.com

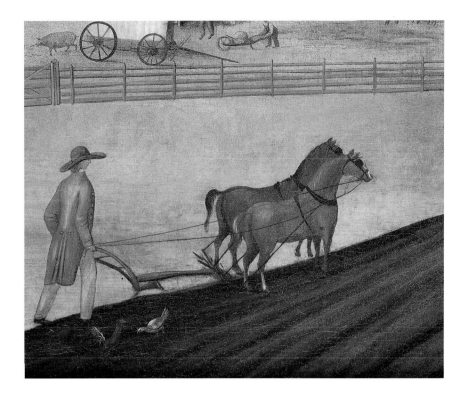

For Alice Ford, Eleanore Price Mather,

Dorothy Canning Miller, and Edna Pullinger

Whose research and writings on the artist remain fertile ground

Contents

President's Message

Colonial Williamsburg is fortunate to have many friends and generous donors who believe profoundly in our work. The Kingdoms of Edward Hicks—as an exhibition and as a book—would not have been possible without the active interest of two special individuals and two extraordinary foundations.

Juli and David Grainger of Winnetka, Illinois, have known Colonial Williamsburg for many years and are frequent visitors. Juli and David and the Grainger Foundation have demonstrated their fondness for Colonial Williamsburg in several ways, but it was Juli's particular interest in American folk art that led her to underwrite the publication of this expansive study of Edward Hicks. My colleagues and I deeply appreciate the Graingers' generosity.

Two distinguished American foundations provided essential additional support for the project. The Henry Luce Foundation of New York and the John S. and James L. Knight Foundation of Miami, Florida, each made substantial grants, allowing Colonial Williamsburg's talented staff to mount the most comprehensive exhibition of Edward Hicks's life and work at the Abby Aldrich Rockefeller Folk Art Center. We thank especially Henry Luce III and Ellen Holtzman at the Luce Foundation and Penelope McPhee and Gary Burger at the Knight Foundation.

ROBERT C. WILBURN
Colonial Williamsburg Foundation

Foreword

The *Peaceable Kingdom* paintings by Edward Hicks, of which sixty-two are known at present, may be the most widely recognized icons of American folk art today. I believe their appeal is archetypal. They strike chords of deep yearning in many people who long for peace and harmony in their lives, for a world where cruelty and violence have been eliminated or at least forgotten, and where the innumerable physical and spiritual beauties that we are afforded in this life may be contemplated and enjoyed without hindrance. The simplicity and directness that most people see in these pictures only makes their resonance more accessible and more appealing.

That such tranquility was actually born of deep inner turmoil should, on reflection, be no surprise. These pictures, as Carolyn Weekley explains with her own masterful clarity, are indeed expressions of yearning by the artist, using the technique he had learned in his trade of coach painter, as he found himself embroiled in controversy in his most important occupation, that of Quaker minister. Thus, the resonance that accounts for their wide appeal today was achieved arduously, with courage and fortitude, and was not just a rote formula that happened to appeal to an audience or to the market.

The Colonial Williamsburg Foundation, of which the grand museum the Abby Aldrich Rockefeller Folk Art Center is an important part, is proud to be the originator of this exhibition and catalog, and proud that its Director of Museums, Carolyn Weekley, is the person in the country most qualified to organize the show and write the catalog. We believe it is the most important and thorough assessment yet of Edward Hicks's work. And it is particularly apt that Colonial Williamsburg should be in this position, for Abby Aldrich Rockefeller, wife of the founder of the Restoration and a major player in the historiography of American museums in her own right, gave her collection of American folk art to the Foundation in the 1930s and, indeed, was among the earliest collectors of Hicks's work.

We hope that this exhibition and catalog enjoy a wide audience and readership, and that viewers will appreciate even more the appeal of Hicks's work as they understand the circumstances from which it was created.

GRAHAM HOOD
Carlisle H. Humelsine
Chief Curator Emeritus

Acknowledgments

The realization of this book on Edward Hicks is a particularly happy event, the result of years of friendship and collegial interests shared with Juli and David Grainger about American folk art and particularly the well-known Quaker artist. I am deeply indebted to Juli and David and to the Grainger Foundation for their generous support of this publication. I am also grateful for Juli's probing questions and insights about Edward Hicks.

Much of the final research for the study and the resources to organize the first major exhibition on Hicks would not have been possible without the encouragement and support of the Henry Luce Foundation of New York, and the John S. and James L. Knight Foundation of Miami, Florida. I especially want to express appreciation to Ellen Holtzman of the Luce Foundation for her early interest and good counsel.

This book represents the efforts of many people over several years of research and writing. Editorial assistance has been skillfully supplied by Donna Sheppard, Publications Department, Colonial Williamsburg. Special thanks go to Joseph Rountree, director of Publications, who coordinated the many details of the book's production, and Helen Mageras, senior book designer, who assisted in evaluating photography. The talent and enthusiasm of Greer Allen, designer of the book, will be obvious to those who turn these pages.

Preparation of the manuscript would not have been possible without the assistance of other staff at Colonial Williamsburg, including Deborah Green, Donald Thomas, and Patricia Waters, who provided essential administrative support. Jan Gilliam assisted in preparation of both the exhibition and the manuscript by coordinating exhibit labels and schedules, organizing and verifying sources, and compiling the book's index. Laura Pass Barry, curatorial intern for the project, deserves a special note of appreciation for her long hours of tracking down obscure documents and research materials in numerous libraries and archives throughout the United States. For her capable handling of photography requests and permissions, I am indebted to Anne Motley, collections manager, Abby Aldrich Rockefeller Folk Art Center, who also coordinated and managed the loans for the exhibition. Appreciation is also due to Colonial Williamsburg museums staff members Mary Cottrill and Elizabeth Pitzer Gusler, who developed educational components, and Richard Hadley, who led the team of talented exhibit design and production staff—Robert Becker, Patricia Bedtelyon, Gloria McFadden, David Mellors, April Metz, Edward Moreno, and Gayle Trautman. I am also grateful to Albert O. Louer, who worked closely with staff and donors to the project.

I owe special thanks to colleagues who read and critiqued the manuscript. Beatrix T. Rumford, Vice President for Special Projects at Colonial Williamsburg, generously shared her knowledge of and early research on Hicks and Pennsylvania Quakers and provided important insights about the Quaker schism. Graham Hood, Carlisle H. Humelsine Chief Curator emeritus, Colonial Williamsburg, and Ellen G. Miles, curator of painting and sculpture, National Portrait Gallery, Smithsonian Institution, Washington, D. C., were particularly helpful in assessing the book's organization and art historical discussions. Ann Smart Martin, Chipstone professor of decorative arts, University of Wisconsin, Madison, Wis., provided valuable comments about Edward Hicks's shop and accounts. I am grateful to Jack L. Lindsey, curator of American decorative arts, Philadelphia Museum of Art, Philadelphia, Pa., and Damon Hickey, director of li-

braries, College of Wooster, Wooster, Ohio, for their careful reading of sections pertaining to Quaker aesthetics and the causes and nature of the Quaker separation. Barbara R. Luck, curator of paintings and drawings, Colonial Williamsburg, also read and commented on the manuscript and assisted with the exhibition.

The book and exhibit required the goodwill and cooperation of numerous private collectors, dealers, and colleagues at other museums, libraries, and related institutions who responded to many questions and provided information and photography. I am particularly indebted to those descendants of Edward Hicks who shared family history and allowed me to examine items that were passed down to them. Special thanks go to Diana L. Guttenberg, John P. Guttenberg, Jr., Mark T. Swartz III, and Marsha A. Swartz. C. David Callahan, Newtown Historic Association, Newtown, Pa., helped track down files and facilitate contacts with others in Hicks's hometown. Mary Catherine Bluder and Cory Amsler, Mercer Museum, Bucks County Historical Society, Doylestown, Pa., also located sources and provided valuable assistance with research and photography.

Thanks for special assistance are also extended to: Tamara Lee Fultz, Brooklyn Historical Society, Brooklyn, N. Y.; Charlotte Blandford, Mary Ellen Chijioke, Pat O'Donnell, and Susanna Morikawa, Friends Historical Library, Swarthmore College, Swarthmore, Pa.; Alice Lubrecht, Janice Neuman, and Raymond Schott, State Library of Pennsylvania, Harrisburg, Pa.; and Margaret Cook and Merle Kimball, Earl Gregg Swem Library, College of William and Mary, Williamsburg, Va. I am indebted to Liz Ackert, Susan Berg, Lois Danuser, Gail Greve, Del Moore, and Susan Shames, John D. Rockefeller, Jr. Library, Colonial Williamsburg, for their assistance in finding and obtaining rare periodicals, books, and other out-of-print sources and for advice and assistance in researching the genealogy of the Hicks family. Colonial Williamsburg photographers Hans Lorenz and Craig McDougal provided many exceptional illustrations for the book.

I also want to thank the following individuals and institutions: Laura Catalano and Douglas Schultz, Albright-Knox Art Gallery, Buffalo, N. Y.; Scott DeHaven and Tom Johnson, American Philosophical Society, Philadelphia, Pa.; Lisa Cain, Terry Carbone, Linda S. Ferber, Barbara Dayer Gallati, Ruth Janson, and Arnold Lehman, Brooklyn Museum, Brooklyn, N. Y.; Sandy Lenthall, Bruton Parish Church, Williamsburg, Va.; Donna Humphrey, Terry McNealy, and Frances Wise Waite, Bucks County Historical Society, Doylestown, Pa.; Richard Armstrong, Honore Ervin, and B. Monika Tomko, Carnegie Museum of Art, Pittsburgh, Pa.; Susan Green, Carriage Museum of America, Bird-In-Hand, Pa.; Dee Ardrey and Linda Cagney, Chrysler Museum of Art, Norfolk, Va.; Henry Adams, Diane De Grazia, Joanne Fenn, and Roberto Prcela, Cleveland Museum of Art, Cleveland, Ohio; Jeanne Chvosta and Kay Johnson, Dallas Museum of Art, Dallas, Tex.; and Marie Adams, Carol Campbell, Lori Iliff, Cynthia Nakamura, and Lewis I. Sharp, Denver Art Museum, Denver, Colo.

Thanks also to: Jacqueline M. De Groff, H. Richard Dietrich, Jr., and Deborah Rebuck, Dietrich American Foundation, Philadelphia, Pa.; Suzanne Selinger, Drew University Library, Madison, N. J.; Robert Byrd, William R. Perkins Library, Duke University, Durham, N. C.; Thomas D. Hamm, Earlham College, Richmond, Ind.; Lois B. Bowman, Menno Simons Historical Library, Eastern Mennonite University, Harrisonburg, Va.; Michael Flanagan and Thomas E. Piché, Jr., Everson Museum of Art, Syracuse, N. Y.; Mary Haas, Kathe Hodgson, Patricia Junker, Steve Lockwood, Steven A. Nash, and Harry S. Parker III, Fine Arts Museums of San Francisco, San Francisco, Calif.; Karen Lightner, Free Library of Philadelphia, Philadelphia, Pa.; Lydia Dufour, Frick Art Reference Library, New York, N. Y.; Ann Morand, Thomas Gilcrease Institute of American History and Art, Tulsa, Okla.; Charles Hilborne, Gulf States Paper Corporation, Tuscaloosa, Ala.; Ann W. Upton, Haverford College, Haverford, Pa.; Linda Brinker, Historic Fallsington, Fallsington, Pa.; and

Kristen Froehlich and Linda Stanley, Historical Society of Pennsylvania, Philadelphia, Pa.

Thanks also to: Andrea C. Ashby and Karen D. Stevens, Independence National Historical Park Library, National Park Service, Philadelphia, Pa.; Terry Harley-Wilson, Indianapolis Museum of Art, Indianapolis, Ind.; Ellen Schall Agnew, Sarah Cash, and Sharon Palladino, Maier Museum of Art, Randolph-Macon Woman's College, Lynchburg, Va.; Linda Delone Best, Susan Danly, and Martha A. Sandweiss, Mead Art Museum, Amherst College, Amherst, Mass.; Deanna Cross, Emily Grahamson, Morrison Heckscher, Peter M. Kenny, Suzanne L. Shenton, and H. Barbara Weinberg, Metropolitan Museum of Art, New York, N. Y.; Emily Badertscher, Methodist Theological School, Delaware, Ohio; Robert E. Coley, Millersville State University, Millersville, Pa.; Lee Ellen Griffith, Monmouth County Historical Society, Freehold, N. J.; Pam Bransford and Alice Carter, Montgomery Museum of Fine Arts, Montgomery, Ala.; Mary L. Sluskonis, Museum of Fine Arts, Boston, Mass.; Alice Ross, Museum of Fine Arts, Houston, Tex.; Merri Ferrel, Museums at Stony Brook, Stony Brook, N. Y.; and Kathy Fieramosca, National Academy of Design, New York, N. Y.

Thanks also to: Judy Cline, Anne Halpern, Lisa Mariam, Earl A. Powell III, and Steve Wilcox, National Gallery of Art, Washington, D. C.; Annie Brose and Linda Hartigan, National Museum of American Art, Washington, D. C.; Heather Egan and Suzanne Jenkins, National Portrait Gallery, Smithsonian Institution, Washington, D. C.; Cindy Cart, Stacey L. Sherman, and Marc F. Wilson, Nelson-Atkins Museum of Art, Kansas City, Mo.; Margaret Tamulonis, New-York Historical Society, New York, N. Y.; Paul D'Ambrosio, Kathleen D. Stocking, Gilbert T. Vincent, and Wayne Wright, New York State Historical Association, Cooperstown, N. Y.; Carolyn Evans, Newtown Friends Meeting, Newtown, Pa.; Philip Hagan, Newtown Library Company, Newtown, Pa.; Dina Schoonmaker, Oberlin College Library, Oberlin, Ohio; Geoffrey Smith, Ohio State University,

Columbus, Ohio; Marietta P. Boyer, Barbara Katus, and Cheryl Lybold, Pennsylvania Academy of the Fine Arts, Philadelphia, Pa.; Caroline Demaree, Anne d'Harnoncourt, Martha Halpern, Mike Hammer, Jack Lindsey, Darrel Sewell, Suzanne Wells, and Nancy Wulbrecht, Philadelphia Museum of Art, Philadelphia, Pa.; Rita Varley, Philadelphia Yearly Meeting, Religious Society of Friends, Philadelphia, Pa.; and Lisa Zarrow, The Phillips Collection, Washington, D. C.

Thanks also to: Ellen Kutcher, Reynolda House Museum of American Art, Winston-Salem, N. C.; Rachel Mauldin, San Antonio Museum of Art, San Antonio, Tex.; Kirk Delman, Scripps College, Claremont, Calif.; Brian Alexander, Hope Alswang, Sharon Greene, Richard Kerschner, and Robyn Woodworth, Shelburne Museum, Shelburne, Vt.; Harold L. Miller, State Historical Society of Wisconsin, Madison, Wis.; Rebecca Englehardt, Mary Ellen Goeke, and Shelly Roman, Terra Museum of American Art, Chicago, Ill.; Nancy Romero, University of Illinois, Urbana-Champaign Library, Urbana, Ill.; Kim Daugherty, University of Missouri, Columbia, Mo.; Elizabeth Dye and Bobbie Sanders, Williamsburg Presbyterian Church, Williamsburg, Va.; Amy Dowe, Grace Eleazer, Brock Jobe, Dwight P. Lanmon, Susan I. Newton, and Neville Thompson, Henry Francis du Pont Winterthur Museum and Library, Winterthur, Del.; Jill Burns and Nancy L. Swallow, Worcester Art Museum, Worcester, Mass.; Jennifer Bossman, Carolyn B. Padwa, and Suzanne Warner, Yale University Art Gallery, New Haven, Conn.; and Bill Massa and Elizabeth Pauk, Yale University Library, New Haven, Conn.

Thanks to the dealers and gallery owners and assistants who have provided information and helped locate the current ownerships of Hicks works: Jessica Mantaro, Berry-Hill Galleries, New York, N. Y.; Susan Collins and Jennifer Olshin, Christie's, New York, N. Y.; Vicki Gilmer, Curtis Galleries, Minneapolis, Minn.; Joseph Barrett, Darby Barrett Antiques, Lahaska, Pa.; Hildegard Bachert and Jane Kallir, Galerie St. Etienne, New York, N. Y.; Robert Coyle, Greenwood Antiques, Trenton,

N. J.; Eric Baumgartner, Hirschl & Adler Galleries, New York, N. Y.; Lillian Brenwasser, Kennedy Galleries, New York, N. Y.; Leigh Keno, Leigh Keno American Antiques, New York, N. Y.; Robert Hunter and Virginia Lascara, Period Designs, Yorktown, Va.; Jeanie Deans, Carroll Janis, and Conrad Janis, Sidney Janis Galleries, New York, N. Y.; Nancy Druckman, Wendell Garrett, and Anne Walker, Sotheby's, New York, N. Y.; Marguerite Riordan, Antique Furnishings and Works of Art, Stonington, Conn.; Peter Tillou, Peter Tillou Works of Art, New York, N. Y.

I am grateful to the following individuals for advice about the provenance and location of objects, research relating to Hicks and Bucks County, and assistance in procuring information and photography: Joseph Amram, Robert H. Bartels, Dr. and Mrs. Gordon Billger, Randl Bye, Malcolm and Martha Cade, Nancy Carlen, Tara Cederholm, Dona Colatriano, Roger Cook, Harry Davis, Susan Detweiler, H. Richard Dietrich, Jr., Pam and Paul Donath, Katherine K. Fabian, Lawrence M. Farmer, Dorothy Fitzgerald, Jim Gergat, Ellin and Baron Gordon, Harry Hartman, Wendy Jeffers, Mike Jensen, Helen Laughon, Nel Laughon, Leigh Photo and Imaging, Thomas Lincoln, Seline Little, David Long, Leslie Miller, Wendell and Anne Pass, Carmine Picarello, Irwin and Anita Schorsch, Martha M. Small, Beatrice Stump, Susan Thompson, Mr. and Mrs. John L. Tucker, Malcolm Varon, Florence Wharton, Graydon Wood, Richard Worley, and those individuals who wish to remain anonymous.

I am indebted to the conservators and their assistants who examined and treated many of the objects, especially Amy Fernandez, Amy Gerbracht, F. Carey Howlett, Scott Nolley, Pamela Young, and the late Steve Ray at Colonial Williamsburg, and Kory R. Berrett, David Goist, Dorothy Teringo, and Dean Yoder. Colonial Williamsburg curators Linda Baumgarten, Margaret Pritchard, Jon Prown, and Janine Skerry shared their enthusiasm and expertise with me. Thanks to staff members Amy Edmonson, Davelin Forrest, Stephen E. Haller, Sophia Hart, Sarah Houghland, Robert Jones, Phoebe Kent, Brenda LaClair, Mike Lombardi, Richard Nicoll, Jean Puckett, Peter Roberts, John Sands, Chuck Smith, Susan Stuntz, Tracy Stecklein, and Osborn Taylor, and volunteers Robert Chope, Marion Fast, Janet Geitzel, Sandy Nahm, and the many others who have helped make the book and the exhibit possible.

No project of this complexity, which requires extended resources and dedicated staff time, is possible without the enthusiastic support and commitment of an institution's administrative leaders. I am deeply grateful to Robert C. Wilburn, President and Chief Executive Officer, D. Stephen Elliott, Vice President of Education, and Ronald L. Hurst, Chief Curator and Vice President, Collections and Museums, and Carlisle H. Humelsine Curator, for their encouragement and leadership.

Note on the Memoirs
of Edward Hicks

Many of the quotes in *The Kingdoms of Edward Hicks* are from Hicks's *Memoirs*, which he began writing on February 12, 1846, and were published posthumously in 1851. Hicks had not kept a continuous journal during his lifetime as was common practice among Friends. Instead, the published version through part of page 139 is a running text based on Edward's memories and, occasionally, on relevant quoted sources. The rest of the *Memoirs* is composed of daily journal entries with annotations.

Hicks completed the *Memoirs* just before his death, but as early as 1845 he was corresponding with friends about making arrangements for publication with transcribers, readers, and publishers. Richard Price of Philadelphia, Edward's longtime friend, wrote on September 12, 1845, that he must decline to be involved in the transactions because he believed others were better able to help Hicks carry them out. Price expressed uneasiness about accepting money for the project from Henry Willet Hicks, Edward's cousin in New York. Price also declined to ask a printer in Philadelphia about printing and binding costs, claiming to be ignorant of such business. He suggested that Edward talk with Oliver Hough about these matters since Hough had more knowledge about publishing.[1]

Oliver Hough must have been involved by September 8, 1848, when Price wrote to Edward noting that Hough had not yet made a copy of the *Memoirs* but would do so soon. Price had apparently read some of the manuscript because he stated, "I observe, that thy Mss. is an argument against Hireling Ministry, which has the merit of some novelty—when I see it, I can form an opinion, which I cannot now do."[2] If Price ever formed such an opinion, it has not been discovered.

Amos Willets of New York wrote to Benjamin Ferris about the manuscript on September 24, 1849: "With thee I have felt as if it was very desirable for some suitable friend to examine Edward Hicks's journal before it was published. Henry [Hicks] said he intended to submit it to Isaac Parry, . . . Henry had thought of thee 'as it would be necessary for some one [to] write a preface.' . . . he would *not* have any thing published that would militate against the character of Edward or the Society and I trust if it is revised by Isaac and his associates, it will be in safe hands."[3]

Two months later, Isaac Parry wrote to Benjamin Ferris that he and Henry Hicks had been reviewing the manuscript while visiting the "bereaved family of our Beloved friend Edward Hicks." He found the text interesting, but noted it required a few corrections and a preface "which the family was very desirous that thee should write, as thou art an intimate friend, and well acquainted with his ministerial labours."[4]

Hicks's family continued to believe as late as 1850 that Benjamin Ferris of Wilmington, Delaware, would write a preface, but he did not. Susan Hicks Carle, Edward's daughter, only saw the manuscript in 1850, at which point it had been edited, probably by several readers, possibly by John Comly, and definitely by Henry Hicks, who "had marked a few places . . . he did not propose any [changes] but thought the initials of names would *be best*—in many places."[5]

The comments in these letters probably suggest noth-

ing unusual in the business of preparing such nineteenth-century manuscripts for publication. It is obvious, however, that they indicate the readers' concerns and a degree of censorship that cannot be fully documented from what exists of the original manuscript. Using only initials to identify individuals to whom Edward referred was standard in most journals. In this case, initials might not be considered an indication of censure were it not for the fact that Susan underlined "be best" to emphasize the importance of using them instead of names. Edward was known for his forthrightness and proclivity to speak and write harshly of those with whom he disagreed. Comparing the surviving pages of the original manuscript, probably in Edward's hand, with the published version suggests uneven editing and subtle changes in words that sometimes altered the impact and less often the meaning. Many of these edits were necessary to correct errors, but sometimes they softened the voice of the writer.

A word of caution about the published *Memoirs* is therefore appropriate. While they are vital to understanding the life of Edward Hicks, the Memoirs are *edited* versions of an original text. Other sources—family letters, published journals of Quakers whom Edward knew, records of the Society of Friends, the host of local records associated with Bucks County, and the research of earlier scholars—should always be consulted and compared with the *Memoirs*.

Chronology

1780
Edward Hicks, future Quaker minister and painter, is born to Isaac and Catharine Hicks in Bucks Co., Pa. His father's family suffers from financial reverses during the American Revolution.

1781
Catharine Hicks dies.

1783–1793
Edward boards with Quakers David and Elizabeth Twining on their farm near Newtown, Pa.

1793–1800
Edward serves an apprenticeship with coach makers William and Henry Tomlinson in Langhorne near Newtown, Pa. He learns the painting trade.

1800
Edward's apprenticeship ends. He earns a living by painting. The first entry in his account book is dated Dec. 22, 1800. About this time, Edward meets John Comly, a Quaker and lifelong friend.

1803
Edward is received into membership of Middletown Monthly Meeting. He marries Sarah Worstall of Newtown, Pa. Five children, Mary (1804), Susan (1806), Isaac Worstall (1809), Elizabeth (1811), and Sarah (1816), are born to Edward and Sarah.

1803–1810
Edward works as a decorative painter and becomes increasingly involved in the Quaker ministry.

1811
Edward sets up his shop in Newtown, Pa. He continues ornamental painting to increase his income. Edward is recorded as a Quaker minister by Middletown Monthly Meeting.

1814
Edward transfers his membership to Wrightstown Monthly Meeting.

1815
Deeply in debt and criticized by Friends for his highly decorative painting, Edward quits painting, buys land, and tries farming. Edward and John Comly become close associates of the well-known Quaker minister Elias Hicks, the artist's second cousin. Elias and Edward continue to correspond and meet until the older minister's death in 1830.

1816–1817
Unsuccessful at farming, Edward advertises in local newspapers that he has returned to ornamental coach and sign painting of all sorts. Friends and relatives help to pay off his debts.

1816–1818
Edward paints the first Peaceable Kingdom. He continues to create Peaceable Kingdoms until the eve of his death.

1819
Edward undertakes his first long ministerial trip through parts of New York and visits Niagara Falls, which he later paints.

1821
Edward worries about growing dissension among two factions within the Society of Friends that would be called the Orthodox and the Hicksites.

1822
Edward's shop burns. He begins to produce more easel pictures. Philadelphia Quakers with Orthodox leanings con-

front Elias and his followers. The two groups are unable to reconcile their disagreements.

1822–1829/1830
Edward paints Peaceable Kingdoms with lettered borders.

1825
Edward paints the sign for the Newtown Library Company and two versions of Niagara Falls.

1827
Orthodox and Hicksite Quakers separate when they cannot reach an accord at the Philadelphia Yearly Meeting.

1827–1832
Edward continues to develop and refine Peaceable Kingdoms.

1829–1832
Edward paints Peaceable Kingdoms incorporating a figure of Elias Hicks and a flowing banner in the composition.

1830
Elias Hicks dies. Edward begins to paint "Penn's Treaty" pictures.

1832–1840
Edward paints his most creative Peaceable Kingdoms, many of which feature a large seated lion.

1833
Edward paints two signboards for both ends of the bridge that spans the Delaware River. He begins to paint "Washington Crossing the Delaware" pictures.

1835–1849
Edward produces the late Kingdoms.

1836–1839
Thomas Hicks, Edward's cousin once removed, works in the shop with the older artist.

1837
Edward delivers a sermon at the Goose Creek meetinghouse in Loudon County, Va. It is the most important source for interpreting his Kingdom paintings.

1839–1841
Thomas Hicks paints Edward's portrait.

1840–1845
Edward paints the "Declaration of Independence" pictures.

1843
Edward begins to write his memoirs.

1844
Edward includes arching leopards and other animals in the Kingdoms.

1845–1847
Edward paints several versions of the "Residence of David Twining" and a scene of Hillborn farm.

1845–1849
Edward works on late Peaceable Kingdoms featuring decrepit lions and animals dispersed over the canvas.

1847–1848
Edward paints versions of the "Grave of William Penn."

1848–1849
Edward paints monumental canvases featuring prosperous Bucks Co. farms of Leedom and Cornell.

1849
Edward is working on a Peaceable Kingdom for his daughter Elizabeth the evening before he dies on August 23.

1851
Edward's memoirs are published posthumously.

Introduction

It seems ironic that the man who called himself "but a poor old worthless insignificant painter"[1] in 1846 was destined to become one of the best-known and loved of America's painters by the early twentieth century. Edward Hicks's multifaceted career and complex personality have been chronicled in numerous publications, beginning with Alice Ford's 1952 book and culminating in the 1983 volume on his life and a comprehensive discussion of nearly all of his extant works by Hicks experts Eleanore Price Mather and Dorothy Canning Miller. Ford published another extensive discussion of his life in 1985.[2] Over the years since the Abby Aldrich Rockefeller Folk Art Center opened in 1957, its staff benefited from the help and generosity of each of these individuals.

Miller's study of Hicks began about the time of the landmark exhibitions on American folk art held in the early 1930s at the Newark Museum in New Jersey and later at the Museum of Modern Art in New York City. A number of the paintings in the Folk Art Center's collection today were featured in those shows, since Abby Aldrich Rockefeller was one of the first to collect works by Hicks. The Center's subsequent acquisitions of additional paintings by the artist have made its holdings the largest single collection of his works.[3]

In 1960, Alice Ford worked with the late Mary C. Black, then curator of the Center, in organizing and presenting one of the first exhibitions and catalogs on the artist.[4] Ford was a tenacious researcher, ferreting out most of the now known Hicks family documents and related period materials that have greatly enlarged our knowledge of Edward's life and sources of inspiration. Mather brought other, very special, insights to the assessment of Hicks, for she had a scholar's knowledge of the Society of Friends and its history during Edward's lifetime. She also possessed an intuitive understanding of his personality, its finer qualities as well as its sometimes darker and troubling side. That this book would be dedicated to these three pioneers in the research of Edward Hicks seemed abundantly clear from the beginning of this project, which would not have been possible without the benefit of their knowledge.

The work of the late Edna Pullinger is little known to those who have been interested in the literature on Hicks. Little known, perhaps, to any but those who live in Bucks County, Pennsylvania, and are familiar with the important research Pullinger published on a wide range of local subjects. The life and work of Edward Hicks were among her special interests. Much of what she discovered and presented in a number of small, focused studies later informed other scholars and became important resources for those who sought to know more about Hicks's family, property, and business associates. An expert researcher, Pullinger was diligent in recognizing the sources and extraordinarily adept in piecing together obscure facts from disparate records to enrich the story of the artist's life in Bucks County.[5]

I have borrowed liberally from the formative work of these historians, just as they continually reevaluated their ongoing research. Occasionally, it was difficult to trace which of these early scholars discovered pertinent material, and thus multiple sources are cited in the notes. This book explores a number of issues they introduced and, where possible, evaluates the evidence they gathered. The checklist of works, for example, combines information collected by Mather, Miller, and Ford with that of others, including AARFAC staff. It should also be

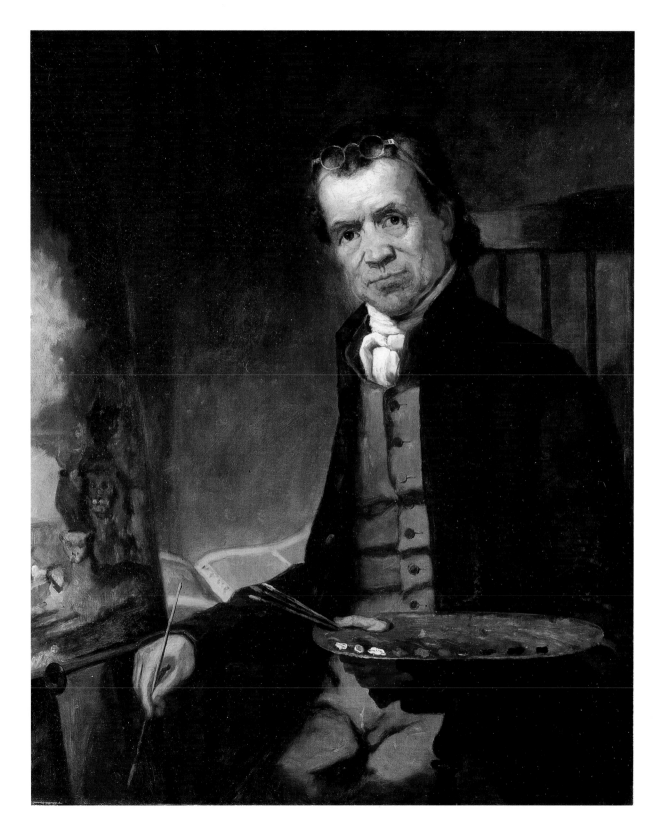

1. Edward Hicks, by Thomas Hicks, 1839–1841, oil on canvas, 27¼″ x 22⅛″.
Abby Aldrich Rockefeller Folk Art Center.

noted that Mather, Miller, and Ford used information from the Folk Art Center's archives in their publications.

Two other early Bucks County historians deserve more than a passing mention in any publication on Hicks. Frederick B. Tolles and Edward Barnsley were among the first to delve into early records on the artist and share their findings with scholars. Like Pullinger, they had the advantage of access to those with firsthand knowledge about the early history and residents of the county. David Tatham prepared a more recent theoretical study devoted principally to the Peaceable Kingdom pictures that was included in the spring 1981 issue of the *American Art Journal*. Tatham's work greatly expanded scholars' understanding of some of the Peaceable Kingdoms' symbolic elements and convinced me of the strong influences that the Quaker schism and division of 1827 had on the painter. Although Ford, Mather, Miller, and others also wrote about these influences, Tatham's work is critical to understanding the core meanings behind most of the Kingdom pictures.[6]

The purpose of this volume is to examine issues introduced but only partially explored by previous researchers, and to discuss several new topics. Chief among them is the nature of the Hicksite-Orthodox controversy, as it is commonly called, and its impact on the art and life of Edward Hicks as first interpreted by Tatham; Hicks's role as a minister and his close association with Elias Hicks, a cousin from whom the term Hicksite derives; and, most importantly, to reassess the symbolism in Edward Hicks's paintings.

It is a rich story, not altogether without confusing twists and turns, but certainly worth the hours required to gather and piece it together. The Kingdom pictures are the focus of this study, just as they were the favored genre and vehicle by which Edward expressed his most personal and impassioned observations about the Quaker religion and the issues deliberated by Friends from about 1811 through the mid-1830s.

Other works by the artist, many of which were directly influenced by Quaker beliefs as expressed in the Kingdom pictures, figure in this story. The farmscapes and pastoral pictures reflect a concern for the orderliness and serenity that can be achieved in earthly and material life as guided by the Quaker tenets of simplicity, pragmatism, and spiritual well being. Most of the historical paintings derived from the artist's deep reverence for spiritual freedom that underscored civil liberty. William Penn's life exemplified these beliefs to Edward. The Declaration of Independence pictures symbolized for Edward the achievements of the Revolution, not the military conflict by which it had been won. The paintings of General Washington and his troops at the Delaware River crossing may be interpreted as contradictory to the idea of peaceable coexistence and harmonious life. Hicks, however, viewed the great general as a leader who won a moral war in which the enemies of civil and religious freedom were defeated.

Of all the types of paintings Edward produced during his lifetime, none was repeated as often or with greater attention to change and refinement than the Kingdom pictures. They are the most familiar, outward expressions of the artist's inward feelings and beliefs, however contrived they may seem to modern viewers. The tension between inward spiritual and religious life and outward worldly life was the catalyst for these paintings and nurtured their creation over many years. The artist's preoccupation with these pictures, of which sixty-two are known today, was deeply personal and was driven by his need to visualize in the most expressive way possible the lessons to be learned from Isaiah's prophecy. Of utmost importance to Quaker quietism, such lessons centered on denying or relinquishing the willful self. Stated another way, one must suppress any participation and interest in superfluous outward and worldly concerns and passions. The failure to do so was, in Edward's opinion, the root cause of the schism. The Kingdom pictures were therefore reminders of a critical Quaker requirement: creaturely concerns were always of lowest priority, and undesirable ones must be purged from one's life so that it could be filled and guided by the divine grace

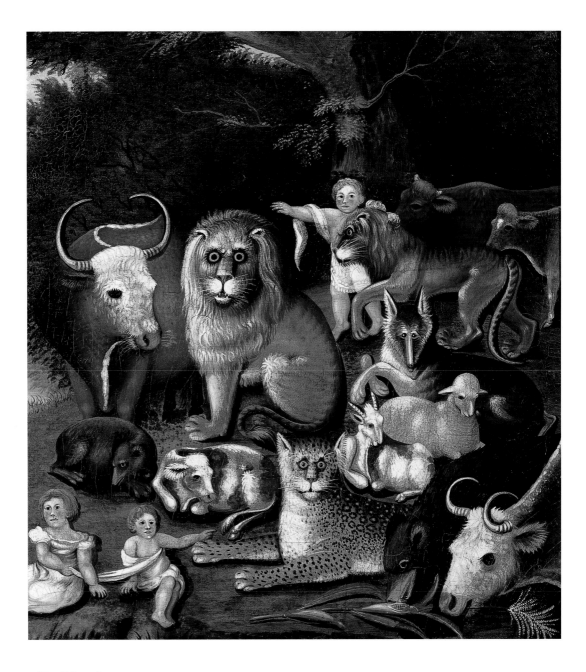

2. Detail from fig. 117.

of God. Only in such a state of inner quiet could one receive God's message, or "Inward Light" of Christ. By 1829 and the early 1830s, Edward reinforced this concept in the Kingdom pictures by combining a figure of Elias Hicks with lettered messages like "MIND THE LIGHT" (fig. 3).

The Kingdom pictures were not a significant or important source of income for Edward Hicks. The only account book and one daybook of shop activities kept by the artist and his son Isaac Worstall Hicks do not mention a single Peaceable Kingdom painting, although they do list a large variety of painting work and provide insight into the careers of the artist and his business associates.[7] It must be emphasized that Edward Hicks was trained as an ornamental painter, one of several trades associated with coach making. He may have learned the rudiments of carriage and coach making, but his specialty was decorative painting. Hicks became one of the primary ornamenters of horse-drawn vehicles crafted by the various coach makers living in and near Newtown. Ornamental painting was his chief source of income, while his easel pictures, such as the Kingdom paintings, were often rendered as presentation pieces for friends and family.

It is clear that easel paintings, those paintings meant to be hung or displayed in buildings, were not a significant part of Edward's business. Few of them are recorded in the surviving shop records; even fewer can be authoritatively documented as items for which Edward received any monetary payment. This is especially true of some of the history paintings, the Kingdoms, a few of the farmscapes, and the pastoral paintings. His rationale for creating works for which he received little recompense seems odd given his financial difficulties, but research by Mather and Miller shows that a large number of the original owners had close relationships with the artist. Most of them were Hicksite, either relatives or good friends who supported Edward's and Elias Hicks's ministries. The Kingdom pictures, the farmscapes, and other paintings were tangible reminders of

important beliefs and ideas Edward shared with the recipients. As such, their value transcended remuneration.

Quaker theology underscored the essential meanings of the artist's easel paintings in both overt and subtle ways. To understand these images requires considerable analysis of Edward's interpretation of Quaker beliefs and especially his work as a minister. Hicks's fame in his own time and after his death was as a Quaker minister, not as an artist. Above all else, Edward was dedicated to religious work within the Society of Friends, often at the risk of jeopardizing the Newtown shop business. His extensive knowledge of the history of the Society and even of some other religious groups and early philosophers consumed Edward's thinking and writing and was the focus of his spiritual and temporal life.

A brief summary of the organization of the Society of Friends during Hicks's life may be helpful.[8] Generally, the meetings of the Society were divided into two functions: meetings for worship and meetings for business. The purpose of the local preparative meetings was worship and dealing with record keeping for the immediate community such as recording births, marriages, deaths, and burials of members. It also recommended persons for the ministry to the monthly meeting for business for review and approval. Edward attended the Middletown Monthly Meeting early in his life and became a member of the Newtown Preparative Meeting about 1815. The Newtown Meeting reported to the Wrightstown Monthly Meeting to which Edward had transferred his membership in 1814.

Monthly meetings were composed of Friends from several preparative meetings and transacted most of the religious affairs of these Friends. In Edward's time, monthly meetings had the authority to nominate and appoint members for specific tasks and to approve marriages and construction of meetinghouses. Nominations of ministers, which usually came from preparative meetings, were reviewed and resolved in monthly meetings. Edward Hicks was recommended to and recorded by the Middletown Monthly Meeting as a minister.

3. Detail from fig. 106.

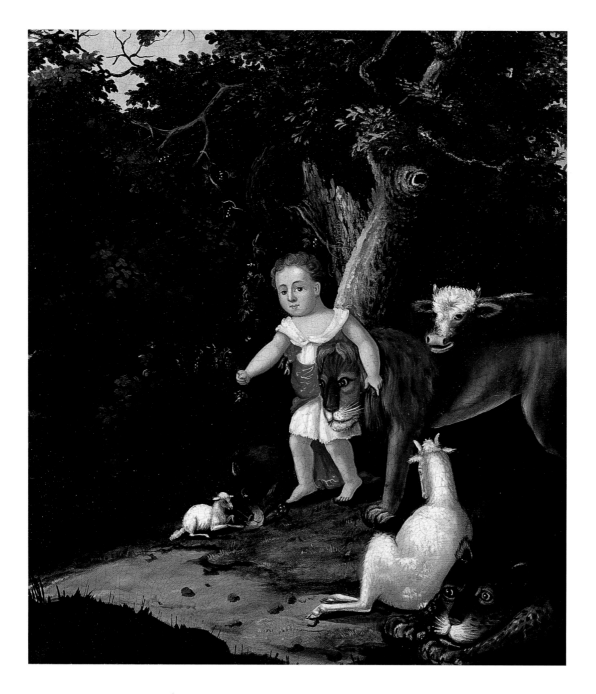

4. Detail from fig. 88.

Members of the meeting reviewed Edward's nomination and were given an opportunity to challenge his beliefs and religious practices. Once he was approved by the meeting, a written "minute" was prepared and issued by the clerk as the recording officer. Edward also was required to obtain such documents from his monthly meeting for each extended ministerial trip.

Quarterly meetings were composed of Friends from several monthly meetings. As the name indicates, they met four times a year. Among their duties were preparing business to be referred to the yearly meeting and selecting representatives to attend it. The quarterly meeting also considered matters referred to it by the monthly meetings.

Yearly meeting was the highest meeting within the Society of Friends. Hicks attended the yearly meetings in Philadelphia and New York on several occasions. As the name implies, yearly meetings occurred once a year. The yearly meeting issued official publications pertaining to discipline, faith, and practice. As needed, it also appointed committees, such as the meeting of sufferings that took special issue with Elias Hicks. Originally, the meeting for sufferings had been established in London to assist Friends imprisoned for their beliefs, but by Hicks's time it had become the central committee of most yearly meetings in Britain and America, conducting much of the business of the Society and guarding it from "error." Detailed records of these activities were kept by the clerk.

Ministers were expected to have a sound working knowledge of Scripture and of the Society's principles and practices and to be proven persuasive speakers. In general, ministers were believed to have prophetic insight. Overseers were responsible for the moral life of the Society's members. Elders attended to the spiritual welfare of the meeting, advised and counseled ministers, and served on yearly meeting committees.

When Edward or other Friends are described in the text as "giving testimony," it usually refers to their ministry voiced in meetings. "The Testimonies" of the Society of Friends concerned larger principles such as peace, equality, simplicity, and truth. "Queries," or questions pertaining to principles and practice, were used for self-examination.

It is critical to understand Edward's role in the Society because he spent so much time in the ministry and addressing the business of the Society. His life was centered in these religious activities. Many who knew Edward acknowledged this, but few recognized his art as an integral part of these activities. That the Kingdom pictures were rarely seen by other than close associates and family may explain why Hicks's motivation in painting them has been so little understood. Yet, the Kingdom pictures have been admired by viewers and sought by collectors since early in the twentieth century. Why is this so?

It is true that they are colorful, charming, and highly appealing. It may be surprising to learn, as John F. A. Sawyer pointed out, that Isaiah's prophecy contained in Isaiah, chapter 11, was used infrequently in the visual arts before the modern era. Only a few depictions of the prophecy created before Edward Hicks's time can be documented worldwide. Sawyer states, "It was without a doubt the paintings of . . . Edward Hicks . . . that gave the passage its popularity, especially in the States."[9] In today's world, and independent of their obvious appropriateness to socio-political causes, the Kingdom pictures and Isaiah's prophecy are used in ways that range from arguments over the slaughter of animals to issues of ecological and environmental ethics. Steven C. Rockefeller explored this issue in an especially useful way by tracing the history and importance of the reverence for life, the fundamental moral principle in Edward's paintings and the prophecy.[10] On reflection, some readers may discover that they, too, intuitively respond in a positive way to Edward Hicks's paintings for this important reason.

The most powerful and moving aspect of the Kingdom pictures for many viewers is the contemplation and hope for peace they portray. We all yearn for peace, how-

ever elusive it may be. But it is also true that other viewers are attracted to certain of these paintings because they evoke an energy and tension that beg to be understood. These qualities are especially noticeable in the Kingdoms dating from the mid-1830s that feature wide-eyed lions and sensuous leopards (fig. 5). The iconography of these paintings is familiar, but on second glance, it seems a little perplexing. The challenge for viewers is to connect the meanings with the animals and other elements in the pictures.

Humans have identified with the world of animals since the beginning of time, using them metaphorically to express all manner of behaviors and actions. Viewers are familiar with creatures and meanings associated with them. Today, a crisis might elicit, "I've got a tiger by the tail." One's timid friend might be called "meek as a lamb"; one who cannot be trusted, "a wolf in sheep's clothing." These symbolic messages have been extended to the material and natural world as well. March roars in like a lion and leaves like the gentle lamb. Putting a "tiger in your tank" is slang for putting gas in the car; "Tony the Tiger" of cereal fame recommends fueling your tummy. Fables, literary works, music, and other forms of art have been and continue to be contrived around themes that use animals to impart messages.

Considerable time has been spent locating and re-viewing extant original documents quoted in earlier works and identifying additional primary sources, especially those in collections of the Bucks Country Historical Society, Doylestown, Pennsylvania, Bucks County Courthouse, Doylestown, Pennsylvania, Friends Historical Library, Swarthmore College, Swarthmore, Pennsylvania, Historical Society of Pennsylvania, Phialdelphia, Pennsylvania, and Newtown Historic Association, Newtown, Pennsylvania.

I have paid particular attention to materials related to Edward's ministry and the schism, although this book is about the schism only as it affected Edward Hicks. I have limited the work to the various points noted here and have simplified, wherever possible, the sometimes difficult and often tedious period prose used to explain or illustrate Hicksite Quaker viewpoints. This has not been easy because many persons, many debates, and many events had to be considered. Furthermore, it was necessary to understand modern theories about the causes and nature of the separation that occurred in 1827. Often these sources offer conflicting information. To understand Edward's life and work, I relied heavily on Hicksite writings and records and their interpretation of the events surrounding the schism.

The back matter includes an updated genealogical chart for the Hicks family since it can be difficult to sort out the roles and relationships of the people associated with Edward Hicks. The accompanying text clarifies the often bewildering relationships that existed among family members with the same or similar name who lived primarily in New York and Pennsylvania. There is an annotated checklist of all the extant works by or attributed to the artist, although not all of the works are discussed or illustrated in the text. Excerpts from Edward Hicks's Goose Creek, Virginia, sermon in which he methodically outlined the meanings and propensities associated with the carnivorous animals in the Peaceable Kingdom paintings is also included. The bibliography contains works consulted.

The story of Edward Hicks's life and art is presented in a chronological framework, which afforded the clearest way to address how the issues of the schism influenced the artist. In the end, simplicity was the best approach to this Quaker's story.

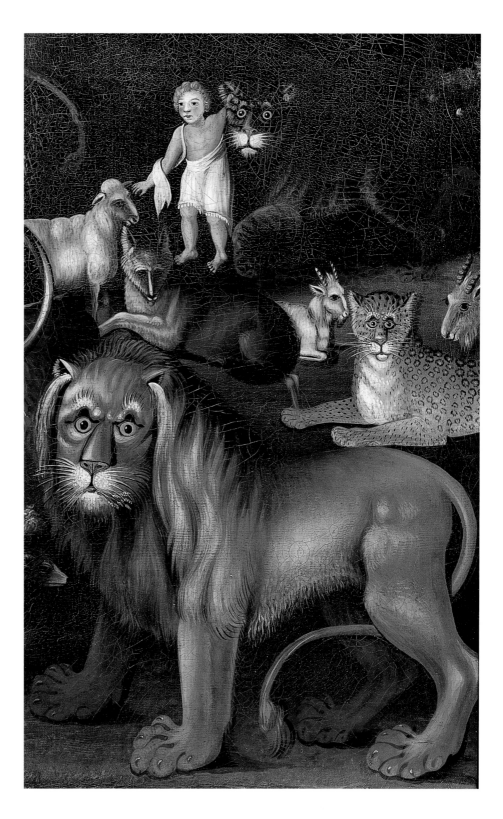

5. Detail from fig. 135.

Early Life and Career

*Where early impressions are neglected, the loss that children sustain
is almost incalculable, for … it is at a time
when the waves of youthful passion roll the highest.*

EDWARD HICKS, *Memoirs*

On his sixty-third birthday, April 4, 1843, Edward Hicks began writing what he called "a short narrative of my life."[1] Early in this account, published posthumously in 1851, Edward outlined the details of his childhood, what he knew of his ancestry, and his trials and struggles as a minister in the Quaker faith and as a decorative and coach painter.

Edward's narrative reveals that some of his early ancestors came to America from England in the seventeenth century. Several of this and later generations were members of the Society of Friends, while others were Episcopalians or Presbyterians. Edward was evidently proud of his heritage, including the important colonial government positions, prosperous businesses, and extensive landholdings owned by relations in Pennsylvania, on Long Island, and in New York City during the eighteenth century. Gilbert Hicks, the artist's grandfather, was born in Flushing, New York, in 1720. He was among those who had inherited wealth. He was also among the earliest of the family to settle in the Middle Atlantic colonies, in Bucks County, Pennsylvania, in 1747.

Gilbert Hicks had married Mary Rodman of Long Island two years before.[2] Mary's father proposed that the couple go "into the new countries, (as Pennsylvania was then called)" and settle on the six-hundred-acre parcel of land he had given them.[3] They moved to this tract in Bensalem Township, Bucks County, in 1747, built a dwelling house, and began their family. Gilbert was well educated, possessed an impressive library, and was considered wealthy by comparison with his Bucks County neighbors.[4] He owned and operated a saw and planing mill with his partner, Hugh Hartshore, as well as a tannery and a hotel in the Bucks County town of Four Lanes End (now Langhorne) where he also conducted merchandising business, land transfers or conveyancing, and practiced law. Gilbert Hicks was one of two justices of Bucks County appointed by the governor and council in Philadelphia on June 15, 1752. A number of slaves were listed among his property during the years he resided in Pennsylvania.[5]

Isaac Hicks, the painter's father, was born in Bensalem Township on April 21, 1748. Isaac was destined to inherit his father's property, including slaves and the material finery to which he was accustomed. Both Isaac and Gilbert were often referred to as "Squire" in Bucks County records, denoting their prestige and stature in local society. There was considerable family opposition when Isaac married his second cousin, Catharine Hicks, in Newtown on November 17, 1771. The family objected to their close kinship and undoubtedly thought it irregular that a Presbyterian minister performed the service since the Hickses were Episcopalian.[6] The newlyweds would live with Isaac's father.[7]

Catharine, Edward's mother, grew up in similar affluent circumstances in New Jersey. Edward wrote years later in his *Memoirs* that she was "brought up in pride, and idleness, and was the very reverse of a perfect

6. Detail from fig. 152.

woman, . . . [with] an education as was calculated to make, what the high church would call, a lady; a friend to kings and priests."[8] The artist's disparaging comments about his mother's formative years are strong but understandable given his devotion to Quaker codes of simplicity by which excessive finery and the social activities associated with genteel living were regarded as extravagant and opposed to godly living. Edward recorded additional thoughts about Catharine on pages that were eliminated from the published version.[9]

The few surviving letters from Catharine's pen indicate that she was an affectionate, attentive wife and a loving mother. As Edward pointed out early in the *Memoirs*, "The tremendous turnings and overturnings that took place in the time of the Revolution, produced a great change in my . . . family, and the success of the American patriots, in laying the foundation of the present excellent government, deprived the royal aristocrats of their lucrative offices, reducing our family to comparative poverty."[10] "This chang[e] must have deeply affected my dear mother who had been used to moving in the gayest the highest and most extravagant circles of society . . . She was frequently seen . . . seting silently by herself with her bible or prayer book bathed in tears. . . . She frequently attended friends meeting . . . she drew nearer and nearer to the society of friends and in her last sickness became fully convinced of the inconsistency of all that gayetty of dress and fashionable etiquette in which she was educated."[11]

On November 30, 1776, Gilbert Hicks, the designated local official, was directed by the king's peace commissioner, General William Howe, to read a proclamation from the courthouse steps in Newtown. The message made it clear that residents could not legally take up arms against Great Britain. Many local citizens were incensed by the British order and considered its unlucky bearer, Gilbert Hicks, a traitor to American concerns and interests. Anti-British sentiment throughout the American colonies, particularly among Patriots, was quite strong during these months, especially so in Penn-

sylvania where the Continental Congress, which was not recognized as a legal body by the king's officials, refused to send members to negotiate with the British as private gentlemen. Accounts state that Gilbert was immediately pursued by local Patriots, presumably with the intention of arresting and incarcerating him, or worse. The alarmed squire managed to escape, abandoning his property and house. Isaac, Catharine, and their children remained there for three years.[12]

Scholars have and likely will continue to debate the nature of Gilbert Hicks's loyalties during the years of war with Great Britain. In his own time, he was called a traitor, a royalist, a Tory. Much has been written about Gilbert's "fleeing" for his life—which he certainly did—to New York to take refuge with the British Army. Documents indicate that Gilbert sympathized with the colonists' position to some degree but felt that resolution should be sought through mediation and negotiation, not war. Several years later, while still in exile on Martha's Vineyard, Gilbert warned Isaac in Newtown, "Do nobly never meddle with Politicks. Your father has made himself Retched by it."[13] Gilbert never returned to Bucks County. His last letter to Isaac was dated July 7, 1786; presumably he died shortly afterward in Digby, Nova Scotia, where he had taken up residence in 1784.[14] He would never know his grandson Edward, the artist.

Isaac Hicks managed to keep his family together for several years in Newtown, although local sentiment against the son of Gilbert Hicks must have been quite strong and difficult to endure. Isaac had served for years in local government positions to which he had been appointed by the royal governor. In 1777, he was asked to resign because he was suspected of being a Tory sympathizer like his father. State officials were sent to Isaac's house to confiscate all keys, public papers, and records, collect and examine all books in Isaac's care, and place the items in the Bucks County public office.[15]

The confiscation of Gilbert's lands by Patriots and the sale of all or most, despite the efforts both Gilbert and

Isaac made to save them, was the final devastating blow to Isaac's young family.[16] On September 27, 1779, he wrote to John Dickinson of Philadelphia, explaining that "I am now about breaking up house keeping, being obliged to it by the sale of my father's house I now live in, and as I am shortly to remove my wife's children and a servant [probably Jane] into a neighbour's house with a large family and going myself to the West Indies."[17]

Isaac wrote Dickinson again in November 1779 that on "Monday next the person [who] purchased my father's house (in which I now live) is to move in when I shall then be reduced to one room untill I remove my family elsewhere."[18] There is no evidence that Isaac ever went to the West Indies, although it is possible since some family members had connections there.[19] If he did, the sojourn was brief, because in April 1781 the Executive Council issued Isaac a pass requesting he leave Bucks County for New York until the war was over. The few surviving records suggest that Isaac may have gone briefly to New York, perhaps to stay with his father, but his family responsibilities in Pennsylvania could not be ignored.[20]

During this difficult period, it is not clear whether Isaac, Catharine, the children, and Jane, whom Edward described as "a colord woman that had been an inmate in the family," were living on property owned by the family, in rented housing, or with a neighbor.[21] Edward Hicks's birth on April 4, 1780, was recorded for Attleborough, Middletown Township, Bucks County, suggesting that the family was possibly still living on Gilbert's land.[22] At this time, the Hicks family included Gilbert Edward, May 11, 1773–September 14, 1836, and Eliza Violetta, March 17, 1778–July 17, 1817.[23]

Catharine Hicks died at age thirty-six (or thirty-seven) on October 19, 1781. Catherine was buried in Burlington, New Jersey, where she had been living with relatives during her illness. The date of her death is difficult to confirm. Edward wrote in the original *Memoirs* manuscript that his mother died on October 21 at age thirty-seven. October 19, 1781, is given in the surviv-

ing Hicks family Bible. So the popular story goes, Edward, then about eighteen months old, was left in the care of Jane, probably a free black or a slave in Gilbert Hicks's former household. Edward wrote that Jane, "being left to shift for herself, took me with her like her own child, for my father was now broken up, having no home of his own, or any business by which he could support and keep his children together."[24] It is unclear where Edward's siblings were when their mother died.[25]

Little else is known about the artist's early life with his natural family. It is difficult to measure what impact these unsettling events had on him, although his mother's death had an enduring effect. Edward's separation from his father for most of his childhood undoubtedly contributed to the uneasy relationship between the two in later years. Edward was given to periods of extreme sadness, anger, and joy, any one of which often reduced him to tears. Such emotional swings may have been a result of childhood experiences and circumstances created not only by the absence of parents but also by the family's reduced financial circumstances and social standing within the community. In his writings after he joined Quaker meeting, Edward continually stressed the importance of motherhood and parental care of children early in life, noting that "where early impressions are neglected, the loss that children sustain is almost incalculable."[26] In light of his young age and chronic frail health, Edward's loss must have been enormous. His mother was dead, and he would never live with his father and siblings as a family unit. He would continue to see and communicate with his father, but their relationship seems to have been distant and difficult at times.

Soon after Catharine's death, Isaac Hicks decided to board out two of his children, providing them schooling as possible. Eliza Violetta (fig. 7) went to live with Catherine Heaton. Edward wrote in the *Memoirs* that his sister was "brought up in the gay world in pride and idleness." Gilbert was now being boarded and schooled by James Boyd, with whom he remained until 1788,

7. Eliza Violetta Hicks, by an unidentified artist, 1810–1816, cut paper, 3¾″ diameter. Courtesy, Newtown Historic Association, Newtown, Pa.

after which he became a medical student with Dr. James De Normandie until April 1792. Gilbert later established a medical practice.[27]

In June 1783, Isaac Hicks recorded in his account book that he had paid David Twining £4 for boarding his youngest son, Edward. Isaac's accounts reveal that he and David Twining had been transacting business as early as the 1770s, so the families had surely known each other for years. Isaac recorded additional compensation at the rate of £12 per year from 1784 to 1787. Although payments after 1787 are not listed in the accounts, the amounts probably were similar. The agreement included Isaac's concern that Edward be allowed to receive an education.[28]

The years following the war were difficult for Isaac, but eventually he was able to secure modest work and positions. In 1783, he was employed in Bucks County for a time as surveyor, a job he continued to do over the following years. In May 1791, he wrote to Thomas Riché, of New Windsor, Pennsylvania, soliciting an appointment as justice in Bucks County. Isaac described himself as "once somebody" but now "hardly anybody." He hoped that Thomas would help him "be made a little some-

body."[29] The following year, Isaac married his second wife, Mary Young. He spent the rest of his life in Newtown.

It is likely that servant Jane lived in Isaac Hicks's household before Edward was boarded out. Edward wrote that she "worked in the neighborhood of Four-lanes-end, or Attleborough and Newtown, for a living, taking me with her." At the William Janney house in Newtown, "Elizabeth, the wife of David Twining, was . . . visiting, she noticed a poor sickly-looking white child, who appeared to be under the care of a colored woman that seemed cross to it."[30] When Elizabeth Twining asked whose child the baby was, friends replied that the boy was "Kitty" Hicks's youngest child.

Whether out of friendship or sympathy for the child's welfare, Elizabeth Twining and her husband arranged with Isaac Hicks to board Edward. This well-to-do Quaker couple, who lived on a sizable farm just outside Newtown, nurtured and raised Edward as part of their family that included four daughters, Sarah, Elizabeth, Mary, and Beulah (fig. 8). Edward did not describe Sarah Twining in his *Memoirs*. Elizabeth married William Hopkins, a friend from Philadelphia. Of Mary, who

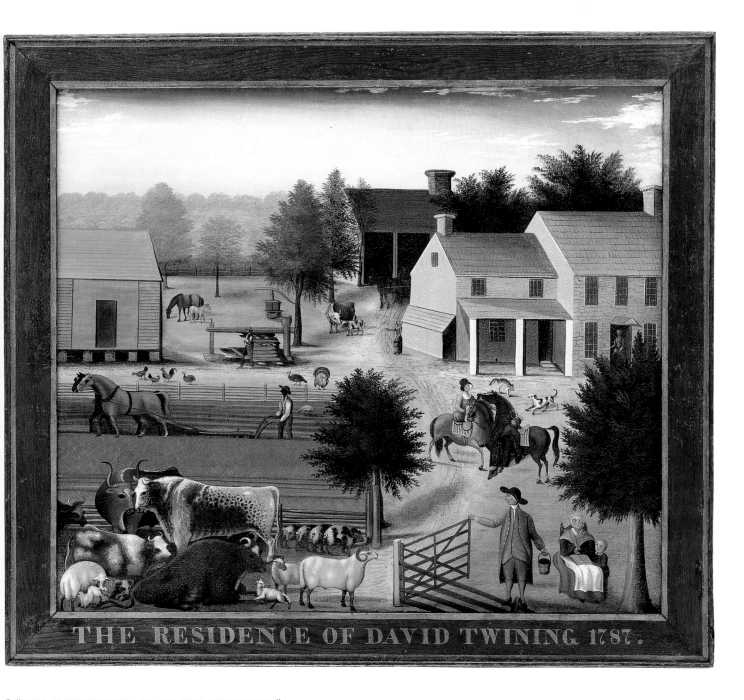

THE RESIDENCE OF DAVID TWINING. 1787.

8. "THE RESIDENCE OF DAVID TWINING,"
by Edward Hicks, 1845–1847, oil on canvas, 26½″ x 31⅛″.
Abby Aldrich Rockefeller Folk Art Center.

married Jesse Leedom of Northampton, he stated, "Should I survive her, I shall have to say, I have lost the best friend I have in the world out of my own family."[31]

Edward wrote that Beulah, the youngest Twining girl who was about fourteen years old in 1783, was "possessed of more than ordinary powers. . . . but the improper indulgence of her eccentric self-will, threw her out of orbit; . . . she was more like the comet that takes an eccentric course among the constellations of heaven, and shines, or rather dazzles, only for a moment, and then sinks into oblivion. Dear adopted sister, Beulah E. Twining, thy history . . . would furnish materials for one of the most interesting pernicious novels, . . . She was the favorite or pet of her father, and transacted the principal part of his business."[32] Beulah married out of the Quaker faith to a Presbyterian minister and physician "whose only recommendation was a handsome exterior," according to Edward. She later divorced the "handsome exterior" and lost all of her estate in a lawsuit associated with the divorce. Beulah subsequently returned to Newtown and "became reinstated a useful member of the Society of Friends." She was a great friend to Edward throughout his lifetime. He remarked, "She was a sister I had reason to love; she was a friend in need, and therefore a friend indeed."[33]

Edward wrote that David Twining (fig. 9) was "a respectable member of the society of friends and . . . one of those extraordinary men that wherever they stand they stand upright and dignified either as pillars of the church or sinues [scions] of the state."[34] The highly respected, successful farmer also influenced Edward's life because of the collection of books he helped form to which Edward had access. In 1760, twenty years before Edward was born, the Library Company of Newtown was organized at Twining's farm. David served as treasurer for twenty-five years and was on the first board of directors. Named librarian, he was among those appointed to procure books for the Library Company in 1761. The books were kept at Twining's home since the company had no building. The library was still at the farmhouse when Edward lived there, and the collection served as his first introduction to literature, particularly those titles approved for Quaker readers.[35]

Edward expressed his devotion to the Twining family in his description of Mrs. Elizabeth Twining (fig. 9). "She was," he wrote, "certainly the best example of humble industry I ever knew for so wealthy a woman. . . . She had the simplicity and almost the innocence of a child. . . . she read the Scriptures with a sweetness, solemnity, and feeling I never heard equalled. How often have I stood, or sat by her, before I could read myself, and heard her read, particularly the 26th chapter of Matthew, which made the deepest impression on my mind."[36]

Edward was closer to Elizabeth and Beulah Twining than to David, probably because the latter died in 1791 when Edward was only eleven years old. After David's death, Beulah, then twenty-one, took over the management of the farm.[37] Edward's four paintings of the Twining farm and its residents commemorate his fondness for the Twining family as he remembered his childhood among them (figs. 8 and 162).

Not much is known about Edward's relationships with his father and siblings during his time with the Twinings. Isaac married Mary Young in 1792 and purchased a frame house on Main Street in Newtown about that time. Eliza Violetta, then fourteen, lived with them.[38] In 1793, Isaac, arranged for Edward's apprenticeship, beginning at age thirteen, with coach makers William and Henry Tomlinson in Attleborough (now Langhorne). Edward observed that his father, "finding himself disappointed in his prospect of making a great man out of a weak little boy, by scholastic learning or education, did the best thing that he could have done, by binding me out an apprentice to an industrious mechanic. . . . He was disappointed in my not taking learning for he intended me for a lawyer, as he had made a doctor of my only brother Gilbert."[39]

During his apprenticeship, Edward lived at Attleborough with William Tomlinson and his wife, Rachel,

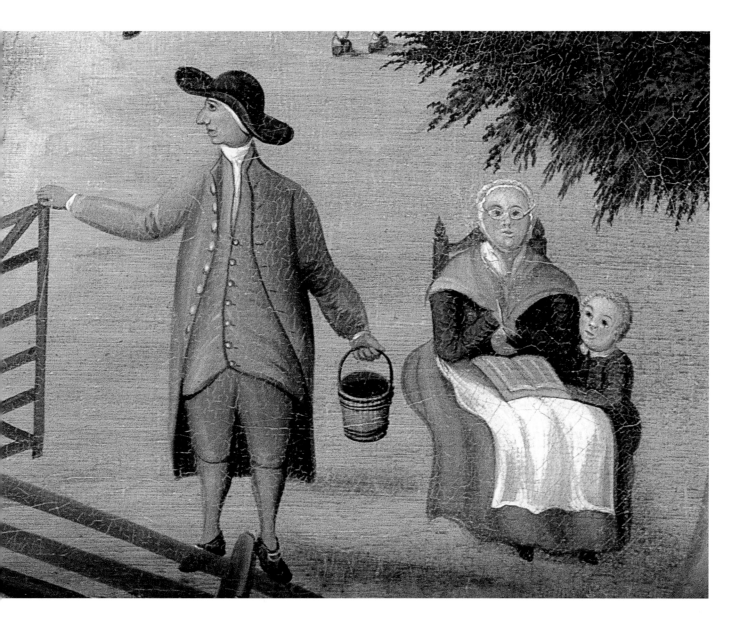

9. David and Elizabeth Twining with young Edward Hicks, detail from fig. 8.

10. Tomlinson-Huddleston House, Langhorne, Pa. As an apprentice, Edward lived in this house on Maple Ave. with William and Rachel Tomlinson. Courtesy, Dona Colatriano and Florence Wharton. Photograph courtesy, Randl Bye.

11. The Langhorne Hotel, Langhorne, Pa. After fire destroyed their shop in 1793, the Tomlinsons operated a tavern in this building. Edward lived and worked at this site until the spring of 1795. Courtesy, Dona Colatriano and Florence Wharton. Photograph courtesy, Randl Bye.

whom he described in the *Memoirs* as being "young married people" in 1793 (fig. 10). According to most sources, the Tomlinson shop burned about six months after Edward arrived, and the firm did not reopen in a new shop until spring 1795. During those years, Edward's uncle, Colonel Augustine Willett, allowed William Tomlinson, who had a tavern license for Middletown Township, to operate Willett's vacant tavern (fig. 11).[40] The Tomlinsons and their apprentices worked in the tavern. Edward served as a lackey, shoeblack, hostler, and bartender in the tavern, where he was "too often exposed to the worst of company." He noted that "it was the time of what is called the Western expedition, when there was a great deal of military parade and excitement."[41] The sights and sounds inspired the impressionable Edward to read about soldiering and war campaigns. Edward enrolled in the militia, although his fascination with martial music and regimental splendor

seems to have been the prime motivation and was short-lived. He apparently resigned in 1801.[42]

Edward's flirtation with the military occurred after the Tomlinsons returned to coach making in spring 1795. The reopened business, located in a stone house on Washington Village in Langhorne, included newly furnished shops for both coach making and coach painting.[43] Edward's apprenticeship with the Tomlinsons concluded in 1800. He remained with the firm as a journeyman for about four months, and then went into business for himself as revealed by his account book.[44] From the beginning, his specialty seems to have been painting. Dr. Joseph Fenton, a Presbyterian living in Northampton Township, was one of his first customers. Edward roomed with the Fentons for an undetermined length of time. While there, he helped the doctor build a new carriage in the winter; when the weather warmed, Edward painted Fenton's house.[45]

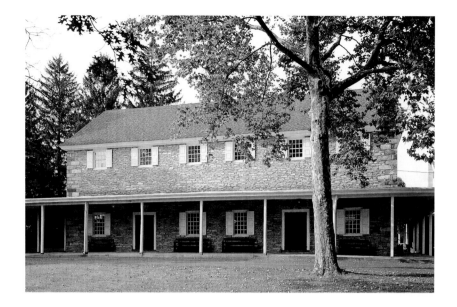

12. Middletown Meetinghouse, Langhorne, Pa.
Courtesy, Dona Colatriano and Florence Wharton.
Photograph courtesy, Randl Bye.

During his stay with the Fentons, Edward began to consider his religious life seriously. He claimed in the *Memoirs* that the suffering he endured after habitual bouts of drinking and frolicking in Philadelphia were a strong motivation:

I was now approaching my twenty-first year, and had left the volunteer company [militia] I belonged to, and was in fact under the preparing hand for a change. I had often serious and even sorrowful thoughts, when alone, and was disgusted with myself and all my conduct, though I could not find that I had ever done an act which, if published before an earthly tribunal, would leave a stain on my moral character in the sight of men. But I continued exceedingly fond of singing, dancing, vain amusements, and the company of young people, and too often profanely swearing when angry or excited, although my associates were more respectable than formerly.[46]

In 1801, Edward returned with a friend from Philadelphia in a snowstorm. Singing all the way, they stopped at several taverns:

About midnight I was awakened with the same alarming symptoms I was attacked with a year before ... when I was only saved from death by a miracle. The thoughts of the promises I then made and broke, . . . produced a horror which I cannot describe. My friend the Doctor [Fenton] gave my body relief, but my mind was too solemnly impressed to be cured by any thing but a heavenly physician. From this time my appearance was somewhat changed from a sanguine to a melancholy cast.[47]

From that day on, Edward claimed to have shunned young company and often walked about by himself. On one such outing, the artist found himself in front of Middletown Friends Meeting (fig. 12). He went in, and

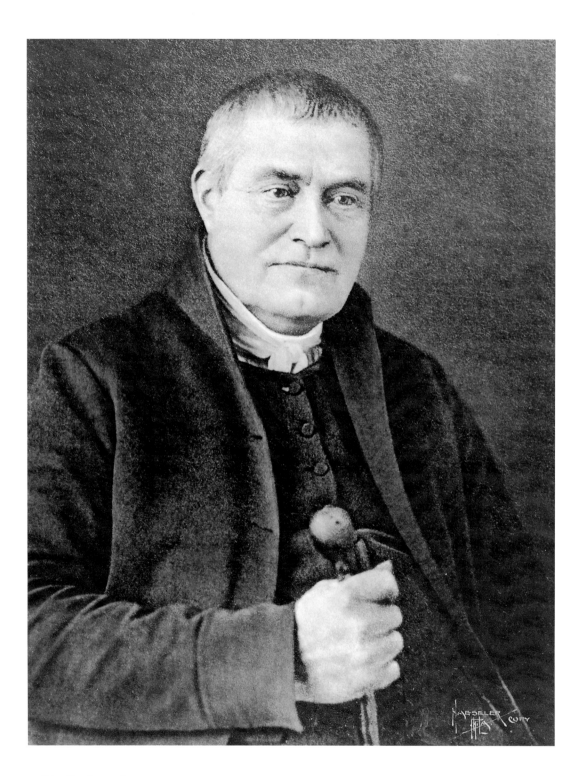

13. John Comly, ca. 1845.
Courtesy, Friends Historical Library, Swarthmore College, Swarthmore, Pa.

thereafter continued to walk five miles to the meeting every First day while he lived with the Fentons.[48]

Dr. Fenton strongly urged Edward to join the Presbyterian church. Edward, though, was already well aquainted with Friends and saw several socially, including the young John Comly and James Walton, whose religious persuasions seemed more in line with Edward's spiritual needs.[49] "About a year before this contest with the Doctor, I had become acquainted, at a debating society in Attleborough, with John Comly and James Walton, young Friends from Byberry. John was considered a great scholar and a great speaker, and appeared to me a very plain, exemplary, and religious young man. James appeared equally exemplary, but, like myself, had no talent for public speaking," wrote Edward.[50] Described as a "Quietist Mystic," Comly had gone to Westtown, Pennsylvania, to teach in 1801 (fig. 13). Sensitive to both temporal beauty and inner spiritual harmonies, Comly was a gifted teacher and administrator of Quaker schools, and, in 1813, he became an acknowledged Quaker minister.[51]

Edward continued to see his good friend Comly over the next years. By February 1803, their relationship had grown close in spiritual and personal matters. Comly, always sensitive to Edward's carefree behavior, remarked on a change in his friend:

This afternoon had the company of Edward Hicks, profitably so, I hope, as his sobriety and seriousness stirred up the pure witness in me, and my mind was brought into a state of more inwardness and humility, and though the channels of free converse were much closed, I trust silence was profitable for us. Hence an important lesson may be learned, that to dwell deep and inward is far better than a loquacious, superficial appearance of friendship.[52]

Edward was invited to join a young Friend, Joshua C. Canby, in the coach-making business in Milford (now Hulmeville), Pennsylvania, several miles from Newtown, in August 1801. Edward assisted in painting coaches and other vehicles, earning $13.00 a month. Since Edward was already attending Quaker meetings regularly, the conditions of his employment included an understanding that he be allowed to attend meetings from 9 A.M. to 2 P.M. every Fifth day, or Thursday. Edward walked the two and one-half miles to Middletown Meeting every week. By 1803, Edward's association with this meeting was well established. He applied for admission to Middletown Monthly Meeting and was received into membership.[53]

Among the members of Middletown Meeting was Sarah Worstall, the daughter of Newtown tanner Joseph Worstall. Sarah and Edward had known each other for years since her parents were neighbors of Edward's father in Newtown. They married on November 17, 1803. The artist wrote forty years later that his wife "was the first object of my youthful affection, even whilst I was a child. I loved her with that love which an all-wise Creator has placed in every perfect nature, . . . and after a union of forty years, I am thankful in being able to say that I feel an increasing love for her."[54]

Artist and Minister

Are poor Friends' necessities duly inspected,
and are they relieved and assisted in such business as they are capable of?

EDWARD HICKS, *Memoirs*

After their marriage on November 17, 1803, Sarah and Edward Hicks rented rooms "in a small house for we were poor, and I had not wherewith to build or purchase."[1] Their first child, Mary, was born in Milford on October 12, 1805. Sometime in that year, Edward, who apparently had little understanding of such transactions, borrowed money to buy land and build a dwelling for his family. The lender may have been Joshua C. Canby or one of his relatives. Edward purchased a small lot on Oxford Road from John Hulme, Canby's father-in-law, for $88.88. The house was completed between 1806 and 1808. In 1808, there was a significant rise in property taxes in Milford on buildings and related "improvements." Higher taxes, interest and principle due on the loan, and a growing family to support marked the beginning of the financial problems that plagued Edward most of his life.[2] Edward wrote, "Better might it have been for us if I had not been persuaded to borrow money and build a house, when I was not able to pay for it. This was the commencement of serious pecuniary embarrassments, . . . I am prepared to give or leave this advice . . . NEVER GO IN DEBT—NEVER BORROW MONEY."[3] Arguments against borrowing money at high interest rates, or "usury" as he continually referred to it, would have a prominent place in Edward's ministry.

Although incomplete, the most important record of these years is Edward Hicks's account book, which he began shortly after completing his apprenticeship in 1800. This document provides a detailed listing of the work Edward performed, including a great deal of painting of various types of horse-drawn vehicles, varnishing, painting floor cloths, "making" (probably gilding) weather vanes, sign painting, house painting, and painting furniture such as chairs, chests, tables, and bedsteads. Edward seems to have been regularly employed, although the number of transactions per year are far fewer than those recorded after he opened his own shop in Newtown.

By late 1810, Edward and Sarah had decided to move to Newtown permanently to be near Sarah's parents, Edward's father, and Edward's sister, Eliza Violetta, all of whom lived there.[4] The Milford house was conveyed by deed to a Mr. Mitchell of Bristol for $1,650 on April 1, 1811. Edward probably used all or a portion of the income from this sale for the future Newtown property, although finding a house he could afford was difficult. He initially proposed buying a house from Abraham Chapman, a lawyer in Newtown, but was unsuccessful. Chapman soon reversed his decision and sold the dwelling on Court Street to Hicks (fig. 15). Edward paid Chapman $1,200.00 for the house with the understanding that Chapman would continue to board in the dwelling for $2.00 per week. The Hicks family moved in on April 16.[5]

Edward probably had other reasons for moving away from Milford. His participation in Quaker meetings had increased. By 1809, he had been appointed by Middletown Meeting to serve testimonies against several individuals, including friends and customers such as

14. Detail from fig. 158.

Thomas Evans and William Janney. He also belonged to a debating society and "got to be a great talker, and a great fault finder, . . . I was moreover a very zealous temperance man, and of course denounced every one, particularly Friends, who sold or used distilled spirituous liquors."[6]

Edward was given to emotional outbursts at this time. In the spring of 1810, he attended the yearly meeting in Philadelphia and noted that it was "ever memorable to me" because it was then that he first "gave up publicly to advocate the cause of *Christ*. I trembled, I wept, and kneeling I offered a few words in prayer . . . for two or three weeks I loved every one I saw."[7] During that year, the matter of advocating temperance came up at one of the Buckingham Quarterly Meetings Edward attended; he was appointed and willingly served on a temperance committee established at Buckingham. Hicks criticized Canby and his sons for trafficking in liquor. Apparently, the artist also chastised and angered the Hulmes. Edward admitted in his *Memoirs* that "I therefore, towards the close of the year, sold our house and lot in Milford, intending to move to Newtown."[8]

Edward remained a diligent attendee at meetings, whether weekly, monthly, quarterly, or yearly. Because there was not yet an official Newtown Meeting, most Friends from the town attended the closest weekly meeting, which was in Makefield. Edward also continued to attend Middletown Monthly Meeting until at least 1813. After several successful speaking opportunities while on business to the Eastern Shore of Maryland and Brandywine and Wilmington, Delaware, Edward was recommended and approved as a minister by Middletown Monthly in the fall of 1811. As Edward remembered, some elderly Friends in Wilmington had "forced" him into the meeting gallery to speak. He was favorably received everywhere he spoke and went home "something like a head and shoulders higher than when I left."[9]

By 1813, the thirty-three-year-old Quaker had already opened a business in Newtown, although maintaining it in light of Edward's growing spiritual need to travel on behalf of the Society proved to be difficult. Having obtained a minute from Middletown Monthly Meeting to visit the meetings in Philadelphia and Abingdon Quarters, Edward was again on the road. He traveled across New Jersey to Great Egg Harbor in the company of the Quaker elder Stephen Comfort in spring 1813.[10] These trips and others took Edward away from his shop and

15. Court Street House, Newtown, Pa.
Edward Hicks purchased this house
from Abraham Chapman in 1811.
Courtesy, Abbeville Press.
Photograph courtesy, Alan Brady.

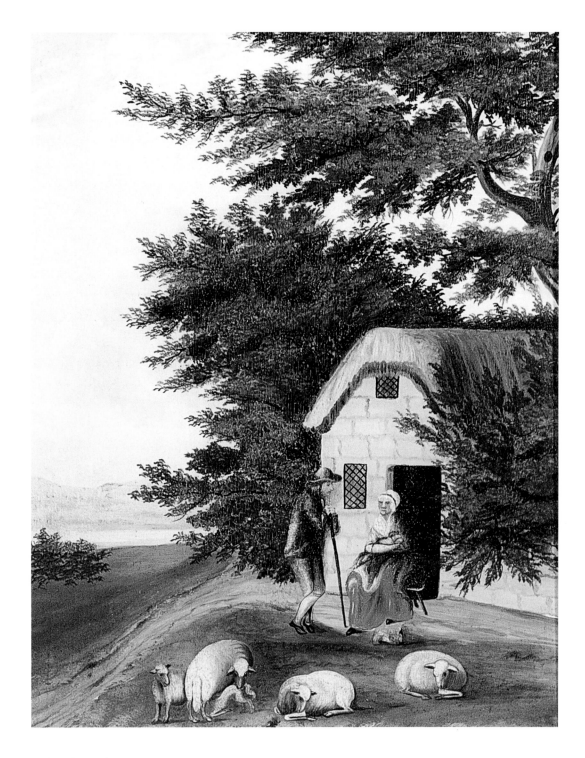

16. Detail from fig. 166.

family for extended periods. Quaker ministers were not paid for their services. Friends in the areas they visited often provided housing and food, but Edward and his companions incurred other expenses they were expected to pay. Although the artist was already in debt, his commitment to the Society appears to have been stronger than his concern for financial stability and the support of his family.

During his first years in Newtown, Edward became aware of growing discontent and the possibility that factions might form within the American Quaker community. Edward eventually was among the vanguard of Quakers who became involved in what some called the Hicksite Separation, named after the artist's cousin, Elias Hicks, from New York.

About 1811, a group of Quakers in England began to agitate for a closer association between Friends there and in America. The goal was to establish one confederation, or union, of Quakers. Some American Quakers traveling abroad or in the United States who knew of this movement rejected the concept because they feared it would jeopardize the liberty and harmony American Quakers enjoyed. In the years following 1810, various English Quakers came to America to advocate union.[11] The reaction of many American Quakers was that these emissaries were "of the high Orthodox stamp."[12]

Edward's first serious encounter with British Quakers occurred in North Meeting, Philadelphia, in 1812 or 1813. The speaker was English Quaker Susannah Horne. Edward spoke after her, to the irritation of at least a few Friends attending the meeting. The artist recalled that "when about to take my seat, a rich pompous merchant said, 'Young man sit down, thy words have not the savour of divine truth.'"[13] Undaunted, Edward returned to the meeting the next day, sat in the gallery, and spoke again, this time with humility, for he believed he had "wandered a little too far" in his comments. Others at the meeting were in unity with Edward, and it closed amicably. Three elders later visited Edward and counseled him about some of his remarks at the meeting. Ed-

ward's reaction was to accept their counseling and advice because he feared "too much like the wolf in the fable, that wanted to quarrel with the lamb for muddying the water so that he could not drink, though the lamb was below him in the stream." This sudden attention paid Edward by the elders of a large, distinguished monthly meeting in Philadelphia was intimidating and left him "in a state bordering on despair." He wrote, "I have thought that had I been of a melancholy complexion I might have been tempted to commit suicide, that dreadful sleepless night."[14]

Elias Hicks (fig. 17) attended the yearly meeting in Baltimore in 1811. A renowned, learned, and eloquent Quaker minister who had traveled widely to meetings throughout America, Elias's opinions and position on church issues carried significant weight with many Friends. In Baltimore, a delegation from the Philadelphia Yearly Meeting proposed a discussion of possible union with English Quakers. Elias rose to his feet and denounced the concept as extremely dangerous to the welfare of American Quaker liberties.[15] As one scholar has noted, "so great was his influence, and so powerful his reasoning, that the matter fell dead."[16] Elias's denunciation did not end the debate, however. Efforts to effect union continued throughout the 1820s and contributed to the crisis in Philadelphia in that decade.

Edward's application in 1814 to join the Wrightstown Monthly Meeting was approved. Although the exact date of the transfer is unknown, it is clear that one of Edward's goals was to serve as a minister at Wrightstown Monthly. The transfer was also precipitated by what the artist called a "secret conspiracy . . . forming in the select Preparative Meeting of Middletown against me, and which broke out in the next sitting of that meeting. . . . They made use of my dear old father, William Blakey [Edward's friend and mentor], as a kind of catspaw."[17] The circumstances of the ensuing conflict are confusing and the outcome puzzling. Edward made clear his leaning toward liberal Quaker interpretations of the discipline issues to the unknown conspirators. He

was so greatly hurt by the episode that, as he wrote, it was "impressed upon my mind to leave them and go to Wrightstown altogether."[18] Another reason for Edward's transfer may have been that the Twinings, his adopted family, were members of Wrightstown. Beulah would become clerk of the meeting in 1816.[19]

Edward and John Comly began to meet with Elias Hicks, whose stance on doctrinal issues and the preservation of religious liberties was well known. They met at the home of Edward's cousin, Samuel Hicks, a New York merchant, in 1815.[20] John Comly visited Elias at his home later that year.[21] Edward was also occupied with the establishment of a meeting in Newtown. The Newtown Meeting, a branch of Wrightstown Monthly Meeting, held its first worship service on April 1, 1815. The county seat of Bucks County had moved from Newtown to Doylestown in 1813, leaving the Newtown courthouse vacant and available for Friends to rent for Tuesday and Sunday meetings. Edward, who was instrumental in forming the meeting, was the first minister to speak there.[22]

The years from 1816 until mid-1818 were especially difficult for Edward Hicks. They were marked by personal tragedy, concerns for a religious life and ministry that often seemed at odds with his profession of ornamental painter, and mounting financial debts. Edward viewed himself as a "Gospel" minister gifted in giving utterance who traveled for weeks—even months—at a time visiting Quaker meetings. Ministry journeys often took Hicks away from his business, the only means of support for his growing family, which by then included Mary (1804–1880), Susan (1806–1872), Isaac Worstall (1809–1898), Elizabeth Twining (1811–1892), and Sarah (1816–1895).

Certainly, Edward was aware of the dilemma, but there seemed no immediate way for him to reconcile or accommodate successfully the pursuit of both interests. Friends close to him voiced their concern, one shared by Edward himself, that ornamental painting was not compatible with Quakerism and his ministry. Although Ed-

17. Elias Hicks, detail from fig. 108.

ward continued to wrestle with this dilemma for many years, in the end, he would not—could not—abandon painting completely. Reflecting later, Edward wrote that his constitutional nature "presented formidable obstacles to the attainment of that truly desirable character, a consistent and examplary member of the Religious Society of Friends; one of which is an excessive fondness for painting."[23]

Sometime in 1815, Edward gave up all or that portion of his painting business categorized as ornamental. He may have continued to paint utilitarian objects and plain signboards and the like. It would be a brief arrangement and a terrible decision because painting was the only

business he was trained to do. Edward knew this. He wrote that he gave up the trade "for which I had a capacity, viz. painting, for the business of a farmer, which I did not understand, and for which I had no qualifications whatever." Believing that farming was "more consistent with the Christian," Hicks was willing to try putting his brush aside. He noted, "I worked hard, I went behind hand daily. The cruel moth of usury was eating up my outward garment, soon to expose me a poor naked bankrupt."[24]

Part of the problem was a misunderstanding between Edward and his father who, according to the artist, had "given" him forty acres of land. Edward counted on farming this acreage. However, his father "altered his mind and took it from me, leaving me with only twenty acres, for which I had given eighty-six dollars per acre at public sale, and which I had to sell for forty dollars."[25] Less land to farm reduced the income Edward could earn from agriculture. Furthermore, he obviously had little experience or skill as a farmer.

Hicks could not expect assistance from his father, who was also in reduced circumstances. Sarah had no independent means. Unsuccessful at farming, Edward's only income had to come from elaborate ornamental work, the highest paying type of painting. He could not earn enough from the "plain" utilitarian painting preferred by his Quaker critics—simple ciphering and lining on common objects and signboards—to support his family. Edward thus tried to reconcile the issue of which types of paintings were appropriate for the trade of a Quaker minister with the need to earn a living. Of course, Edward was not a Quaker when he had been apprenticed to the Tomlinsons. He wrote extensively in the *Memoirs* about how he vacillated:

If the Christian world was in the real spirit of Christ, I do not believe there would be such a thing as a fine painter in christendom. It appears clearly to me to be one of those trifling, insignificant arts, which has never been of any substantial advantage to mankind. But as the in-separable companion of voluptuousness and pride, it has presaged the downfall of empires and kingdoms; and in my view stands now enrolled among the premonitory symptoms of the rapid decline of the American Republic.[26]

This was a bold, reactionary statement, an extreme of sentiment that Edward quickly mollified. Ultimately, he found justification for at least some of the work he did by rationalizing Quaker liberal principles:

But there is something of importance in the example of the primitive Christians and primitive Quakers, to mind their callings or business, and work with their own hands at such business as they are capable of, avoiding idleness and fanaticism. Had I my time to go over again I think I would take the advice given me by my old friend Abraham Chapman, a shrewd, sensible lawyer that lived with me about the time I was quitting painting; "Edward, thee has now the source of independence within thyself, in thy peculiar talent for painting. Keep to it, within the bounds of innocence and usefulness, and thee can always be comfortable." . . . And from my own observation and experience, I am rather disposed to believe that too many of those conscientious difficulties about our outward calling or business that we have learned as a trade . . . which are in themselves honest and innocent, have originated more in fanaticism than the law of the spirit of life in CHRIST JESUS.[27]

The account book indicates Edward returned to ornamental painting, at least on a modest scale, by mid-1816. In late spring 1817, Hicks's business was advertising locally, offering the usual line of work including "Coach, Sign, and Ornamental Painting, of all descriptions, in the neatest and handsomest manner."[28] Thomas Goslin operated the shop with Edward and continued to work with him for a number of years.[29]

But the issue was much more complex than Edward admitted. It involved centuries-old Quaker practices and beliefs as well as changing perceptions of Quaker aes-

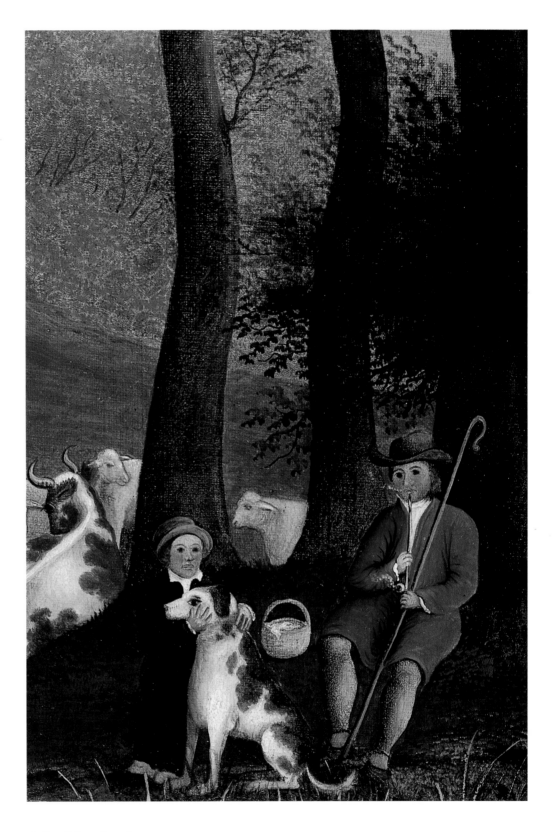

18. Detail from fig. 158.

thetics. The types of work for which Edward was criticized were the elaborate tavern signboards and pictorial art for public display that either overtly or indirectly promoted activities or ideas inconsistent with traditional Quaker beliefs.

John Comly, Edward's longtime friend, was among the first to comment on the striking incongruities between the items offered in Edward's advertisement and the artist's conversations about reconciling painting with Quaker beliefs in which he expressed a desire to follow Quaker attitudes on "useful" work. Comly wrote to Isaac Hicks, Edward's wealthy cousin in New York, in June 1817. It is the most interesting of several exchanges between the two as they considered the appropriateness of Edward's work and how to resolve the painter's financial problems. Comly wrote:

It appears that from the time he gave up to the heavenly vision, and joined in fellowship with Friends—he felt convictions in his mind on the subject of ornamental painting—These scruples he sometimes attended to—but not so fully as he believes he ought to have done, tho for some years past, he declined to indulge what is called a native genius for such paintings,—a genius, and taste for imitation, which if the Divine law had not prohibited, might have rivalled Peale or West—but as the indulgence of it, appeared to him, to feed a vain mind, and promote superfluity—and having a testimony given him to bear in favour of Christian simplicity, he clearly saw the contradiction and inconsistency of such a calling . . . Thou wilt wonder to think that with such impressions . . . [what] should induce such a man as Edward to return again with eagerness and such application as often keeps him up till near twelve o clock at night painting pictures—and to make the thing more glaring has advertised in the Bucks county papers.[30]

Alarmed about the advertisement and its disregard for Quaker codes, Comly joined forces with James Wal-

ton and visited the artist prior to writing to Isaac to report Edward's thoughts and plans:

By farming he cannot support his family and pay his interest, and as he dreads the idea of failing so as that his creditors shall lose and the cause of Truth suffer by him, he has resorted to the forbidden tree, to retrieve himself, and appears as he thinks under a necessity to make money, even at the expense of his own peace—His plans are to pursue this very lucrative branch of his business, for a time, hoping to clear $1200 a year by it—a delusive dream!! and then when his debts are paid quit it.[31]

The difficulty of paying his debts by a "delusive dream," as Comly had called it, was also an accurate assessment. The artist could barely meet his interest payments. Comly wrote time and again to Isaac Hicks about the need for funds to reduce the artist's debts. Many details about Edward's assets and financial status passed between these two men and were shared with another of Edward's wealthy relatives, Samuel Hicks, the brother of Isaac. Comly and James Walton were also secretly contacting Friends who could help. In October 1817, Comly reported to Isaac that he had advised Edward to sell some of his property since "it is not advisable for him to retain all." Comly continued:

Whether this will be effected is yet to prove—Were he to dispose of his house and lot on which he resides—and continue farming and plain painting. I think there is a rational prospect of his being able to hold the rest, . . . I unite with thee in sincere desire that he may get down to the right spot, . . . for truly he has a precious gift committed to him, that if rightly occupied and administered may be a blessing to the church.[32]

Writing again to Hicks a month later, Comly was less encouraging. He noted that efforts to obtain information from Edward about the true extent of his debts had been difficult and that the artist had given him only a partial accounting that totaled a shocking $5,000. Comly cau-

tioned that "we have reason to think on the above sum, considerable interest is due."[33] It was probably Comly who had encouraged Edward to apply to his father for the deed for the forty acres of land that he could use as collateral. Understandably, Edward's pride kept him from approaching his father because the subject was "too delicate to be attempted and likely to involve disagreeable consequences."[34]

Comly was becoming increasingly frustrated with the situation. Edward's stubbornness was part of the problem; he seems to have made little effort to help himself. Comly described the seriousness of the situation and the mounting tensions with the artist:

What then is to be done? Shall we let him sink, and all his usefulness to society be lost? Or shall we let him pursue his chimerical scheme of extricating himself by ornamental or portrait painting, in violation of the scruples in his own mind, and in contradiction to the testimonies he has borne . . . He even requests us to let him alone . . . unless he can be relieved, without being exposed, I fear, you will never see him on Long Island or elsewhere as a preacher of the gospel.[35]

More letters that expressed frustration about the situation and contained financial information and discreet requests for money for Edward followed. All of those who assisted Edward as a result of Comly's, Walton's, and Isaac and Samuel Hicks's efforts are not known, although these friends played important parts in resolving the matter. An unidentified Friend assumed one of Edward's mortgages. Beulah Twining helped too. By August 1818, Comly wrote Isaac that the financial situation seemed to have improved and that Edward, relieved of these earthly concerns, was moving on in his affairs with renewed energy.[36]

The matter of Edward's "useful" or "plain" painting versus inappropriate or "ornamental" painting seems never to have been clearly resolved or challenged again. Edward's stubborn attitude and liberal interpretation of Quaker codes as they related to his trade seem to have prevailed and were reluctantly accepted by his critics on the grounds that the artist's gift as a minister was of greater importance. In sum, his painting took the course that Edward laid for it. Edward's ministry was to continue only if his ornamental painting continued too. This testimony from Makefield Monthly Meeting appears at the beginning of his *Memoirs*:

And while he was "fervent in spirit, serving the Lord," he was also "diligent in business," laboring with his hands for the support of his family, so that he could say with the apostle, "these hands have ministered to my necessities, and those that were with me."[37]

Voices of Discord

*He travelled much in the ministry; and being favored with a comprehensive mind,
a clear vision, and ready utterance, he was enabled, when clothed with Gospel authority,
to open and explain the doctrine of the Christian religion, . . .
his testimonies were often severe. . . . yet to the penitent, to the returning prodigal,
the sinner awakened to a sense of his guilt, and to the seeking children,
his doctrine dropped as the dew.*

Testimony about Edward Hicks, *Memoirs*

Edward Hicks's reputation during his lifetime was based on his successful ministry, not on the work he did as a painter. His deep religious convictions, his spiritual life, and, ultimately, his ministry formed the center around which everything else revolved.

Like other Friends ministers, Edward devoted long periods to traveling great distances and attending as many meetings as he could. His first extended journey began on September 4, 1819 (fig. 19). It was a memorable trip. Edward later wrote, "I have told some of the anecdotes so often that perhaps, being a painter, I may have added to them a little fresh color at times."[1]

He left Newtown with Isaac Parry, an elder of the Abington Quarter, and Mathias Hutchinson, a member of Bucks Quarter. Hutchinson included an account of the trip in his unpublished journal. It corroborates Edward's.[2] Traveling through northern Pennsylvania into western New York, the men held their first meeting in Bath, New York. They attended or held meetings in many places in New York State—Rochester, Shelby, Hartland, and Lewistown—crossed the Niagara into Canada, and attended a number of meetings there. They returned home via Batavia, Scipio, Manlius, Saratoga, Troy, Cooperstown, and Newburg.[3] Among the highlights Edward mentioned were the Ridge Road,

which he described as "as great a curiosity almost as the Falls of Niagara," and the great falls themselves, which he thought a mighty wonder of the world.[4] The impression left by the falls later inspired Edward to create scenes of it on one fireboard and on a nearly identical canvas painting (figs. 20 and 21).

Edward and Hutchinson returned early in 1820. The artist had been away from his business for four months. Still, Hicks felt his mission was incomplete. After only a month in Newtown, he was back in New York State with his good friend James Walton. Elias Hicks attended nearly all the meetings on Long Island with Edward and recorded them in his journal.[5]

If the artist's recollections are accurate, it must have been about this time that he drew closer to Elias in convictions about the divisions then affecting the Society of Friends. They held similar beliefs about the Inward Light, the divine presence that guides and enlightens one's soul. Edward, Elias, and many Quakers believed it was the guiding conscience of all religious truth and was superior to the Scriptures of the church; it did not require sacraments or regulate forms of worship.

Edward received a letter from Elias asking the artist whether he "had to Combat with Beasts at Ephesus," meaning the Orthodox Friends.[6] Elias wrote to him

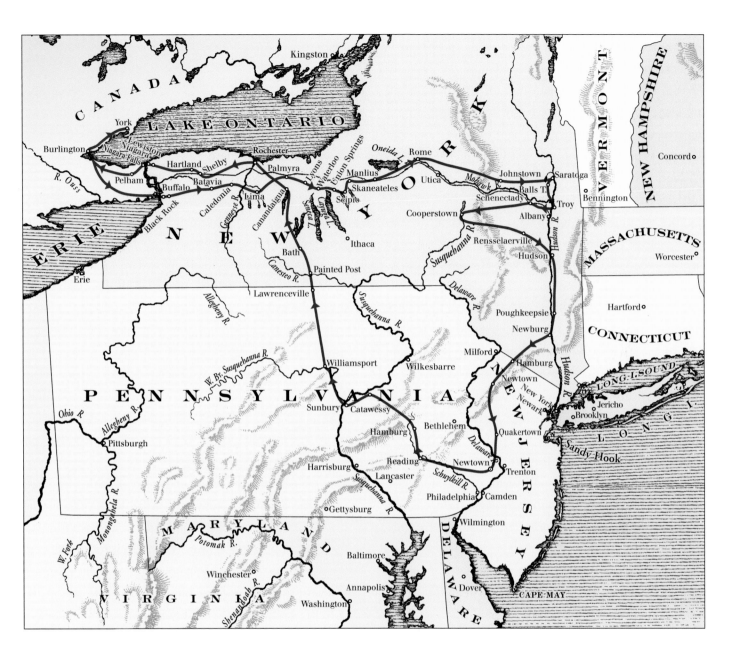

19. Map of 1819 Ministerial Journey. This shows the route Edward Hicks and his companions took through New York and Canada and the locations of the meetings they attended.

again on December 28, 1820. Edward considered this letter so important that he quoted what appears to be the entire piece, or a large portion of it, in the *Memoirs*. Elias discussed the principal causes of the division taking place among Quakers, strongly expressing the opinion that his ministry, Edward's, and those of numerous Quakers represented the true teachings of George Fox, William Penn, and others whose views formed the cornerstone of primitive Quaker discipline. They believed the "kingdom of *God* was within us, so when the soul enlists under his banner and gives *God* the whole rule and government, there that soul is in Heaven."[7] Elias regarded himself and his associates as guardians of fundamental historical Friends' teachings, warding off the "beasts of prey, or such as are seeking, by hidden and indirect means, to make an inroad on the borders of Zion, and at some seasons the warfare rises so high as to resemble fighting with beasts of Ephesus. . . . Nay, more than beasts, or creatures that range in darkness, has thy poor Elias to struggle with."[8]

Edward believed that "dear old Elias" was the "butt of Orthodox persecution" and that his words, often misquoted and taken out of context, became the focus of a conspiracy to compromise primitive Quaker discipline.[9] Both ministers frequently referred to these issues in their published sermons and other writings. The following quote by Edward captures best his feelings during the first years of debate and controversy:

The beast assumed its leopard appearance—for we must remember that the beast which John saw, was like unto a leopard, and his feet were as the paws of a bear, and his mouth as the mouth of a lion—hence the variety and beauty of our theological writings, and verbal arguments, in the form of sermons; our increasing restless state, with the carnivorous cruelty of the leopard; while the discipline was laid hold of as a sword, and wielded with all the weight of the paw of the bear, and the redoutable English lion thundered out its excommunications against Elias

Hicks, Edward Stabler, John Comly, and others, though more than one half of the Society went with the latter.[10]

Edward's strong words are typical of his style of writing and preaching. It is important to consider them because they reflect the deliberate metaphoric style commonly employed by many Quaker ministers. Elias and Edward were masters of this technique. Edward used this method in evolving the imagery in his Peaceable Kingdom paintings where animals represent as well as act out moral and religious beliefs. This kind of moralistic teaching derived from medieval humoralism. Both ministers had extensive knowledge of the four humors and their animal counterparts and meanings, although neither acknowledged their historic pagan roots.

Although he did not always agree with Elias's methods of explaining his position, Edward was nevertheless a loyal supporter of the older minister's efforts to preserve primitive Quaker discipline and eighteenth-century quietism. Elias's ministry had emphasized these issues since its beginning about 1775. Elias had a large following and was a powerful influence on those who heard him. By the first quarter of the nineteenth century, he, along with Edward's friend John Comly, were known as the principal proponents of Quaker quietism. They were conscientious men, passionately concerned with the welfare of the Society, and each brought particular strengths to the debates and events that ensued and led ultimately to the separation that occurred in 1827.[11]

The two opposing groups eventually called each other "Hicksites" (after Elias Hicks) and "Orthodox."[12] Elias neither caused nor led a movement supporting separation. His standing as America's most prominent and well-respected Quietist minister made him a natural focus for Quakers holding similar views. For many, Elias's ministry epitomized the heart of Quaker theology.[13] The passions that fueled the debates between the opposing groups had festered for years and embraced a number of complex factors, which are summarized here.

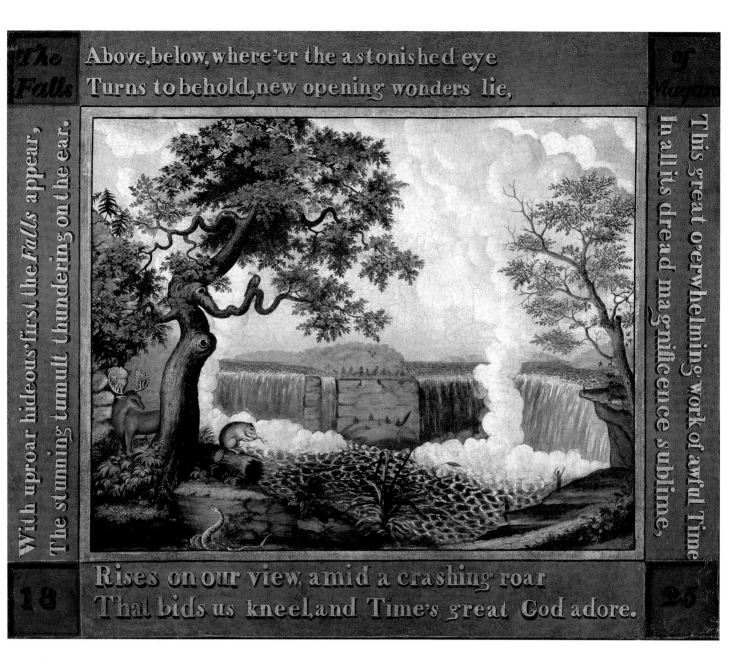

20. "The Falls of Niagara," by Edward Hicks, 1825, oil on canvas, 31½″ x 38″.
The lettered border quotes lines from Alexander Wilson's poem, "The Foresters."
Courtesy, Metropolitan Museum of Art, New York, N. Y., gift of Edgar William and Bernice Chrysler Garbisch, 1962.

Chief among the issues were the distinctions that had evolved between the English Quaker Church and the Society as it emerged in colonial America. By Edward's lifetime, the two bodies were not closely connected. After the Revolution, American Quakers enjoyed a level of personal freedom that was not paralleled abroad. The social and cultural attitudes shaped by the young democracy, ones that embraced the rights and equality of men, were widely supported by Quakers because they reflected some of their own religious beliefs.[14] Although as a Quaker he was also a pacifist, Edward Hicks ardently upheld the social philosophy of the new nation and even

praised and painted its principal hero, George Washington (figs. 6, 150–152).[15] For Quakers such as Edward, arbitrary authority would be intolerable and unbearable, and thus was a reason for debate.

The issue of authority within the Quaker yearly meetings, as held through the meetings for sufferings, became a persistent complaint of the Hicksites. Composed mainly of wealthy urban elders, the meetings for sufferings exerted the most influence and dominated nearly all matters brought to their yearly meetings. The Hicksites felt that this select group tried to impose a more rigid "external discipline [that] tends to beget blind faith in outward compulsion and skepticism as to the worth and power of spiritual forces."[16] A general revolt against the elders' use of authority thus became one of the principal events of the controversy.

Elias and Edward Hicks kept informed about current concepts, proposals, and debates on these issues. More importantly, they were familiar with the fundamental and historical roots of such theological debates since the formation of the Society of Friends in seventeenth-century England had resulted from them. They both had read and occasionally quoted Thomas Paine's *Age of Reason*, much of which the author based on the writings of Voltaire.[17] Both ministers understood that the important subjects of the seventeenth and eighteenth centuries had been spiritual and temporal authority. They knew that two basic concepts, reason and nature, had driven much of the theological thinking and writing during those formative years. The evangelical movement in eighteenth-century England and America was an outgrowth of these philosophical ideas.

Elias was modestly influenced by the newer tactics and methods used by evangelicals, particularly in the way he presented theological arguments and explanations. He was well known for attempting to rationalize the belief in the Inward Light by using Scripture and other materials to support it. As Elbert Russell wrote, "His theology was not important in itself, since it was never adopted even by the section of the Society which

championed his right to think for himself and which has been called by his name. It was, especially in its negative aspects, merely the occasion of the conflict which led to the separation—a conflict which would probably have arisen over some other issue in any case."[18] Most Hicksite Quakers took the position that the supremacy of the belief in the Inward Light was not novel or a new theological position. Instead, it had been emphasized and interpreted time and again in Quaker history.

Most scholars agree that differences between urban and rural Friends contributed to the separation. After the Revolution, Friends in Baltimore, Philadelphia, and New York greatly increased their assets by their diligence in business. Many became quite affluent and held leading positions in their respective towns and Quaker meetings, including quarterly and yearly meetings as well as those for sufferings. With wealth and leadership came influence. They could surround themselves with more and finer goods—often in conflict with the traditions of simplicity, plainness, and usefulness so dear to the Quaker way of life. Surviving objects owned by Quakers indicate that a number of them adopted affluent lifestyles that emphasized worldliness at the expense of plainness.

Most rural Quakers were self-sufficient and not inclined to spend extended periods in cities. They relied on farming or a trade—or often a combination of the two—to support their families and communities. They often felt "ill at ease and under restraint. In many topics discussed and opinions expressed at their hosts' tables they sensed worldliness and non-Friendly innovations" when they attended quarterly or yearly meetings in cities. Rural Quakers complained that the urban Quakers, from whom the elders were usually chosen, gave "little attention to their views." After unfamiliar or complex issues were addressed, they felt "confused and baffled, . . . [and] that policies had been put over on them."[19]

Elias Hicks, John Woolman, and Job Scott were among the first to comment on the growing worrisome

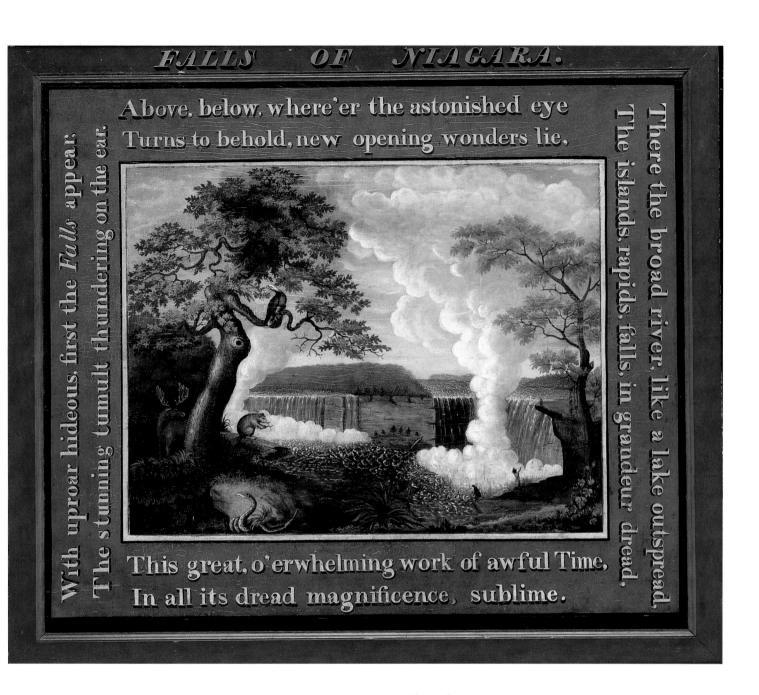

FALLS OF NIAGARA.

Above, below, where'er the astonished eye
Turns to behold, new opening wonders lie,

With uproar hideous, first the *Falls* appear;
The stunning tumult thundering on the ear.

There the broad river, like a lake outspread,
The islands, rapids, falls, in grandeur dread,

This great, o'erwhelming work of awful Time,
In all its dread magnificence, sublime.

21. "FALLS OF NIAGARA," by Edward Hicks, 1825–1826, oil on wood panel, 22¾" x 30⅛".
Some of the lettered verses, derived from "The Foresters" by Alexander Wilson, are taken from a different section of the poem than those in fig. 20.
Abby Aldrich Rockefeller Folk Art Center.

preoccupation with material life, or the outward life, which brought exposure to heretofore unacceptable social activities, excessive dress, the influence of "pernicious" literature, and the like.[20] Rural Quakers of the next generation like Comly and Edward Hicks also enjoyed less prosperity and had little experience with the elaborate mercantile systems that filled urban Quakers' purses. They continued to support the concepts of eighteenth-century quietism and usually were scrupulous in enforcing outward simplicity in personal dress, household furnishings, and social activities.[21]

The evangelical movement as it developed in England and moved to America also contributed directly to the separation. The 1740s manifestation known as the Great Awakening initially had little impact on Quakers abroad or in America. A powerful movement, the Awakening was fueled in the following years by the Wesleyan revival that embraced a rational defense of Orthodox doctrine. Its contributions to religious education, revival of the Christian faith, missionary fervor, concern for social reform, and charismatic leaders could hardly be ignored. By the end of the eighteenth century, the Awakening's steady growth and widespread appeal had attracted British Quakers' attention. By the 1800s, English Friends were moving away from the quietism of earlier years and embracing a new evangelical spirit. They began to express belief in orthodox terms and called for complete acceptance of the Scriptures.

In eighteenth-century America, members of the Society of Friends were cautious about the evangelical movement and the activities of its leaders, particularly their attitude towards the Scriptures, their emotional preaching, and their conduct in church meetings. Contact in American cities between evangelicals and Friends became more frequent by the early nineteenth century. Usually those involved felt the need to shape the Society's theology in more specific, orthodox Christian terms. These Quakers, many of whom lived in mercantile centers, also recognized the Scriptures as a basis of authority. Ideas were further communicated through members of other Christian churches who joined Quaker meetings. These converted Quakers often brought with them disparate theological ideas and evangelical experiences.[22]

The belief in the Inward Light and Quaker quietism espoused by Elias's followers and Quakers before them were in direct conflict with evangelical doctrines that included "the final outward authority of the Scriptures and the total depravity of human nature."[23] Within the Hicksite framework, spiritual freedom was essential and included the belief that only the divine spirit determined how one worshipped and what messages would be given.[24]

The Society of Friends thus divided along these lines: One group, with a large portion of its membership being rural, represented those who held strong allegiance to the traditions of eighteenth-century tenets, with a renewed emphasis on the Inward Light. Edward and Elias Hicks, John Comly, and others embraced this position. Another group, influenced and supported by English Friends, was more urban in its constituency and shared trading and other mercantile connections. This group included the elders and others who were alarmed by what they perceived as a force that threatened the authority of the Quaker discipline. Their solution was to tighten the limits of tolerance on spiritual freedom and attempt to impose greater disciplinary actions, especially against those who seemed to express unsoundness or unbelief. Both Elias and Edward would be accused of unsoundness or speaking unsoundly in meetings. On more than one occasion, they were accused of being heretics since heresy, as judged by the elders, included rebellion against their authority to interpret and administer the doctrine. Conflict that led to separation seemed inevitable, and impassioned debates over these issues would be long and without resolution. The accusations on both sides would be severe, often contorted, and very damaging.

Elias and the Elders

O Philadelphia/Philadelphia thou that killest minesters & stones some.

*Nothing short of the power and virtue of the Divine spirit, can change the heart of man,
fallen under the influence and direction of the sensual nature.
As is the fountain, so will be the stream.*

EDWARD HICKS, *unpublished Memoirs*

Four men played the most prominent roles in events leading up to the Quaker separation.[1] Elias Hicks and John Comly represented one faction. Elias, Edward's second cousin once removed, was the youngest of the three great Quaker ministers of the eighteenth century, and the only one of the three to carry his ministry well into the nineteenth century. Elias's *Journal* records that he was born on March 19, 1748, in Hempstead, Queens County, Long Island, the third child of Quakers John and Martha Hicks. His mother died about 1759, leaving five children, including eleven-year-old Elias. Like Edward, Elias did not spend his entire childhood with his natural parents and siblings. Placed with an older brother and his wife, Elias noted that he lost much of his "youthful innocence."[2]

In 1765, he was apprenticed to learn the trade of house carpenter and joiner with a master who, although he attended Friends' meetings, seemed more preoccupied with attaining wealth than with following Quaker discipline. Again like Edward, Elias went through a period of attending parties, dances, and general frolicking accompanied by liberal drinking. These were considered unacceptable activities for Quakers, and he later regretted them. On January 2, 1771, Elias married Jemima Seaman at the Friends' meeting in Westbury, Long Island. The young couple moved to her parents' home the

following spring, where Elias helped with the farm and presumably carried on his carpentry trade.[3]

Elias experienced considerable anxiety about the state of his religious life about 1774 during the period of rapidly deteriorating relations between Great Britain and the American colonies. He was deeply troubled by these events, although as a Quaker, and thus a pacifist, Elias would be exposed to many "severe trials and sufferings" during these years. For Quakers, liberty and civil rights were cherished beliefs, but attaining them through armed warfare was unacceptable.[4]

From about 1779 until his death in 1830, Elias traveled extensively, attending meetings in the Northeast, Middle Atlantic region, and occasionally in the South. His earliest documented trip to Pennsylvania occurred in December 1797.[5] Elias attended the Newtown and Makefield, Pennsylvania, meetings in 1801. He "felt in this meeting [at Newtown] the pressure and prevalence of a spirit of darkness and unbelief; and was led . . . to show its inconsistency with the self-evident experience of every rational mind."[6] Elias was addressing the belief in the Inward Light and the denial of self-will, which he considered "wills and creaturely appetites, without any controul; . . . and which they will never be able fully to divest themselves of by all their carnal reasonings and fleshly wisdom."[7] Clearly, such words influenced the

thinking and actions of his young cousin Edward. Trips to Newtown and Makefield meetings occurred regularly over the years.[8]

Although Elias received little formal education, he was well read and possessed a remarkably logical mind, one that embraced rationalism as a means by which to interpret the belief in the Inward Light. It was his method that critics seized upon because in defending this tenet, Elias appeared to deny all outward religious authorities, including the Scriptures and the doctrine of the divinity of Christ.[9]

Elias addressed the belief in the Inward Light many times, even on the eve of his death. On February 14, 1830, shortly before he suffered a paralytic stroke, Elias completed a letter to his friend Hugh Judge, a Quaker minister. Elias's last formal message was one of his most important. Published posthumously, it circulated widely. Elias focused on the inward law and light, which he believed was so beautifully expressed in Isaiah's prophecy:

The wolf also shall dwell with the lamb, and the leopard shall lie down with the kid; and the calf and the young lion and the fatling together; and a little child shall lead them. And the cow and the bear shall feed; their young ones shall lie down together: and the lion shall eat straw like the ox. And the suckling child shall play on the hole of the asp, and the weaned child shall put his hand on the cockatrice' den.[10]

He further noted that "no rational being can be a real Christian and true disciple of Christ, until he comes to know all these things verified in his own experience, as every man and woman has more or less of all those different animal propensities and passions in their nature."[11] While Elias wrote of these religious issues in a broad context by referring to the religious life of all people, he had used such words earlier in reference to his opponents. In the last days of his life, he also stressed the strong association between the Isaiah prophecy and the Quaker discipline he had always supported. Elias ended

the letter on a more encouraging tone, alluding to the difficulties of the separation: "Be of good cheer, for no new thing has happened to us; for it has ever been the lot of the righteous to pass through many trials and tribulations."[12] Elias Hicks died on February 27, 1830.[13]

John Comly had been Edward's friend since about 1800. Comly's thoughts on the controversy and his strong yearning for peace between the two groups probably influenced Edward more than either realized. Comly longed for reconciliation between the Hicksites and the Orthodox. During the historic 1827 yearly meeting in Philadelphia at which the self-effacing Comly was present, the discussions were intense and many rose to speak. Although he wanted to offer his opinions, Comly was never recognized. He later expressed his concerns in his journal: "The way and manner of this separation was clearly unfolded to my mental vision; that on the part of Friends it must be effected in the peaceable spirit of the non-resisting Lamb." Both before and after the meeting, Comly implored other Quakers to walk quietly away from "those who had introduced the difficulties, and who claimed to be the orthodox part of the Society"; he could not convince them to do so.[14]

Orthodox Quakers who opposed the Hicksites included Samuel Bettle. He was an influential and successful Philadelphia businessman who became an elder of the Philadelphia Yearly Meeting in 1823 and its clerk in 1827. Scholars have characterized him as conscientious and persistent in his conservative administration of the discipline.[15] Bettle agreed with those Philadelphia Friends who saw the virtue in some of the practices associated with evangelical English Quakers. Strict adherence to certain procedures and regulations, if adopted by Philadelphia Quakers, would affect the degree to which tolerance of a different position, that is, Hicksite, would be permitted. Bettle and other elders became the chief judges of "unsoundness." During the struggle, they focused on those who questioned their authority as it pertained to the discipline. Elias, Edward, and other Hicks-

22. Thomas Shillitoe, by an unidentified artist, 1827–1845, cut paper, in August Edouart, *A Quaker Album*, p. 205. Courtesy, Friends Historical Library, Swarthmore College, Swarthmore, Pa. Courtesy, Helen and Nel Laughon.

23. Elizabeth Robeson, by an unidentified artist, 1827–1845, cut paper, in August Edouart, *A Quaker Album*, p. 163. Courtesy, Friends Historical Library, Swarthmore College, Swarthmore, Pa. Courtesy, Helen and Nel Laughon.

ites believed that the elders had arbitrarily assumed authority, while the elders felt they had every right to exercise it. It was this group that challenged Elias Hicks in 1822 during what would become one of the most serious encounters leading to the separation.[16]

Thomas Shillitoe was also an important participant in the events before the separation (fig. 22). He was English, had been a member of the Church of England, and was familiar with the evangelical creed. His preaching was characterized as powerful and charismatic.[17] American Quakers who heard Shillitoe speak were aware of his missionary zeal.

Shillitoe came to New York in 1826. At first, he got along with both Hicksite and Orthodox members, but he eventually became a strong, combative advocate of Orthodox positions. In the following years, he became Elias's shadow, following him from meeting to meeting, finding fault with the older man's ministry and accusing him of unsoundness. Shillitoe became a worrisome and persistent thorn in the side of the Hicksites.[18] Shillitoe

recorded in his *Journal* the story of two female English Quaker ministers, Mary Ridgway and Jane Watson, whom he said prophesied as early as the 1790s that Elias Hicks would "some day or other, be a troubler in Israel."[19]

Shillitoe was not the only notable English Friend to challenge Elias Hicks, nor was he the only one to report to London Yearly Meeting on the sad state of affairs within the Society of Friends in America. William Forester, who visited America from 1820 to 1825, wrote to his wife that Elias's ministry seemed to mirror that which had caused so much trouble with Friends in Ireland. He described Elias's beliefs as "false, unscriptural," and stated that Elias's followers leaned toward "utter infidelity." Stephen Grellet, a Franco-American Quaker who went to England several times between 1811 and 1818, severely questioned Elias's ministry. He charged that Elias "advanced sentiments repugnant to the Christian faith, tending to lessen the authority of the Holy Scriptures, to undervalue the sacred offices of our holy

and blessed Redeemer, and to promote a disregard for the right observance of the first day of the week."[20]

Other American and English Quakers contributed to the separation. Edward Hicks believed that visiting British Quakers were the catalysts for fueling the fires of the American schism. He often wrote about their travels:

The English Friends spread themselves over the continent, and wherever they went they separated husbands and wives, parents and children, brothers and sisters, and the nearest and dearest friends. And I think I may add with safety, that in Philadelphia Yearly Meeting the division was so far anticipated, that the ecclesiastical machinery for disowning which had operated so successfully on poor Friends in Ireland, was transported to America, either to be set in operation here, or to be a pattern for a new machine that might better suit this country. . . . Such appears now to have been the movements, especially of Orthodox Friends, preparatory to the expected struggle at the Yearly Meeting of 1827.[21]

By 1820, the number of English Quakers visiting America had increased, although there had been a brief hiatus during the Napoleonic wars and the economic panic that followed them. They had moved farther away from eighteenth-century quietism and were embracing more of the new ideas and practices associated with evangelicalism. British Friends also advocated acceptance of the Scriptures as the indisputable authority; this issue became central to the controversy and Elias's position on the Inward Light.

Edward first met English Quaker Elizabeth Robeson (fig. 23) at Bucks Quarterly Meeting in the 1820s. He questioned her right to speak since the meeting had not endorsed her certificate to do so. Edward "made what the Orthodox called a flaming speech, consisting of false statements and downright lies."[22] His remarks were more like baiting and probably were meant to embarrass Robeson. At the meeting, Hicks asserted that there had been a decline of Friends and Friends' meetings in En-

gland, the cause of which "emanated from the British hierarchy, . . . [who] taught the children of Israel to partake of things sacrificed to idols, joining Bible societies, Missionary societies, and other popular institutions set up in the self-will of man; . . . And happy would it have been for Friends in America, could that evil genius that is producing such sad effects, have been kept on the other side of the Atlantic." Edward concluded that the work of such Quakers would "sap the foundations of our religious liberty."[23] Edward encountered Robeson the next day and argued with her. Bartholomew Wistar, Robeson's companion, called Edward "a public liar."[24]

Edward Hicks was worried about growing dissension within the Society of Friends at least as early as 1821. He was concerned about the way in which the elders had used their authority.

I had the first clear view of the policy and management of those Friends who were about turning the two great committees of care, that were to preside over the concerns of society, during the recesses of the Yearly Meeting, into this head of aristocracy. . . . I thought I saw clearly now, what was going on; or if I may be permitted to make a parody of a part of one of the prophet Ezekiel's visions— I had seen something like the image of jealousy, that provoked to jealousy. I had met it several times in the entry, and I now saw, I thought, through something like a hole in the wall, what the ancients of Israel were doing in the dark.[25]

Writing to David Seaman in late 1822 regarding an incident at Philadelphia's Green Street Monthly Meeting, Edward described the effects of the elders' efforts to curtail Elias's ministry. Edward wrote, "[I am] not much surprised at the spirit you have met with in the city of Brotherly love . . . Elias has nothing to fear . . . I feel greate unity & simpithy with my dear friend but I have antisepated that he would meet with difficultys in Phila the storm has been long time a bruing but they cannot hurt Elias."[26] Edward had been encouraged to attend, probably by Comly, but he refused because of "my warm

attachment to Elias/which involves a degree of prejudice gainst his ennemys; might lead one in to extrums so that I should over doo the next is these very friends have a greate objection to me then they have to Elias and my presence might stur up a greater degree of enmity."[27]

As Edward anticipated, Elias's trip to Philadelphia in late 1822 heralded a historic confrontation. The elders in that city were concerned that Elias, who had a certificate to attend and speak at Green Street Monthly Meeting, "preaches doctrines contrary to the doctrines of our Society."[28] After the formal Philadelphia Meeting of Sufferings adjourned in August 1822, an unofficial group of elders remained to discuss a plan to curtail Elias's ministry. Among them were Jonathan Evans, Ellis Yarnall, Samuel Bettle, Samuel P. Griffiths, Richard Jordan, and Joseph Whitehall. Evans spoke first, explaining that Elias had a certificate to speak in their city, but that the minister held "doctrines that are not doctrines of Friends."[29] Friends in New York and Wilmington, Delaware, who had heard Elias speak in their meetings averred that Elias's beliefs were unsound because he openly denied the divinity of Christ and lessened the divine authenticity of the Holy Scriptures. Evans proposed that the group intervene to prevent Elias from disseminating his ideas in Philadelphia. After discussion, the elders nominated Yarnall and Griffiths to call on Elias when he arrived in Philadelphia and dissuade him from attending the Green Street Meeting.[30]

Elias's supporters considered the elders' meeting irregular and the way in which he was to be confronted as unprecedented. Meetings, or "visitations," to counsel and advise members were a long-established, accepted practice. These sessions were intended to guide, not mandate. Elders could not forbid a minister to attend a meeting; denial to attend was determined by consensus, or "sense of the meeting." Those who supported Elias felt that the elders had assumed authority they did not have and were conspiring against him. The Quaker *Book of Discipline* stated:

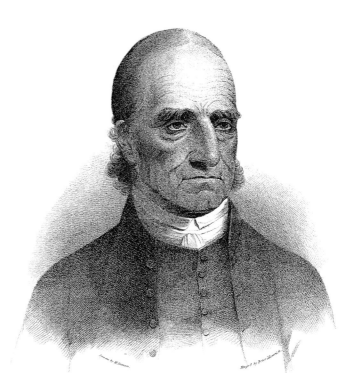

24. Elias Hicks, 1830, engraving.
Courtesy, Friends Historical Library,
Swarthmore College, Swarthmore, Pa.

If any in the course of their ministry shall misapply, or draw unsound inferences, or wrong conclusions from the text, or shall misbehave themselves in point of conduct or conversation, let them be admonished in love and tenderness by the elders or overseers WHERE THEY LIVE.[31]

If Elias was to be accused of unsoundness and spreading false doctrines, the elders of his own meeting should have been the ones to admonish him. However, none of the members of the New York meetings had objected to Elias's words and they had approved his traveling to other meetings.[32]

When Elias arrived in the city in early December, he met with Yarnall and Griffiths, who "came in love as brethren."[33] The larger group of elders, not satisfied with the outcome, requested that Elias meet with them the next day. Unwilling to acknowledge their authority,

25. *Creed Manufactory*, Plate 2 in *Hole in the Wall:
or a Peep at the Creed-Worshippers*,
by an unidentified artist [possibly Benjamin Ferris],
1828, engraving. Courtesy, Haverford College Library,
Haverford, Pa., Quaker Collection.

Elias refused, but was later convinced to attend. The elders maintained that only ministers and elders should attend this "select" meeting, but Elias insisted on bringing a number of Friends including Comly. He would not meet alone. Elias contended that he had been treated cruelly and had been prejudged on false reports. Those with him were there as witnesses on his behalf. After further exchanges in which no solution was reached, the elders walked out.[34]

This episode became known almost immediately to Quakers in Pennsylvania and the Middle Atlantic. Over the next months, elders in Philadelphia, Elias, and others exchanged a flurry of letters and memoranda either supporting Elias and his beliefs or further accusing him of making unsound statements in meetings. Elias denied the charges, considering them arbitrary and contrary to the discipline of the Society, as did many who quickly became his supporters.[35] The news was disturbing, although few imagined that this single encounter would lead to other, more serious, events culminating in the division of the Society.

Accusations of Elias's unsoundness as a Quaker minister continued to be voiced in the following years. Elias remained firm in his use of the Scriptures as an external authority, not as the final or spiritual authority revealed only through the Inward Light. As ministers who adhered to Elias's point of view traveled throughout the country speaking on these subjects, they were usually challenged by Orthodox and English Quakers supporting the original doctrine and practices of the Society and enforced by the elders. During these travels, outlying meetings were made aware of the debates fueling the controversy. Word also spread through pamphlets and Quaker publications. The issues were confusing.[36] Those who did not understand the arguments or consider them important remained neutral, seeking to maintain the unity of their local meetings.

Soon after Elias left the city, the Philadelphia Meeting for Sufferings produced a written statement that Hicksites considered evangelical in tone. Friends such as

Comly worried that if such a statement were printed, it would "have the appearance of a definite creed," and, if approved by the yearly meeting, "stand as an official declaration of the faith."[37] Although copies entitled *Extracts from the Writings of Primitive Friends* were made, the document was deferred until the next yearly meeting. When the members met in 1823, the minutes of the meeting of sufferings, which contained the full Extracts, were read aloud. The Hicksites strongly objected to this, considering it to be in opposition to true Quaker beliefs and an example of arbitrary ruling. As a compromise, the published Extracts were not distributed, but the text remained in the minutes.[38] Orthodox Quaker Samuel Bettle, as clerk of the meeting of sufferings, is depicted manufacturing the controversial creed in figure 25.

John Comly, having attended these meetings, was fully aware of the extent to which members of the Society differed in their beliefs. Edward noted, "There was one thing appeared to him [Comly] certain, that society was in danger of being scattered, and that something ought to be done immediately to preserve and keep us together."[39] Comly met with Friends in both country and city meetings to determine if "any door of hope remained for healing the awful breach." He saw "little prospect for reconciliation" and admitted that a separation seemed the only means of "saving the whole from a total wreck." He noted that any division must be "effected in the peaceable spirit of the non-resisting Lamb—first by ceasing from the spirit of contention and strife, and then uniting together in the support of the order and discipline of the Society of Friends, separate and apart from those who had introduced the difficulties, and who claimed to be the orthodox part of the Society."[40] He spent much of the winter and early spring of 1827 traveling to various meetings, encouraging Friends to separate peaceably.

By the time of the Philadelphia Yearly Meeting, Comly was prepared to attend believing that the outcome might be separation. Some Hicksites felt that they could still gain control of the meeting by choosing a clerk from their ranks. Quaker discipline required that clerks be selected by a committee composed of representatives from quarterly meetings who then attended the yearly meeting. The Hicksites sent an unusually large number of representatives in order to select Comly as clerk, but the Orthodox, who wanted Bettle for the position, "asserted that the weightier part of the representatives were opposed" to Comly.[41] Figure 26 depicts Samuel Bettle "testing the 'weight of the meeting' . . . whereon one Orthodox 'Rabbi' outweighs the entire Hicksite leadership [at the top of which is probably Comly]."[42] The committee could not come to an agreement. For this reason, the former clerks, including Samuel Bettle, continued to serve, which left John Comly in his former position as assistant clerk to Bettle. Comly was uncomfortable with this arrangement, but continued to serve in order to place his proposal of separation before the meeting.[43]

On the third day of the meeting, Comly made his proposal, after which "a solemn stillness pervaded the meeting." Once the members began to discuss the matter, Comly realized that they would not agree. "To me it appeared clear that all was over, and the case utterly hopeless of a reconciliation and healing of the breach now existing. Hence nothing remained for us who wished for peace, quietness, and liberty of conscience and of speech, but quietly to withdraw from communion and break off all connection in religious society with our opposing brethren."[44]

Some Quaker meetings responded immediately to the separation. Edward recorded: "I can never forget Bucks Quarterly Meeting, . . . in the Fifth month, 1827." As the only minister from his area present, he felt responsible for representing the Hicksite point of view. Six of the elders present also supported his position. At the meeting, "Friends arose in the full majesty of their strength, and Orthodoxy was defeated at every point." Despite this victory, the "battle" continued over the next few months at the subsequent monthly and quarterly meetings "which completed the separation."[45]

The full effect of the separation was not felt by many American Quakers until the next year. Conflicts and division took place in other yearly meetings when representatives of the rival Philadelphia factions attempted to gain recognition at these meetings, thereby reviving the conflict.[46] There were occasional acts of physical violence over the possession of official records in Ohio and New York Yearly Meetings. In Pennsylvania, lawsuits argued which group owned meetinghouses, graveyards, and the like. The Orthodox attempted to confiscate the properties of the Newtown and Makefield meetings.[47]

Publications about the division of the Society and events surrounding it were written from both the Hicksite and Orthodox points of view.[48] *Hole in the Wall; or A Peep at the Creed-Worshippers*, published in 1828, referred back to the 1822 meeting of sufferings and the Extracts that were then proposed but never distributed. This book, with its accompany illustrations, presents an anti-Orthodox discussion of the creed (figs. 25–27). In a parody of a passage from Ezekial, figure 21 depicts Elias Hicks looking through the "hole in the wall" at the "wicked abominations that they do here" and "creeping things, and abominable beasts" of the Orthodox standing in front.[49] Edward had drawn this parallel earlier between the Israelites and the Orthodox who did their work in the dark.

Although biased toward the Orthodox position, much revealing early nineteenth-century commentary on the schism appeared in *The Friend, a Religious And Literary Journal*, published weekly in Philadelphia.[50] The October 17, 1829, issue featured a discussion of the ministries and positions of Edward and Elias Hicks. Edward's discourses at Green Street and Carpenter's Hall shortly after the separation were described as distorting the Scriptures and touted as examples of Edward's ingenuity in explaining away "the pre-existence of our Lord."[51] The next issue stated that many of Edward's principles were "the mere speculations of his own brain, what he has learned to conceive, not the revelations of the holy Spirit."[52] Elias Hicks fared no better. Even after

his death the next year, articles questioning the soundness of his ministry continued to appear in *The Friend* and other publications. *The Friend* also published a critical assessment of Elias's obituary, describing it as "apparently editorial, is very extravagant, and even *romantic*, in some of its representations."[53]

The extent to which Edward Hicks was a leading spokesperson in the Hicksite-Orthodox debates is not clear. His allegiance to Elias Hicks and the position they

27. *Prophetic Vision*, Plate 1 in *Hole in the Wall: or a Peep at the Creed-Worshippers*, by an unidentified artist [possibly Benjamin Ferris], 1828, engraving. Courtesy, Haverford College Library, Haverford, Pa., Quaker Collection.

26. *Weight of Members*, Plate 3 in *Hole in the Wall: or a Peep at the Creed-Worshippers*, by an unidentified artist [possibly Benjamin Ferris], 1828, engraving. Courtesy, Haverford College Library, Haverford, Pa., Quaker Collection.

held on matters of limited authority and discipline are well documented. Comments throughout the *Memoirs* and in his letters indicate that Edward was aware both of his ability to speak forcibly and with great passion and of his inability to control his quick temper and emotions in moments of contention. More than once, Edward regretted his outbursts, although he rarely changed his position or his mind. Edward also intentionally stayed away from major meetings where heated dis-

cussions were anticipated, noting that his "hot-headed Americanism" might make matters worse.[54]

The writings of Edward and other Friends indicate that he was not well liked by Philadelphia Orthodox Quakers. Edward blamed them for defaming his character, calling him "so notorious a liar and unprincipled a man" and making him out to be "an infidel, and an unbeliever in the great doctrines of Christianity."[55] Even some Hicksites found his words abusive and extreme.

There had been attempts to quell Edward's ministry even before the separation. Benjamin Ferris, writing in 1828 about the "prominent facts and causes" of the separation, solicited an account from Benjamin Davis of the treatment of Hicks in an incident that occurred in 1826 at Upper Evesham, New Jersey. The elders of the local meeting, hearing that Edward was to attend the following day, refused to announce the appointment to their members. Other Friends, learning of Edward's planned visit, spread the word. When Edward arrived for the meeting, the elders of Chester Monthly Meeting, who had made the initial plans and were accompanying Edward on his ministry, would not attend because the elders had not sanctioned the visit. Although the elders were not present, the meeting went on as planned.[56] A similar incident happened on October 9, 1828, when Fallsington Quarterly Meeting issued a minute against Edward as "Testimony of Disownment from membership in the society of Friends on account of preaching unsound Doctrines."[57]

Edward strove to restrain his opinions in public speeches, but how well he succeeded is unknown. His loyalties to Elias and to Comly, an important Hicksite spokesperson, and his belief in the Hicksite position were steadfast; on these he would never compromise. But he continued to agonize in private, giving clear and impassioned voice to issues in his correspondence with those supporting primitive Quaker testimonies. In pub-lic, he often chose to phrase his positions metaphorically, the less offensive style preferred by most Quaker ministers. Although he did not name names, Edward drew strong connections between the behavior of Orthodox Quakers and the causes and effects of the separation in a surviving published sermon he gave at Goose Creek, Virginia.

That Edward's ministry during the late 1820s became more important to him is underscored by the number of trips he took to meetings outside Bucks County. Many of these meetings remained basically the same after the division because the membership had chosen the Hicksite way. Others were divided, and still others had become Orthodox. By the end of the 1820s, Hicksites and Orthodox Quakers were about equal in their membership. Most of those who became Hicksites did so as a protest, not because they completely supported the theology of Elias Hicks. They were against the arbitrary manner in which proceedings leading up to the division had been handled. They also believed that the Orthodox party was too conservative and theologically intolerant.

As both branches developed during the next decade, they formed relationships with other churches. It came as no surprise that the Orthodox Quakers aligned themselves with evangelical churches, sometimes borrowing their teachings, literature, and music. The Hicksites found fellowship with denominations that were non-creedal.[58]

The Nature of the Beasts

May the melancholy be encouraged and the sanguine quieted;
may the phlegmatic be tendered and the choleric humbled;
may self be denied and the cross of Christ worn as a daily garment;
may his peaceable kingdom for ever be established in the rational, immortal soul.

EDWARD HICKS, *Goose Creek sermon, Memoirs*

By the 1820s, Edward found that the rigors of travel and long hours of physical labor required for shop production had taken their toll. Never noted for his physical strength, he developed symptoms of "pulmonary consumption" that eventually turned into a "chronic cough."[1] The artist suffered bouts of coughing, colds, and fevers for the remainder of his life. His family's primary concern was Edward's health since he often traveled in the winter.[2]

The destruction of his shop by a fire in 1822 was also a serious problem.[3] Rebuilding and replacing tools was exhausting and left him ill with a high fever and chills. News of both the fire and his sickness spread rapidly. Elias Hicks, knowing that these were difficult times for Edward, was among the first to counsel the artist. Elias urged Edward to consider his hardships as "lessens of very deep instruction."[4] Although he did not elaborate, the older man was probably warning Edward to mind his physical as well as his spiritual health.

Throughout these troubling years, especially when Edward was traveling to other meetings as a minster, he relied on his wife, Sarah, daughters Mary and Susan, and son Isaac to carry on the routine management of the household. Beulah Twining also kept a watchful eye on the family and seems to have visited them regularly. She was a faithful, supportive friend to the artist-minister, and Edward deeply felt her death in 1826.[5] His son Isaac assisted in the shop during these years as well as caring for the livestock and harvesting crops for them and the household. Letters between Edward and his family, chiefly his daughters, reveal that family life in Newtown went on as usual.[6]

Despite his health problems and travels that often meant days spent away from home, Edward's shop took in business on a regular basis. Thomas Goslin and apprentices performed routine work with Isaac Hicks assisting. The majority of the 1820s entries in Edward's account book and in extant receipts and letters describe jobs similar to those done in previous years. The one notable exception was a marked increase in the number of pictorial pieces produced. Sign painting was a growing part of the business, but the commission of two pictures for Dr. Joseph Parrish's family (figs. 21 and 86) and a similar one for Harrison Streeter of Fallsington Meeting signaled a change in the artist's interests.[7] From this point on, Edward produced more easel pictures. With the exception of the Parrish view of Niagara Falls, the subjects of Edward's first efforts in easel painting are unknown.[8]

Scholars have traditionally suggested that he began the Peaceable Kingdom paintings about 1820, before Elias Hicks's 1822 encounter with the elders in Philadelphia.[9] The earliest known Peaceable Kingdom (fig. 28), which probably dates 1816–1818, differs remarkably from those that followed. Its visual message emphasizes the importance of quietism as represented by the artist's

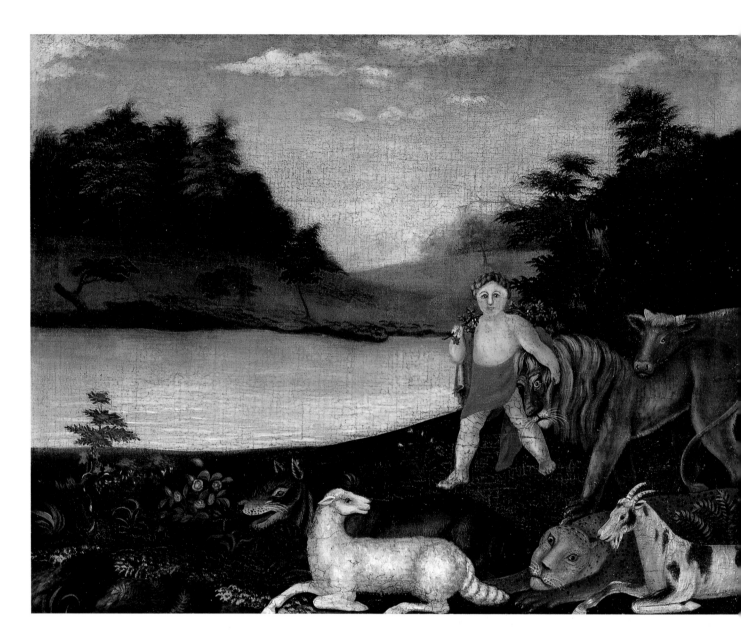

28. Peaceable Kingdom, by Edward Hicks, 1816–1818, oil on canvas, 18¾″ x 23½″.
Courtesy, Cleveland Museum of Art, Cleveland, Ohio, gift of the Hanna Fund.

call for peace between the two Quaker factions. The animals and child are characteristically sweet and mild; there is no sense of struggle, no tension visible in the child's or animals' expressions. They exude a peace and harmony that quickly evaporated in Edward's later versions. If the scene is related to the schism, it is clear that Edward had yet to realize the magnitude of the disagreements. At this early date, he did not view them as cause for formal separation; the notion probably had not occurred to him. This Kingdom must therefore be viewed as a formative concept about establishing unity between the two groups. Those that immediately followed (figs. 86–90) are best interpreted in this manner, although they are more highly organized and reflect Edward's increasing understanding of the prophecy and the controversy.

As Edward became more preoccupied with the schism in his ministry and correspondence, he became more obsessed with the Kingdom pictures, continually refining and changing the artistic and metaphorical devices well known to nineteenth-century Quakers. By doing so, he was able visually to interpret the Hicksite position on a number of issues.

Each animal in these paintings represented traits of human nature that Edward associated with both Orthodox and Hicksite behavior. He believed that natural behaviors, when left to develop without the guidance of the Inward Light, produced a variety of unacceptable results. Acquiring worldly wealth could lead to greed, usury, and jealousy. Edward and other Hicksites also viewed the Orthodox abuse of authority and power as outgrowths of affluence. The artist could neither accept nor depict the unity he yearned for without references to the Hicksite view or to Orthodox behaviors and how they must change. Both in their whole compositions and in their individual components, the Kingdom pictures provide highly symbolic allusions to the artist's position. They can be fully understood only if one knows the history of the period and Edward's sources of inspiration.[10]

Several sources are critical to understanding the

Kingdom pictures. Isaiah's prophecy, the primary biblical theme, identifies the animals, notes their relationships, and provides insight about how aggressive animals must behave in order to achieve peace:

The wolf also shall dwell with the lamb, and the leopard shall lie down with the kid; and the calf and the young lion and the fatling together; and a little child shall lead them. And the cow and the bear shall feed; their young ones shall lie down together: and the lion shall eat straw like the ox. And the suckling child shall play on the hole of the asp, and the weaned child shall put his hand on the cockatrice' den. They shall not hurt nor destroy in all my holy mountain: for the earth shall be full of the knowledge of the LORD, *as the waters cover the sea.*[11]

Edward's initial selection of animals for the Kingdom pictures was based on the prophecy in chapter 11 of the book of Isaiah; over the years, he included other animals, although the principal prophecy animals continued to be the key characters in his compositions. As the organizing theme for the paintings, the Isaiah prophecy corresponded to the state of harmony resulting from God's communication to mankind through the Inward Light. The prophecy forecast what must be done to achieve peace: the denial of self-will was the only means of establishing harmonious coexistence. Thus, the paintings interpret the prophecy through colorful, engaging groupings of animals that have achieved peace by self-denial—the relinquishing of self-will—as communicated through the Inward Light.

Edward's knowledge of animal symbolism was more extensive than just the prophecy and included a deep awareness of medieval humoralism as it had been adapted and used in many cultures. Edward also divided mankind into four groups based on the four humors. The first class was the melancholy, symbolized by the wolf, while the leopard exemplified the second, the sanguine. The third classification was the phlegmatic, characterized as cold and unfeeling and associated with the bear. The lion represented the fourth class, the choleric,

which was dominated by the element of fire. Hicks also associated the four humors with the metaphoric use of animal symbolism in Quaker sermons and writings common since the seventeenth century, a pervasive influence on him. Elias Hicks's letters to Edward and his writings were among these rich resources.

At least two scholars have suggested that the Peaceable Kingdom paintings were intended as memorials to Elias Hicks, with whom Edward had a close spiritual and personal relationship.[12] It is certain that the father-son bond suggested by Tatham formed late in the artist's mind, after Elias's death and perhaps as Edward was writing the *Memoirs*. In a sermon published seven years after his cousin's death, Edward's allusion to a leader of the Society appeared to be a direct reference to Elias:

The most valuable father in the church of Christ I ever knew, was a man of a choleric complexion, and in his first nature like a lion; but when I knew him, he was as patient, submissive and powerful as an ox. He was truly to me a precious father, taking me by the hand in my youth, and leading by precept and example; and when my poor soul was under discouragement, or tossed on the tempestuous billows of confusion and darkness, he has taken me as it were in his arms, and, with all the tenderness of a natural father to an only son, he comforted and encouraged my poor drooping spirit.[13]

It is therefore likely that the metaphoric use of animals in the sermons of Elias provided a powerful yet familiar reason for Edward to use such imagery in his pictures, not only as a subtle way to honor the older minister's messages, but also to commemorate their shared convictions. That Comly and others of the period, even non-Quakers, also utilized animals to convey moral and religious teachings strengthens this argument. Edward was one of only a few to paint or sketch such scenes repeatedly, however.[14]

The majority of the large number of works known to have been painted by Hicks can be classified as shop production, items best described as utilitarian. In this cate-gory are signboards, carriage and wagon painting, house painting, fire buckets, furniture, and other everyday objects. The second large group, known through surviving examples, comprises works that can be called easel painting—views of places and events meant to instruct, remind, and adorn. Of the known easel paintings, there are two main categories. The historical pictures, such as the views of Washington Crossing the Delaware, the Declaration of Independence, or Penn's Treaty with the Indians, formed the first. The Kingdom pictures, which comprised the second group, were especially important to Hicks. They are by far the most numerous of his easel works and were obviously the most enduring and important subject for the artist.[15] Grouped with the Kingdoms are the pastoral views, a few religious pictures, and the farm scenes. All evoke impressions of orderliness, harmony, and peace.

While Edward rarely varied the compositions and principal elements in versions of the farmscapes and history pictures, he regularly revised these features in the Kingdoms, changing them as his interpretations of the schism changed. That Edward was proud of these pictures is reinforced by the circa 1837 portrait in which Thomas Hicks depicted Edward working on a Kingdom (fig. 1). He continued to paint this subject until the very eve of his death, a remarkable indication of the intense interest and dedication with which he pursued the theme.

It is ironic that the Kingdom pictures, which modern viewers often appreciate for their simplicity, pure colors, and cuddly animals, carry such weighty messages. Yet, they are complex in content while also contrived to appeal to the senses. One must reach deeply into Edward's personal knowledge and experience of Quaker life as well as his writings to understand them.

Edward Hicks's sermon, delivered at the Goose Creek meetinghouse in Loudon County, Virginia, on Feburary 22, 1837, is the most important source for interpreting the Kingdom paintings (fig. 29). The sermon was recorded at Goose Creek by an unidentified witness. Ed-

29. *A Little Present for Friends and Friendly People: In the Form of a Miscellaneous Discourse,* title page of the Goose Creek Sermon, in *Memoirs of the Life and Religious Labors of Edward Hicks,* 1851. Abby Aldrich Rockefeller Folk Art Center.

ward later revised and expanded this written account to his satisfaction. Hicks described the final text of the sermon as a "Miscellaneous Discourse" by a "Poor Illiterate Mechanic." The Goose Creek sermon was significant to Edward and other Friends and family. Titled *A Little Present for Friends and Friendly People,* it was included in the artist's *Memoirs,* published posthumously in 1851.

Edward believed strongly in the power, poetry, and eloquence of the Holy Scriptures, to which he often referred. He viewed the Scriptures as inspired by God but a product of man; they were not to be confused with direct communication with God through the Inward Light. Of mankind, Edward noted that "the animal body of man was the finishing work of all animated nature, and consequently the highest order of terrestrial creation."[16] This concept is important for understanding origins and beliefs rooted in Quaker thought as well as in much of Christian thought during the eighteenth and nineteenth centuries. Edward's religious and spiritual life was influenced as much by such older theological and scientific beliefs as it was by new ideas introduced from the English Enlightenment that focused on the experimental philosophies of Locke and Newton and emphasized natural history and physical science.[17]

Primitive Quakerism, championed by Edward and Elias Hicks, emerged in England in the sixteenth and early seventeenth centuries when beliefs about nature and the universe were largely based in Copernican theory. In this system, terrestrial matter was thought to be composed of four elements that represented certain qualities: fire (hot and dry), air (hot and moist), water (cold and moist), and earth (cold and dry).[18] All living creatures were composed of these elements and possessed degrees of the humors or qualities they represented. Each person was thought to have a dominant humor that determined behavior and personality attributes. Balance between the humors was essential to good health.[19] The theory of the four humors was still considered viable, and its basic concepts remained central to emerging scientific and philosophical theories.

Many people also believed that the universe was inextricably bound together and was arranged in a specific hierarchical pattern called the chain of being (fig. 30). God had created the universe. The chain of being was complete; all that could be created had been created. Everything was ranked in order along the chain of being, with mankind highest among the living forms but below the celestial hierarchy. Various levels along the chain of being were thought to have special relationships. For example, rulers or heads of state were related to lions, the kings of the beasts.[20]

In America, numerous late seventeenth- and early eighteenth-century colonists had neither wholly dis-

30. The Chain of Being, by Didacus Valades, 1579, reproduced in Robin Headlam Wells, *Elizabethan Mythologies.* Courtesy, Cambridge University Press.

carded the concept of the four humors nor completely accepted the universe as explained by Newtonian physics. Some attempted to combat the new scientific theories with religion. This was particularly true of conservative groups, and it was true, even in the nineteenth century, of people such as Edward Hicks who saw aspects of the new knowledge as a threat to spiritual life. By this time, however, many perceived the chain of being as a less valid way of organizing human society because it did not mesh with new scientific inquiry.[21]

Edward knew humoralism well. Sections of the Goose Creek sermon could easily have been derived from popular treatises on the subject. Of the four principal elements, he wrote:

As either of these predominated in the animal economy, it gave rise to the constitutional character or complexion, called by the physician and philosopher—melancholy, sanguine, phlegmatic and choleric. Hence arises that astonishing variety in the appearances and actions of men and women, as creatures of this world. As the animal man possessed the nature and propensities of all other animals, being superior to them all,—so that strong law of animated nature, called self or self-will, was commensurate with or equal to his standing in the scale of beings; that is, his self-will was as much stronger as he was superior to other animals; being the spirit of the animal so essentially necessary to its perfection, and in man was to be governed by his superior rational, immortal soul, which was created in the image of God, who said—Let us create man in our own image:... Hence the correctness of the conclusion that the soul of man is the lowest order of celestial, and his body is the highest order of terrestrial creation.[22]

Edward went on, noting that man, as a superior being, was composed of two natures, material and immaterial. The first was the mortal man whose flesh was a part of the material, worldly universe; the second was the immortal life of man "that can never be annihilated." It was this immortal nature of man into which "God breathed the breath of life, and it became a living soul—not a living body."[23] As it related to Quaker beliefs, the Inward Light was the immortal nature of man in which God existed, not the body of flesh and blood. Man's innate and mortal body was thwarted by temptation and sin as represented by the story of Adam and Eve. Quakers were committed to observing the calling of the Inward Light and to find it always in others.

Edward explained that man was tempted and strayed because of his own "lust" which, "when lust hath conceived, it bringeth forth sin; and sin, when it is finished, bringeth forth death." This was the death of Adam the day he transgressed and lost the

heavenly light and love that united him to his Heavenly Father,... his soul fell from its dignified station in the divine harmony, (when it governed the animal man with all its propensities, making them subservient to the purposes for which they were intended,) and became a slave to that cruel, selfish nature, emblematically described by the wolf, the leopard, the bear, and the lion;... Therefore the Lord's prophet [Isaiah] was bid to make the use of the interesting figure contained in the text. The lamb, the kid, the cow, and the ox, are emblems of good men and women—while the wolf, the leopard, the bear, and the lion, are figures of the wicked. These last,... if they were confined in a small enclosure, would cruelly destroy each other, while the four innocent animals in the same enclosure would dwell harmoniously together.[24]

Edward wrote in a highly structured and didactic style, reinforcing his messages with Scripture stories to show the outcome of sinful behaviors. For example, he described Cain as carnivorous and having the nature of a wolf; Abel, that of a lamb; Esau is a wolf, leopard, bear, and lion; Jacob is also a lamb. Edward next addressed the condition of the family of man using humoral and animal example. He then connected the behaviors of the carnivorous animals with Orthodox and evangelical behaviors. Edward pointed out that many with undesirable propensities were redeemed by relinquishing self-will to

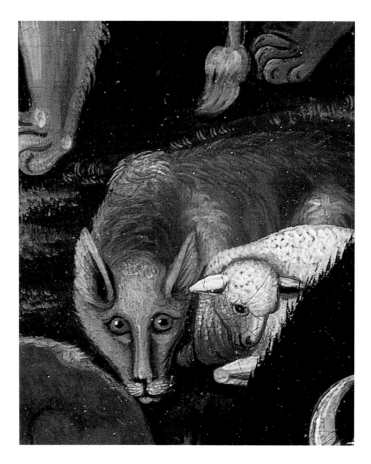

31. Detail from fig. 113.

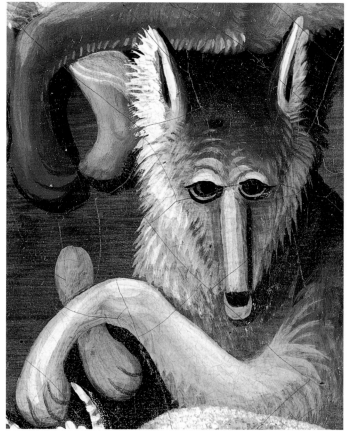

32. Detail from fig. 119.

the will of God. This is the core message of the Goose Creek sermon and the Kingdom pictures.[25]

If earth is the dominant element, it produces in men and women

that peculiar constitutional trait of character called melancholy, in their unregenerate state [they] have all the characteristics of the wolf; . . . The skulking solitary habits of the wolf, who generally retires in the daytime to the inmost recesses of the swamp, or the gloomiest glens of the forest, only coming forth to prowl and devour innocent and helpless animals under cover of the darkness of night, —he whose carnivorous appetite can never be satiated, presents the strong law of nature called self, in one of its most incorrigible attitudes.[26] (figs. 31 and 32)

Those of this nature will not deny the cursed self; they have reserved dispositions:

When these make profession of religion without being regenerated and born again, they are wolves in sheep's clothing, and hence the origin of hypocrisy and deception in the religious world; for this complexion being naturally disposed to be religious, there is more of them than all the other three put together. Their steady, solid deportment, and very serious, solemn countenances, enable them to pass, as religious men and women, for more than they are worth; and they are put forward in religious communities, as the leaders of the people. . . . and indeed it may be said at this door [of hypocrisy] the enemy entered and made great devastation in the Christian church, and none have suffered more according to their relative numbers, than the Society of Friends.[27]

Edward believed that Primitive Quakers, organized in the era of George Fox, William Penn, and Robert Bar-

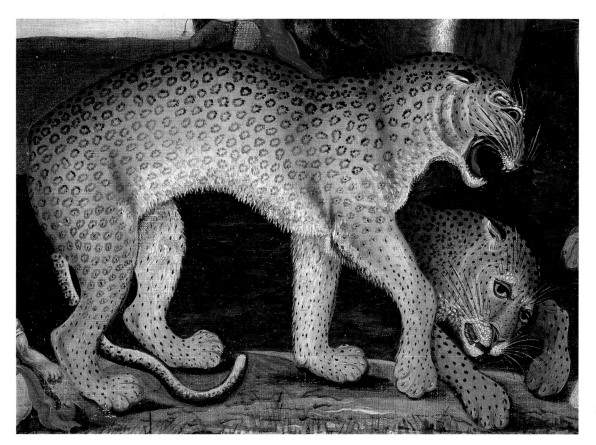

33. Detail from fig. 125.

clay, were closer to the discipline than any other Friends at any other time.[28] He pointed out that events which led to the recent Quaker separation included a large number of men and women who had strayed from those practices. They were of melancholy complexion by virtue of "their quiet, steady, unobtrusive habits—their silent retirement—exemplary industry and frugality." These people filled the most important positions in the Society, had respectable connections, and were "in the way of making money."[29] In the next breath, however, Edward made it abundantly clear that although visiting English Quakers who supported the Orthodox seemed exemplary, they were "puffed up with pride":

In the small circle in which I have moved, I have, alas, known too many Friends, and among them three ministers, two of which crossed the Atlantic ocean, come to this most wretched and melancholy end. I am aware I may lay myself open to censure . . . but the time has come that the hidden things of Esau must be brought to light, and effects traced to causes: for I have no doubt but that one of the principal causes of the weak state of Society is the injudicious appointment or promotion of Friends, both young and old, to important stations, that are what the apostle Paul called Novices, *that is, men and women without heartfelt religious experience; having never denied self, or witnessed the wolf to dwell with the lamb. Hence the spiritual pride, religious consequence and malignant enthusiasm that characterized the belligerent party [Orthodox] among Friends, in the late unhappy and disgraceful controversy.*[30]

"Important stations" alluded to elders whose positions Edward thought had been achieved through political and social connections.

The sanguine leopard figured prominently in the Kingdom paintings, especially those painted during the artist's last years (fig. 33). Always sleek, sometimes sinuous and sensual, the feline embodied all of those characteristics outlined in the Goose Creek sermon. Edward claimed he was the "most beautiful of all the carnivorous animals of the cat kind." Although subtle, often cruel, the leopard was a "restless creature." Edward warned

unsuspecting admirers of its beauty, should they attempt to manifest any personal familiarity or kindness, because it will destroy the very hand that feeds it. Men and women of this class, in their sinful state, are not to be depended upon. . . . Excessively fond of company, more especially where there is gaity, music and dancing, they frequent taverns and places of diversion, where young men too often become an easy prey to the demon of intemperance and sensuality; and the poor negatively innocent female is too often seduced by these beautiful monsters.[31]

This passage rings with particular familiarity; Edward probably was describing his own youthful behavior before he joined Quaker meeting and moved from his "sanguine state."

Sanguine people "do the most injury to the cause of Christ; for they are quite disposed to be religious, provided they can have it on their own terms; but it must be spotted, like the beautiful animal that rules in them, and full of excitement and activity."[32] This referred to those who, with evangelical zeal, supported various sorts of reform through meetings—prayer meetings, temperance lectures, and so forth. A number of those within the Quaker community who organized and promoted these popular causes during Edward's lifetime were Orthodox.

Edward was not opposed to temperance, abolition, or similar issues, but he detested any structured effort that involved compensation for the work, and endless public debate without action. It was also his opinion that wealthy Orthodox Quakers believed they could gain license to material affluence so long as they supported the public good and provided substantial monetary contributions to their meeting. He felt that proselytizers should walk in humble industry, and "maintain or support themselves and families by the labor of their own hands (not their heads)"; they should not be paid, nor their "expenses borne out of the funds of the Society."[33] Many Quakers believed that issues such as temperance or abolition were inseparable from faith and religious practice. Others felt that social reform was a logical extension of faith but should be addressed outside of the religious interactions of the meeting. The methods some Orthodox used, especially their organized and often public antislavery activities, fell in that category. They were considered inappropriate by many Hicksites.

Edward believed "there are fewer sanguine people among Friends, in proportion to their numbers, than any others, . . . and what there is are mostly birth-right members, who are too often finding fault with the order of Society—particularly plainness of dress, behaviour and apparel, and animadverting with great severity on the bigoted notion of keeping to their own meetings."[34] His observation was also directed toward Orthodox Friends who increasingly were persuaded that some primitive Quaker tenets, including simplicity and usefulness, were too restrictive. Edward feared they "would turn Christian liberty into licentiousness."[35]

Dominated by the element of water, the phlegmatic were "powerful by its great weight and influence upon the other elements; and when put in motion by the laws of gravitation, or agitated by air or fire, its strength is irresistible. Hence the Lord's prophet [Isaiah] . . . brings forward in poetical figure two of the larger and more powerful animals: 'And the cow and the bear shall feed, their young shall lie down together.'"[36] (fig. 34) Those who fell in this class were described as insensitive,

but when agitated by some of the stronger passions, they are too often powerful, cruel and voracious, and therefore more like the bear than any other animal. For the bear is a

34. Detail from fig. 130.

dull, sluggish, inert creature, and appears more peaceable and contented than most of the carnivorous tribe, and will seldom if ever prey upon other animals, if they can find plenty of nuts, fruit, grain, or even roots; . . . Could the prophet have found in the whole chain of carnivorous animals, one link that would so completely describe a phlegmatic worldly-minded man, wholly intent on the acquisition of wealth? One who adopts for his motto the Dutch proverb, "My son, get money; get it honestly if you can, but be sure to get it."[37]

Allusions to money lending, or "usury" as Hicks termed it, were directed toward the Orthodox leadership of previous years; they also referred to the strong mercantile ties between urban American and English Quakers. Edward particularly associated bearish behavior with getting and lending money at high interest rates,

which he had experienced himself. Moneylending drove many unsuspecting poor people deeper into debt whereby they lost everything. The artist perceived these practices, prevalent among some wealthy Quakers, as anathema to the first principles of the Society of Friends in which mutual love bred charitable assistance and support. He lamented, "Oh this love of money, if it has not been the root of all, it has been and still is the root of much evil in the religious Society of Friends, and the cause thereof appears to me to be that evil seed of usury."[38] Edward concluded that the steady decline in Quaker meetings in England, Ireland, and Scotland, which began in the seventeenth century and continued in his time, was a direct result of usury and an "attachment to those beautiful idols of a fallen world—*wealth, power* and *scholastic education*." These bearish men and women "are too often put forward in religious society as

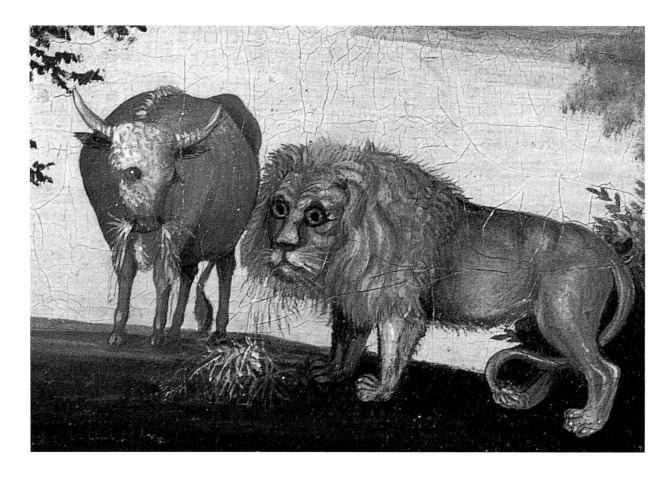

35. Detail from fig. 113.

leaders of the people, in consequence of their wealth and steady habits, instead of Christian experience."[39]

Hicks's account of one man's experience in receiving true Christian charity is especially interesting. It describes perfectly Edward's own years of trouble when he had given up painting and was seriously in debt:

I knew a poor minister, near twenty years ago, that, by imprudence and want of capacity, was brought into serious difficulties, for he had quit a business that he understood, and for which the Author of Nature had peculiarly qualified him, because he then thought it was inconsistent with his profession, and undertook a business he did not understand, by which he was brought to the eve of bankruptcy. . . . he exerted himself by working with his own hands, day and night, till his health was broken, and the symp-

toms of a pulmonary consumption caused him to look with sorrow and discouragement on a beloved wife and little family of children that in all probability must soon be left destitute.[40]

The story ends with the "poor minister's" receipt of money from a friend, who told him "not to suffer himself to be improperly discouraged for the want of any little pecuniary assistance—that he was at liberty, at any such time to draw on him."[41]

The fourth class, ruled by the element of fire, was called the choleric. Strong in intellect, very powerful and brave, they were represented by the lion, who "shall eat straw like the ox" (figs. 35–37). The lion was thought to be the most destructive of animals below man.

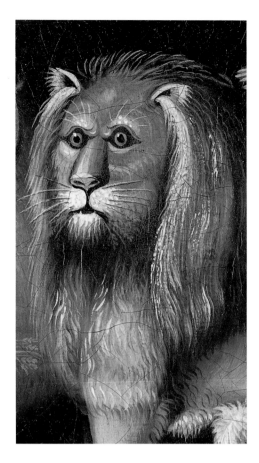

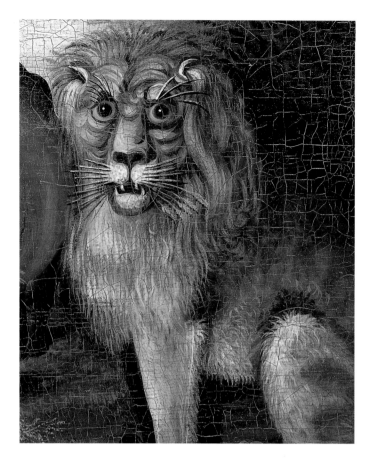

36. Detail from fig. 119.

37. Detail from fig. 114.

Consequently the fear or dread of him is so universal . . . that he is styled the king of beasts. The besetting sin of men and women of this constitutional make is pride and arrogance; proneness to anger; impatient of contradiction, fierce, cruel. . . . for men and women of this class, when they profess to be religious, and have never denied self, or witnessed the lion to eat straw like the ox, become leaders of the people, (for leaders they will be,) that the cause of truth suffers; which is abundantly proved by the page of history, from the orthodox priests and their satellites in the Jewish church, at the advent of the Messiah, down to the present day. For such choleric professors of religion are predisposed to be orthodox. And here I wish distinctly to be understood as not casting any reflections upon my Friends that differ from me in opinion. What I mean by orthodoxy is, that malignant, persecuting spirit, that has *shed more blood, and been guilty of blacker crimes, than any other spirit in Christendom. A spirit that I have detected in my own breast, . . . and which I am ashamed almost to think of.*[42]

Edward wrote this passage ten years after the separation and his subsequent reflection on its issues and causes. On first reading, the statement seems to contradict his earlier stance on Orthodox behavior, although this was not the case. He understood that orthodoxy was neither new nor exclusively a Quaker phenomenon, but had been embraced by Christian churches for centuries. He was simply explaining his knowledge of orthodoxy by referring to historic events and to his experience that many Christians, including some Friends, had been subjected to "that malignant, persecuting spirit" for years.

Edward's explanation of the nature of the lion, like that of the bear, wolf, or leopard, is marked by reinforcing views and criticisms. From Edward's perspective, all of the carnivorous animals shared certain undesirable behaviors that paralleled those of Orthodox Quakers. The leopard, whose pride was fed chiefly by his worldly interest, was also a proselytizer for social reform. The wolf, a solitary animal with a reserved disposition, was also a moneymaker. Bearish Quakers also joined committees and worked for causes outside their communities instead of looking inward to care for the needy in their hometowns.

The Goose Creek sermon does not offer a detailed discussion of the innocence of the lamb and other benevolent creatures mentioned in the prophecy and included in Hicks's paintings. There are two possible reasons for this. While the sermon begins with a reference to Isaiah's prophecy and is religious in tone, it is significantly based on the characteristics of the four humors and their undesirable behaviors. Secondly, the behaviors of the quiet, grass- and grain-eating animals had represented proper moral and religious life for centuries; they were therefore the more familiar models to his audience.

Quaker attitudes toward animals of all sorts are less easily understood, however. In general, the Society opposed oppression, including abuse of animals. One scholar observed that "Quakers were not sure about the presence of the [Inward] Light in animals," although "it is a short step to go on to the belief that in some degree the same Light shines, in and through animal life. . . . George Fox felt that his vision of creation was so clarified, because he had come into the condition of Adam before the Fall, that he could see into the nature of plants and animals."[43] Fox also felt that hawking and hunting for sport were sure symptoms of avarice. John Comly, and probably Edward and other Quakers too, took the same position.[44]

Edward's sermon cleverly combined Isaiah's prophecy, the four humors and their attributes, Scripture passages, and allusions to historical Quaker practices and beliefs in a detailed argument against orthodoxy. All of the artist's and Hicksite party's principal observations and objections to conservative, structured religion are discussed in the document. Elias Hicks, a powerful influence on Edward, is acknowledged only by allusion, but anyone who heard or later read Edward's sermon would have recognized its connection with Elias's ministry. Edward left a perfect source for interpreting his position on the schism and the imagery he used in his Peaceable Kingdom pictures which were, like the Goose Creek sermon, strong statements against orthodoxy and its effects.

Ornamental Painter

My constitutional nature has presented formidable obstacles to the attainment
of that truly desirable character, a consistent and examplary member
of the Religious Society of Friends;
one of which is an excessive fondness for painting,
a trade to which I was brought up.

EDWARD HICKS, *Memoirs*

The variety of images that Edward Hicks painted, especially the easel pictures, makes it difficult to place him in the Quaker aesthetic of "simplicity" as it was applied to art. In the seventeenth and early eighteenth centuries, Quakers were expected to adhere to the concept of "plain and simple." The pursuit of a useful trade, often combined with farming, was considered appropriate for most Friends. Materials and objects produced or consumed by Quakers were to be guided by simplicity and plain styling; ornamentation and the production of items that served only to embellish were unsuitable.[1] Quality was another matter; an item could be finely made and of the best sort. Early Quakers "were ultra-Protestant in their conviction that, though one must live in the midst of the world, one must never let its attractions clog the channels of the Spirit. . . . no matter how enticing or delightsome the beauties of this world might be." A member of the Society of Friends "must be careful not to let his sensibilities linger in sensuous appreciation upon the fading things of this world, lest he forget the lasting beauty that existed only in the world of the spirit."[2] Paintings and other highly decorated objects were usually banished from the lives of early Quakers.

This position had been modified by the mid-eighteenth century. Ironically, the reason may be that the Quaker aesthetic was rooted in the concept of the Inward Light which, through the spiritual experience of it, guided life. No formal doctrines existed; only general guidelines in the *Rules of Discipline*, or testimonies, directed attitudes and behavior. Although the *Rules* remained an important guide in matters of plainness and vain, prideful, or immodest behavior, they were not specific and did not address decorative embellishments on furnishings or pictorial art.

Attitudes toward aesthetic matters among eighteenth- and early nineteenth-century American Quakers are confusing. As more and more city Quakers acquired wealth and status, they attained greater influence and social sophistication and could afford more impressive material goods. Surviving objects owned by some urban Friends are not especially plain, which suggests that a more subtle interpretation of the plainness code was developing. A gradual breakdown in the earlier rigid rules had occurred in New York and Philadelphia by the time of Elias Hicks's ministry in the late eighteenth century.[3]

The Quakers' ambiguous feelings about art, and their broad interpretation of the *Rules* were well known, however. Some commissioned paintings, and a few created graphic art. Writing to Edmund Jenings in 1771, Charles Willson Peale noted that Quakers in Philadelphia "are a principal part of the Money's People there and If I can get a few of the Heads to have their familys

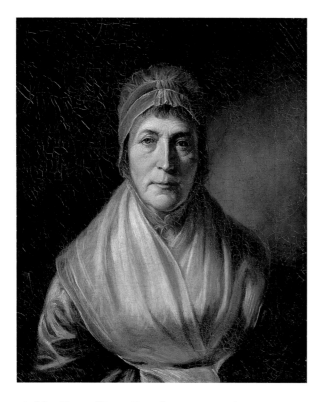

38. *Mrs. Charles Willson Peale* (Hannah Moore), by Charles
Willson Peale, 1816, oil on canvas, 24⅛″ x 20⅛″. Peale depicted
his wife, a Quaker, in dress that typified the attire of Quaker
women. The artist described Hannah as being "as plain as any
amongst friends." Courtesy, Museum of Fine Arts, Boston,
Mass., gift of Mrs. Reginald Seabury Parker in memory of
her husband.

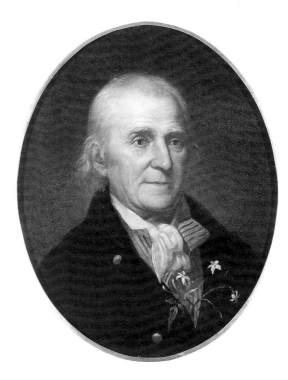

39. *William Bartram*, by Charles Willson Peale, ca. 1808,
oil on canvas, 23″ x 19″. Courtesy, Independence National
Historical Park Collection, Philadelphia, Pa.

portray'd."[4] The next year, Peale told his friend and sup-
porter John Beale Bordley that he had completed the
"portrait of a Quaker Lady who is very perty in the
dress of the Sect, . . . I have some prospect of the Quak-
ers encouragement for I find that none of the Painters
heretofore have pleased in Likeness—whether I can a
little time will shew."[5] (fig. 38) Friends commissioned
portraits from other painters, among them John Single-
ton Copley and John Hesselius.

Edward Hicks has been identified as the "first"
Quaker to paint decorative pictures in America, but this
begs the point since Friends before him also produced or
painted images. William Bartram, the famous Philadel-
phia botanist (fig. 39), was noted for his drawings of na-
tive species. Hicks would have branded him a Deist as
others have, but technically Bartram was a Quaker. Like

other Friends, he had his portrait painted in 1808.[6] Sur-
veyor Benjamin Ferris (fig. 40) of Wilmington, Dela-
ware, sketched numerous buildings like Old Swedes
Church (fig. 41). Some believe he was responsible for the
drawings from *The Hole in the Wall* (figs. 25–27).[7]

Art patronage among Quakers was "somewhat con-
tradictory . . . one, that Quakers did not approve of picto-
rial art; two, that they did not forbid it."[8] Part of the
confusion lies in the differing attitudes of wealthy urban
Quakers and those with modest incomes who lived in
outlying areas and usually manifested the most simplic-
ity in their dress and possessions. The "worldliness" of
wealthy Quakers as judged by the Hicksite interpreta-
tion of simplicity may have applied to the quantity of
goods as well as to the degree and style of ornamenta-
tion on them.

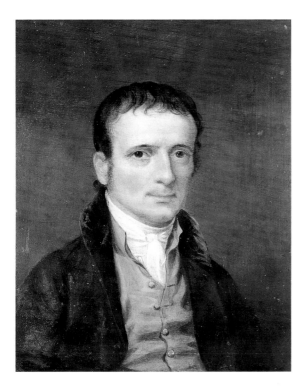

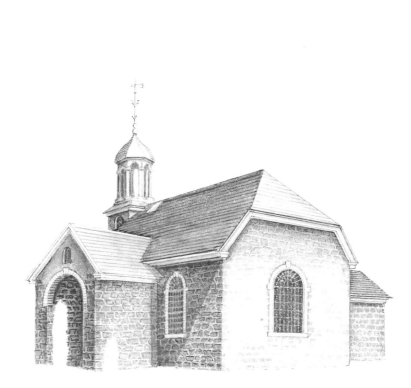

40. Benjamin Ferris, by Bass Otis, 1830–1831, oil on tin, 12″ x 10″. Courtesy, Henry Francis du Pont Winterthur Museum, Winterthur, Del., gift of Miss Frances Canby Ferris.

41. *Old Swedes Church*, by Benjamin Ferris, ca. 1820, watercolor on paper, 8¾″ x 5½″. Courtesy, Winterthur Library, Winterthur, Del., Joseph Downs Collection of Manuscripts and Printed Ephemera.

The use of colors and their intensity were important issues. While no colors were prohibited among Quakers, even in the early days of the Society, neutral tones seemed best suited to the Quaker lifestyle. Red was avoided during Edward's time when "an absence of vivid color had become central to the Quaker aesthetic."[9] "Ask anyone the color of Quakerism, and he or she will answer, 'Gray.'" "Drab" or "neutral" were also used to describe both the fabrics and the clothes worn by Quakers in the eighteenth and nineteenth centuries.[10]

The Society of Friends in Edward's time considered ornamental painting a suitable trade for members so long as it was done within the Society's general aesthetic guidelines. It must be emphasized that Edward Hicks completed his apprenticeship with the Tomlinsons in 1800, before he became a Friend. The firm's middle-

and upper-class clients, many of whom were not Quakers, ordered goods ranging from the simple to the elaborate. Vehicles, furniture, fire buckets, and other items were embellished with often lively painted decorations as customers requested. In the Tomlinsons' shop, Edward learned the skills and techniques he needed to satisfy patrons of many religious persuasions with a variety of goods and degrees of elaboration. As his commitment to the Society increased, however, the artist became aware that some things he produced were not deemed appropriate for the plain and simple Quaker lifestyle.

A large carriage shop such as the Tomlinsons' employed a variety of tradesmen.[11] Painters were considered important because the ultimate appearance of the vehicles depended largely on their skill in preparing paints, assessing their durability, and judging how var-

44. Palette, used by Edward Hicks, wood, 14″ x 18½″ x 1⅛″
This palette owned by the artist is probably the on[e]
shown in the portrait of Edward by Thomas Hicks (fig. 1)
Courtesy, National Portrait Gallery
Smithsonian Institution, Washington, D. C.

43. Spectacles, owned by Edward Hicks, metal and glass, 4″ x 5¼″. Either this pair or similar ones were shown on his head in the portrait by Thomas Hicks (fig. 1). Abby Aldrich Rockefeller Folk Art Center.

42. Windsor Chair, maker unidentified, 1800–1845, oil on wood, 46″ x 23½″ x 17¼″. This is believed to be the chair in which Edward sat while Thomas Hicks painted his portrait (fig. 1). Courtesy, private collection.

nish would affect them. Color matching of paints for repairs was also an important skill, one that Edward employed frequently. As an accomplished carriage painter, Edward was judged less by his purely mechanical abilities than by his skill in painting details such as lines and lettering and by the deftness with which he could apply certain colors of paint over others. Black paint on yellow, a technique that Edward often used in lettering borders on some of his paintings, was considered particularly difficult.[12]

Equally important to ornamental painting was an understanding of certain general rules of "taste."[13] Specific combinations of colors—green and red, purple and yellow, orange and blue—produced pleasing effects through their contrast. Brown and amber gave the appearance of harmony. Edward's signboards and the lettering on his paintings indicate that he had been instructed in color selection and its effects. He knew the basic rules: there were two classes of color—warm depicted in reds and yellows, and cold represented by greens and blues. Dark green did not wear well but looked very rich; browns were more durable but were less interesting by themselves and could be made richer by adding red.[14] Edward's choice of colors was anything but plain. He used bright yellows, blues, and occasionally reds to depict roof tops or small features such as the sashes on some of the divine children. Edward also had training in ciphering and preparing figures and heraldic and other devices

46. Mortar and pestle, maker unidentified, nineteenth century, cast iron, 12″ x 7⅜″ x 7⅜″. Edward Hicks used these implements to grind dried pigments into fine powder.
Courtesy, Newtown Historic Association, Newtown, Pa.

45. Muller, stone, 5⅜″ x 5¼″. Hicks used the muller, or grinding stone, to prepare dried pigments. It descended in the family and was acquired along with Thomas Hicks's portrait of Edward. Abby Aldrich Rockefeller Folk Art Center.

used in the spaces of a vehicle's panels.[15] Finally, he had a complete knowledge of the different sorts of paints, grounds, and, especially, colors that were suitable for various materials and parts of vehicles.[16]

Still, there is little literature from Edward's period or subsequently derived from the analyses of surviving horse-drawn vehicles of the period to help develop a detailed comparison of paint surfaces and techniques the artist used. It can only be assumed that Edward had access to handbooks and trade literature from Europe and England or that the Tomlinsons, with whom he apprenticed, had access to this information. By the 1860s, the American coach and carriage industry had produced a number of manuals and related materials. While pub-

lished too late for Edward's use, they detail historic techniques he probably employed. Evident from the manuals is that the painting work was labor intensive. Finishes were achieved through "building up and rubbing down successive layers of paint and then varnish." Sometimes as many as "two dozen layers of paint and varnish" were applied, each layer requiring days of drying time.[17]

To appreciate Edward's shop work and put his dilemma in perspective, it is important to understand some fundamentals about the trade of coach and carriage making, which thrived in America after the Revolutionary War. Most domestic production reflected the kinds of vehicles produced in Europe and England, al-

47. Herald and Ornament Painting, Plate XIX from William Felton, *A Treatise on Carriages*, 1794–1796. The top portion of the plate features samples of coats of arms and ciphering that were painted on the doors of carriages. The lower portion shows examples of bordering and designs to ornament the panels of the carriage. John D. Rockefeller, Jr. Library, Colonial Williamsburg Foundation.

Painting.

THE subscribers inform their friends and the public, that they continue to execute Coach, Sign, and Ornamental Painting, of all descriptions, in the neatest and handsomest manner, with the greatest despatch.

**Edward Hicks, &
Thomas Goslin.**

Newtown, 5th-Mo. 21. 1 tf.

48. Advertisement in *Star of Freedom* (Newtown, Pa.), May 21, 1817. Courtesy, Newtown Historic Association, Newtown, Pa.

though some American types did emerge. The carriages most commonly painted by Edward are illustrated in figures 49, 50, and 51. Nineteenth-century American designs emphasized use rather than the elaborate ornamentation associated with the aristocratic models of the previous century, although carriage painters had to be prepared to provide both simple and more ornate decoration (fig. 47).[18]

A number of coach- and carriage-making centers existed in America during Edward's lifetime. Bucks County, Pennsylvania, particularly the Newtown area, was among them. In 1831, the *Register of Pennsylvania* noted that "four or five extensive coaching-making establishments, and a proportionate number of other thriving industrious mechanics were located there." Many of the mechanics, Edward among them, supplied specialized work to the coach-making firms.[19]

Some of Edward's work for area coach makers such as elaborate ciphers and coats of arms, as well as the ornamented signboards he made for others, was considered inappropriate by Friends. It is unlikely, however, that the artist's decision to abandon this work for farming in 1815–1816 closed the Hicks shop. Thomas Goslin, who worked with Edward, seems to have taken over the business as revealed in his advertisement:

COACH, SIGN & HOUSE
PAINTING
The subscriber respectfully informs his friends and the public, that he has commenced the business of
COACH, SIGN & HOUSE PAINTING,
in Newtown, in the shop formerly occupied by E. Hicks, where he will execute orders in his line with neatness and dispatch. He hopes, by particular attention to his business, to meet with encouragement.
THOMAS GOSLIN.
N.B. Carriages, Giggs, Chairs, and Waggons, repaired with dispatch. Newtown, April 26, 1815.[20]

When the artist returned in 1817, he and Goslin had agreed upon some sort of partnership (fig. 48).[21]

49. Coach, Plate XXII from William Felton,
A Treatise on Carriages, 1794–1796.
John D. Rockefeller, Jr. Library,
Colonial Williamsburg Foundation.

50. Gig, Plate XLIII from William Felton,
A Treatise on Carriages, 1794–1796.
John D. Rockefeller, Jr. Library,
Colonial Williamsburg Foundation.

51. Post-Chaise, Plate XXVII from William Felton,
A Treatise on Carriages, 1794–1796.
John D. Rockefeller, Jr. Library,
Colonial Williamsburg Foundation.

Only a handful of decorative household items can be assigned to Edward's shop, chiefly on the basis of family history and descent. They may be helpful in eventually identifying other examples. The chair in figure 52 is simple and plain in ornamentation, making it appropriate for a Quaker household such as Edward's. Although badly abraded, a painted and pinstriped child's chair with similar restrained decoration also survives in the family. Neither piece reflects the more expensive, ornate work that Edward's shop could have produced. Hicks's account book rarely described the design elements provided, although it does include several tantalizing references to techniques that often resulted in fancy work. Newtown cabinetmaker Oliver Norton contracted with Edward for work that ranged from gilding and silvering frames to painting window cornice boards and furniture. An unknown client commissioned Edward to gild six "setting" chairs about 1811. Occasional references to painting furniture or interior woodwork "mahogany" color suggest some type of graining.[22]

Among the variety of utilitarian objects attributed to Edward's hand are a decorated small round box for his oldest daughter and a miniature chest for his wife (figs. 53 and 54). Both descended in the family, and both display the kinds of fanciful floral motifs popular during the early nineteenth century. Rare survivals, they represent a dimension of Edward's shop work that records indicate was common.

One other item should be mentioned, although it seems to have been a personal project of Edward's, rather than associated with his shop work. Frederic Newlin Price and Edward Barnsley, Newtown historians, discovered an article in the *Newtown Journal and Working-Men's Advocate*, May 2, 1843, that described "Hicks's Alphabet Blocks":

A few days since, we called on our friend Edward Hicks, and spent some time in examining some of his paintings; among which we noticed a large quantity of his alphabet blocks, . . . They are small square blocks, lettered on all sides, and executed in a style exceedingly neat, being designed, we believe, for the amusement and instruction of children. So far as we are able to judge, Friend Hicks has hit upon an excellent plan; as it possesses sufficient attraction to interest the youthful mind; and also instruct and benefit. The child seizes upon the blocks with avidity; commences building his 'castles in the air', and soon becomes familiar with all the letters, . . . How vastly superior are such things as these to the toys which are commonly used to amuse children; such as whirligigs, tops, miniature men and dogs, etc. . . . if any of our friends are disposed to examine them, they can do so by calling on the manufacturer, or at our office. . . . from the long experience our friend has had in the business of painting, he is enabled to furnish them at a very low rate.

The plan for producing and selling these toys had apparently fizzled by 1845. Edward received a letter from Philadelphia merchant Richard Price, who had the box of blocks for about a year and regretted that "thy alphabets did not meet with a ready Sale.—I have spoken to T. Ellwood Chapman and Wm. D. Parrish, but neither of them think, a sale can be made in our City."[23] None of these little blocks has been discovered yet. Had the product succeeded, they likely would have been made in Edward's shop.

Edward Hicks's accounts help clarify the sorts of work he and his workers performed. The small group of signs and fireboards identified as being by Hicks represent only a fraction of the decorative works the artist executed during his lifetime. Some of the thirty-five entries for signs in the account book between 1806 and 1833 indicate they were simple jobs for which he charged 50 cents to $3.00 for lettering. The price of others suggests they were more elaborate. Hicks painted a tavern sign featuring the Pennsylvania coat of arms for James Corson in 1810. It cost $25.00. He made expensive tavern signs for Samuel Hellings about 1810, Samuel Thornton in 1813, Joseph Whitall about 1812, and an unidentified patron in 1817. The most expensive signs,

52. Rocking Chair,
decorated by Edward Hicks,
1830–1845, oil on wood,
43½″ x 23¾″ x 33⅜″.
Courtesy, Newtown Historic Association,
Newtown, Pa.

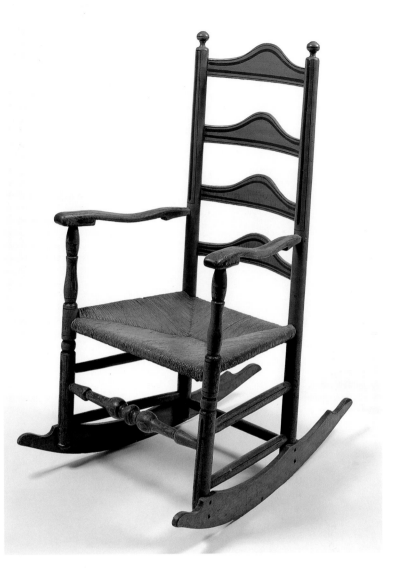

53. Tin Box, decorated by Edward Hicks,
ca. 1835, oil on tin, 1⅜″ x 3″ x 3″.
Courtesy, Newtown Historic Association,
Newtown, Pa.

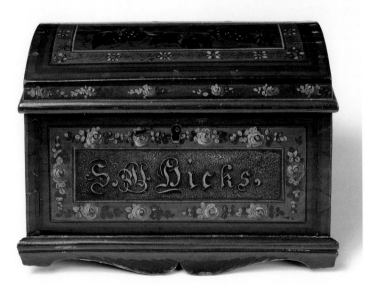

54. Miniature Chest, decorated by Edward Hicks,
ca. 1835, oil on wood, 5⅜″ x 8″ x 4″.
Courtesy, Newtown Historic Association,
Newtown, Pa.

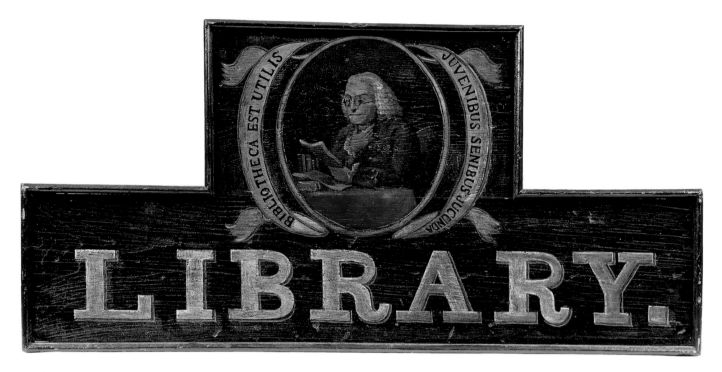

55. Newtown Library Sign, by Edward Hicks, 1825, oil on wood, 17¾″ x 37½″.
Courtesy, Newtown Library Company, Newtown, Pa.

56. Detail from fig. 55.
The central motif features
a portrait of Benjamin Franklin
based on an engraving after the
1767 original by David Martin.

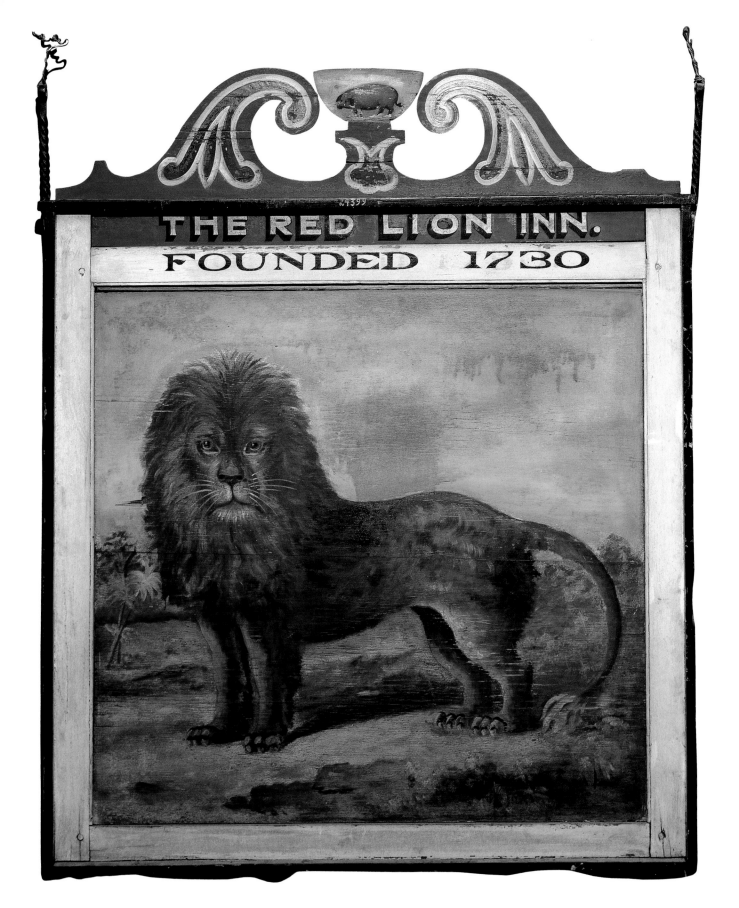

THE RED LION INN.
FOUNDED 1730

57. Red Lion Inn Signboard, by an unidentified artist, Bensalem, Bucks County, Pa., ca. 1825,
oil on wood, 67¾″ x 59″ x 2¼″. Courtesy, Mercer Museum of the Bucks County Historical Society, Doylestown, Pa.

58. Henry Vanhorn Signboard, by Edward Hicks, 1800–1805, oil on wood, 17⅛″ x 54⁵⁄₁₆″.
Abby Aldrich Rockefeller Folk Art Center.

listed at $50.00 each during 1809 and 1810, were for
Daniel Larrew and John Hulme. Hicks did not indicate
what the designs for the signs were, but their costs sug-
gest decoration on both sides. By comparison, Edward
charged Thomas Jenks and Abraham Chapman $15.00
apiece for landscape paintings in 1818, Doctor Phineas
Jenks $40.00 in 1817 for a landscape fireboard, and,
about the same time, William Watts and Beulah Twin-
ing $25.00 and $20.00 respectively for decorated chim-
ney boards.[24] These probably were fireboards similar in
size and ornamentation to the ones Hicks created for the
Parrish family (figs. 21 and 86).

Printed sources and signboards painted by other
tradesmen inspired Edward's work. Although Edward

did not produce the Red Lion Inn sign (fig. 57) origi-
nally from Bensalem, Bucks County, it represents the
fine quality of sign painting achieved in many areas of
the country during these years. Edward may have been
aware of the work of John Archibald Woodside, Sr.,
"one of the best sign painters in the state, and perhaps
in the country, and was the first to raise this branch of
the art to the degree of excellence here which it has now
attained."[25] Holger Cahill was among the first re-
searchers to observe a stylistic relationship between Ed-
ward's pastoral work and Woodside's paintings.[26]

Based on their style, a few signboards can be docu-
mented or attributed to Hicks. With the exception of the
1825 Newtown Library sign (fig. 55) and the one for

Henry Vanhorn (fig. 58), most have been assigned to the mid-1830s and later. Included are the two signs on either side of the Delaware River that commemorate Washington's historic crossing (fig. 59). They were painted—presumably in 1833—for the January 1, 1834, opening of a bridge spanning the river from Pennsylvania to New Jersey.[27]

It is well known that Edward borrowed the composition for these signs from an engraving (fig. 60), probably by George S. Lang (1825 version) after Thomas Sully, *Washington at the Passage of the Delaware*, 1819 (fig. 62).[28] The signs encouraged Hicks or prompted his admirers to commission a number of unlettered oil on canvas versions. Seven are known today (figs. 61, 150–152), one of

which has been assigned the unlikely date of 1825. They are similar, although only the Folk Art Center example has the moonlit sky of the signboards and the Lang engraving. Hicks added details to other versions, like the house in the distant background in figure 61.

Other historical signboard compositions appear to have resulted in requests for easel pictures. In 1836, Hicks painted a tavern sign for Joseph Archambault's recently purchased Brick Hotel in Newtown.[29] No longer surviving, it reportedly featured an image of the signing of the Declaration of Independence on one side and George Washington on the other. The Declaration of Independence scene probably was similar to the pictures Edward painted during the 1840s (fig. 63). Most likely, it

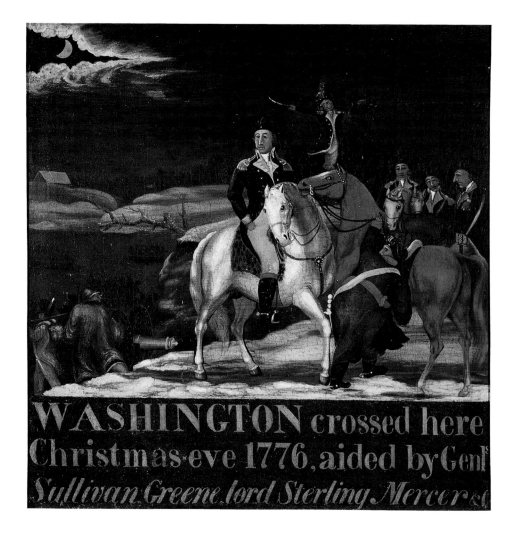

59. "WASHINGTON crossed here . . . ,"
Signboard, by Edward Hicks, 1833, oil on canvas
originally mounted on wood panel, 31½" x 31½".
Courtesy, Mercer Museum of the Bucks County
Historical Society, Doylestown, Pa.

60. "WASHINGTON PASSING THE DELAWARE,"
by George S. Lang, 1825, engraving, 13½" x 17¼".
Abby Aldrich Rockefeller Folk Art Center.

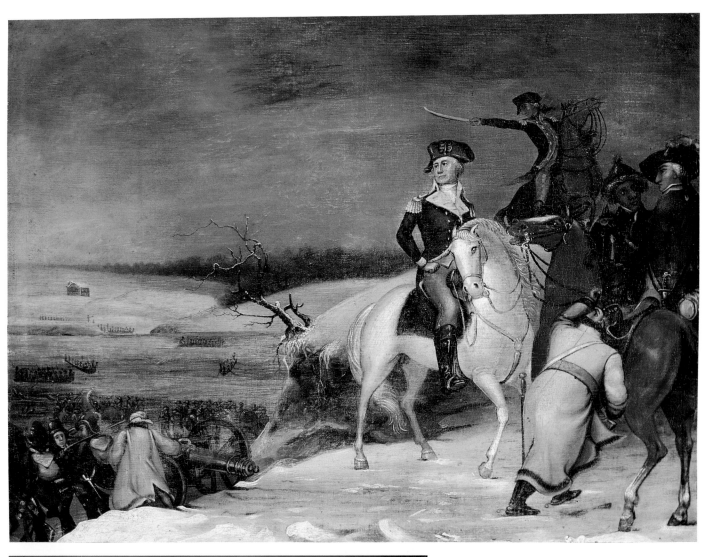

61. Washington at the Delaware,
by Edward Hicks, 1835–1840,
oil on canvas, 17¼″ x 23¼″.
Courtesy, Mercer Museum of the Bucks County
Historical Society, Doylestown, Pa.

62. *The Passage of the Delaware,*
by Thomas Sully, ca. 1819,
oil on canvas, 146½″ x 207″.
Courtesy, Museum of Fine Arts, Boston, Mass.,
gift of the Owners of the Old Boston Museum.

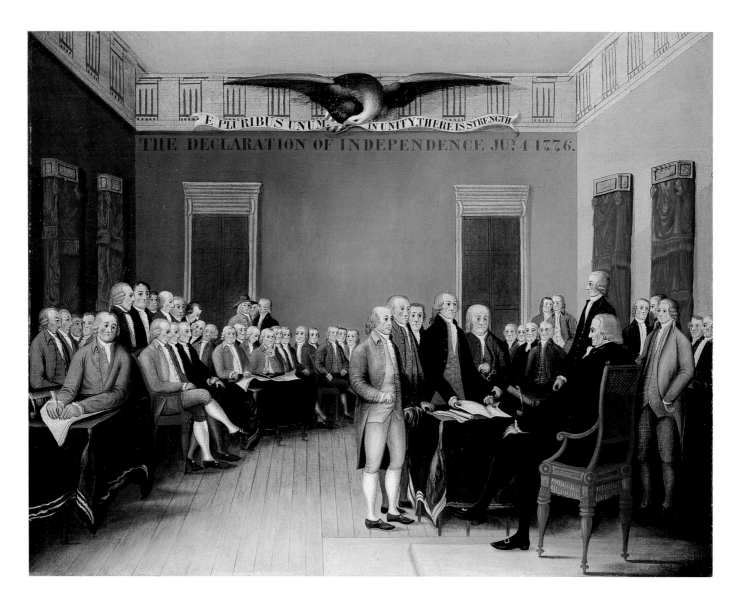

63. "THE DECLARATION OF INDEPENDENCE, JU,ᵞ 4, 1776,"
by Edward Hicks, 1840–1845, oil on canvas, 24″ x 34¾″. Abby Aldrich Rockefeller Folk Art Center.

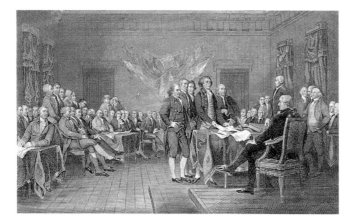

64. Declaration of Independence,
by Illman and Pilbrow, 1820–1829, engraving.
The engraving is the frontispiece
in Charles A. Goodrich, *Lives of the Signers
to the Declaration of Independence*,
1829. John D. Rockefeller, Jr. Library,
Colonial Williamsburg Foundation.

65. Penn's Treaty Signboard (recto and verso), by Edward Hicks, 1844, oil on wood, 57″ x 57″.
Courtesy, Newtown Historic Association, Newtown, Pa.

was inspired by an engraving after the original painting by John J. Trumbull. Earlier researchers believed that Edward based his copy on Charles A. Goodrich's 1829 book containing the engraving, which Hicks is known to have owned (fig. 64).[30] Why scholars have dated all three of the Declarations of Independence to 1840–1844 when the lettered title of only one is dated "1844" is puzzling. The others may have been created as early as the 1830s. The lettering, architectural details, and, in two instances, the inclusion above the signers of American eagles, one of which holds an olive branch and the other an unfurled banner, vary considerably.

The Penn's Treaty sign that originally hung in front of Washington House, a temperance hotel in Chester, Pennsylvania (fig. 65), has been dated 1844.[31] It is badly weathered and difficult to assess stylistically. The details that can be discerned are similar to the Treaty vignettes in the Peaceable Kingdom pictures and the larger individual versions of Penn's Treaty that Hicks painted from

1830 through the 1840s (figs. 66, 153–155). The famous elm tree shading the treaty group is the most obvious difference. Its placement may have been symbolic, or, perhaps more likely, for symmetry. The Indians appear on the left and Penn's group on the right, with the tree uniting them. Benjamin West's famous painting of Penn's Treaty, popularized through an engraving by John Hall, was a likely source for Edward to have used (fig. 67).[32]

Verbal tradition holds that Hicks painted another Treaty signboard for Samuel Willet's tavern in Buckingham, Pennsylvania, a "Bird-In-Hand" sign for a building in Newtown, and a sign featuring Noah's Ark on one side and a fleet of boats on the other for the Ferry Inn in Taylorsville.[33] None is documented in the account book.

The Henry Vanhorn carpenter's signboard, owned by the Folk Art Center (fig. 58), and two signs painted for hatter Jacob Christ, owned by the Mercer Museum, Bucks County Historical Society (figs. 68 and 69), are

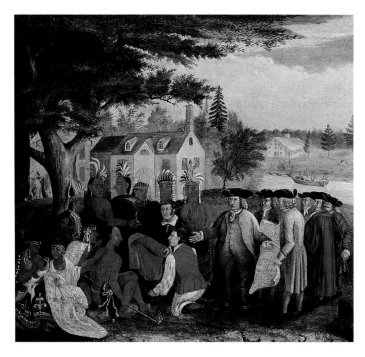

66. William Penn and His Party with Indians, detail from fig. 154.

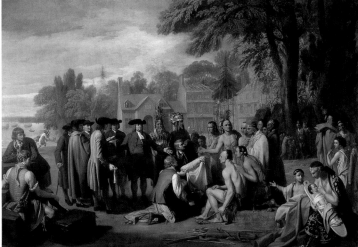

67. *Penn's Treaty with the Indians,*
by Benjamin West, 1771–1772,
oil on canvas, 75½″ x 107¾″.
West displayed the painting
in Independence Hall in Philadelphia in 1772.
Courtesy, Pennsylvania Academy of Fine Arts,
Philadelphia, Pa. Gift of Mrs. Sarah Harrison
(The Joseph Harrison, Jr., Collection).

extraordinary survivals. The Folk Art Center example is in the best condition and has its original frame. It is believed to date about 1800 to 1805, the period in which Vanhorn is thought to have operated his first carpentry shop. Henry Vanhorn, the nephew of Alexander Vanhorn, carriage maker in Newtown, operated a carpentry business in Bucks County. Vanhorn family tradition claims that the carpenter's first shop was in operation for only a year, after which he took the sign down and moved to another location. The sign was never installed on the second shop.[34] Clear colors, well-preserved surface, and clever symbolic devices make this sign noteworthy. Reading from right to left, Vanhorn made items of all sorts, serving his customers from cradle to grave!

The seventh signboard illustrates an image of Robert Morris (fig. 70) and is dated circa 1825. Mather and Miller attributed it to Hicks on the basis of an article from the *Doylestown Democrat,* June 8, 1875. The sign originally hung at the Carlisle Hotel, Morrisville, Bucks County, Pennsylvania. It is actually composed of two boards: a portrait of Morris on one side and Morris receiving a bag of money from another gentleman on the verso; a lettered, horizontal board hung beneath these scenes. An exceptional example of sign craft, its attribution to Edward Hicks is questionable. The lettering bears little resemblance to that on other works attributed to the artist. "Pictorial Sign Co./206 North 8th St. Phila." is stamped on the verso of the pictorial board.[35]

The last reference to Edward Hicks's sign painting is in a *Doylestown Democrat* article relating news of the renovation of the old Willow Grove Hotel. One of the improvements was a

new sign recently erected. It was painted by Edward Hicks, an aged and much beloved minister in the society of Friends, and is such a one as we would expect to emanate from this eminent artist. It is one of the best specimens of the skill of the painter now hanging between Philadelphia

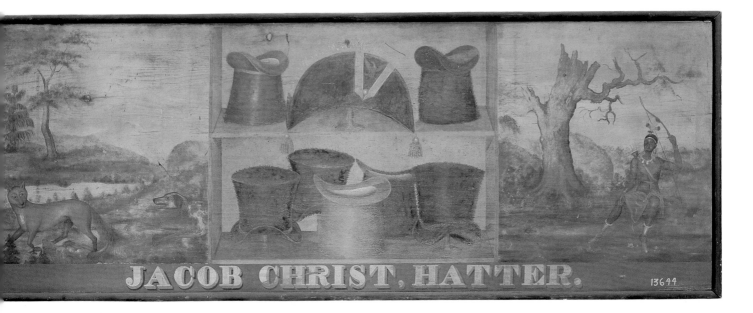

68. Jacob Christ Signboard, by Edward Hicks, 1810–1840, oil on wood, 36″ x 98″.
Courtesy, Mercer Museum of the Bucks County Historical Society, Doylestown, Pa.

69. Jacob Christ Signboard, by Edward Hicks, 1810–1840, oil on wood, 20½″ x 33″.
Courtesy, Mercer Museum of the Bucks County Historical Society, Doylestown, Pa.

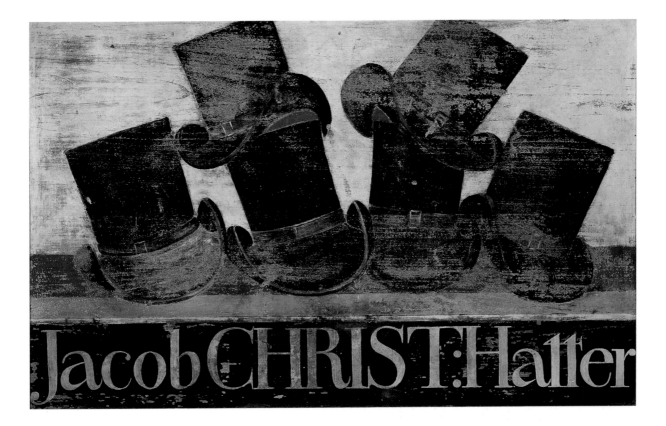

THY WORD IS THY BOND.

ROBERT MORRIS
A Distinguished Member of the Illustrious Congress of 1776 for whose financial labors, next to Washington, America is indebted for turning the tide of success in the American Revolution, in taking the Hessians at Trenton on Christmas Morning 1776, reviving the desponding cause of Liberty and Independence.

70. Robert Morris Signboard, attribution uncertain, ca. 1825, oil on wood, 48″ x 36″. Courtesy, Mercer Museum of the Bucks County Historical Society, Doylestown, Pa.

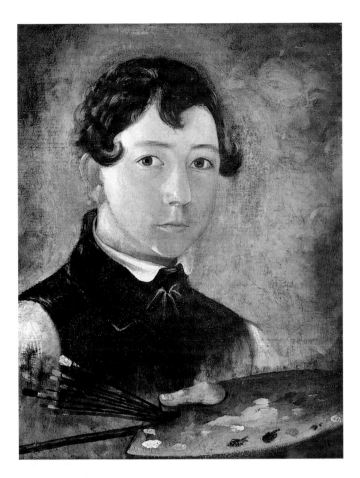

71. Self-Portrait, by Thomas Hicks, ca. 1836–1840,
oil on canvas, 20″ x 16″.
Courtesy, Mercer Museum of the Bucks County Historical Society,
Doylestown, Pa

and Doylestown, or even Easton; and we do not doubt but
that thousands will call, if for no other purpose than to
take a leisure view of this beautiful work of art.[36]

Unfortunately, the author did not describe the sign
further, leaving no clues as to its imagery.[37]

There is some information about the workers, ap-
prentices, journeymen, and others Edward employed.
Goslin has been mentioned; the length of his tenure in
the shop is unclear.[38] Edward Hicks employed John
Hubbord for various kinds of simple painting. One
source stated that he served an apprenticeship with Ed-
ward. Morris Croasdale and Luis Jones, often mentioned

in the Hicks family correspondence, also worked in the
shop in unspecified capacities.[39] The account book pro-
vided names of other workers in Edward's shop such as
Thomas Evans, Charles Shoemaker, and David
Twining.[40]

Thomas Hicks, Edward's first cousin once removed,
was working with him, probably as an apprentice, as
early as 1836. Edward supported the younger man's tal-
ents. While employed in Edward's shop, Thomas (fig. 71)
executed a number of portraits, fifty-three of which
were recorded in a daybook maintained mostly by Ed-
ward's son Isaac (fig. 75).[41] Edward borrowed a portrait
for Thomas to study and, about age sixty, posed for
Thomas (fig. 1). The younger artist later made at least
two copies of Edward's portrait.[42] Thomas's likenesses
are tributes to the older artist and his favorite subject,
the Peaceable Kingdom, and underscore the interest Ed-
ward took in Thomas's career. In 1839, Thomas left to
study at the Pennsylvania Academy, later continuing his
training in New York City and abroad.[43] He became a
well-respected, skilled artist (fig. 72).

Artist Martin Johnson Heade may have worked
briefly in Edward's shop when Thomas Hicks was there.
Heade probably received instruction from both Edward
and Thomas.[44] Although Thomas was younger, he seems
to have influenced the development of Heade's style.
Their friendship continued long after their youthful
training in Edward's shop (fig. 73). There are similari-
ties between works by Heade and those by Thomas
Hicks.[45]

Edward's son Isaac (fig. 74) also was employed in the
business, although the nature of his work and the extent
of his involvement remain unclear. By the 1830s and
continuing into the 1840s, some payments to the shop
recorded in Isaac Hicks's daybook and Edward's account
book were made to "Edward Hicks and Son."[46] Keeping
the record books may have been among Isaac's responsi-
bilities.

Most of the work done in the shop was contractual.
The Tomlinsons, Alexander Vanhorn, and Joshua C.

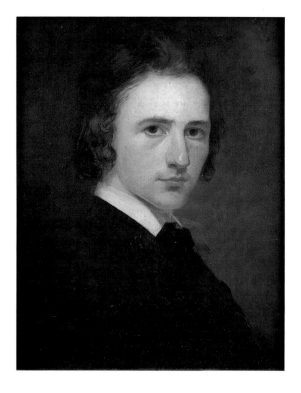

72. Self-Portrait, by Thomas Hicks, ca. 1840–1842,
oil on canvas, 19⅞″ x 16″.
Courtesy, Collection, National Academy of Design,
New York, N. Y.

73. Martin Johnson Heade, by Thomas Hicks, 1841, oil on canvas, 30″ x 25″.
Courtesy, Mercer Museum of the Bucks County Historical Society, Doylestown, Pa.

Canby, Edward's former employer, operated large coach-
and carriage-making establishments in the area and
were the chief sources of work for Edward (fig. 76).[47]
Alexander Blaker, Charles V. Craven, Robert Croasdale,
Silas Phillips, Benjamin T. Yardley, and the coach and
carriage firm of Yardley and Buckman also procured
Hicks's services. Numerous smaller accounts recorded in
the book reflect a miscellany of patrons, most of whom
were local, and a variety of work on personal vehicles
and domestic objects.[48]

Not surprisingly, Edward's personnel made few me-
chanical repairs to vehicles. These tasks were usually
farmed out to tradesmen living in or near Newtown.
Among them were blacksmiths, carpenters, harness
makers, ironworkers, millwrights, and the like.[49] Cabi-
netmakers are mentioned, among them Oliver Norton,
who was succeeded by Robert S. Sellers, and a man
named Trego, possibly the Edward Trego who took over
William Brooks's cabinetmaking shop about 1836.[50] The
connection between Edward Trego and Edward Hicks,

74. Isaac Worstall Hicks,
by Thomas Hicks, 1839–1840,
oil on canvas, 23″ x 22¼″.
Courtesy, private collection.
Photograph courtesy, Frick Art Reference Library,
New York, N. Y.

75. Entries for Thomas Hicks
Isaac Worstall Hicks's Daybook.
Courtesy, Katherine K. Fabian.

Joshua C. Canby Dr

		$		
2nd	To Ballance brought over		45	51
	To 8th of Veal		0	45
14 "	To painting Coachee Body		17	50
26 "	To Carpet & work done by Thos Evans		3	33
11 "	To painting Chair Body & to Carpet		17	37
13 "	To painting Chair Body & to Carpet		17	25
20th	To Sundries paintings		19	51
24th	To painting Two Chair Body		17	00
5 th	To painting old Chair Body		5	51
23th	To painting do do		2	75
17th	To painting Two New do		20	00
	To painting gig Body		10	00
	To painting do do		10	00
	To painting Two old do		9	00
6	To Sundries paintings		1	25
	To painting old gig Body		6	00
24th	To Sundries painting		5	75
	To painting Coach Body		18	00
11	To painting do do		17	00
2	To painting old Chair Body		4	50
	To painting Two New do		20	00
15	To painting Three do doe		28	50
3rd	To painting old Charidge		35	00
	By Cash received for the same $35.00			
	To painting gig Body		10	00
30	To painting do & Chair Body		20	00
2nd	To Cash payd for oil		13	00
	To painting old Charidge		24	00
	By Cash received for same 22.75			
26	To painting gig Body & pollishing Body		11	67
	To Lew Anderson acct which he assumed		62	50
	To painting Three Chair Bodys		18	51
	To painting one New do		10	00
11	To Nathan Milnor acct which he assumed		14	00
1	To painting Waggon Body		12	00
	To some Wheels		1	25
6	To painting Three Chair Bodys & some paint		30	92
			792	8

76. Page of Joshua C. Canby's business transactions with the artist from Edward Hicks's Account Book. Courtesy, Mercer Museum of the Bucks County Historical Society, Doylestown, Pa.

New Town 2nd morn 9 moth 23rd 1844
Dear Joseph

I send thee by my son one of the best paintings I ever done (at my be the last) the price as agreed upon is twenty dollars with the additional sum of one dollar 75 cents which I give Edward Trego for the frame I thought it a great deal cheaper then thee would be likely to get a frame with ten coats of varnish any where else — Thee can pay the money to Isaac who can give thee a receipt if necessary but I have no account against thee — With gratitude & thankfulness for thy kind patronage of the poor painter & a grateful remembrance of many favours from thy kind parents — I bid the dear child & affectionate farewell

Joseph Watson Edw. Hicks

77. Edward Hicks to Joseph Watson, Sept. 23, 1844. Abby Aldrich Rockefeller Folk Art Center.

noted in other publications about the artist, is known because Trego made a frame for the Peaceable Kingdom picture Edward created in 1844 for Joseph Watson. The artist wrote to Watson explaining that Trego had applied nine coats of varnish to the frame (fig. 77).[51] The construction details of this frame compare favorably with other frames containing the artist's work that have been attributed to Trego. However, a small study of selected original frames on Hicks's pictures revealed that more than one cabinetmaker provided them.[52]

Edward's business depended largely on his continuing good relationships with tradesmen and potential customers living in and near the community of Newtown.

Many were Friends who shared Edward's religious beliefs; others were his friends and relatives. Hicks adhered throughout his lifetime to the Quaker principles of industry and tending to an honest business. Three years before his death, he wrote that he was "working with my own hands . . . ministering to my own necessities and them that are with me, which always produces peace of mind to an humble, honest Christian."[53] Edward's work ethic, so closely allied with his Quaker religion, was expressed again when he quoted St. Paul: "Study to be quiet and do your own business, and work with your own hands that you may provide things honest in the sight of all men."[54]

The Early and Middle Kingdoms

Paint what thou canst upon the living scroll!
And pour a ray of genius round the whole.

SAMUEL JOHNSON, *Poems on Various Subjects (1835)*

There has been considerable controversy about the attribution and dating of the Peaceable Kingdom in figure 28, which is owned by the Cleveland Museum.[1] Ford believed it too crude to have come from Edward's hand, suggesting instead that it might be an early (1836–1839) effort by Thomas Hicks, who was working in Edward's shop and probably saw some of his Kingdom paintings.[2] If this were a copy by Thomas, it is not listed among his work in Isaac's daybook, and it copies no known Kingdom format by Edward.

Many of the stylistic details in the Cleveland Museum's Kingdom picture suggest an attribution to Edward Hicks. Its naive composition and awkwardly positioned group of animals indicate an early effort. At this stage in his career, Edward had little experience with canvas or easel painting and had yet to learn how to integrate a number of elements naturally and comfortably within a balanced composition. His signboard work emphasized the distinctive, age-old tradition of linear painting—clear colors and shapes that were easily recognizable forms or symbols. Various systems and abilities to render lifelike images in both color and linear perspective were desirable, but not necessary; bold, direct, and believable emblems were of paramount concern in signage. Both the support medium, usually wood (occasionally metal) and the methods of sign painting were distinct from easel painting. Many American trade-trained or minimally trained painters combined such techniques with what they knew of fine arts

practices in rendering easel pictures. Edward was no exception.

Edward's earliest Kingdom reveals many of the fine arts technical inadequacies as well as the trade methods he knew well. The Cleveland painting possesses a flat, almost medieval quality in the painting and positioning of the lamb and wolf, both profiled, and in the tedious preoccupation with the foliage and flowers in the lower left (figs. 79, 80, and 81). This sort of labored detailing occasionally appears in Hicks's later works, but it tends to go unnoticed in the more complex compositions. The lion, child, and fatling calf, all borrowed directly from Richard Westall's Bible print (fig. 78), are less pristine and sharp in delineation. Edward tried to achieve the shading and depth observed in the original print, but with only modest success.[3] The unremarkable landscape setting serves only as a neutral backdrop for the foreground subjects, as in a signboard. Edward did not copy Westall's lamb or kid, the latter of which faces the child and was posed in a more complicated way that might have been too difficult for the artist to attempt. Although it is a modest painting by Hicks, the Cleveland picture is an important survival that marks the artist's early inception of the Kingdom concept. It also represents a transition in which the knowledge of ornamental painting was combined with more difficult passages based on fine arts models.

The Kingdom pictures have been interpreted as aesthetic expressions of Quaker quietism, as testimonies on

79. Detail from fig. 28.

78. *The Peaceable Kingdom of the Branch*, by Richard Westall,
1800–1815, engraving. The engraving was published in Charles Heath,
The Holy Bible, 1815, Vol. II.
Abby Aldrich Rockefeller Folk Art Center.

80. Detail from fig. 28.

81. Detail from fig. 28.

peaceful coexistence, and, more recently, as Edward's efforts to satisfy critics of his easel art.[4] But why did Hicks select the Peaceable Kingdom theme in Isaiah? Why not Noah's Ark, of which only one version by Edward (fig. 82) survives? Why not another biblical subject—Daniel in the Lions' Den, for example? Isaiah's prophecy was not only a central and concise statement that embodied key Quaker beliefs, including the issues of inward and outward religious life. It was also a part of the common metaphorical language of the Quaker ministry that often alluded to man's animal propensities and natures. Such meanings are not stressed in the story of Noah's Ark or some other popular as well as illustrative biblical teachings. Other reasons may have influenced Edward's decision to depict the Isaiah prophecy. He cleverly selected a subject that was acceptable to Friends and reinforced the timely messages of his and Elias's ministries. By doing so, he could pursue his art which admittedly he loved.

The irony is that by creating a pictorial format in easel painting that satisfied—or at least quelled—the concern of his critics, Edward elevated himself to something beyond a tradesman who produced largely utilitarian work. He would never be a "fine arts" painter, but he could have achieved that rank had the circumstances of his life been different since his talent far exceeded the limitations he imposed on it by adhering to the Quaker way of life. His choice, although self-imposed, was shaped significantly by peer pressure that epitomized the prevailing conservatism and rural nature of his Bucks County world.

The composition and rendering of the group of Peaceable Kingdoms Edward painted after the Cleveland picture are significantly more sophisticated (compare figs. 28 and 87). It has been assumed that after Edward began the Kingdom pictures, he continued to paint them at regular intervals. This assumption probably is not true of Edward's earliest efforts.[5] What had begun as a way to express his religious convictions and legitimize his easel work had not yet become a genre through which the artist depicted his perception of growing dissension within the Society of Friends. Three or perhaps four years may have elapsed before Edward began to create the surviving Kingdoms that followed the Cleveland picture.

Scholars have also assumed that the compositions of the Kingdoms evolved chronologically; once Edward changed a picture or major element, he usually did not return to it. While generally true, there were occasional overlaps between the various types. With the exception of the thirteen paintings comprising the first Kingdom group, a reconsideration of the dates for many of the extant Kingdom pictures is necessary. The thirteen paintings discussed here (figs. 86–98) were created after the Cleveland Peaceable Kingdom. All but one retain their original borders. Five were titled either by the artist or later scholars as "the peaceable kingdom of the branch." Eight have rhymed borders that paraphrase the Isaiah prophecy.[6] Edward signed five of the paintings, one of

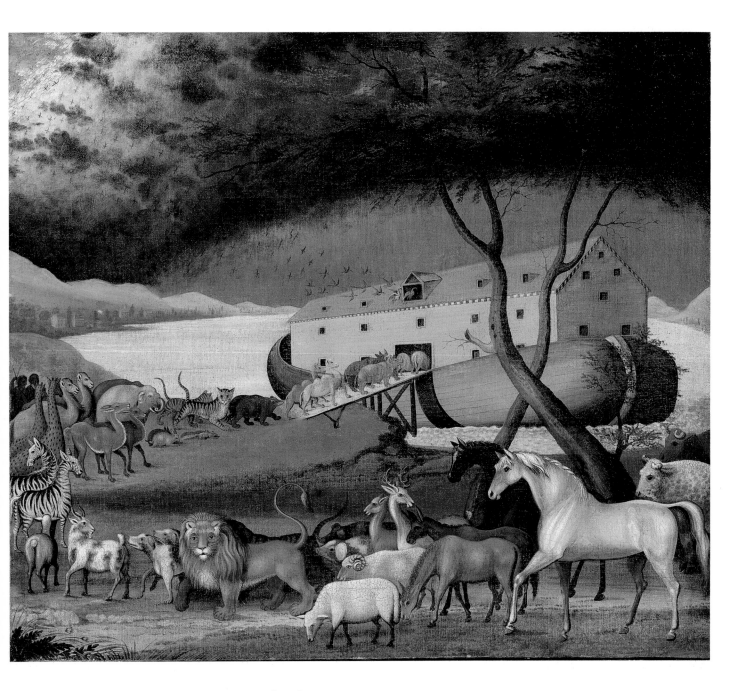

82. Noah's Ark, by Edward Hicks, 1846, oil on canvas, 26″ x 30″.
Courtesy, Philadelphia Museum of Art, Philadelphia, Pa., bequest of Lisa Norris Elkins.

which was dated 1826. Hicks probably painted the thirteen between 1822 and 1829–1830,[7] so this group overlaps another type of Kingdom. Edward rarely signed or dated Kingdom pictures, further complicating the assignment of dates.

An important feature of this group is the borders, a strong link to sign painting. Although it appears in other works by the artist, lettering of this sort disappeared from the Kingdoms about 1829. The border Kingdoms, including those with the prominent grape vines or "branch," and the two Niagara fireboards created about the same time have these lettered features. The vignette from the Henry S. Tanner map showing the Natural Bridge of Virginia, published in 1822, presumably served as a source for the backgrounds in the earliest border Kingdoms (fig. 84), while other elements from the map were used in the Niagara views (fig. 85).

The Kingdom fireboard thought to have been painted for Dr. Joseph Parrish of Philadelphia (fig. 86) is usually considered the earliest of the border Kingdoms, chiefly because the divine child's pose is similar to that in the Cleveland picture.[8] The child, except for the clothing covering the bodice, and the animals with their sleepy, dreamy expressions, came directly from the Westall print. Edward faithfully copied the grape clusters and leaves on the branch held by the child from Westall as well. In its Westall context, the branch undoubtedly represented the redemptive blood of Christ.[9] Fully aware of a little-quoted passage from the Isaiah prophecy, Edward used the device to emphasize the "branch of Jesse."[10] The branch with grapes is seen throughout a number of the later Kingdom pictures and was, for Edward, an important icon.

Hicks included a small but nonetheless important view of William Penn signing his famous treaty with the Leni-Lenape Indians under the bridge. The bridge is a masterful reference to nature, one of God's magnificent creations. Placed beneath it, Penn and the Indians appear to be surrounded by God's grace and protection as they achieve their historic peace. The child

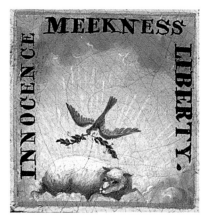

83. Detail from fig. 94.

and peaceful animals placed along the meandering stream that connects both groups thus reinforce the idea of mankind's ability to achieve peaceful coexistence through the belief of the Inward Light. The tone of this Kingdom is quiet, serene, yet much richer and telling in its symbolism than the previous Kingdoms.

Which of the undated bordered Kingdoms with the Natural Bridge were painted after the Parrish example can be debated. Those in question include one at the Abby Aldrich Rockefeller Folk Art Center (fig. 87), a rhymed bordered version in the collection of Amherst College (fig. 88), and a comparatively smaller version at Reynolda House Museum (fig. 89). Stylistic analysis of this group does not help in dating them.

The importance of the four pictures is the constant refinement that Edward brought to the painting process as he experimented with the interpretation of the prophecy theme and its relationship to American Quaker history. Still heavily reliant on the Westall engraving as a source for many of the figural elements, he began to experiment with different poses and clothing for the child, created new positions for some of the animals, and modified his palette of colors. More important, however, were the changes in the expressions of the animals. He opened their eyes, and the lion's head is occasionally turned more toward the viewer (fig. 89). The Treaty scene in the four paintings is small but

84. *A Map of North America*, by Henry S. Tanner,
1822, 48″ x 61¾″.
Department of Collections,
Colonial Williamsburg Foundation.

85. Detail from fig. 84.

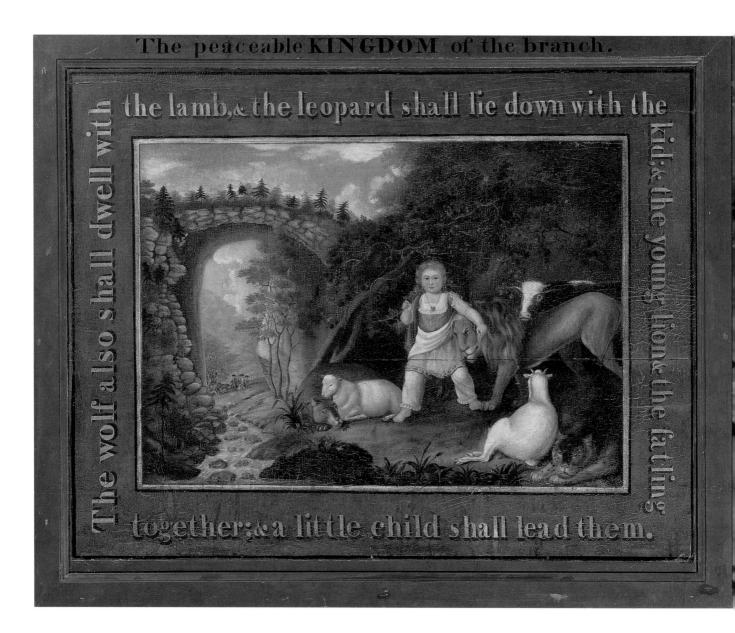

86. "The peaceable K I N G D O M of the branch," by Edward Hicks, 1822–1825, oil on wood, 37¼″ x 44⅞″.
Courtesy, Yale University Art Gallery, New Haven, Conn., gift of Robert W. Carle.

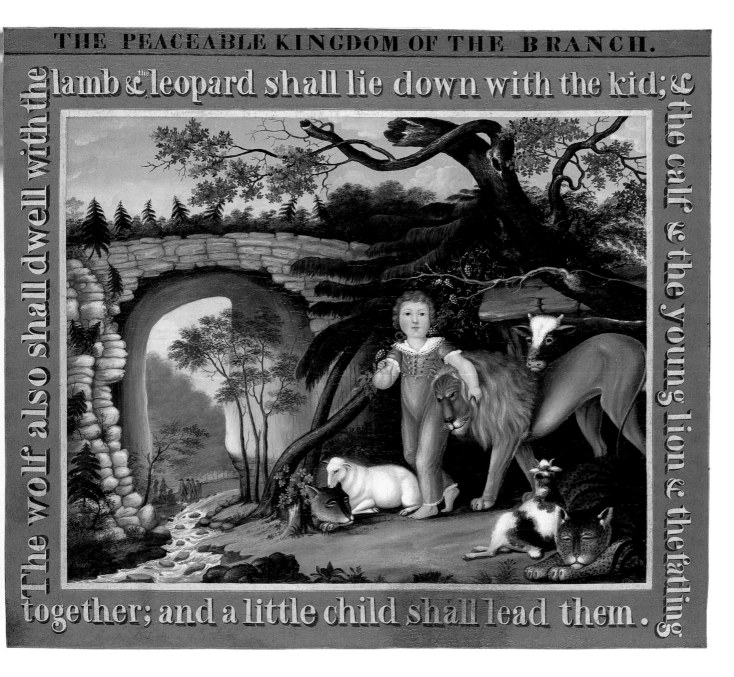

87. "PEACEABLE KINGDOM OF THE BRANCH,"
by Edward Hicks, 1822–1825, oil on canvas, 32¼″ x 37¼″.
Abby Aldrich Rockefeller Folk Art Center.

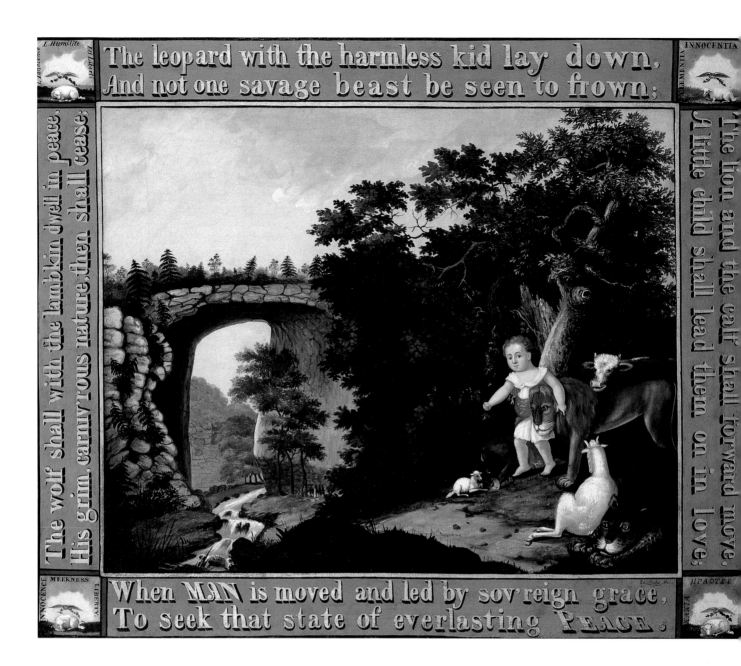

88. Peaceable Kingdom, by Edward Hicks, 1822–1825, oil on canvas, 30¼″ x 36″.

Courtesy, Mead Art Museum, Amherst College, Amherst, Mass., gift of Stephen C. Clark.

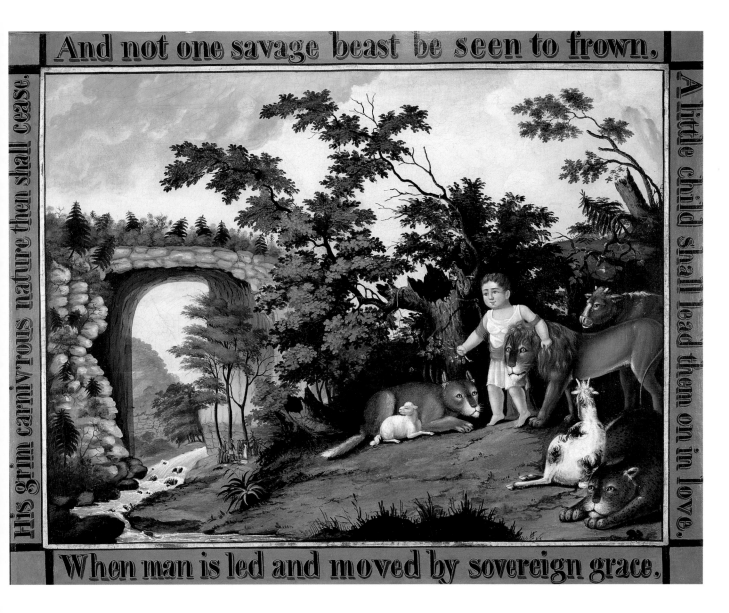

89. Peaceable Kingdom, by Edward Hicks, 1822–1825, oil on canvas, 23½″ x 30¾″.
Courtesy, Reynolda House, Museum of American Art, Winston-Salem, N. C.

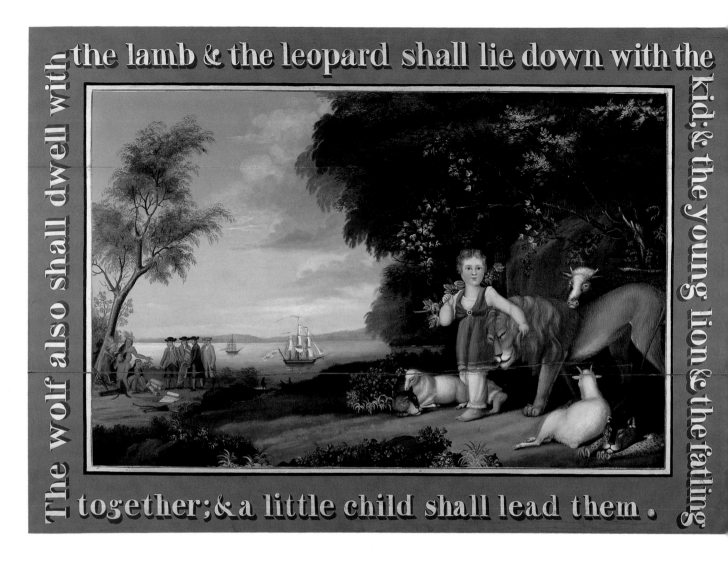

90. "THE PEACEABLE KINGDOM OF THE BRANCH," by Edward Hicks, 1822–1825, oil on wood, 33⅝″ x 49½″. Courtesy, private collection. Photograph courtesy, Joseph Amram.

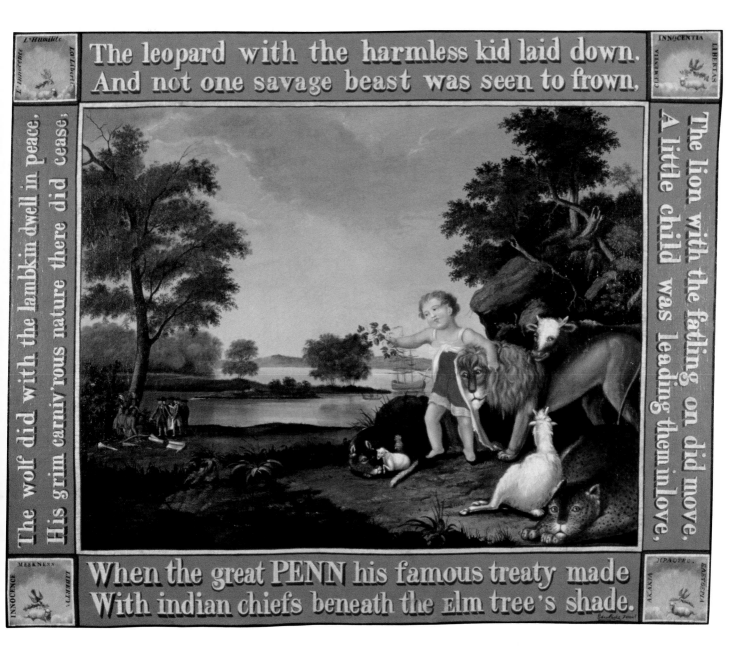

The leopard with the harmless kid laid down.
And not one savage beast was seen to frown,

The wolf did with the lambkin dwell in peace.
His grim carniv'rous nature there did cease;

The lion with the fatling on did move.
A little child was leading them in love,

When the great PENN his famous treaty made
With indian chiefs beneath the Elm tree's shade.

91. Peaceable Kingdom, by Edward Hicks, 1826–1829, oil on canvas, 29″ x 36″.
Courtesy, Friends Historical Library, Swarthmore College, Swarthmore, Pa.

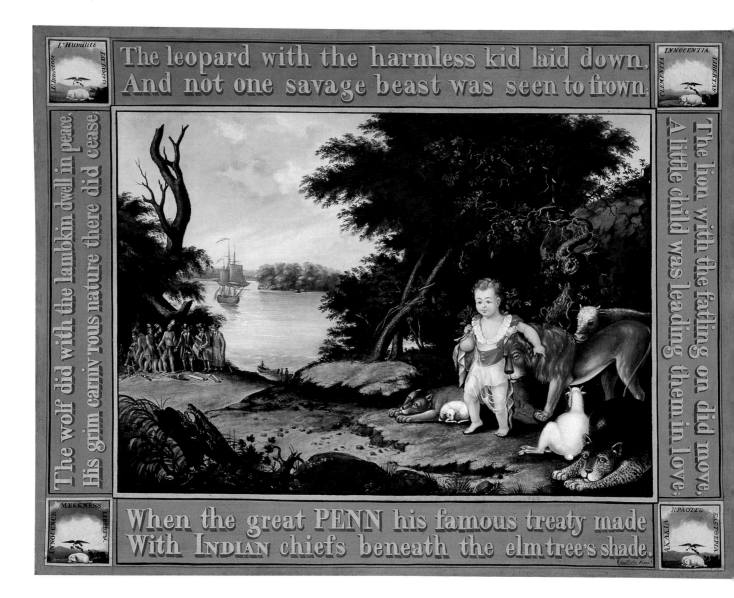

92. Peaceable Kingdom, by Edward Hicks, 1826–1828, oil on canvas, 32⅜″ x 42⅜″.
Courtesy, Museum of Fine Arts, Houston, Tex., Bayou Bend Collection, gift of Miss Ima Hogg.

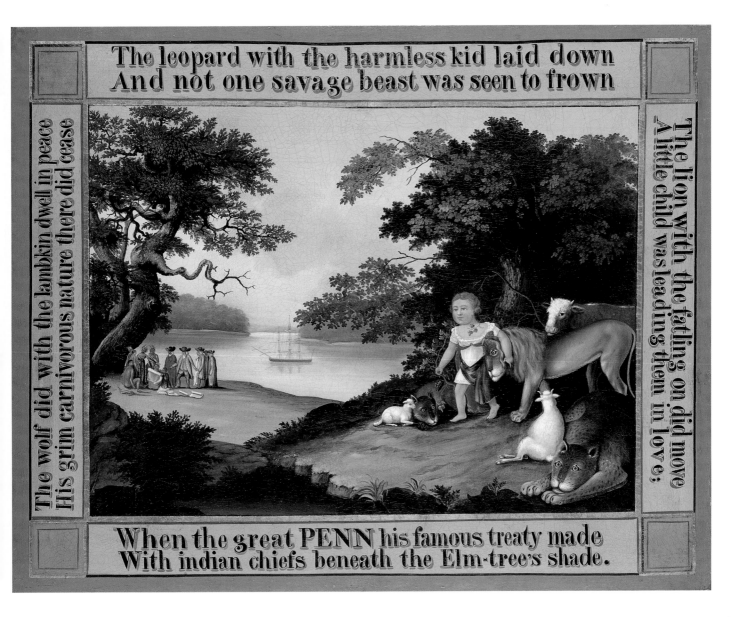

93. Peaceable Kingdom, by Edward Hicks, 1826, oil on canvas, 32⅞″ x 41¾″.
Courtesy, Philadelphia Museum of Art, Philadelphia, Pa., bequest of Charles C. Willis.

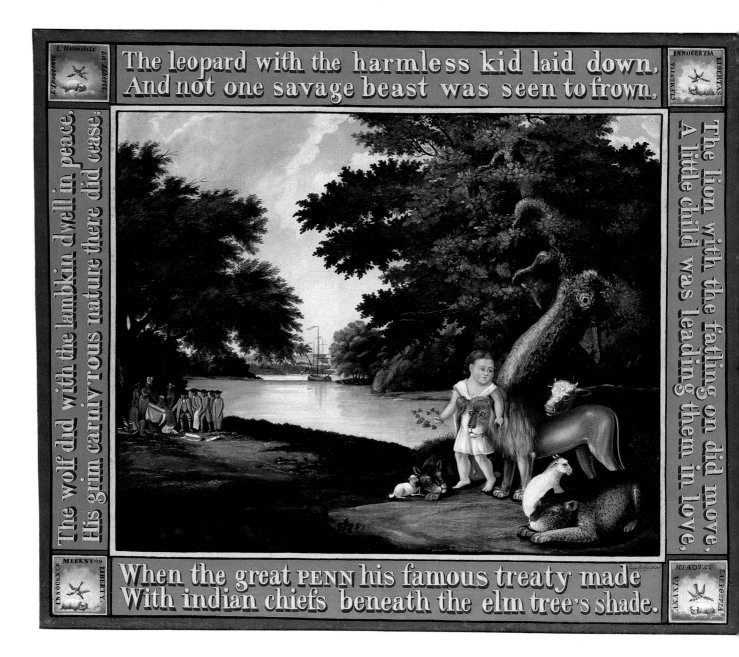

94. Peaceable Kingdom, by Edward Hicks, 1826–1828, oil on canvas, 29¼″ x 35¼″.
Abby Aldrich Rockefeller Folk Art Center.

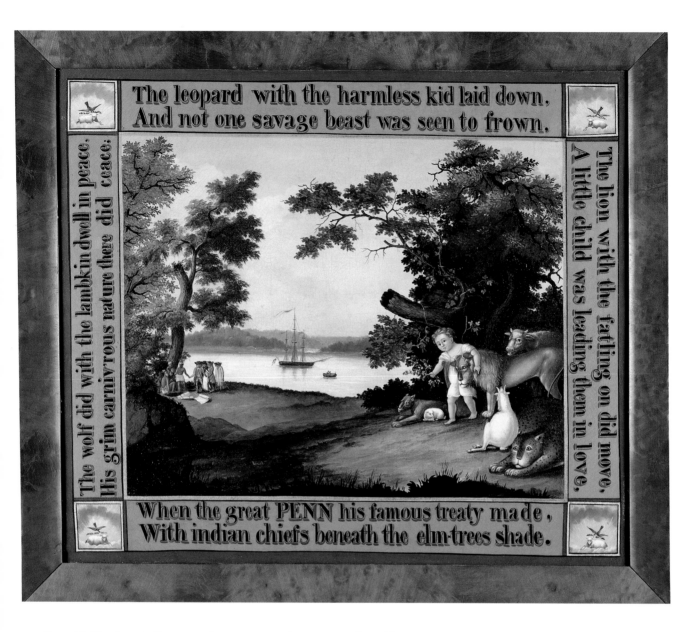

The leopard with the harmless kid laid down,
And not one savage beast was seen to frown.

The wolf did with the lambkin dwell in peace,
His grim carnivrous nature there did cease;

The lion with the fatling on did move,
A little child was leading them in love.

When the great PENN his famous treaty made,
With indian chiefs beneath the elm-trees shade.

95. Peaceable Kingdom, by Edward Hicks, 1826–1828, oil on canvas, 30″ x 35½″.
Courtesy, New York State Historical Association, Cooperstown, N. Y.
Photograph courtesy, Richard Walker.

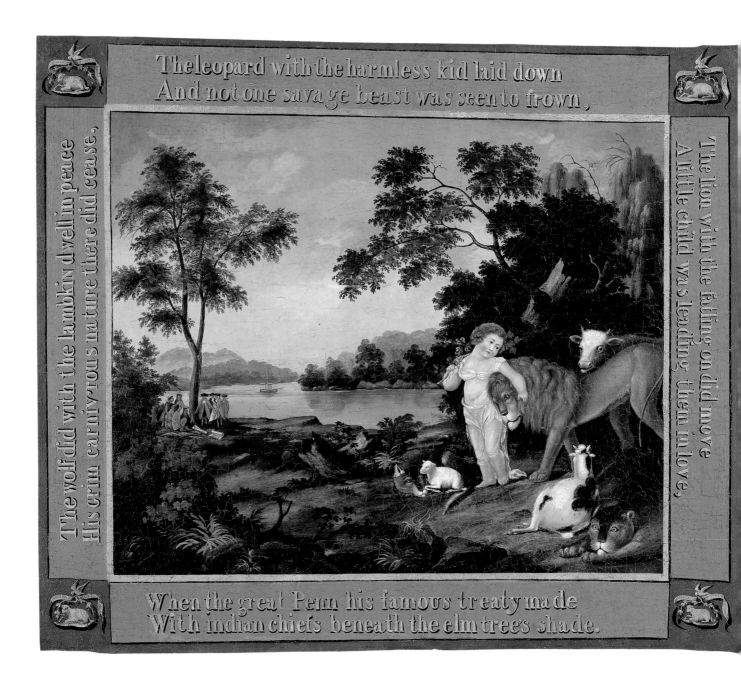

The leopard with the harmless kid laid down
And not one savage beast was seen to frown,

The wolf did with the lambkin dwell in peace
His grim carnivrous nature there did cease,

The lion with the fatling on did move
A little child was leading them in love,

When the great Penn his famous treaty made
With indian chiefs beneath the elm trees shade.

96. Peaceable Kingdom, by Edward Hicks, dated 1826, oil on canvas, 32⅛″ x 38⅛″.
Courtesy, private collection, on loan to the National Museum of American Art,
Smithsonian Institution, Washington, D. C.

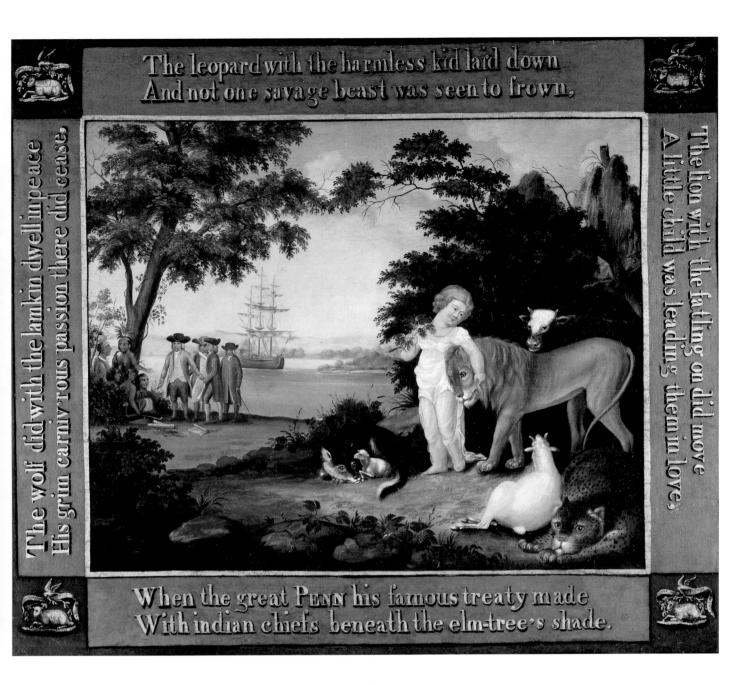

The leopard with the harmless kid laid down
And not one savage beast was seen to frown,

The wolf did with the lambkin dwell in peace,
His grim carniv'rous passion there did cease,

The lion with the fatling on did move,
A little child was leading them in love,

When the great PENN his famous treaty made
With indian chiefs beneath the elm-tree's shade.

97. Peaceable Kingdom, by Edward Hicks, 1826–1829, oil on canvas, 30″ x 36″.
Courtesy, private collection.

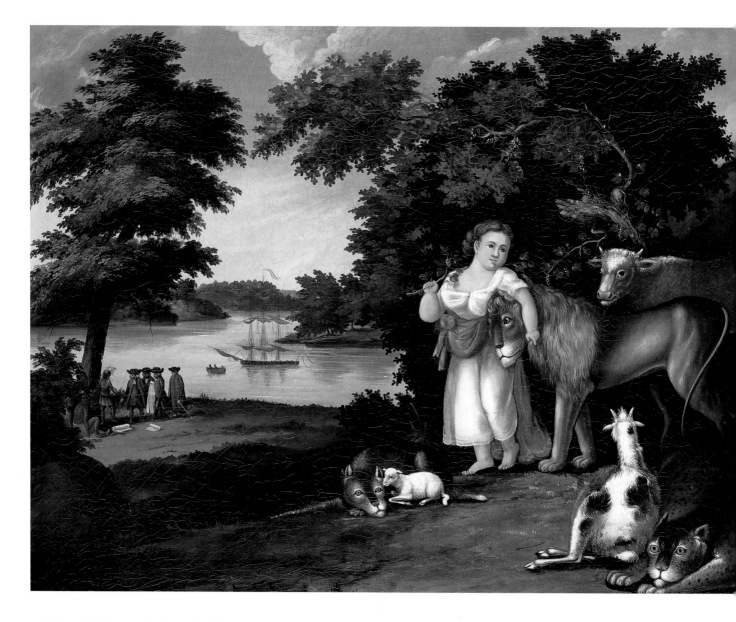

98. Peaceable Kingdom, by Edward Hicks, 1822–1825, oil on canvas, 21¹¹⁄₁₆″ x 27″.
Recent examinations suggest that this painting once had a border that probably
was similar to others in this early group. Courtesy, private collection.

99. Penn Street House, Newtown, Pa. Hicks built this home in 1821 and lived there until his death in 1849. Edward's son, Isaac Worstall Hicks, announced plans to demolish the carriage house on the property, the second floor of which was his father's painting shop, in 1875. Photograph courtesy, Roger Cook.

would be given greater prominence in the Kingdom versions that followed. The tree behind the child and animals also became more prominent, no longer a small dead trunk as seen in the Cleveland picture.

In the later border Kingdoms, Hicks began to detail the child's clothing more skillfully, gradually reshaped the wolf's head so it was sleeker and resembled the real animal more closely, and greatly enlarged the Treaty vignette. Created in two styles (figs. 94 and 96), corner blocks were added as another interpretive device. Each contains a dove above a recumbent lamb. In one version, the words "Liberty," "Meekness," and "Innocence" appear in a banner held by a dove; in the other style, the words are lettered to the left, right, and top (fig. 83).[11]

The border Kingdoms rank among the finest in the genre by Edward Hicks. A great deal of care was given to the coloring and the painting of details. Similarly, they have the added dimension and time-consuming expense of the lettered borders. Those titled by the artist also have lettered frames. For Edward, these were highly

creative and still experimental works that constantly were being revised, although perhaps not as radically as the Kingdoms that followed.

The sequence of events that occurred in Edward's life during the period from about 1821 to 1826 probably contributed to his obvious and increasing devotion to the Peaceable Kingdom theme. By this time, the paintings reflect considerable confidence that paralleled other aspects of his life. Edward's financial situation had improved; he sold his Court Street house and built a new and larger stone one on Penn Street (fig. 99). These active, eventful years, marked by the inevitable inward struggles and fears about the future of the Society, seem to have fueled Edward's creative sensibilities.

Hicks began to create Peaceable Kingdoms that have been described as "transition" in the late 1820s and may have continued to paint them into the early 1830s.[12] The earliest, which probably dates from late 1827 or 1828, may be a privately owned example. Assigning a slightly earlier date to this painting—and perhaps to others—moves their creation closer to the time of the Hicksite-Orthodox separation and enables interpretation within that context.

The obvious change in the demeanor of the animals, now more alert and tense, and the prominent cleft in the tree trunk behind the group (figs. 100 and 104), a symbolic reference to the separation that occurred between the Orthodox and Hicksite groups, are of paramount importance. The blasted tree trunks in Edward's earlier Kingdoms do not have the prominent cleft, which he continued to include in Kingdoms painted during the late 1820s to about 1832. With the exception of this tree that is always behind the prophecy figures and a dead limb sometimes shown above the Treaty participants, viewers should avoid reading too much into the damaged or decaying trees and vegetation that regularly appear in Edward's paintings, including several pastoral scenes. Only rarely can symbolic meaning be associated with them; more often, they are generic artistic devices Edward knew from a variety of print sources.

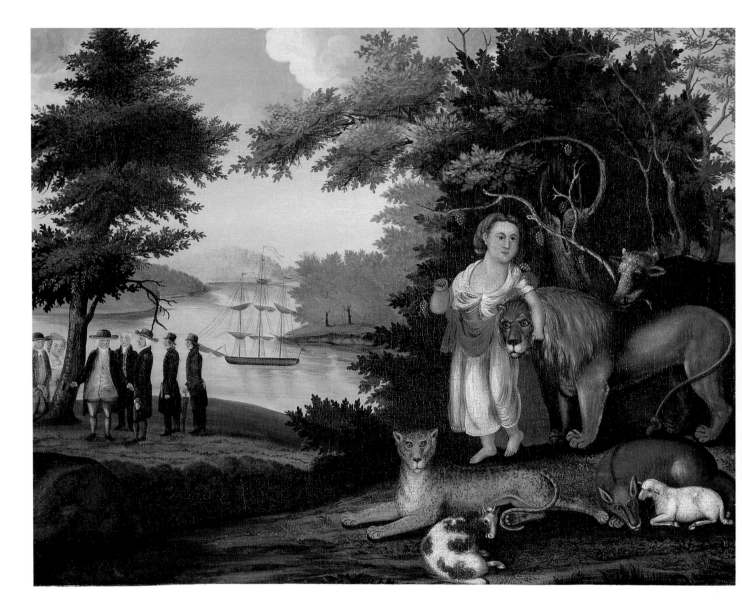

100. Peaceable Kingdom, by Edward Hicks, 1827–1828, oil on canvas, 21¼" x 28".
Courtesy, Mr. and Mrs. John L. Tucker. Photograph courtesy, Carmine Picarello.

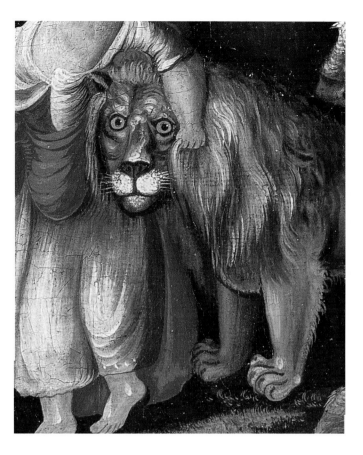

101. Detail from fig. 113.

102. Detail from fig. 100.

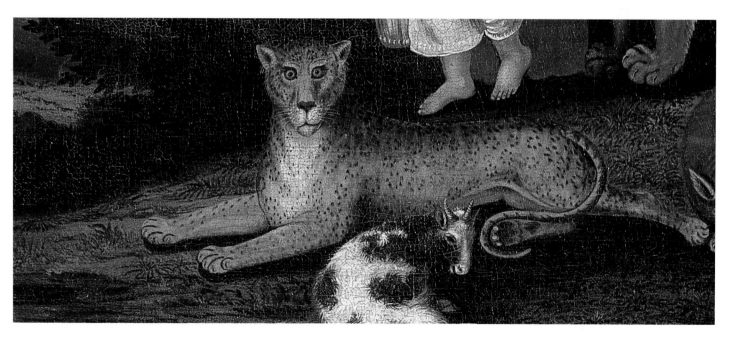

103. Detail from fig. 100.

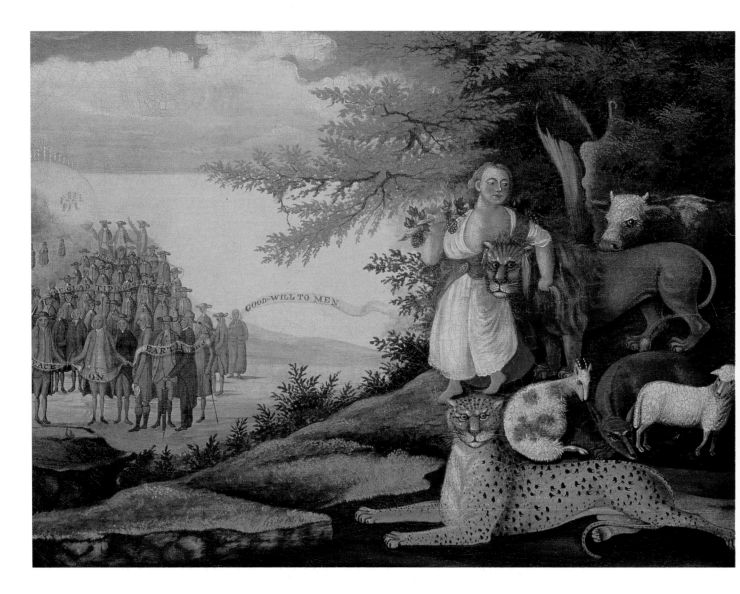

104. Peaceable Kingdom, by Edward Hicks, 1829–1830, oil on canvas, 17¾″ x 23¾″.

Courtesy, Friends Historical Library, Swarthmore College, Swarthmore, Pa., gift of William P. Sharpless.

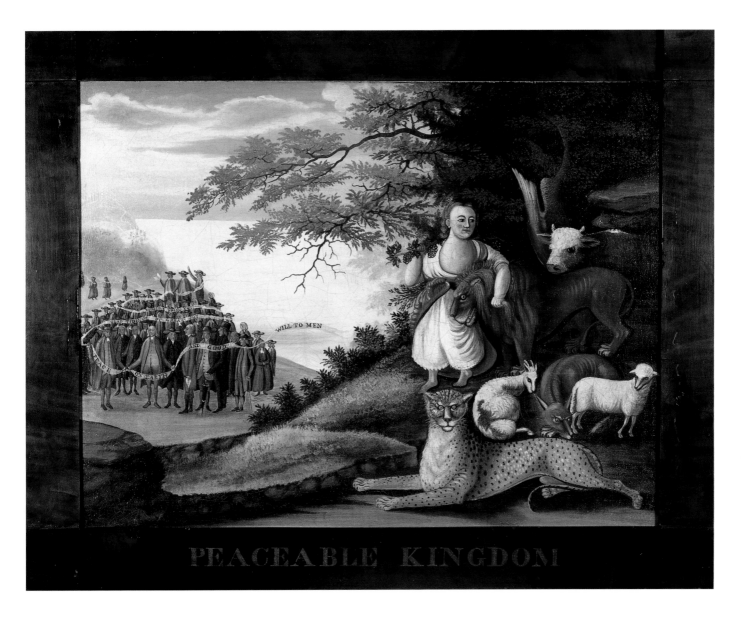

105. "PEACEABLE KINGDOM," by Edward Hicks, 1829–1830, oil on panel, 18″ x 24″.
Courtesy, San Antonio Museum of Art, San Antonio, Tex.,
given in memory of Eva Halsell McCluskey by the Ewing Halsell Foundation.

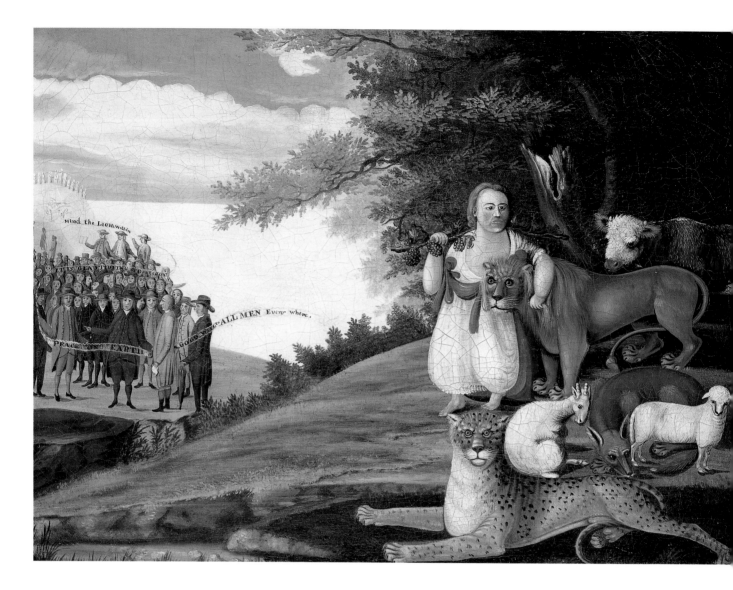

106. Peaceable Kingdom, by Edward Hicks, 1829–1830, oil on canvas, 17⅞″ x 23⅝″.
Courtesy, Terra Foundation for the Arts, Daniel J. Terra Collection, Chicago, Ill.
Photograph courtesy, Terra Museum of American Art.

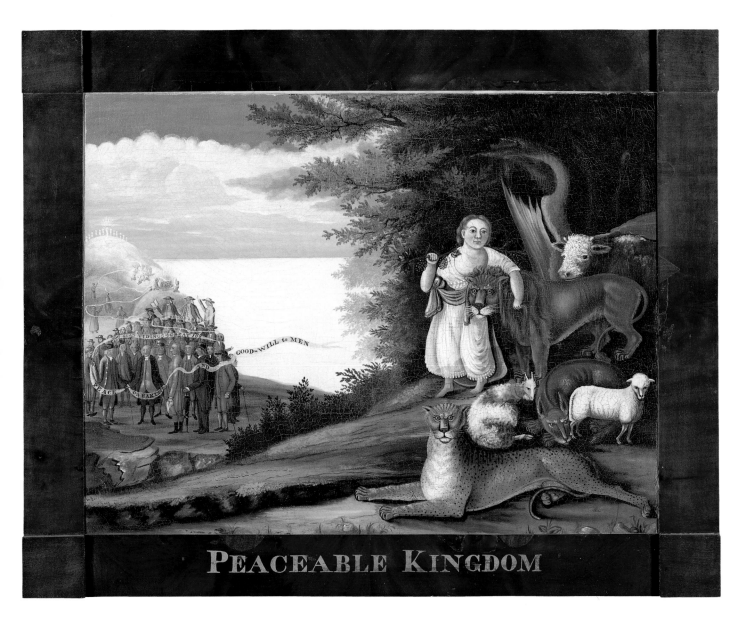

107. "PEACEABLE KINGDOM," by Edward Hicks, 1829–1830, oil on canvas, 17½″ x 23½″.
Courtesy, Yale University Art Gallery, New Haven, Conn., bequest of Robert W. Carle, B.A. 1897.

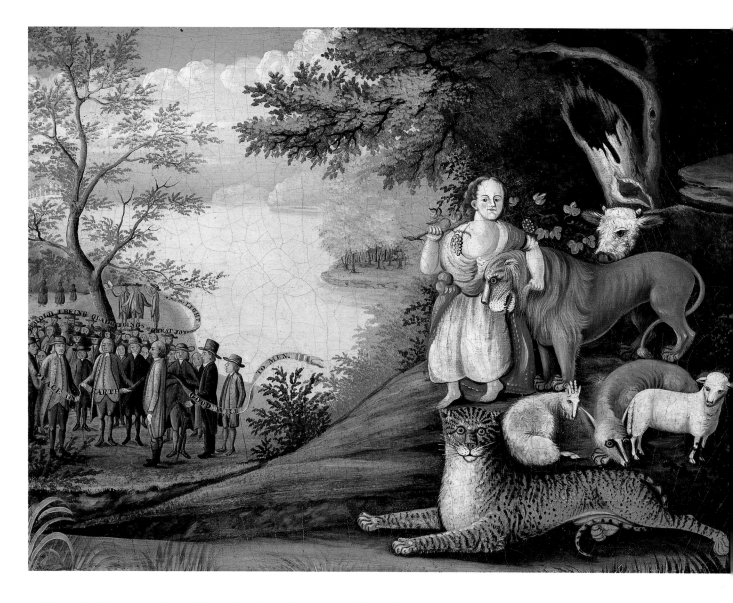

108. Peaceable Kingdom, by Edward Hicks, 1829–1830, oil on canvas, 17⅝″ x 23⅝″.
Courtesy, Henry Francis du Pont Winterthur Museum, Winterthur, Del.

Edward frequently used the lion and the leopard to indicate change in the "transition" Kingdoms. They are more alert, on their guard, and anxious (figs. 102 and 103), and both display carnivorous and aggressive behaviors that seem out of place in the artist's contrived setting of peace. The tension, restlessness, and uncertainty that Edward ascribed to these creatures endowed them with strong symbolic meanings.

In late 1829 or early 1830, a little later than other scholars have suggested, Hicks began to formulate a se-

ries of Peaceable Kingdom pictures featuring a group of figures bearing flowing banners with inscriptions (figs. 104–108). This vignette replaced the scene of Penn's Treaty with the Indians in the upper left quadrant of the paintings. Edward used the Quakers with banners vignette in the Kingdoms until about 1832.

The earliest of the nine known banner Kingdoms must be one of the five that feature leopards whose spots are defined by single daubs of paint like those of the earlier Kingdoms (figs. 91 and 94, for example). The

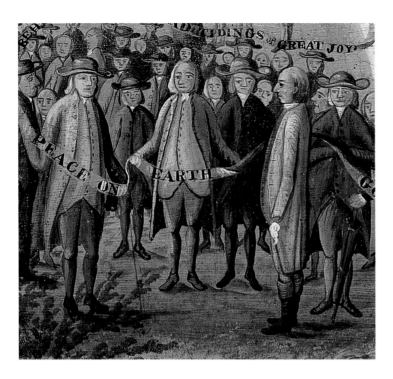

109. Detail from fig. 108.

110. Elias Hicks, by an unidentified artist, 1827–1845, cut paper, in August Edouart, *A Quaker Album*, p. 16. Courtesy, Friends Historical Library, Swarthmore College, Swarthmore, Pa. Courtesy, Helen and Nel Laughon.

banner Kingdom owned by Winterthur Museum may be the last because of the unusual, perhaps transitional, treatment of the leopard's coat, a combination of dots and stripes (fig. 108). It seems that Edward introduced a new technique, the use of multiple dots of paints in a circle formation, the center of which is sometimes highlighted with a slightly different ochre or yellow color, for the leopard spots in the last four banner Kingdoms. Ford suggested that Edward may have derived this more realistic method from an encyclopedia published between 1810–1840.[13] Other sources were also available, however. Jonathan Fisher stated of leopards that "their yellow skin are diversified with a multitude of small black spots, in circular groups."[14] Although Fisher's book was not published until 1834, well after Edward had changed the spots, it indicates that this information was generally known. A single source for Edward's changes to the leopard or for many of the animal poses cannot be identified.[15]

What is most important about the banner Kingdom pictures is the inclusion of the figure of Elias Hicks, who died in 1830, and other notables, apparently all of whom were deceased, engaged in a kind of heavenly conversation beneath a bright sky (fig. 109). The theory that the banner Kingdoms were inspired by an exchange of poems between Samuel Johnson and Edward Hicks was supported by Tolles.[16] The problem with this concept, which Mather and Miller acknowledged, is that the poems were written several years after most of the banner paintings had been created.[17] In 1985, Ford described them as "memorials to Elias Hicks" and suggested they may have been mourning picture.[18] Tatham stated it more clearly in 1981, writing that "Edward memorialized Elias not by showing his worldly likeness but rather by evoking his ideas."[19]

The banner paintings are more celebratory than expressive of mourning. Surely, Elias was deeply mourned by many, including Edward. But, as Tatham suggested,

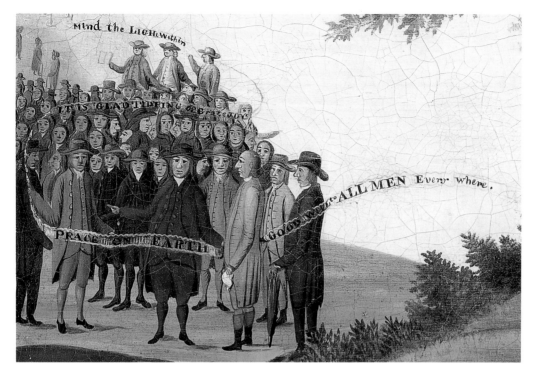

Mind the Light within

IT IS GLAD TIDING of GREAT JOY

GOOD WILL to ALL MEN Every where.

PEACE on EARTH

111. Detail from fig. 106.

it was Elias's ministry and exemplary life, so perfectly aligned with Isaiah's prophecy and Hicksite beliefs— not the beloved Elias of the flesh—that Edward commemorated in the banner Kingdoms. Like all other elements of the Kingdom pictures, Elias's figure became a symbol that reminded viewers of a recent but not unprecedented era of difficulty in the history of the Society of Friends.

Elias is shown in profile, handkerchief in hand, a pose Ford noted could have derived from a printed version of an original silhouette by John Hopper (fig. 110).[20] The printed version appeared in 1830, about the time Hicks began these Kingdoms, and Mather and Miller raised the possibility that Hopper might have copied Elias's profile from Edward's painting.[21] It is more likely that several original profiles were cut during Elias's lifetime and any number of copies were made from them, a common practice during the period. Solid profiles as opposed to painted portraits were acceptable to many Quakers.[22]

Who are the other notables surrounding Elias in these paintings? Scholars have traditionally identified three as

George Fox, Richard Barclay, and William Penn, the founding Quaker fathers. William Penn, the heavyset man usually painted with outstretched hands in a pose similar to those in the Treaty vignettes, is the only figure that can be identified with confidence. It is logical that Edward would also have included Fox and Barclay in these groups. Four, sometimes five, male figures traditionally were placed near the prominent Elias in these compositions. George Washington and Isaac Penington, the step-father-in-law of William Penn, have also been suggested as subjects.[23] I have been unable to identify the others. The folks behind the principal figures likely represent a gathering of Friends.

Edward painted Elias, who is standing a little forward of and facing the others, most prominently to suggest a dialogue in which the elder Quaker gave testimony to his religious ancestors, perhaps relating his battles with the "beasts of Ephesus." Elias also symbolized the crucial role he played in the history of the Society in America. Throughout the controversy and even after the separation, the writings and teachings of Barclay, Fox,

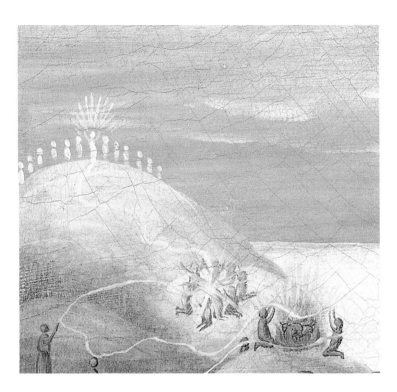

112. Detail from fig. 107.

and Penn about struggles during their lifetimes were continually compared and interpreted in light of the debates then current. This is what Elias meant in his last letter when he wrote, "no new thing has happened to us."[24]

Scholars have pointed out that Edward usually set the host of Friends against or sometimes fading into a brightly lit area of the canvas they associated with the "light within," a heavenly light.[25] The banners intertwined among the group related its collective theological message to viewers and were symbolic of Elias's teachings. In 1820, Elias had written to Edward that it was only when one "enlists under [God's] banner" that one's soul would be in heaven.[26] The words in the banners are not identical in all of the versions, and it is doubtful that a chronology for the group can be based on such minor changes. Paraphrasing passages from the book of Luke, the messages range from "BEHOLD I BRING GLAD TIDINGS OF GREAT JOY. PEACE ON EARTH GOOD WILL TO MEN" to "MIND THE LIGHT of Truth PEACE ON EARTH GOOD WILL TO ALL ME[N]." In one version (fig. 111), Hicks combined the popular greeting from Luke with the Hicksite doctrine: "Mind the LIGHT within IT IS GLAD TIDEING of Grate Joy PEACE ON EARTH GOOD WILL to ALL MEN Everywhere." This message reflected the intent of the whole banner series—Friends must mind the "Light" by denying self-will. Positioning the aggressive beasts near gentle ones symbolized this denial. For example, the lion, having given up his natural diet of meat, is eating grain in several Kingdom paintings. Stated another way, the winding banner messages connected both historical and contemporary figures that represented the evolution of the Society of Friends with the peaceable animals that demonstrated the benefits to be gained from fulfilling what the artist considered its most important religious requirement.

The gathered groups of dignitaries and others seen in the banner Kingdoms were also modified, although again such changes do not serve a purpose in dating the pictures. For instance, the thirteen rays of light emanating from the hilltop in the Yale University version are

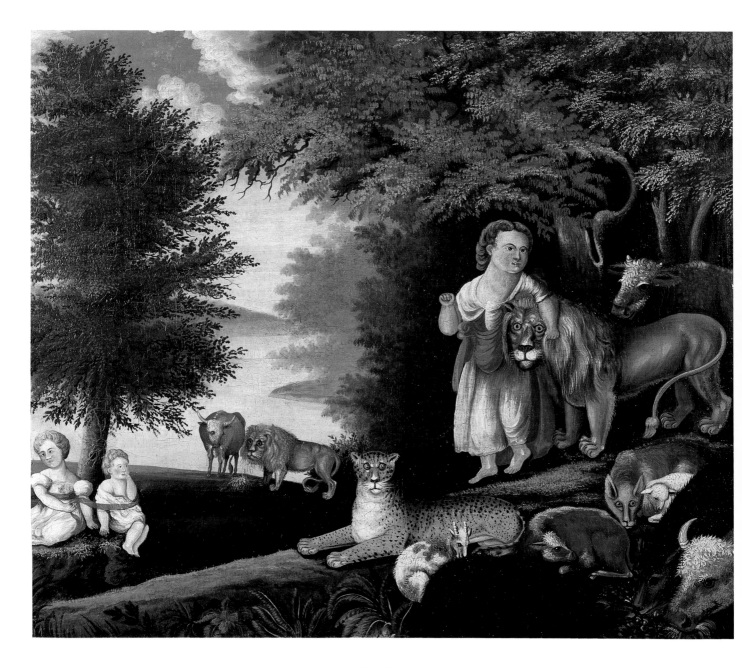

113. Peaceable Kingdom, by Edward Hicks, 1829–1831, oil on canvas, 16¾″ x 20″.
Courtesy, collection of Conrad Janis.

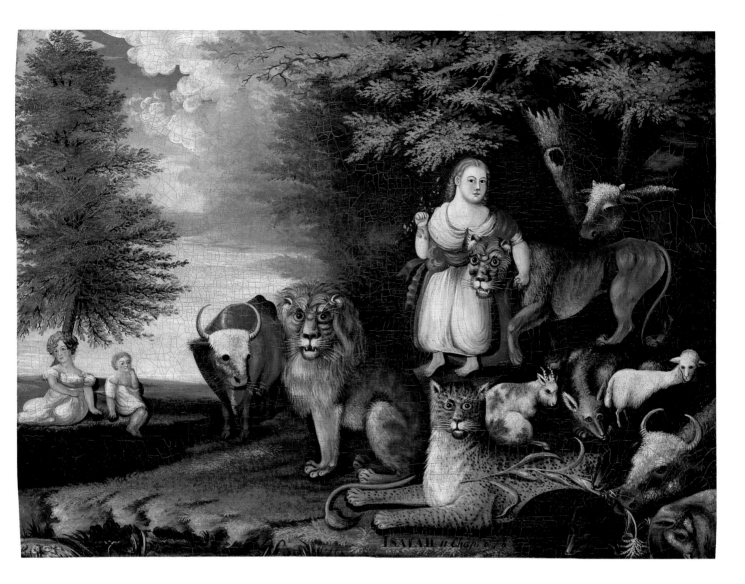

114. Peaceable Kingdom, by Edward Hicks, 1830–1832, oil on canvas, 17⅞″ x 28⅛″.
Courtesy, Metropolitan Museum of Art, New York, N. Y., gift of Edgar William and Bernice Chrysler Garbisch, 1970.

actually small human figures (fig. 112). They represent Christ and the Apostles.[27] In another version, one scholar speculated whether the figures around the fire on the mountaintop might depict the "martyrdom of Servetus [a Spanish heretic] on his 'flaming pyre.'" Early reformers and persecuted Protestants were suggested for the other figures surrounding the pyre.[28] It is difficult to substantiate whether or not the structure is really a funeral pyre. That the artist used the robed figures to represent early Protestants, both reformers and those persecuted for their beliefs, may be valid, however.

Edward's treatment of the animals during the brief period in which the banner Kingdoms were created, from 1829 to about 1832, is significant. It was during these years, not later as some have proposed, that Edward began to experiment with the groups of beasts, including the creation of another Kingdom format (figs. 113 and 114) where the animals are more numerous and extend into the left half of the picture and into the background. The banner Kingdoms also illustrate some

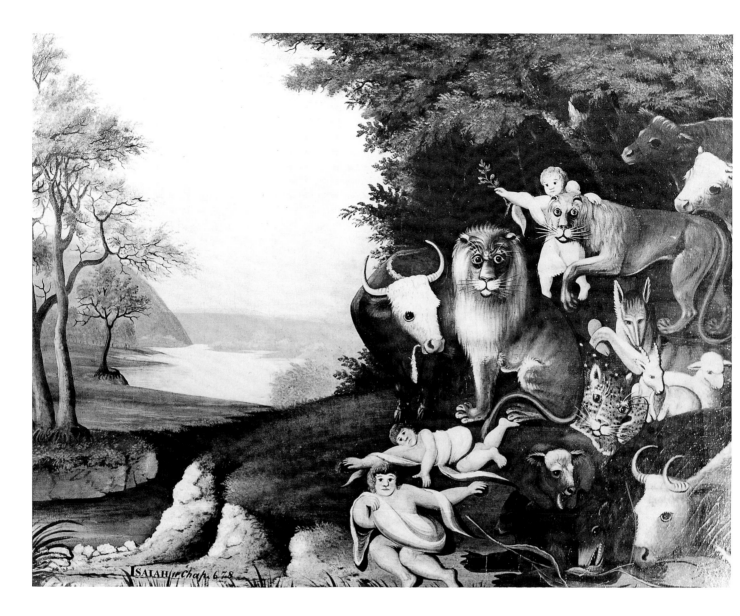

115. Peaceable Kingdom, by Edward Hicks, 1829–1832, oil on wood, 17¼″ x 23½″.
Courtesy, Scripps College, Claremont, Calif., present location unknown.

of the same experiments; the leopard's entire body is shown, and more of the calf is included. In the newer format, Edward abandoned the vignette of the distinguished Quakers and banner and returned to the familiar Penn's Treaty scene. Doing so allowed him more space for the development of the animals, especially the lion whose expression became increasingly fierce. He is occasionally shown full face.

For the first time, Edward painted bears, not one but two lions, additional cattle, animals sharing food, and three children (fig. 113). A second male lion is eating straw with an ox or steer (figs. 35 and 114); in figure 115, the artist positioned the divine child between a seated lion and a smaller standing female lion, a feature that Edward apparently liked and continued for a number of years. The introduction of a mate for the lion and, later, mates for the other large animals and the addition of their offspring undoubtedly had some significance. Edward was deeply concerned about how children were raised and the importance of the family in establishing values. Further, he felt strongly about the vital role women had in the Society as ministers and leaders. He admired several female ministers.

The large bears eating corn with cattle and the lion sharing straw with the oxen paralleled explicitly the words of the prophecy and emphasized the denial of self-will symbolized by the beasts' carnal eating of meat. The wolf curled around a lamb and often near a kid appeared first in the banner Kingdoms. His face, like the leopard's, has changed drastically, becoming sharper and more reflective of his natural kind. Edward rarely showed a standing wolf in profile. The leopard lies on the ground, usually in the foreground, either half- or full-bodied and with his head erect and alert in all of the Kingdoms of this period.

As Edward continued to experiment with and revise the Kingdom formats over the next ten years, the animals gradually occupied even more space. By 1840, they consumed over half of the picture. The artist's preoccupation with animal expressions, placements, poses, and

juxtaposition with one another, the introduction of more explicit symbols (two children playing at holes of asps) associated with the Isaiah prophecy, and more elaborate foliage and landscape backgrounds are hallmarks of the Kingdoms dating from about 1832 to 1840. They represent a second highly creative period of Kingdom pictures during which Edward was driven by a profound and renewed sense of purpose in expressing in every way possible the rich language of the prophecy and the urgency of its message.

It would be pointless to attempt to enumerate and describe all of the variations in how the lions, leopards, and other animals looked and were placed. The changes were extensive and, at times, visually bewildering. Edward knew, as only an artist intimate with the subject could know, that it was possible to arrange and rearrange the elements to suit his own eye and ends and to reflect the power of the prophecy almost endlessly. As this process moved forward, he continued to add more animals and their young. The number of humans, especially children, also increased, and they often interacted with or touched the animals.

Edward ultimately arrived at a formula that seemed to fulfill his goals. Six of the surviving Kingdoms (figs. 116–121), three of which may be the most sophisticated he ever painted (figs. 118–120), illustrate this point. The most impressive pictures are those at the Folk Art Center and a nearly identical version owned by the Worcester Art Museum. All feature large, seated, centrally placed lions. The gazes of the seated lions and the powerful, outstretched leopards in these paintings are intense, riveting, and magnetic. Neither at peace nor angry, they exude energy and appear ill at ease and somewhat startled. Their poses suggest a tenuous peace, a delicate balance of difficult and unresolved issues. The bear and wolf, also carnivorous beasts, are complaisant in comparison.

Did Edward perceive the lion and leopard as the greatest threats to his peaceable kingdom? It seems he did. The lion, king of the beasts and first among the ani-

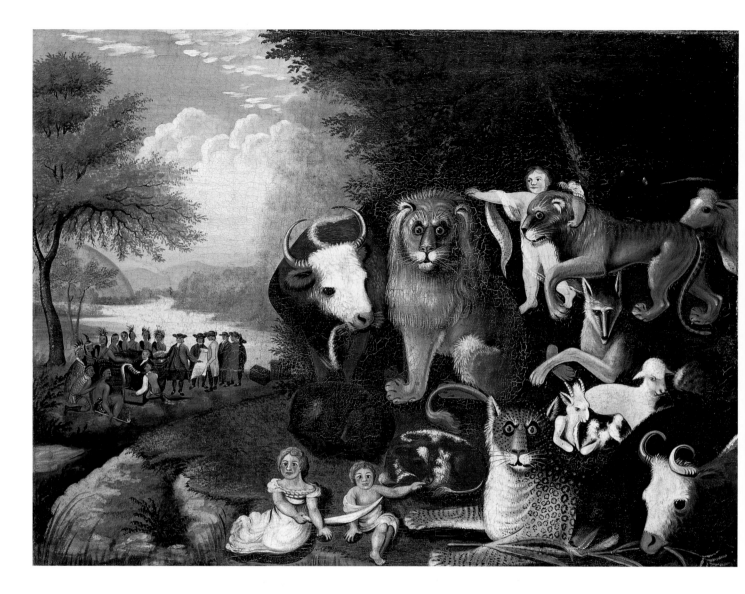

116. Peaceable Kingdom, by Edward Hicks, 1829–1832, oil on canvas, 18″ x 24⅛″.
Courtesy, Brooklyn Museum of Art, Brooklyn, N. Y., Dick S. Ramsay Fund.

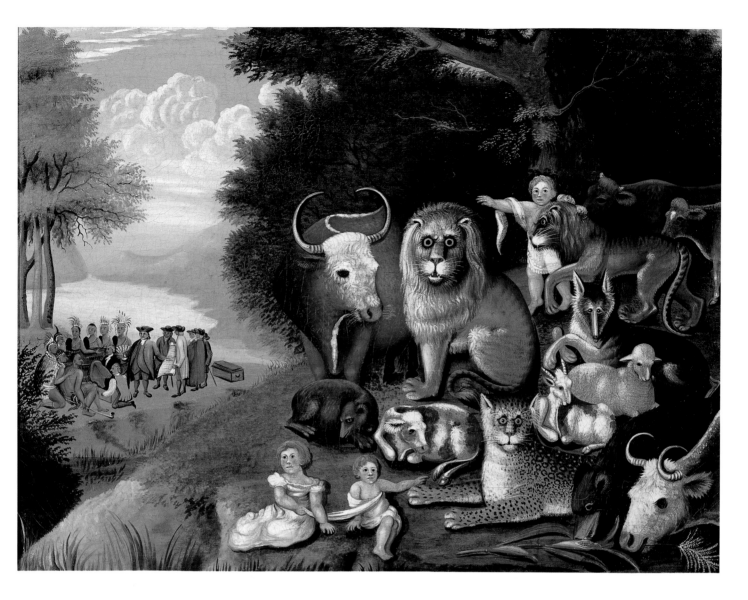

117. Peaceable Kingdom, by Edward Hicks, 1829–1832, oil on canvas, 17½″ x 23½″.
Courtesy, Maier Museum of Art, Randolph-Macon Woman's College, Lynchburg, Va.,
bequest of Phyllis Crawford, '20, 1980.

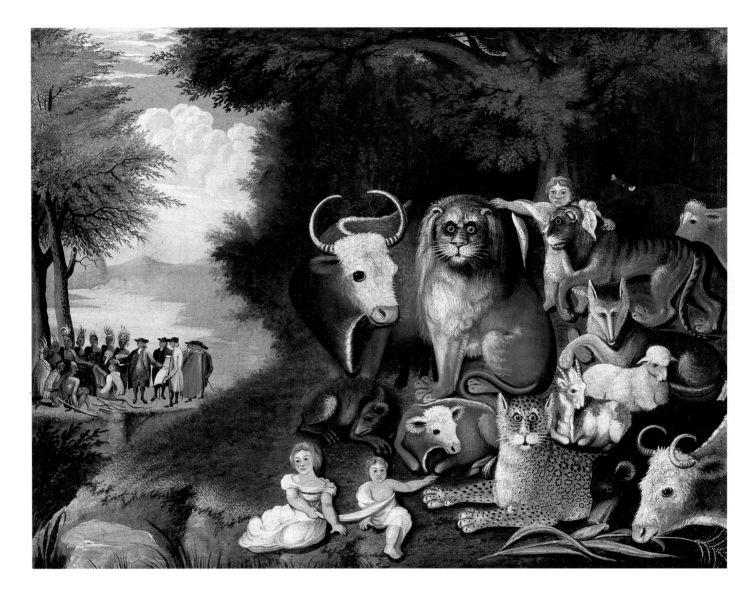

118. Peaceable Kingdom, by Edward Hicks, 1832–1834, oil on canvas, 17⅞″ x 25¹⁵⁄₁₆″.
Courtesy, Pennsylvania Academy of Fine Art, Philadelphia, Pa. John S. Phillips bequest, by exchange
(acquired from the Philadelphia Museum of Art, originally the 1950 bequest of Lisa Norris Elkins).

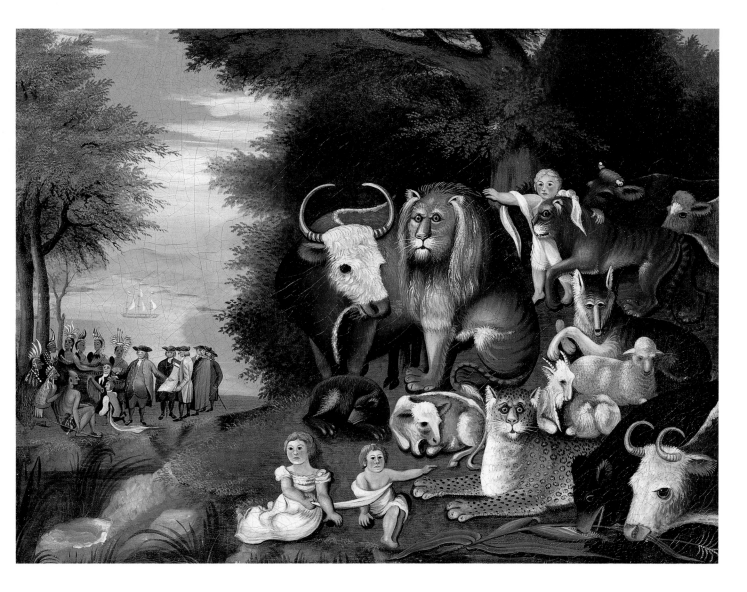

119. Peaceable Kingdom, by Edward Hicks, 1832–1834, oil on canvas, 17⅛″ x 23¼″.
Abby Aldrich Rockefeller Folk Art Center.

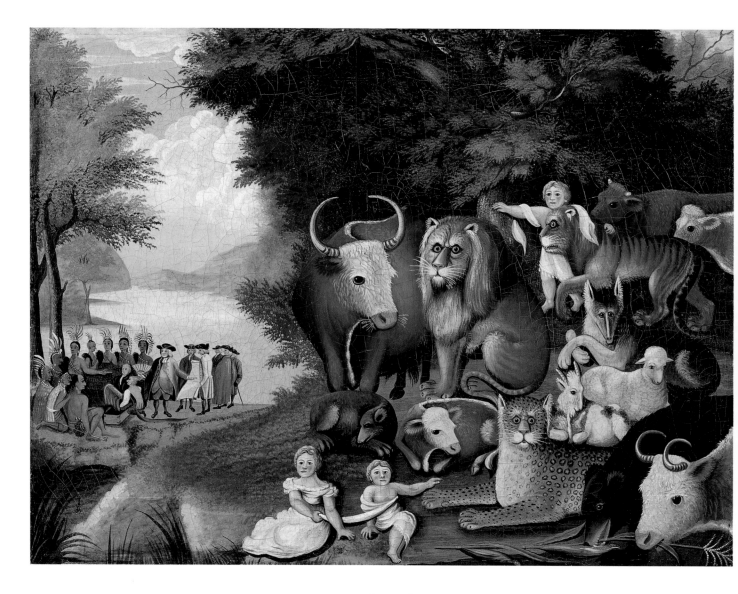

120. Peaceable Kingdom, by Edward Hicks, 1832–1834, oil on canvas, 17½″ x 23¹¹⁄₁₆″.
Courtesy, Worcester Art Museum, Worcester, Mass. Museum purchase.

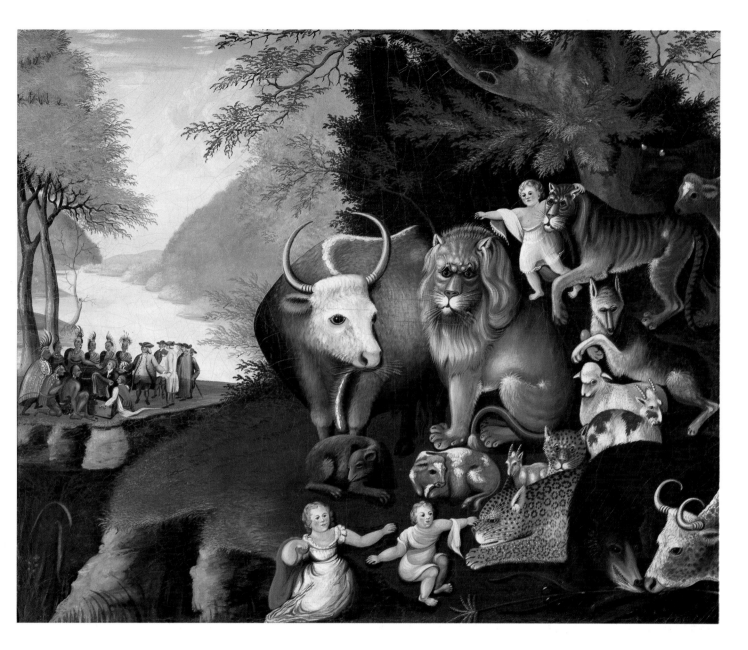

121. Peaceable Kingdom, by Edward Hicks, documented to 1834, oil on canvas, 29⅜″ x 35½″.
Courtesy, National Gallery of Art, Washington, D. C., gift of Edgar William and Bernice Chrysler Garbisch.

mals under man in the chain of being, symbolized those lionlike humans wielding power usually derived from wealth. Those with animal traits represented by the leopard were subtle, restless, the sanguine men and women who "do the most injury to the cause of Christ; for they are quite disposed to be religious, provided they can have it on their own terms."[29] Edward associated the leopard with social worldliness and those whose self-serving interests led them to organize reform groups of all sorts, particularly ones devoted to abolition. It is well to recall that during these years and into the 1840s, Edward wrote bitterly about the formation of such abolitionist organizations; in turn, his position was severely criticized by some Hicksites as well as by many Orthodox.

Edward may have used the monumental lion to remind viewers of the dangers inherent in secular kingdoms and the misuse of temporal power. The artist must also have associated the lion, long a symbol of the might of the British Empire, with the American Revolution since his family and his country had suffered greatly during the conflict. Finally, Hicks detested the interference of English Quakers, often and openly blaming them for the schism. As the lion in the banner Kingdoms evolved into these majestic seated creatures, the animal represented Edward's deep and enduring distrust of English Quakers. The key word is "distrust," for who among the Hicksites would trust the seated lion that represented a chief cause of the schism and all that they abhorred about the misuses of power by "Creed loving" English and Orthodox Friends.

Many consider the Peaceable Kingdoms of Edward's middle years the most captivating and striking of the genre because of the stories they relate, their successful compositions, and the fine quality of their painting. The artist may have borrowed elements from other sources and combined them in various ways, but a single source for the Peaceable Kingdoms of this group does not exist. They are Edward's compositions.[30]

The Late Kingdoms

I had a hope at the time of the seperation
I should live to see the society of friends come together
but the wall that has been built by the orthodox disownments &
the disccipline [sic] that has chang'd by the ranting un[settled] spirit among friends
together with the feeblenes of my hold on life has disapated that hope.

E D W A R D H I C K S , *unpublished Memoirs*

Edward painted versions of the Peaceable Kingdom for the remainder of his life. The lion and leopard continued to be the dominant elements in the paintings. On a few occasions, Edward reduced the leopard to only a simple head and positioned its front legs and paws on the tree behind one of the lions (fig. 122) or placed the animal deep into the background. The artist painted a standing lion that sometimes assumed a lunging position. The various animals became intertwined, separated, and moved about the canvas time and again.

The artist may have been trying to work out yet another format that would satisfy him. If he ever achieved one, it is not obvious from the surviving paintings Hicks rendered from the mid-1830s to the 1840s. The curious mixture of compositions, one or two of which occasionally are similar, make the dating of some extremely difficult. The Penn's Treaty vignette, although modified continuously, is the most consistent feature in these pictures. The artist always placed it in the upper left quadrant of every Peaceable Kingdom he created from the mid-1830s to the one he was working on at the time of his death.

It may be possible to establish a tentative sequence for some of the late paintings based on the facial expressions of the large male lion and the leopard (figs. 127 and 131) and on the inclusion of more leopards. From about 1835 onward, the large lion's face assumed a serene or complacent expression, and, by the end of the decade, one of growing fatigue. Eventually, his brow became furrowed and his eyes more deeply set. The light-colored pigments Hicks used below the eyes created an aged, sunken expression. In several of the pictures from the late 1840s, Edward painted equally decrepit lions with sagging facial features and flattened upper eyelids that emphasized the creature's age.

Although the reclining leopard went through a similar metamorphosis, his appearance never paralleled that of the lion.[1] Figures 122–132 show some of the most obvious changes. However, details from all of the Kingdoms under consideration have not been included in this discussion, and so it is impossible to develop a chronology that is based on these illustrations alone.

Other new elements in the late Kingdoms should be noted. Edward introduced yet another child, this one clearly female, which he derived from an unidentified print source featuring the figure of Liberty. She is occasionally larger and appears slightly older than the other children, but is still a youth. Edward painted a dove, symbolizing peace, landing on her upheld right hand and an American bald eagle, a national emblem, feeding from the left hand extended below her waist (fig. 133). The meaning of this figure becomes clear when it is

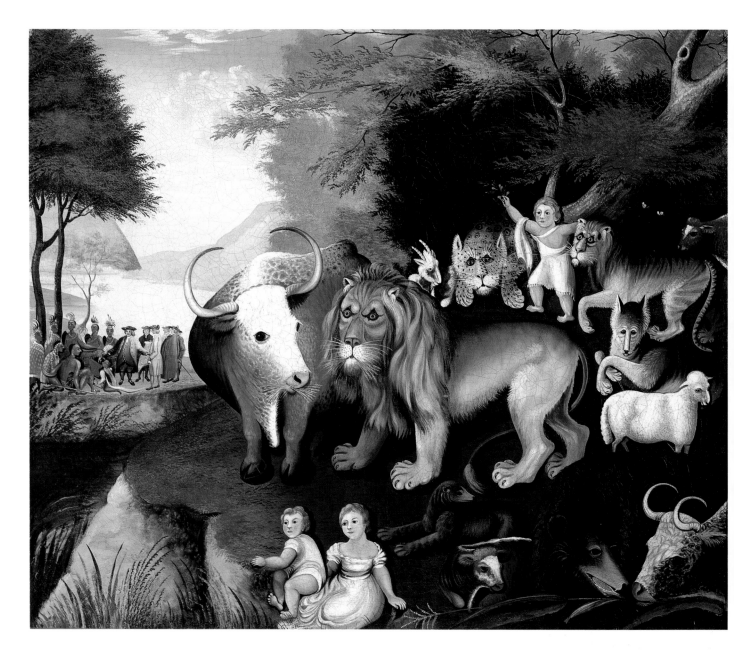

122. Peaceable Kingdom, by Edward Hicks, 1835–1840, oil on wood, 29″ x 35¼″.
Courtesy, Everson Museum of Art, Syracuse, N. Y., purchased with funds from the Community
and Friends of Syracuse and Onondaga County, 1978. Photograph courtesy, Courtney Frisse.

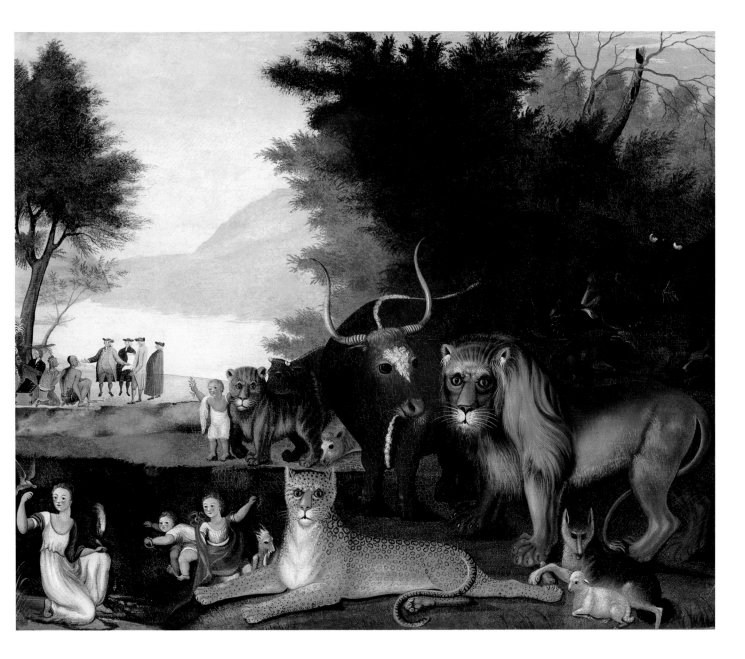

123. Peaceable Kingdom, by Edward Hicks, ca. 1837, oil on canvas, 29″ x 36″. Courtesy, private collection.

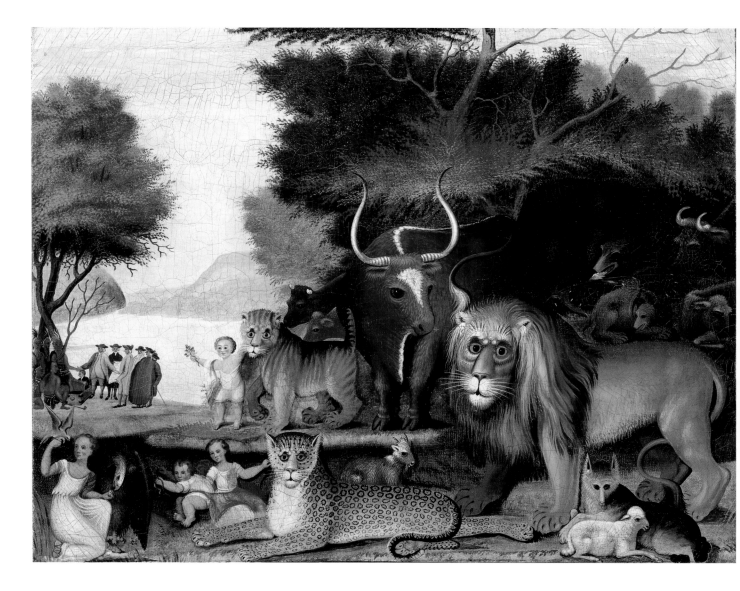

124. Peaceable Kingdom, by Edward Hicks, 1835–1844, oil on canvas, 17¾″ x 23¾″.
Courtesy, private collection.

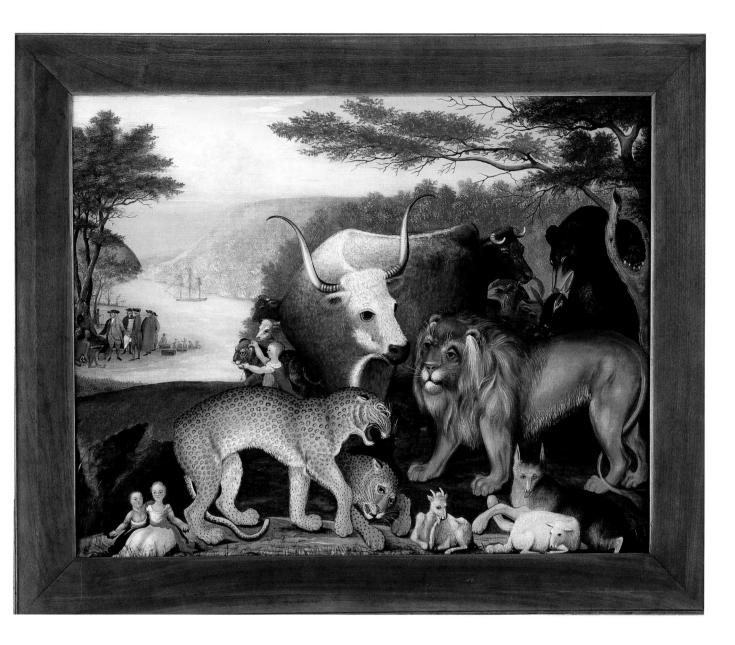

125. Peaceable Kingdom, by Edward Hicks, 1844,
oil on canvas, 24″ x 31¼″.
Abby Aldrich Rockefeller Folk Art Center.

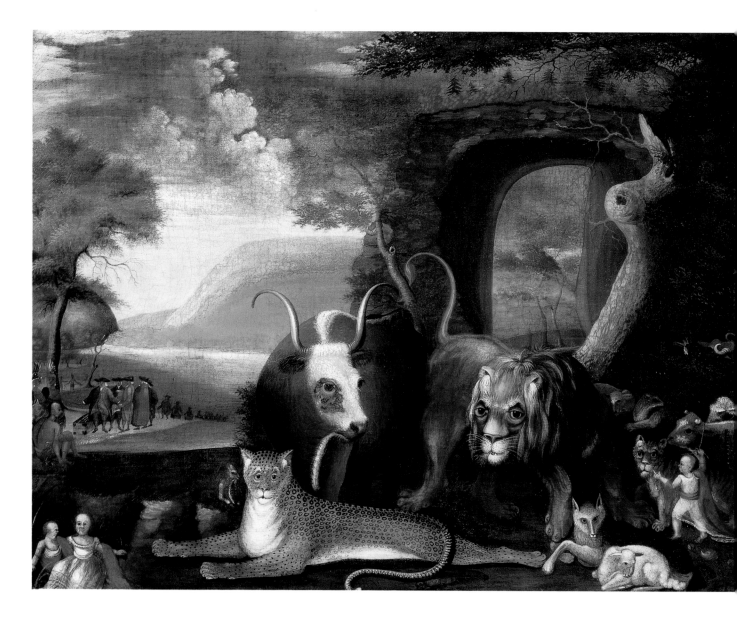

126. Peaceable Kingdom, by Edward Hicks, 1845, oil on canvas, 24¼″ x 31″.
Courtesy, Yale University Art Gallery, New Haven, Conn.,
bequest of Robert W. Carle, B.A. 1897.

127. Detail from fig. 126.

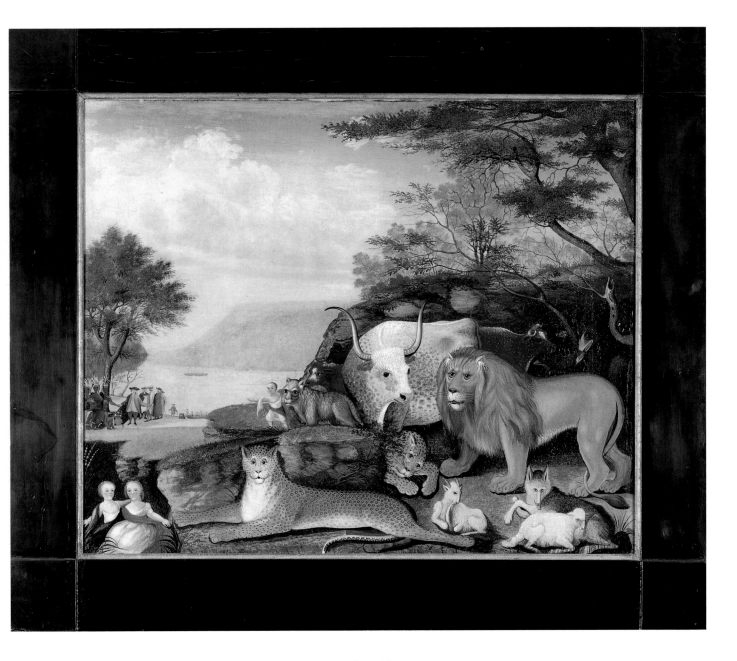

128. Peaceable Kingdom, by Edward Hicks, 1845–1847, oil on canvas, 24½″ x 30½″.
Courtesy, Leslie Miller and Richard Worley. Photograph courtesy, Graydon Wood.

129. Peaceable Kingdom, by Edward Hicks, 1846,
oil on canvas, 24⅛″ x 32⅛″.
Courtesy, Phillips Collection, Washington, D. C.

130. Peaceable Kingdom, by Edward Hicks, 1847, oil on canvas, 24″ x 32″.
Courtesy, collection of Carroll Janis.

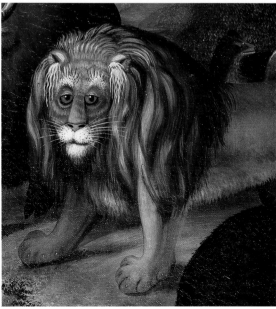

131. Detail from fig. 130.

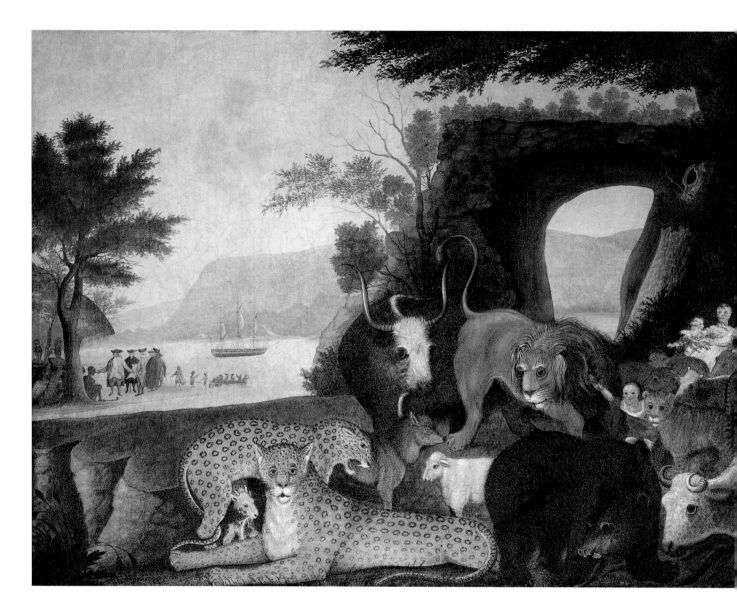

132. Peaceable Kingdom, by Edward Hicks, 1847, oil on canvas, 23¾″ x 31⅛″.
Courtesy, Denver Art Museum Collection, Denver, Colo., gift of Charles Bayly, Jr.

133. Detail from fig. 137.

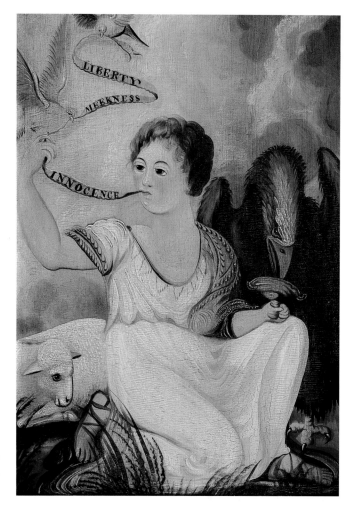

134. Liberty, Meekness, and Innocence, by Edward Hicks, 1830–1835, oil on wood, 14" x 9¾". Courtesy, private collection.

compared to an oil on a small wood panel (fig. 134) the artist painted about the same time that combines nationalistic and religious ideas united in liberty. The female figures with doves and eagles in the Kingdoms are nearly identical to the youths shown in the panel picture (figs. 123 and 130, for example).[2] An unfurled banner with "LIBERTY," "MEEKNESS," and "INNOCENCE" flows from the child's mouth, through her hand, and to the two doves above. These messages are identical to those on the Kingdom corner blocks Edward painted in the 1820s. The artist included the symbolic youth in about half of the Kingdoms he completed before his death.

Liberty and her attendants may represent a greater sense of freedom on the part of its creator to experiment with these popular motifs. Edward introduced a number of new or revised elements in all of his late pictures, including the farmscapes, pastorals, and historical pictures, with increasing frequency. Most often, the newer elements reflected a more sophisticated knowledge and selection of poses and types of animals (figs. 140 and 144, for example), drawn from other visual sources or nature (fig. 141). There are, however, occasional curiosities that may be observed in these paintings, including the strange animal, presumably some sort of bovine, that is seen at lower right in a late Kingdom (fig. 143).

Edward usually positioned two of the younger children in the late Kingdoms near or touching the serpents'

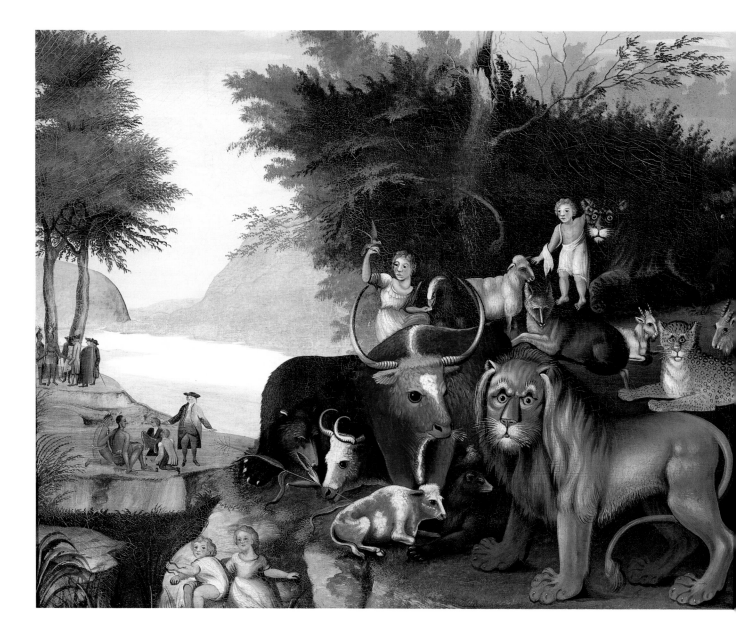

135. Peaceable Kingdom, by Edward Hicks, 1835–1837,
oil on canvas, 28″ x 35″.
Courtesy, Mercer Museum of the Bucks County Historical Society,
Doylestown, Pa.

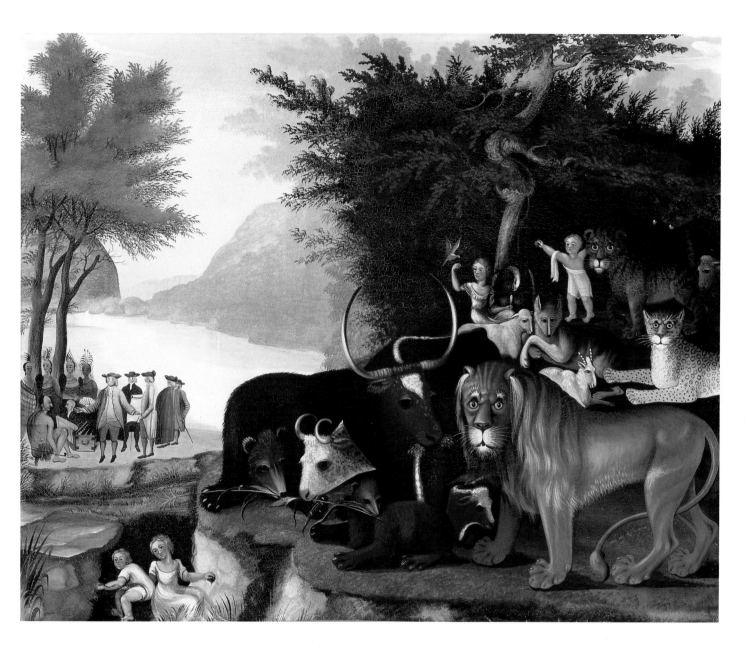

136. Peaceable Kingdom, by Edward Hicks, 1855–1840, oil on canvas, 29″ x 35¾″.
Courtesy, Carnegie Museum of Art, Pittsburgh, Pa., bequest of Charles J. Rosenbloom.

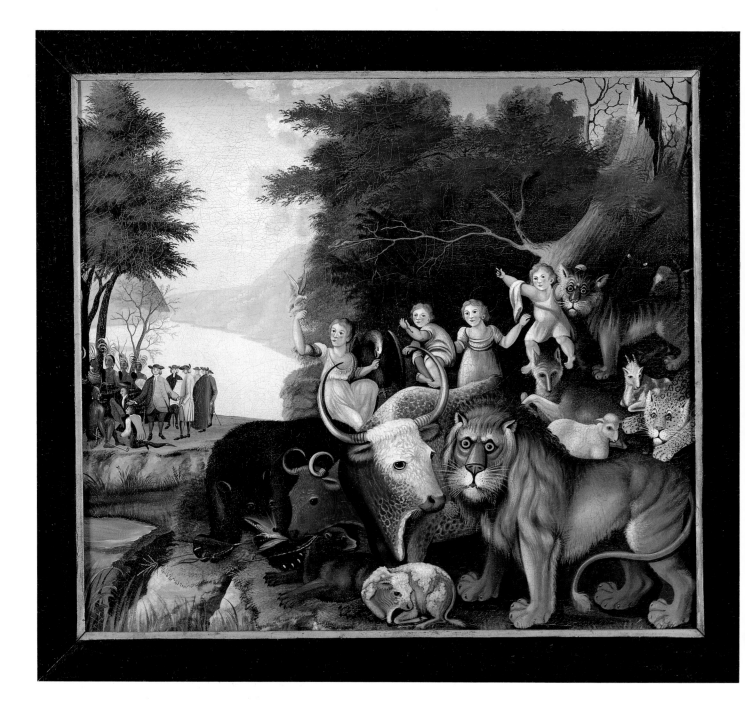

137. Peaceable Kingdom, by Edward Hicks, 1835–1840, oil on canvas, 30⅛″ x 34½″.
Courtesy, New York State Historical Association, Cooperstown, N. Y.
Photograph courtesy, Richard Walker.

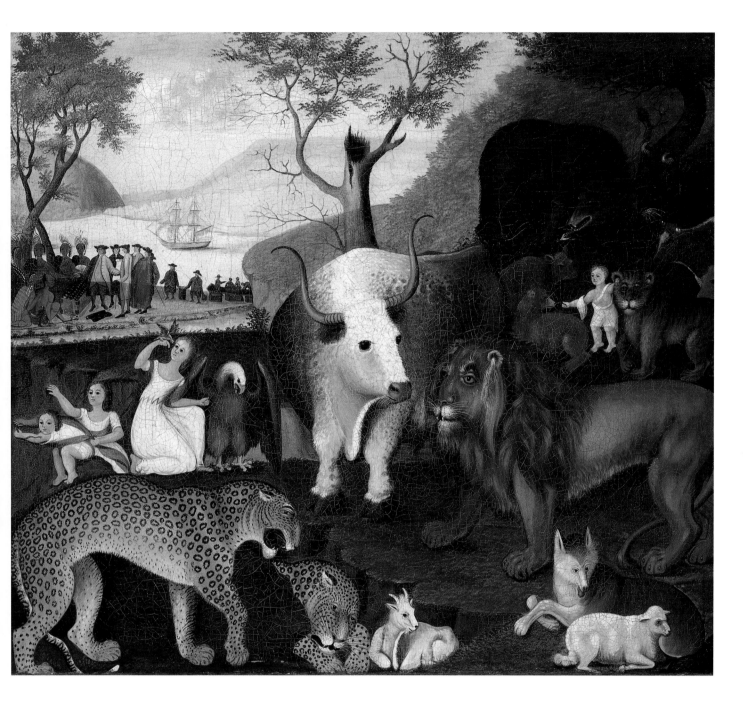

138. Peaceable Kingdom, by Edward Hicks, 1845–1846, oil on canvas, 25″ x 28½″.
Courtesy, Fine Arts Museums of San Francisco, San Francisco, Calif.,
gift of Mr. and Mrs. John D. Rockefeller 3rd.

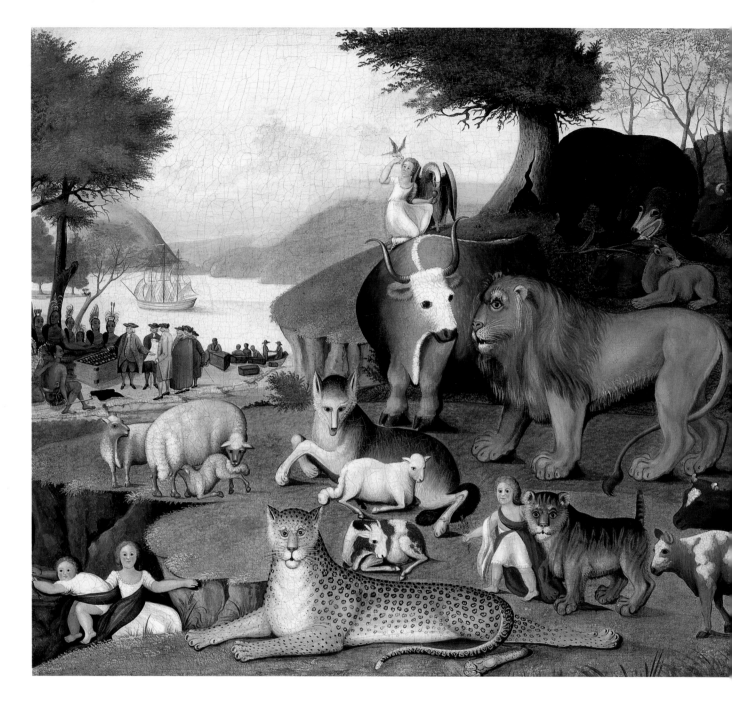

139. Peaceable Kingdom, by Edward Hicks, 1846–1848, oil on canvas, 26⅛″ x 30″.
Courtesy, private collection. Photograph courtesy, Malcolm Varon.

140. Detail from fig. 139.

141. Lamb, by Edward Hicks, ca. 1831,
pencil on paper, 5″ x 5½″.
Courtesy, private collection.

142. Detail from fig. 144.

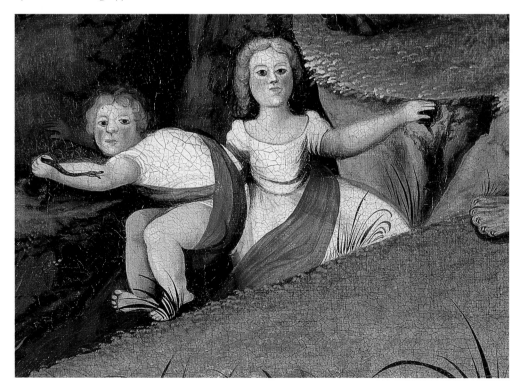

143. Detail from fig. 139.

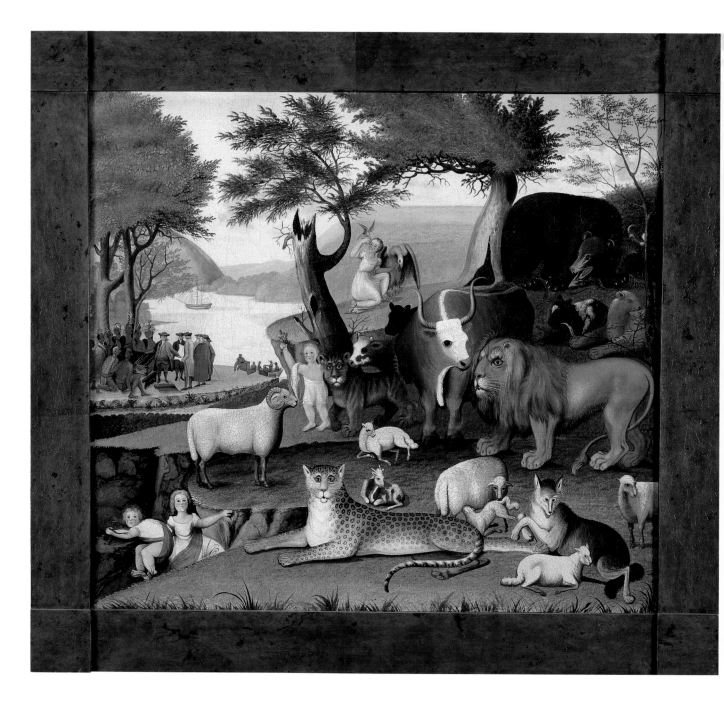

144. Peaceable Kingdom, by Edward Hicks, 1846–1848, oil on canvas, 26″ x 29½″.
Courtesy, private collection.

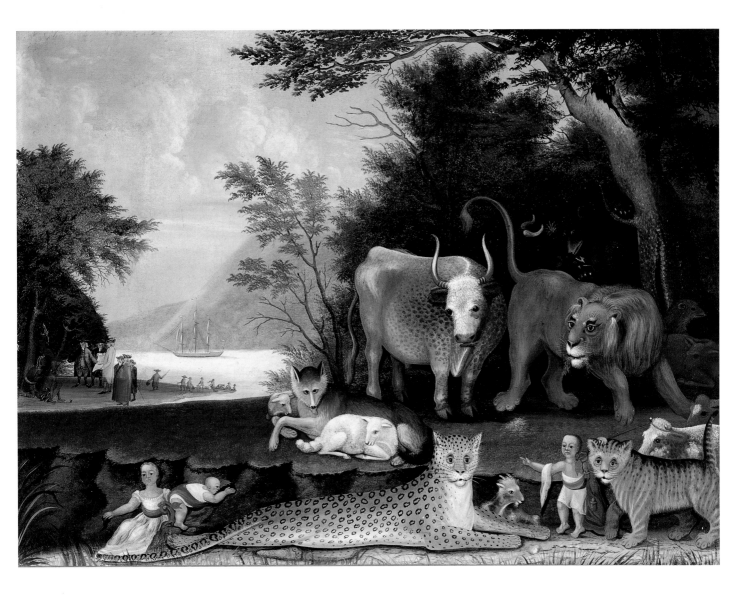

145. Peaceable Kingdom, by Edward Hicks, 1845–1847, oil on canvas, 23⅞″ x 31⅛″.
Courtesy, Albright-Knox Art Gallery, Buffalo, N. Y., James G. Forsyth Fund, 1940.

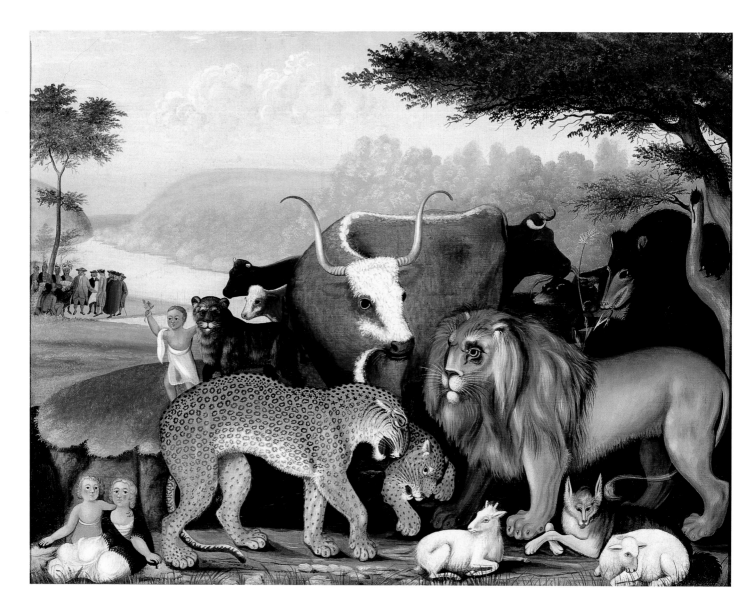

146. Peaceable Kingdom, by Edward Hicks, 1844–1846, oil on canvas, 23⅞″ x 31¼″.
Courtesy, Dallas Museum of Fine Arts, Dallas, Tex., Art Museum League Fund.

holes in the ground. In the last Kingdoms, they handle the snakes (fig. 142), a bold departure wherein the Isaiah reference was expressed more graphically: "And the suckling child shall play on the hole of the asp, and the weaned child shall put his hand on the cockatrice den."

By 1837, Edward had begun to paint the single, large leopard in the lower center of the canvas (fig. 145). The sleek, sometimes sensuous, fellow, stretched out across fully one-half of the width of the picture, stares straight at the viewer. His subdued expression matches the lion's, as it usually did in earlier Kingdoms.

Around 1845, the artist began to use two leopards in the Kingdom pictures. Edward painted only the upper third of the first leopard, which he portrayed as recumbent and submissive. The second stands over and in front of its mate, arching its back and growling (figs. 138 and 146). The two cats appear in nearly the same positions in all but one of the paintings from this period. Although their sex is not indicated, it might be conjectured that the standing leopard is male, the one lying on the ground, female. In previous compositions, only the gentle animals had been paired with the carnivorous ones. The angry, arched cat with its submissive mate indicated conflict and marked a new way in which Hicks interpreted the difficulties of attaining peace.

Scholars have explained the presence of the arched growling leopard in the late Kingdoms by pointing out that Edward was using the animals to portray a system of checks and balances between the qualities they represented. Mather and Miller devoted an entire chapter in their book to the subject, which still provides one of the best and most interesting explanations.[3] In Isaiah's prophecy, the leopard's counterpart was cited as the kid, but Edward failed to develop this significant element in the later Kingdoms. Mather and Miller noted, "This failure . . . suggests Hicks's secret sympathy with the leopard and his works. Conceivably it is the protest of Hicks the artist against the moralism of Hicks the preacher and his fellow meeting-goers."[4] To modify their conclusion slightly, perhaps Hicks saw some of his own youthful indiscretions in the leopard's behavior. The leopard symbolized sensuality and was associated with the sorts of boisterous activities in which Edward had participated as a young man and often recalled in later years. Edward wrote that he had moved from the "sanguine" qualities of youth when he began to attend Quaker meeting.

By including two leopards, Edward signaled a renewed interest that was directly related to the Goose Creek sermon in which he wrote, "The poor negatively innocent female is too often seduced by these beautiful monsters." People could be easily beguiled by those with leopard propensities, only to learn that persons who had such traits often destroyed the very ones who were kind to them. In the sermon, Edward described Friends with leopardlike traits as always being "full of excitement and activity," by which he probably meant those who ignored plainness of dress and participated in dancing and other social activities that undermined Quaker simplicity and, ultimately, the discipline.[5] The arched leopard provided a heightened sense of drama and tension that was new and is rarely observed in these pictures. Phrased another way, perhaps all was not and never would be peaceable in this earthly Kingdom among temporal creatures, or perhaps the achievement of Isaiah's prophecy, as a symbolic approach to unite divided Quakers, was unattainable in Edward's lifetime.

The Peaceable Kingdoms Edward painted after those with arching leopards, between about 1845 and 1849, are characterized once again by the languid demeanor of the carnivorous animals (figs. 144, 145, 147, and 148). These curious pictures are dramatically different from those Hicks produced in the 1820s and 1830s. Mather and Miller called them "Kingdoms of Departure" (fig. 147) and saw in them a relationship with a set of paintings depicting the grave of William Penn that Hicks began in 1847.[6] The authors observed a "tranquil preoccupation with oncoming death" as a prominent feature of the Penn's Grave paintings.[7] They also interpreted the late Kingdoms as the artist's response to the Hicks-

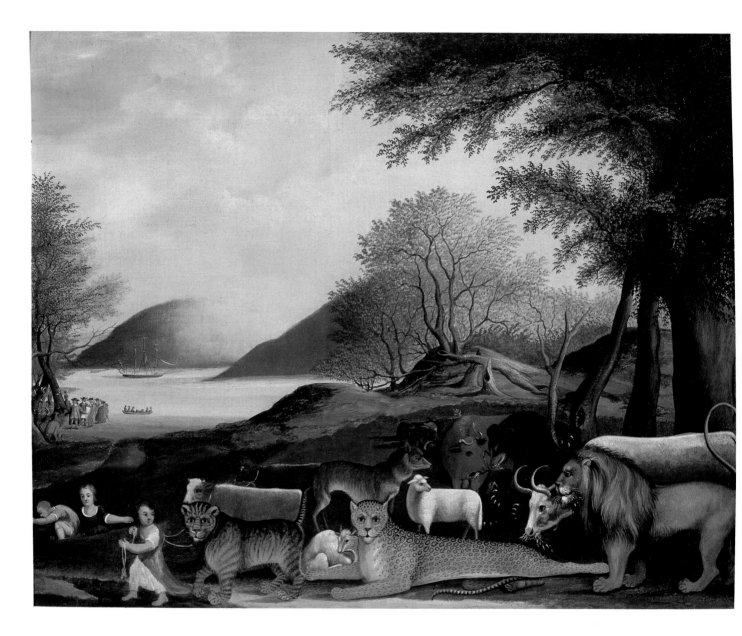

147. Peaceable Kingdom, by Edward Hicks, 1848–1849, oil on canvas, 24″ x 30¼″.
Courtesy, private collection. Courtesy, Galerie St. Etienne, New York, N. Y.

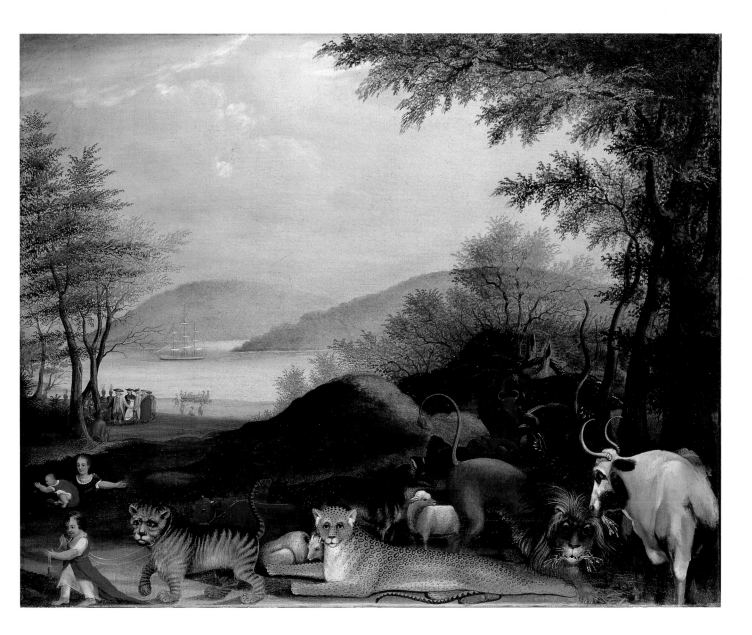

148. Peaceable Kingdom, by Edward Hicks, 1849, oil on canvas, 24½" x 30⅜".
Courtesy, Nelson-Atkins Museum of Art, Kansas City, Mo. (Anonymous loan).

ite-Orthodox separation: "Hicks remained contentious to the last. Much as he longed for peace, he was doomed not to find it till after further dissension. The Hicksites, who had stood together so staunchly in the face of Orthodox oppression, were now divided: . . . they seemed to him to be forsaking the mystical heart of Quakerism."[8]

It is therefore accurate to view the late Kingdom pictures as emblems of departure—departure from the burdens of a ministry that could no longer battle with the multiple sets of "beasts of Ephesus," and from an earthly existence in which men's wills could not be easily tamed or led to embrace a single approach to a religious life that led to peace. What remained was an image in Edward's mind of a place of peace that could be attained only after its occupants fully relinquished their self-will to the will of God.

It had become obvious by the mid-1840s that much of the heat and fervor associated with the 1827 schism had subsided. Many of the older Hicksites, including Edward's dear cousin Elias, were deceased. Edward and John Comly were among the few remaining Hicksites who had actually been involved in the disputes of those troubling times. To some Friends, particularly those younger and rising to positions of influence in meetings, Edward's old-fashioned views may have seemed increasingly irrelevant as other issues had to be addressed. Makefield Monthly Meeting, of which Edward was a member, frequently supported his views, more often, it seems, out of deference to the minister's age and past accomplishments than to his position on current matters.

The artist-minister's correspondence seemed pessimistic. Of himself, Edward wrote to a friend, "For testifyng aginst this . . . highly popular evil [solicitations for various societies and organized abolitionist meetings] I have become obnoxious to them and the object of their censure . . . I received from a friend in Phila through an elder of our quarter that the young people would rather be ruled by hireling [priests] than be [by] such a man as Edward Hicks in [illeg.] hireling spirit—I confess this hurt my feelings."[9] Edward was past his prime; much of

his zest for openly defending certain positions had sorely diminished. The story is more complex than the Mather-Miller analysis indicates, and it warrants further comment. Although the Hicksites experienced divisions, so did the Orthodox. The last section of the *Memoirs*, written near the end of his life, reveals that Hicks had become resigned to the existence of different opinions in the Society of Friends.[10] Edward still feared for the Society, and he saw little hope for reconciliation. He wrote more reflectively about the events of the late 1830s and 1840s. In the end, Hicks offered a solution which—surprisingly—did not support the unity of *all* Friends. The Orthodox and Hicksites were both "scattered and divided," and Edward suspected they would separate further. The Orthodox, he said, were "in two parties called Gurneyites and Wilburites."[11] Branching off from the Hicksites were the "Foxites." Edward observed that the Hicksites

appear to me fully prepared to amalgamate with the Unitarians, as the Unitarians are prepared to unite with the Deists, and finally join the confederacy or conspiracy to destroy the religion of Jesus in its blessed simplicity, and introduce the reign of reason instead of revelation. The Foxites, or rather the Society of Friends that unite, or are in union with Fox, Penn, and Barclay, with which I include myself, are in a society capacity in a suffering state, and which will be most likely to increase. The friendly Orthodox are in a similar state and condition. Now if the extreme Orthodox or Gurneyites would quietly go to the Episcopalians where they properly belong, and our ultra reformers go to the Unitarians, their right place, and religious Friends and religious Orthodox could hold a conference, and let that "charity that suffereth long and is kind," sit as moderator, I think there would be but little to prevent their uniting again. The greatest difficulty will be the deep rooted prejudice against that excellent Friend, Elias Hicks.[12]

The Kingdom illustrated in figure 148, documented as the last by the artist, was created for his daughter

Elizabeth. It is an interesting painting since it contains many of the elements Edward used in previous Kingdoms, although it does not seem to be as extraordinarily elegiac or euphoric as other scholars have perceived. Its quiet tone and gently interwoven placement of animals in a serene landscape recall the Kingdom pictures Edward had just painted. This Kingdom is significant because it was Edward's final artistic effort. The subject had meant so much to him, had captured his imagination and innermost yearnings for so long, first as gentle statements of faith, then as more emotional testimonies of religious discipline, and finally as reflections of acceptance and personal peace achieved only through resignation and prayer. Much like the bear, the wolf, the leopard, and the lion, Edward had been both willful and combative in matters of religious discipline on numerous occasions. The Peaceable Kingdoms Hicks painted at the end of his life symbolize the ultimate surrender of his will to continue the battle.

With regard to his own emotional and spiritual state, Edward now placed more emphasis on solitary prayers in an increasing preoccupation with his spiritual life. A month before his death, he wrote, "I feel an incontestible evidence that this prayer has been granted, and my poor soul has become established in the eternal *Truth,* . . . with that *faith* that works by love."[13] Edward spoke of his need to "mind my own business, which if I am not mistaken is to bear a simple, child-like testimony to this mercy and goodness of my blessed *Saviour.*"[14] Edward thought that he might be pitied "as a fool, or ridiculed as an enthusiast; my doctrine considered madness, and my end without honor."[15] All Edward's hopes and wishes now rested not in his earthly reputation but in attaining "that precious life that is hid with Christ in God, as a passport from this world to the Heaven of Heavens."[16]

149. Detail from fig. 147.

Painter at Peace

He had no prospect of living through the Eighth month . . .
he had never been so happy at anytime of his life!
His concern as a minister,
that had rested on him for nearly forty years, was removed;
and it had left him in peace!

TESTIMONY ABOUT EDWARD HICKS, *Memoirs*

During the last fifteen years of his life, Edward completed about twenty-five of the Peaceable Kingdom paintings and a larger number of farmscapes, pastoral scenes, and historical works. This was the artist's most productive period for easel pictures; not only did he generate a large number of such works, he explored a greater range of subjects. Edward became less involved in the ministry and more preoccupied with achieving inner personal harmony and spiritual peace. He seemed to have enjoyed greater artistic freedom. Hicks's thoughts, which the artist expressed in the often expansive and rambling texts of the *Memoirs*, suggest that his life had taken on a substantially different rhythm and flow.

Always stated in slightly contradictory ways, Edward's ideas about art perhaps became more liberal—if not liberated—in these last years.[1] The artist was busy in his shop with ornamental or easel painting most of the time. After a last, long ministerial trip in 1837, Edward rarely ventured much beyond Philadelphia, and then only for brief periods.

Although death touched the family several times, events in Hicks's family life and business were unremarkable. On October 5, 1836, Squire Isaac Hicks, the artist's father, died at the age of eighty-eight.[2] Edward mourned his beloved granddaughter, Phebe Ann Carle, who died in March 1846. Edward had formed a strong attachment to the child, and he grieved her loss to the end of his life.[3] Toward the end of the *Memoirs*, when they became a journal of his daily activities, Edward wrote that he had attended a significant number of funerals of friends and relatives, events that undoubtedly called to mind thoughts of the artist's own mortality.

Edward was awarded the commission to paint identical commemorative signs featuring George Washington for both ends of the Delaware River Bridge (fig. 59) during this period.[4] The artist continued to paint versions until 1849 (figs. 150–152). One example, inscribed for Doctor M. Linton of Newtown, the son of Edward's friend and "fellow Soldier, James Linton," was painted when Edward was sixty-nine (fig. 151). Another, owned by the Chrysler Museum, was also dated the same year.

Based on the only dated version, the series, which features the Declaration of Independence and is discussed in chapter six, was created from about 1840 to at least 1844. The various examples of Penn's Treaty with the Indians, the last of which are thought to date to about 1847, were also associated with Edward's sign painting work (figs. 153–155).

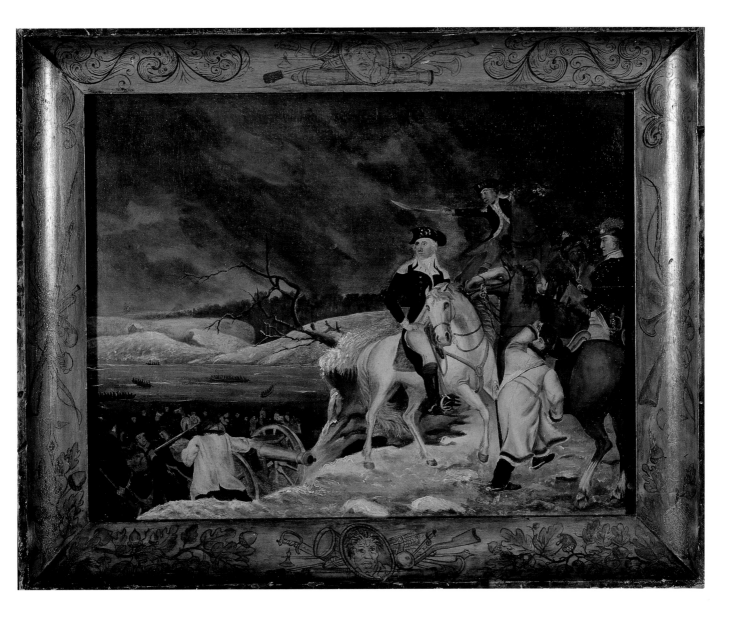

150. "Washington Crossing Delaware," by Edward Hicks, 1833–1835, oil on wood, 17″ x 21½″.
Courtesy, private collection. Photograph courtesy, Leigh Photo & Imaging, Princeton, N. J.

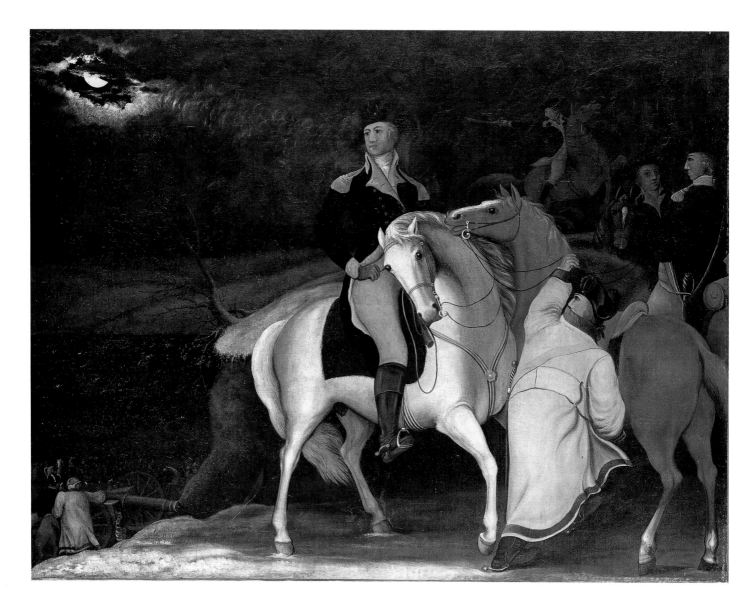

151. "George Washington with his army crosing the Delaware . . . ," by Edward Hicks, 1848,
oil on canvas, 36⅛" x 47⅜".
Abby Aldrich Rockefeller Folk Art Center.

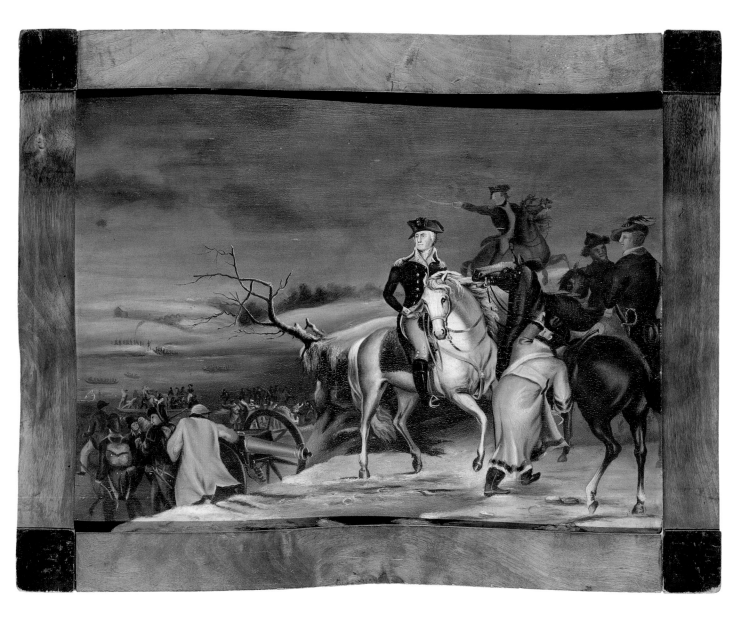

152. "Washington Passing the Delaware . . . ," by Edward Hicks, 1835–1840, 14¾" x 20".
Courtesy, collection of H. Richard Dietrich, Jr., Philadelphia, Pa. Photograph courtesy, Will Brown.

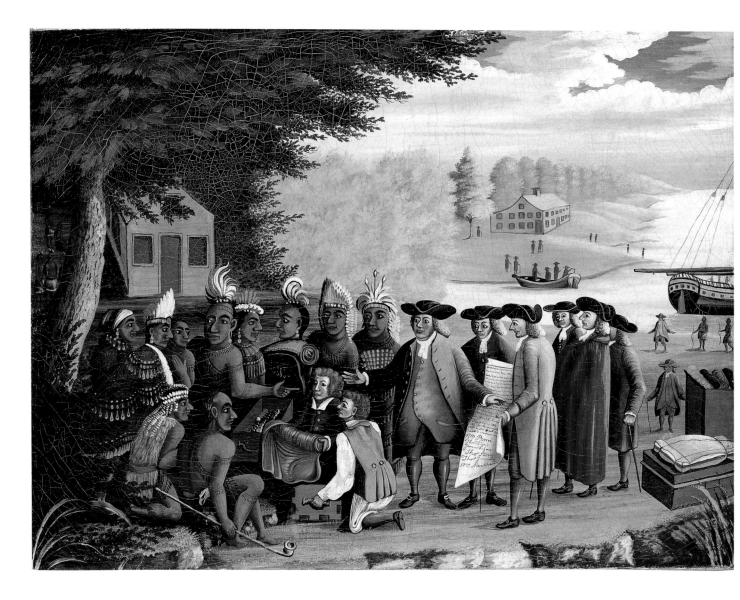

153. "PENN'S TREATY," by Edward Hicks, 1830–1835,
oil on canvas, 17⅛" x 22¾".
Abby Aldrich Rockefeller Folk Art Center.

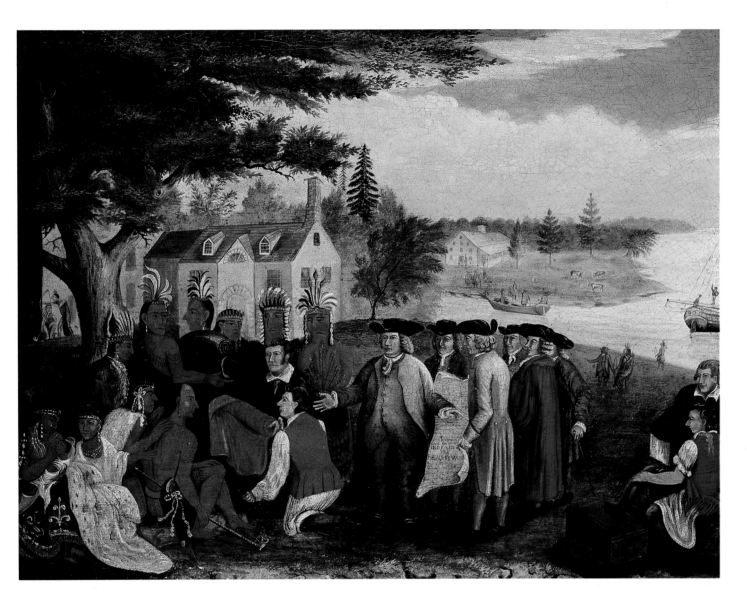

154. "PENN'S TREATY," by Edward Hicks, 1835–1840,
oil on canvas, 20⅛" x 27⅛".
Courtesy, Mercer Museum of the Bucks County Historical Society, Doylestown, Pa.

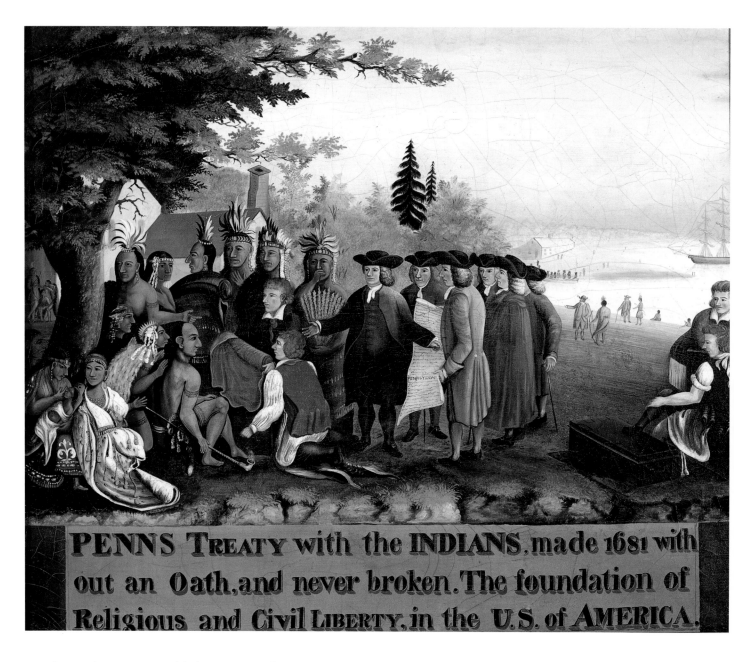

PENNS TREATY with the INDIANS, made 1681 with out an Oath, and never broken. The foundation of Religious and Civil LIBERTY, in the U.S. of AMERICA.

155. "PENN'S TREATY with the INDIANS," by Edward Hicks, 1840–1845, oil on canvas, 25″ x 30¼″.
Courtesy, Shelburne Museum, Shelburne, Vt. Photograph courtesy, Ken Burris.

156. Andrew Jackson, by Edward Hicks, ca. 1835, oil on carriage cloth, 21½″ x 19¹³⁄₁₆″.
Courtesy, Nelson-Atkins Museum of Art, Kansas City, Mo. (Anonymous loan).

Among the other historical images possibly related to Edward's sign work is the curious picture of Andrew Jackson painted on carriage cloth that was discovered rolled up and stored in the shop after his death (fig. 156).[5] Carriage cloth, although unusual for a painting, is not its peculiar feature; Edward sometimes used this material when his stock of canvas was depleted.[6] What is unusual is the composition of the Jackson picture. Its strong symbolic background suggests it may have served as a commemorative parade banner or some sort of sign. Unlike signs on wood panels, painted fabrics would not have withstood long exposure to weather. The drawing and painting of the Jackson picture lack the degree of detailing and careful brushwork seen in Edward's easel paintings. In recent years, two flags or banners have been attributed to him, although his account book does not document flags, banners, or similar work.[7] The second banner (fig. 157) shares with the Jackson picture the same sketchy quality. One or both may have been painted in part by Edward's shop workers. Scholars stated that the Jackson canvas was derived from Thomas Illman's print after a drawing by Henry Hoppner Meyer; Meyer made the drawing after Ralph E. W. Earl's portrait of Jackson completed about 1835.[8] Edward added the national emblematic devices so popular during the early republic to the composition.[9]

The pastoral and farmscape pictures are the most remarkable paintings of the last decade of Edward's life. The pictures that feature the Grave of William Penn at Jordans in Buckinghamshire, England (figs. 158–160), share the peaceful serenity of the late Kingdom pictures. The Grave of Penn series, of which six are known, were inspired by Hendrik Frans de Cort's painting of the scene popularized in a lithograph by Paul Gauci.[10] Four were dated and inscribed as presentation pieces to friends Ann Drake and Elizabeth Cary, both of Newtown; Job Roberts, of Montgomery County; and Joshua Longstreth, of Philadelphia, probably the father-in-law of Edward's friend Richard Price. The fifth may have been painted for William Hicks Macy, a distant relative.[11]

157. Holland Sabbath School banner, by Edward Hicks, ca. 1821, oil on silk, 31½″ x 32¼″.
Courtesy, Mercer Museum of the Bucks County Historical Society, Doylestown, Pa.

Edward may have affirmed his own beliefs by rendering these small, peaceful views of the grave of an early leader of the Society of Friends. If Hicks intended to symbolize departure from this earth in the Penn's Grave pictures, he may also have wanted to underscore the endurance of Penn's teachings after his death.

Edward used his sign painting skills to title boldly in block letters the example painted for Job Roberts (fig. 160). More discreet inscriptions appear at lower left on the others. Many animals in the pictures of Penn's Grave are also present in Edward's farmscapes and Kingdoms of the late years. Of interest are a shepherd and a small boy with a sheep dog, pastoral elements borrowed from unidentified sources, in the lower right corners of two of the pictures.

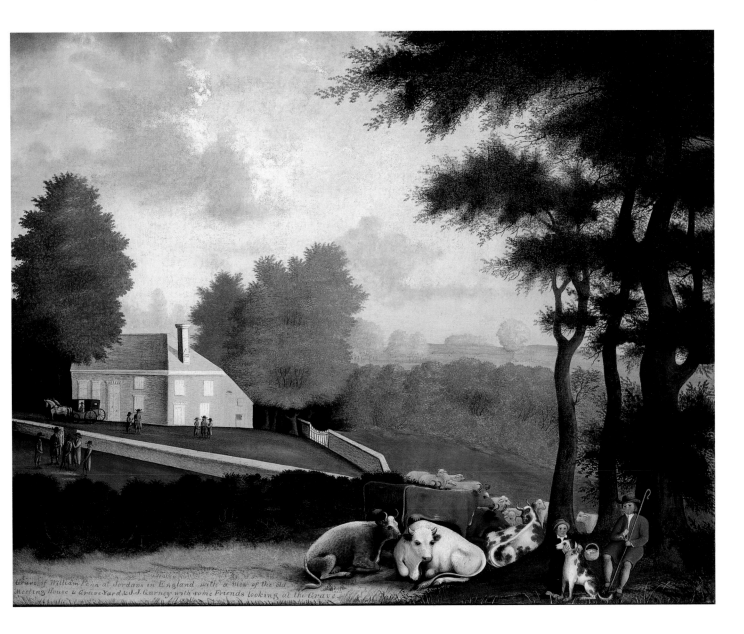

158. "Grave of William Penn at Jordans in England . . . ," by Edward Hicks, 1847–1848,
oil on canvas, 23⅝" x 29¾".
Courtesy, National Gallery of Art, Washington, D. C., gift of Edgar William and Bernice Chrysler Garbisch.

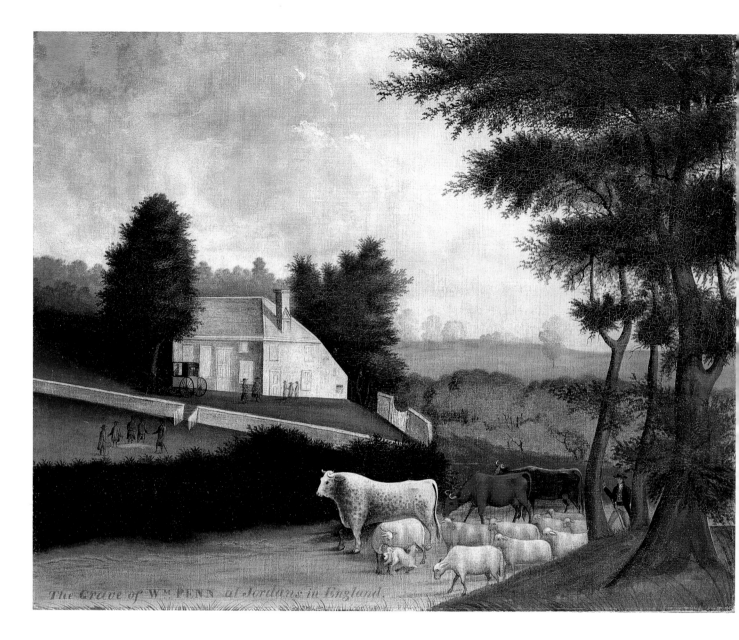

159. "The Grave of W ᴹ P E N N at Jordans in England," by Edward Hicks, 1847, oil on canvas, 24″ x 30″.
Abby Aldrich Rockefeller Folk Art Center.

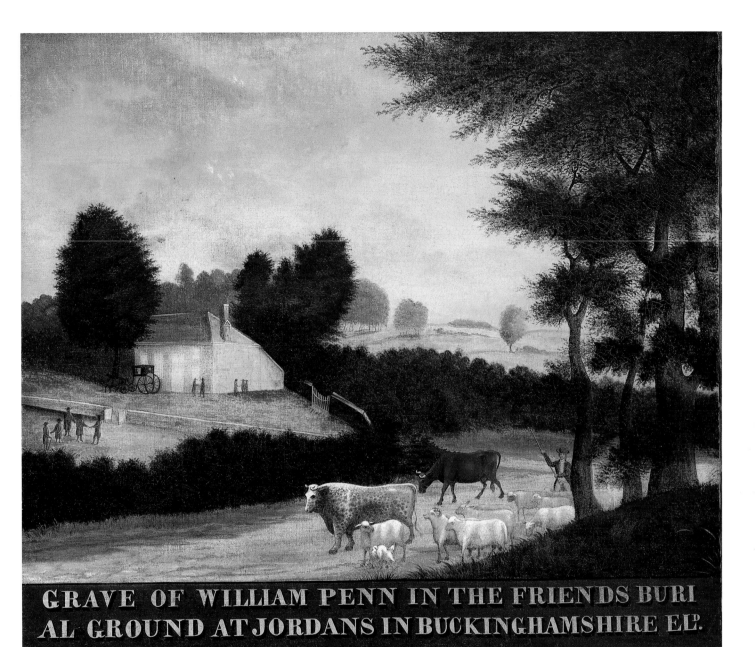

GRAVE OF WILLIAM PENN IN THE FRIENDS BURI
AL GROUND AT JORDANS IN BUCKINGHAMSHIRE Eᴰ.

160. "GRAVE OF WILLIAM PENN . . . ," by Edward Hicks, 1847,
oil on canvas, 25¾″ x 29⅞″.
Courtesy, Yale University Art Gallery, New Haven, Conn., gift of Robert W. Carle, B.A. 1897.

The Bucks County Agricultural Society held its second annual exhibition at Hough's Hotel on October 16, 1845. Among the exhibitors was the manufacturing firm of Brown & Eyre, noted for plows, stoves, and other farm implements. The artist had completed a sign for Brown & Eyre, and, although not referred to specifically in the account book, Hicks had lettered a sign for the firm about the same time. Ford was the first to discover a mention of the sign in the *Doylestown Democrat* along with a reference to a "rural scene," which she speculated was Edward's earliest known farmscape, the home of Thomas Hillborn (fig. 161).[12] Since the newspaper did not identify the picture by name, Ford's association is difficult to substantiate. The article did not indicate whether the "rural scene" was part of the sign or a separate work, a specific place or an imaginary one:

An elegant sign, painted by Edward Hicks for Brown & Eyre, was exhibited, and attracted much attention. It presented the variety of stoves and implements of husbandry which they are engaged in manufacturing, truly and beautifully, also a rural scene, including farm buildings, groves, landscape, and all the operations of the farmer, handsomely arranged and true to nature.[13]

No signboard for Brown & Eyre by Edward's hand survives for comparison. It seems odd that the article did not identify the view as Hillborn farm, which would have been familiar to those who attended the exhibition.

An early lettered inscription on the lower member of the painting's strainer noted the Hillborn view represented the farm as it looked in 1821. Edna Pullinger, who documented the ownership of the farm, noted that 1821 was the year in which Thomas Hillborn was forced to sell the homestead to satisfy a debt. Cyrus Hillborn, Thomas's son, commissioned the painting of the family property from Edward in 1845.[14] Then a successful merchant in Philadelphia, Cyrus responded in January 1846 to a plea from Edward that he purchase land and return to Bucks County:

I was sorry to see so much said in thy letter in respect to what—little I have done & as to my merits—I feel poor in Spirit, not so happy as when a boy I labored upon my Fathers farm & I have often regretted it ever became necessary for me to seek a living in so worldly and bad a place as this city . . . my opinion is people are better off in their old homes than in new ones amongst Strangers . . . I would strongly recommend all friends to be contented in their own neighborhoods—I wish I had always lived in so good a place as Bucks County—I might not have been quite so well off in worldly affairs but I have no doubt I should have been a better & a happier man & had less to repent of.[15]

Cyrus did not mention the painting, but just two months later, on March 4, 1846, he bought the former family farm.[16]

The Hillborn farmscape is the least refined in its painting, another indication that it may be the earliest of Hicks's domestic views. It is somewhat experimental and lacks the confident painting qualities in the other farmscapes. The strong horizontal line of the ploughed field that runs from the lower left corner to the middle of the canvas on the right, accentuated by the figure of Thomas Hillborn behind the horse-drawn plough, was not unusual for Hicks. This was typical of the way he organized a canvas and is similar to compositional features in a number of Kingdoms. Edward tended to cluster the primary elements of paintings on the right. A degree of this approach is seen in Hillborn Farm, where the taller trees, yard activities, and house are on the right, although Edward also filled other areas with interesting details. They are counterbalanced by the barn and livestock below the building. Hillborn Farm also reflects the artist's equally strong penchant for overlapping elements in a series of horizontals—animals layered one upon the other followed by the field, then the fence, and finally the yard proper with its buildings and activities laid out across the canvas. In some of Edward's paintings, portions of animals and other elements were often placed

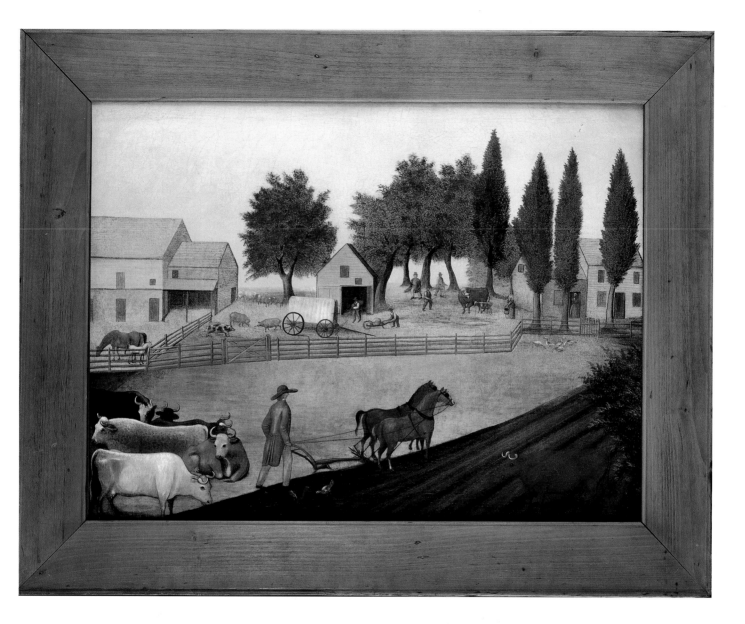

161. Residence of Thomas Hillborn,
by Edward Hicks, 1845–1847,
oil on canvas, 23⅝″ x 31⅞″.
Abby Aldrich Rockefeller Folk Art Center.

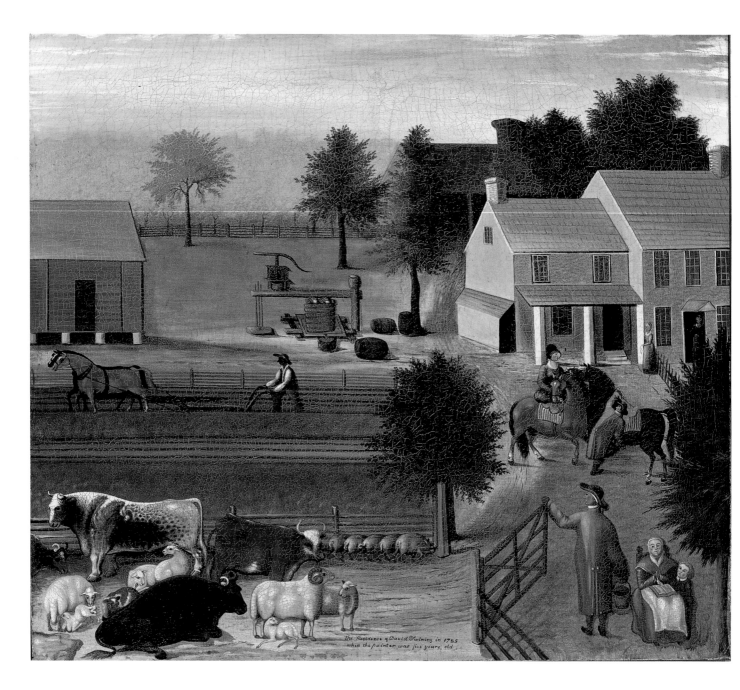

162. "The Residence of David Twining in 1785," by Edward Hicks, 1845–1847,
oil on canvas, 26″ x 29½″.
Courtesy, Carnegie Museum of Art, Pittsburgh, Pa., Howard N. Eavenson Memorial Fund
for the Howard N. Eavenson Americana Collection.

163. Detail from fig. 172.

beneath fully developed features painted in front of them, another indication of layering. A noteworthy example are the two figures standing in front of the fence, center left, in Leedom Farm (fig. 163).

Most scholars believe that Edward created four canvases depicting the residence of David Twining between 1845 and 1847, immediately following the Hillborn view (figs. 8 and 162).[17] In the absence of firm documentation and in light of the lesser quality of the view of Hillborn Farm, this conclusion may be reasonable. Edward's work, as it developed over the years in similar formats, particularly the Kingdom pictures, was often uneven, however; some of the best were painted early, and some of lesser quality later. It is possible that one of the Twining versions may have preceded the Hillborn farm view.

Three of the paintings, among them the Sarah Twining Hutchinson version, are similar (fig. 162). The most elaborate includes elements and activities missing in the others and also boasts the lettered title on its original frame (fig. 8). It may have been the prototype for the others. The Twining pictures bear no presentation inscriptions. The earliest version is usually identified as one now privately owned that was originally painted for Thomas and Sarah Twining Hutchinson. Sarah was the eldest Twining daughter; she and her husband purchased the farm in 1826.[18] It is difficult to confirm which of the four Twining pictures came first. The Folk Art Center example, probably commissioned by Charles Leedom, the son of the Twinings' third daughter Mary Twining and Jesse Leedom, could have been the earliest or the last.

The views were intended to show the Twinings' farm as Edward remembered it in the 1780s, when he was a small child living there. The central vignette is the most significant focal point. It features Mary Twining Leedom, whom Edward called his best friend, and her husband, Jesse. Mary holds Jesse's horse while he mounts it—with the wrong foot, it should be noted. The grouping of Mary and Jesse was adapted and reversed from a similar scene used by Hicks in the *Washington Crossing the Delaware* series.

The other people in the painting held special significance for Edward, particularly Elizabeth Twining, who is shown in the foreground reading from a book (undoubtedly a Bible) while Edward stands by her (fig. 9). David Twining is near his wife, with one hand on the gate and the other holding a feed bucket; his back is to the viewer in all except the Folk Art Center version (fig. 9). The couple typify industry and faith, and their position in the lower part of the picture is a solid foundation from which their two daughters and son-in-law rise. Beulah Twining, the youngest and liveliest of the daughters, is in the shadowy right background near the farmhouse door as it looked in the 1780s. After marrying and then divorcing Dr. Torbet, "the handsome exterior," she returned to the farm and assumed leadership for its operations until her death in 1826. She emerged in later life as a strong individual and became one of Edward's closest and most supportive friends. Sarah Twining Hutchinson, the owner of the presumed earliest version, left the farm about the time Edward came to live there. She does not appear in any of the versions of Twining Farm.

164. Landscape with Stream, by Edward Hicks, 1845–1848, oil on academy board, 7½″ x 9½″.
Courtesy, Martha and Malcolm Cade. Photograph courtesy, Mike Jensen.

Little can be substantiated about the original owner-ship of the other two paintings of the farm. One is be-lieved to have been painted for Sarah Hopkins Loines, the granddaughter of David and Elizabeth Twining and the daughter of Elizabeth Twining Hopkins.[19] The his-tory of the other places it in the Philadelphia area early in the twentieth century.[20]

Are the Twining Farm paintings typical of a late eighteenth-century Bucks County farm? Are they realis-tic portrayals that reflected life as it was lived then? To answer this difficult question requires an understanding of how Edward approached his subject and how he in-tended the paintings to function. The individual ele-ments—persons, generic types of livestock, buildings,

165. Landscape, by Edward Hicks, 1845–1849, oil on wood panel, 16¾″ x 20″.
Abby Aldrich Rockefeller Folk Art Center.

166. Pole Screen with Landscape,
painting by Edward Hicks, 1825–1835,
oil on poplar panel, 20″ x 23³⁄₁₆″,
with mahogany pole, 57¼″ x 23³⁄₁₆″.
Abby Aldrich Rockefeller Folk Art Center.

equipment, fences, perhaps even trees and significant landscape details—captured the nineteenth-century place. It was a busy environment, perhaps too busy to duplicate an actual moment in life. The painting appears intentionally orchestrated to illustrate activities that might have occurred over several hours, days, or even weeks. Some elements are not believable. For instance, real pigs line up around a trough to feed, but they do not organize themselves according to size. Similarly, would Mrs. Twining have read her Bible beside the livestock yard? And where are the mud and mire? In the Twining Farm pictures, Edward painted an idealized place and time that symbolized the goodness and industry of a Quaker farmstead he remembered fondly.

In 1846, Edward painted a small but important picture inscribed on the back of its support "Prize Bull/ Edw. Hicks/1846" (fig. 167). The receipt, which originally was attached to the verso, reads "James Cornell/To Edward Hicks De/To painting his prize bull, $15.00/ Rec'd 5th mo 16th 1846 the above in full/of all demands by me/Edward Hicks."[21] Of all of Edward's paintings, this is most suggestive of the work of a trained artist. Edward achieved greater realism in the background and the arrangement of the sheep, ram, and goats around the central figure of the bull. In both character and anatomical drawing, the bull is much more sophisticated than any other Edward painted. One scholar saw a strong relationship between Edward's animals and earlier Dutch pastoral scenes.[22] The sources for this painting are three lithographs by Gustavus Canton (figs. 168–170).[23]

Edward faithfully interpreted two of the sources featuring sheep, but used only the pose of Canton's bull. Hicks's rendering was careful and studied, a significant departure from the customary simpler and flatter methods he used elsewhere. Such realism occasionally appeared in Edward's earlier paintings as exemplified by the child figures and young goats in three of the border Kingdoms (figs. 96–98). That he could paint in this manner but rarely did so is not surprising. That Edward

would have chosen not to do so, given the constraints of his religion and the way many Friends viewed his art, is understandable. He would not have made an already controversial situation worse by continuing to paint fine arts pictures. Some of these qualities may also be observed in figures 90 and 165.

Edward is known to have painted four other pastoral scenes, among them those illustrated in figures 164 and 165. Again, it is difficult to date them when one recalls the unidentified "landscapes" listed in the artist's accounts in 1818. Like Cornell's prize bull, they sold for $15.00. The prices for the four extant pastoral pictures are unknown, as are the dates. Only one was signed by the artist. Stylistically, they are refined but simple pictures that are similar to other works by Edward. They contain diverse animals and vegetation, including the favorite blasted trees. Of the four, the small painting adorning a polescreen may be the earliest, perhaps dating to the 1830s (fig. 166). The other three appear to be related to the last two farmscapes and may date to the 1840s.

These small works, characteristically serene, occasionally include a human figure or two, but there are no overt symbols or messages in them. They were clearly inspired by popular images that Hicks knew and may have owned, and were intended to be pleasing depictions of peaceful rural life.

Edward painted monumental canvases featuring two well-known, prosperous Bucks County farms, Cornell Farm (fig. 171) and Leedom Farm (fig. 172), in 1848 and 1849. Hicks inscribed the earlier one, now owned by the National Gallery of Art, "An Indian summer view of the Farm & Stock of JAMES C. CORNELL of Northampton, Bucks County, Pennsylvania, That took the Premium in the Agricultural Society: October the 12, 1848/Painted by E. Hicks in the 69th year of his age." Cornell stands among a group of men described as his brothers near the center of the picture and behind his magnificent herd of livestock that often earned prizes at county agricultural exhibits (fig. 173).

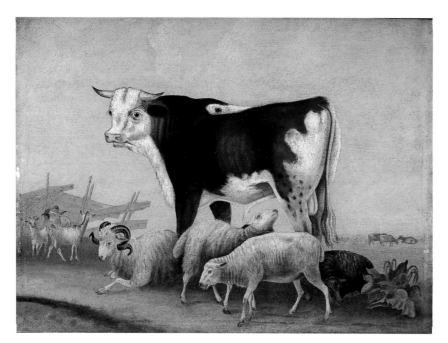

167. James Cornell's Prize Bull,
by Edward Hicks, 1846,
oil on wood, 12″ x 16⅛″.
Abby Aldrich Rockefeller Folk Art Center.

169. Curly-Horned Ram,
by Gustavus Canton,
nineteenth century, lithograph.

168. Three Ewes, by Gustavus Canton,
nineteenth century, lithograph.

170. Bull, by Gustavus Canton,
nineteenth century, lithograph.

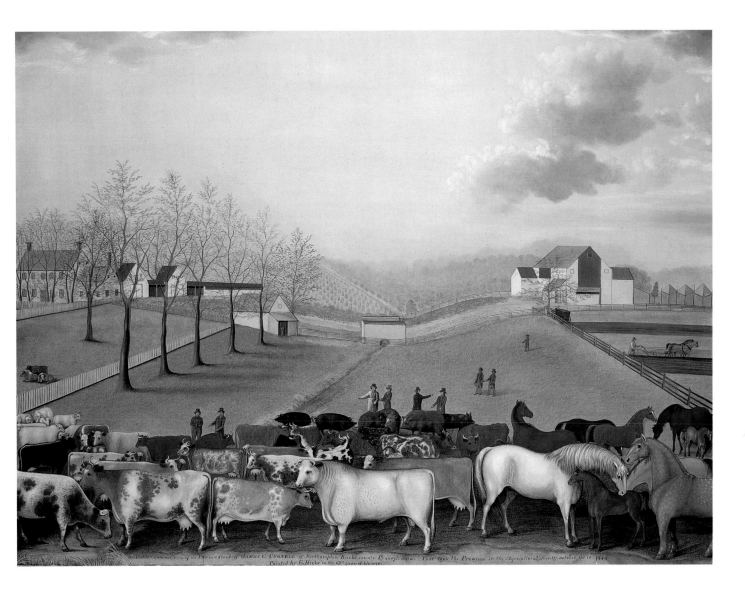

171. "An Indian summer view of the Farm & Stock of J A M E S C . C O R N E L L . . . ,"
by Edward Hicks, 1848, oil on canvas, 36¾″ x 49″.
Courtesy, National Gallery of Art, Washington, D. C.,
gift of Edgar William and Bernice Chrysler Garbisch.

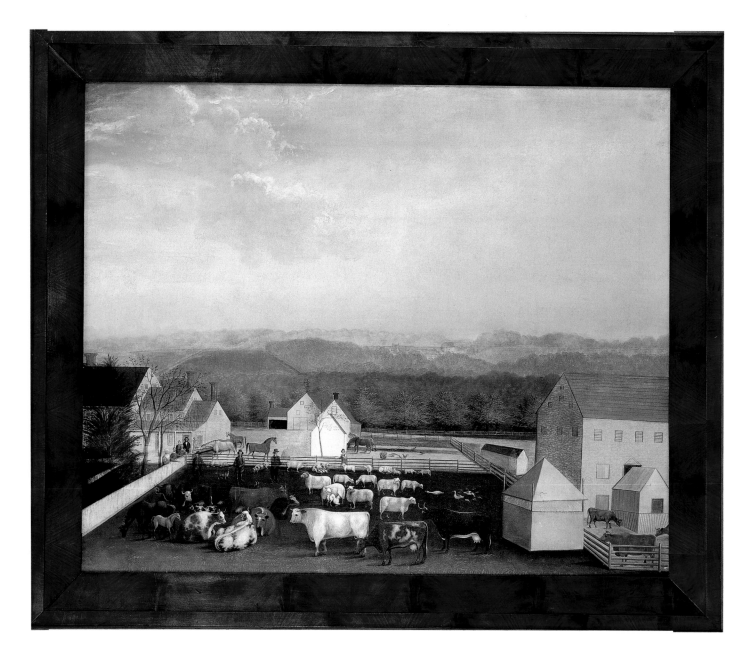

172. "A May morning view of the Farm and Stock of David Leedom . . . ," by Edward Hicks, 1849, oil on canvas, 40⅛″ x 49¹⁄₁₆″.
Abby Aldrich Rockefeller Folk Art Center.

173. Detail from fig. 171.

In the Cornell and Leedom farmscapes, Hicks captured the expansive nature of these properties by placing the fields and buildings against large, luminous skies and soft, distant landscapes. Like Twining Farm, the details in these canvases appear to represent real elements, but, viewed in the whole, they seem otherworldly and larger than the life they portray. Ordered trees, well-kept buildings, precisely aligned and maintained fences, and extraordinary livestock represent an environment both foreign and appealing to modern eyes. The idyllic—even romantic—qualities that Hicks captured, the harmonious balancing of colors, and the neat mingling of man and domestic beasts wrapped within these sweeping natural vistas with no imaginable end make these pictures so powerful and memorable.

Edward turned seventy in April 1849. Soon after, he began to work on Leedom Farm, the last landscape he painted (fig. 172). The bottom of the canvas is inscribed "A May morning view of the Farm and Stock of DAVID LEEDOM of Newtown, Bucks County—Pennsylvania/ with a representation of Himself, Wife, Father, Mother, Brothers, Sisters and Nephew." "Painted by Edw. Hicks in the 70th year of his age" appears below. Leedom Farm shares with Cornell Farm many of the same qualities. Not as deeply colored because it was a different sea-

son, the soft blue, pink, and green tones of the sky are equally expansive and beautiful. The dreamlike trees and hillsides in the distance meet the horizon at an indeterminable point in space. The buildings are more prominent in this picture, and the livestock occupy a larger space in the center. Scattered about, many were painted full-length instead of in the tightly clustered group in Cornell Farm.

In addition to David Leedom, his wife, and other living members of the family, Hicks included Mary Twining Leedom and Jesse Leedom, both of whom had died before 1849 (fig. 163). Although peculiar, their inclusion was meaningful to the broader message about family, kinship, and the history of the farm that had been their home before David inherited it in 1845.

There is no work activity in Leedom Farm.[24] The plough is idle in the field, and the family members, lined up from the house door down along the fence and in the foreground pasture, simply gesture toward one another or to the animals. It is thought that Edward envisioned this gathering of loved ones and gentle animals, several of which suckle their young, as a final, highly personal, statement on the serenity he wished for mankind and which he found within himself in his final days.

Much has been written about the Leedom painting.

As the last of the artist's farmscapes, it was a summation of his previous domestic views.[25] The farm buildings "have somehow been transformed into symbols of order and belief, as if they are places of worship."[26] Leedom Farm is the most dreamlike and tranquil of the farmscapes known to have been painted by Edward. Perhaps better than any other picture, Leedom Farm captured Quaker quietism and the innate concern for order, simplicity, and man's good works on earth.[27]

The importance of Leedom Farm goes beyond its aesthetic qualities, however, since it was, besides the Kingdom painting Hicks was working on when he died, the artist's last easel picture. The painting had special meaning for Hicks because it was commissioned by David Leedom, the son of his childhood friend and favorite Twining daughter Mary, and her husband. It was therefore a painting motivated by fond memories and the love he felt for his foster family. The lengthy, lyrical inscription identifying the family members captured these sentiments.

The most informative account of Edward's death on August 23, 1849, comes from the testimony prepared by the clerks of the Makefield Monthly Meeting of Friends, Joseph Flowers and Sarah P. Flowers, printed in the front of the artist's *Memoirs* in 1851. Friends and family observed that "he continued painting till the day before he died, when, finding himself very weak, he returned to the house, saying he 'believed that he had paid his last visit to the shop!' The next morning his daughter observed, she 'thought him better.' He replied, he *was* better; he was comfortable; but requested they would not flatter themselves, for he was going to die.'"[28] Edward rested in his chamber that morning, but in the afternoon he grew worse. He continued to be alert, addressing his family in those hours, and then about nine in the evening he died quietly.

The artist's remains were interred from the Newtown meetinghouse on August 26. It was reported that more than three thousand people attended the funeral. According to one historian, it was the largest funeral ever held in Bucks County. There was a large meeting after the service, "wherein the language went forth, 'Know ye not that there is a prince, and a great man fallen this day in Israel?'"[29]

Back Matter

Hicks Family Genealogy

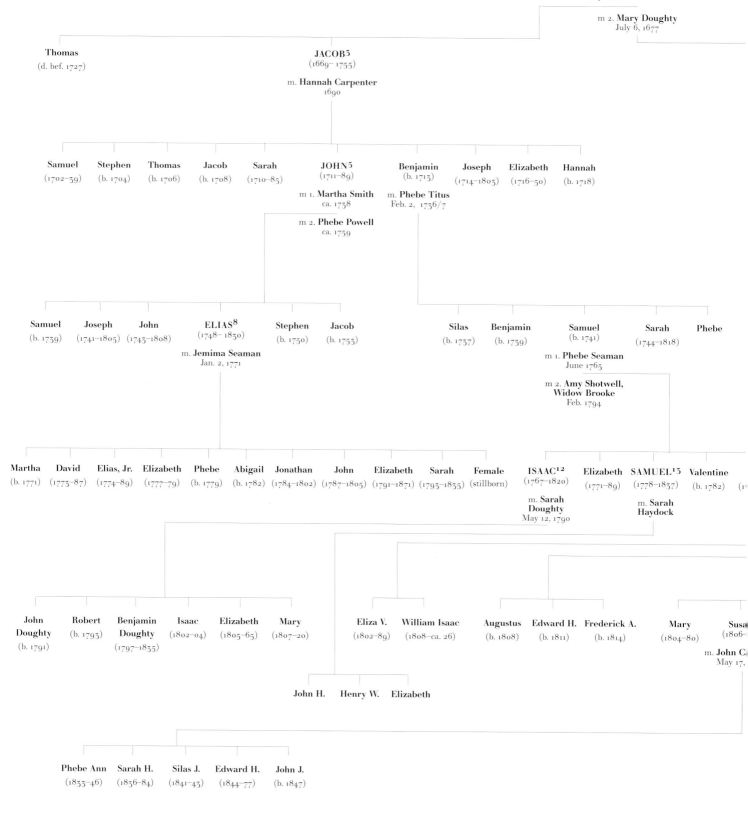

JOHN HICKS[1]
(1607–72)

m 1. **Herodias Long**
Mar. 14, 1636/7

THOMAS[2]
(ca. 1640– ca. 1741)

m 1. **Mary Butler, Widow Washburn**

m 2. **Mary Doughty**
July 6, 1677

Thomas
(d. bef. 1727)

JACOB[3]
(1669–1755)

m. **Hannah Carpenter**
1690

Samuel
(1702–39)

Stephen
(b. 1704)

Thomas
(b. 1706)

Jacob
(b. 1708)

Sarah
(1710–85)

JOHN[5]
(1711–89)

m 1. **Martha Smith**
ca. 1738

m 2. **Phebe Powell**
ca. 1759

Benjamin
(b. 1713)

m. **Phebe Titus**
Feb. 2, 1736/7

Joseph
(1714–1803)

Elizabeth
(1716–50)

Hannah
(b. 1718)

Samuel
(b. 1739)

Joseph
(1741–1805)

John
(1743–1808)

ELIAS[8]
(1748–1830)

m. **Jemima Seaman**
Jan. 2, 1771

Stephen
(b. 1750)

Jacob
(b. 1753)

Silas
(b. 1737)

Benjamin
(b. 1739)

Samuel
(b. 1741)

m 1. **Phebe Seaman**
June 1765

m 2. **Amy Shotwell,
Widow Brooke**
Feb. 1794

Sarah
(1744–1818)

Phebe

Martha
(b. 1771)

David
(1773–87)

Elias, Jr.
(1774–89)

Elizabeth
(1777–79)

Phebe
(b. 1779)

Abigail
(b. 1782)

Jonathan
(1784–1802)

John
(1787–1805)

Elizabeth
(1791–1871)

Sarah
(1793–1835)

Female
(stillborn)

ISAAC[12]
(1767–1820)

m. **Sarah
Doughty**
May 12, 1790

Elizabeth
(1771–89)

SAMUEL[13]
(1778–1837)

m. **Sarah
Haydock**

Valentine
(b. 1782)

**John
Doughty**
(b. 1791)

Robert
(b. 1793)

**Benjamin
Doughty**
(1797–1835)

Isaac
(1802–04)

Elizabeth
(1805–65)

Mary
(1807–20)

Eliza V.
(1802–89)

William Isaac
(1808–ca. 26)

Augustus
(b. 1808)

Edward H.
(b. 1811)

Frederick A.
(b. 1814)

Mary
(1804–80)

Susa
(1806–

m. **John C.**
May 17,

John H.

Henry W.

Elizabeth

Phebe Ann
(1833–46)

Sarah H.
(1836–84)

Silas J.
(1841–43)

Edward H.
(1844–77)

John J.
(b. 1847)

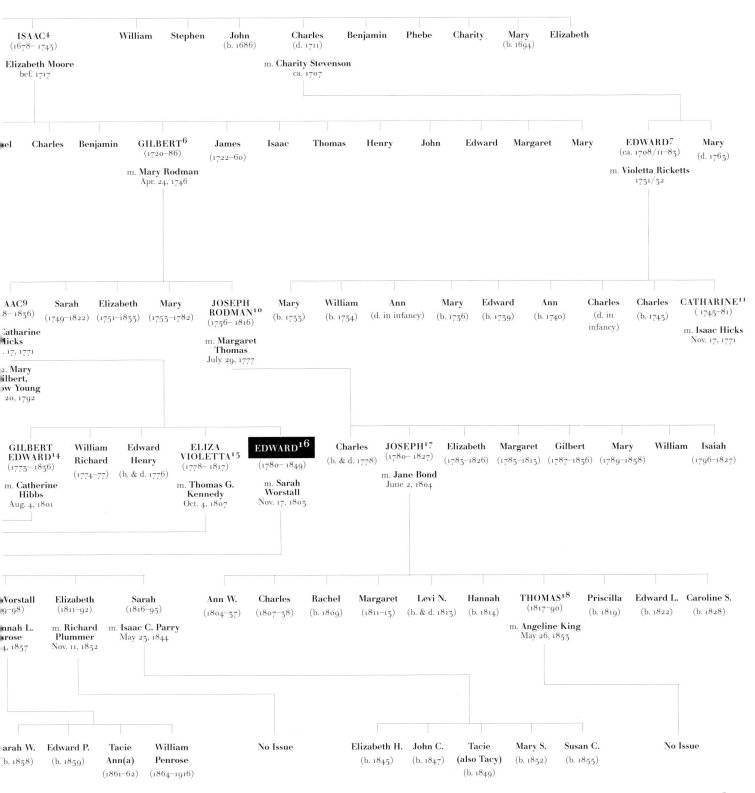

m 2. **Florence Carman**
bef. 1661

Rachel Stacy, Widow Starr
Jan. 2, 1662

Hannah
(1641–1712) **Elizabeth?**

ISAAC⁴
(1678–1745) **William** **Stephen** **John** **Charles** **Benjamin** **Phebe** **Charity** **Mary** **Elizabeth**
 (b. 1686) (d. 1711) (b. 1694)

Elizabeth Moore m. **Charity Stevenson**
bef. 1717 ca. 1707

...el **Charles** **Benjamin** **GILBERT⁶** **James** **Isaac** **Thomas** **Henry** **John** **Edward** **Margaret** **Mary** **EDWARD⁷** **Mary**
 (1720–86) (1722–60) (ca. 1708/11–83) (d. 1763)

 m. **Mary Rodman** m. **Violetta Ricketts**
 Apr. 24, 1746 1731/32

..AAC9 **Sarah** **Elizabeth** **Mary** **JOSEPH** **Mary** **William** **Ann** **Mary** **Edward** **Ann** **Charles** **Charles** **CATHARINE¹¹**
8–1836) (1749–1822) (1751–1833) (1753–1782) **RODMAN¹⁰** (b. 1733) (b. 1734) (d. in infancy) (b. 1736) (b. 1739) (b. 1740) (d. in (b. 1743) (1745–81)
 (1756–1816) infancy)
Catharine m. **Margaret** m. **Isaac Hicks**
licks **Thomas** Nov. 17, 1771
. 17, 1771 July 29, 1777

. Mary
ilbert,
w Young
20, 1792

GILBERT **William** **Edward** **ELIZA** **EDWARD¹⁶** **Charles** **JOSEPH¹⁷** **Elizabeth** **Margaret** **Gilbert** **Mary** **William** **Isaiah**
EDWARD¹⁴ **Richard** **Henry** **VIOLETTA¹⁵** (b. & d. 1778) (1780–1827) (1783–1826) (1785–1815) (1787–1836) (1789–1858) (1796–1827)
(1773–1836) (1774–77) (b. & d. 1776) (1778–1817) (1780–1849)

m. **Catherine** m. **Thomas G.** m. **Sarah** m. **Jane Bond**
Hibbs **Kennedy** **Worstall** June 2, 1804
Aug. 4, 1801 Oct. 4, 1807 Nov. 17, 1803

Worstall **Elizabeth** **Sarah** **Ann W.** **Charles** **Rachel** **Margaret** **Levi N.** **Hannah** **THOMAS¹⁸** **Priscilla** **Edward L.** **Caroline S.**
9–98) (1811–92) (1816–95) (1804–37) (1807–38) (b. 1809) (1811–13) (b. & d. 1813) (b. 1814) (1817–90) (b. 1819) (b. 1822) (b. 1828)

nnah L. m. **Richard** m. **Isaac C. Parry** m. **Angeline King**
arose **Plummer** May 23, 1844 May 26, 1853
4, 1857 Nov. 11, 1852

arah W. **Edward P.** **Tacie** **William** **No Issue** **Elizabeth H.** **John C.** **Tacie** **Mary S.** **Susan C.** **No Issue**
b. 1858) (b. 1859) **Ann(a)** **Penrose** (b. 1845) (b. 1847) **(also Tacy)** (b. 1852) (b. 1855)
 (1861–62) (1864–1916) (b. 1849)

1. John Hicks

John Hicks, the progenitor of the family in America, was born in London and baptized on Oct. 12, 1605. He was educated at Oxford University. John married an Englishwoman named Herodias Long on Mar. 14, 1636/7, at St. Faith's Church, London.

The couple emigrated to Weymouth, Mass., in 1637, and moved to Newport, R. I., in 1640. In 1642, John and his brother Stephen are said to have joined an English company that acquired land in Flushing and Hempstead, N. Y. Herodias filed for divorce from John on Dec. 3, 1643. She remained in Newport while John and his three children moved to Hempstead in 1644. In 1645, Governor Keith granted a patent to several individuals, including John Hicks, for the township of Flushing, N. Y. John divorced Herodias in New York in 1655, more than ten years after his wife filed.

John's second wife probably was Florence, widow of John Carman. She most likely died before 1661, the year her children petitioned John for an account of her estate. John made a prenuptial agreement with Rachel Stacy Starr, who became his third wife, on Jan. 2, 1662.

John Hicks was elected town delegate of Hempstead in 1663; two years later, he was a delegate in the General Assembly. He had died in Hempstead by June 14, 1672, when his will was probated.

Sarah W. Hicks, Notebook of S. W. Hicks, Newtown Historic Association, Newtown, Pa., pp. 15–16; G. Andrews Moriarty, "Parentage of George Gardiner of Newport, R. I.," in *The American Genealogist, Volumes 21–23*, ed. Donald Lines Jacobus (Camden, N. J., 1989), pp. 191–200; Josephine C. Frost, "John and Harwood Hicks," *New York Genealogical and Biographical Record*, LXX (1939), p. 116; Edith Carman Hay and Sidney Wilson, "John Carman," *ibid.*, pp. 332–335; Harriet Woodbury Hodge, *Hicks (Hix) Families of Rehoboth and Swansea, Massachusetts: Some Descendants of Thomas Hicks of Scituate and his son, Daniel Hicks of Scituate and Swansea* (Winnetka, Ill., 1976), p. 64; Florence E. Youngs, The Hicks Family of Long Island, Copied from the Records of the Late Benjamin Doughty Hicks, 1924, I, Brooklyn Historical Society, Brooklyn, N. Y., pp. 1–7.

2. Thomas Hicks

Edward Hicks cited Thomas as a "native of Long Island," but it is more likely he was born ca. 1640 in Newport, R. I. Thomas married Mary, daughter of Richard Butler and widow of John Washburn of Hempstead, N. Y., about 1660. Thomas obtained a patent for land in Flushing in 1666, subsequently owning around 4,000 acres.

Family records state that he was the first judge of Queens County, N. Y. Thomas's second marriage was to Mary, daughter of fellow judge Elias Doughty, on July 6, 1677. Thomas was well respected in his community and by his family. Over a hundred years later, Edward Hicks proudly recorded in his *Memoirs* an encounter between Thomas and Samuel Bownas, a Quaker blacksmith who was jailed in 1702 and sued for attacking the doctrines of the Anglican Church during a visit to Long Island. Although he was Anglican, Thomas visited Bownas while the Quaker was incarcerated.

By 1686, Thomas owned 160 acres of land at Cow Neck, Long Island. He died in Flushing, Long Island, N. Y., at the age of 100.

Hicks, *Memoirs*, pp. 15–16; Youngs, Hicks Family of Long Island, VII, pp. 74–75; S. W. Hicks, Notebook, pp. 16–17; Peter R. Christoph and Florence A. Christoph, eds., *New York Historical Manuscripts: English. Books of General Entries of the Colony of New York, 1674–1688* (Baltimore, Md., 1982), p. 161.

3. Jacob Hicks

Jacob was born in Queens County, N. Y., in June 1669. He and his wife, Hannah Carpenter, were members of St. George's Anglican Church where Jacob served as churchwarden and vestryman. Hannah's father founded the Baptist Church in America.

In spring 1799, Jacob died in Rockaway, Hempstead Township, Nassau Island, N. Y. He was buried in the Hicks cemetery located on property owned by the family.

Youngs, Hicks Family of Long Island, II, p. 87; Forbush, *Elias Hicks*, pp. 4–5.

4. Isaac Hicks

Isaac was born in Queens County, N. Y., on Dec. 12, 1678. As early as 1719, he was listed as the commissioner of New York and the commissioner of North Partition, located between New Jersey and New York. In 1737, Isaac was elected representative for Queens County, Long Island, N. Y. He served as judge of the county from 1730–1738 and as a representative to the colonial Assembly of New York for Queens County from 1716–1739. An officer in the British army, he was often referred as "Colonel" Isaac.

Isaac married Elizabeth, daughter of Captain Samuel Moore of Newtown, Long Island, N. Y. Gilbert, identified as their third or fourth son, was born in 1720. Isaac's will, proved on Sept. 3, 1755, listed him as a Hempstead resident who owned land in Flushing. Gilbert was one of the executors of his father's estate.

S. W. Hicks, Notebook, p. 18; James W. Moore, comp., *Rev. John Moore of Newtown, Long Island, and Some of his Descendants* (Easton, Pa., 1903), pp. 54, 356; *Abstracts of Wills, 1730–1744, Collections of the New-York Historical Society for the Year 1895* (New York, 1896), pp. 55–56.

5. John Hicks

John was born Anglican on Dec. 25, 1711, but joined the Westbury Monthly Meeting (New York) of the Society of Friends a few years prior to his son Elias's birth in 1748. His wife, Martha, daughter of Gorshom Smith of Hempstead, Long Island, N. Y., died about 1759, leaving six children.

John married Phebe Powell ca. 1765. He died in 1789.

Youngs, Hicks Family of Long Island, II, p. 171; Forbush, *Elias Hicks*, pp. 4–6; Elias Hicks, *Journal*, pp. 7–8.

6. Gilbert Hicks

In 1720, Gilbert, the artist's grandfather, was born in Flushing, Queens County, N. Y. He married Mary, daughter of Joseph Rodman of Flushing, on Apr. 24, 1746. The couple lived on a 600-acre tract in Bucks Co., Pa., which they received from Rodman. In 1763, they purchased 100 acres of land at Four Lanes End (now Langhorne) and built a brick house that still stands.

Gilbert's property was confiscated by the American government and his belongings were auctioned. In 1779, the estate was advertised in the *Pennsylvania Gazette* as being for sale. General Augustine Willett, husband of Gilbert's daughter Elizabeth, contested the sale. Gilbert apparently had given Willett and his wife a house and garden, but the county disputed their claim. Isaac also fought for a portion of his father's estate and eventually won, but only by being the highest bidder at public auction.

Gilbert died about 1786, most likely in Digby, Nova Scotia, where he had settled along with fellow Tories after having fled to New York.

S. W. Hicks, Notebook, pp. 18–19; S. W. Hicks, "Life and Expatriation of Judge Gilbert Hicks," pp. 247–255; *Pennsylvania Gazette*, Oct. 17, 1767, Apr. 14, 1779; "Forfeited Estates, Inventories and Sales," Thomas Lynch Montgomery, ed., *Pennsylvania Archives*, 6th Ser., XII (Harrisburg, Pa., 1907), pp. 107–110, 148, 151, 153–155, 159, 160, 164, 165, 176.

7. Edward Hicks

Colonel Edward Hicks was the son of Charles and Charity Stevenson Hicks. The artist wrote in his *Memoirs* that his paternal and maternal grandfathers, Gilbert Hicks and Colonel Edward Hicks, were first cousins, making his parents, Isaac Hicks and Catharine Hicks, second cousins. Colonel Edward Hicks, the father of Catharine, married Violetta, daughter of William and Mary Walton Ricketts of New York and the island of Jamaica in the West Indies on Mar. 7, 1731/2. She died in 1747 and was buried at Christ Church, Philadelphia, on Dec. 24.

Edward was a merchant in Philadelphia until the mid-1750s. In 1757, the *Pennsylvania Gazette* listed him as a merchant in New York City where he relocated. He later moved to Staten Island and lived with his daughter Mary.

Edward was buried at Christ Church, Philadelphia, on May 10, 1783.

Youngs, Hicks Family of Long Island, I, pp. 13–14, VII, pp. 159, 177; Hicks, *Memoirs*, p. 18–20; S. W. Hicks, Notebook, pp. 42–43; Burials 1747, XXIX, microfilm, reel 8, Christ Church, Philadelphia, Records, Historical Society of Pennsylvania, Philadelphia, Pa.; Burials 1783, Apr./May, XXXVII, reel 10, *ibid.*; Pa. Gaz., Mar. 10, 1757.

8. Elias Hicks

Elias Hicks, the artist's second cousin once removed, was a well-known Quaker minister. He was born in Hempstead Township, Queens County, Long Island, N. Y., on Mar. 19, 1748. His mother, Martha Smith Hicks, died while he was a schoolboy.

In addition to his involvement with other causes, the Hicksite separation in particular, Elias was active in the fight to free slaves. Many of his sermons on the topic were published in the early nineteenth century. In his will of May 4, 1829, he bequeathed:

to David the coloured man that has long lived with me, the

use, or interest of three hundred and fifty pounds for his comfortable support during his natural life . . . and I desire my executors to put the money at Interest with good security and should the interest arising therefrom be not sufficient for his comfortable support I hereby authorize them to make use of as much of the principal as they may judge necessary for that purpose and should David not need all the interest arising from said sum I will and desire my Executors to hand out the surplus to his mother Ellenor as her needs may require.

Elias died in Jericho, N. Y. His funeral was held on Feb. 27, 1830.

Forbush, *Elias Hicks*, pp. 4–6; Elias Hicks, *Journal*, pp. 7, 450; Will of Elias Hicks, May 4, 1829, Surrogate's Court, Queens County, N. Y., transcription, Hicks Manuscript Collection, Friends Hist. Lib.

9. Isaac Hicks

Isaac was born in Bensalem Township, Pa., on Apr. 21, 1748. He married his second cousin Catharine, daughter of Edward and Violetta Ricketts Hicks, in Newtown on Nov. 17, 1771. They were probably Anglicans since their first two children were baptized at Christ Church, Philadelphia, and Catharine was buried in an Episcopal churchyard.

Several years after Catharine's death, Isaac married widow Mary Gilbert Young in Christ Church, Philadelphia, on Oct. 20, 1792. He and Mary lived in Newtown for the rest of their lives. She died on Feb. 22, 1812. Isaac died on Oct. 5, 1836, and was buried in the Presbyterian graveyard. After his father's death, Edward relinquished his rights as administrator of Isaac's estate and granted power to his son Isaac W. Hicks and to his nephew Edward H. Kennedy.

S. W. Hicks, Notebook, pp. 23–25; Marriages 1792, June, XXXVI, reel 9, Christ Church Recs.; Hicks family Bible; Renunciation of Edward Hicks, Oct. 25, 1836, #7010, microfilm, Bucks County Courthouse, Doylestown, Pa.; Settlement of the Estate of Isaac Hicks, Esq., Late of Newtown, deceased, 1837, #1010, microfilm, *ibid.*

10. Joseph Rodman Hicks

Joseph, Edward's uncle, was born in Bensalem Township, Pa., on Nov. 12, 1756, and died in Dolington, Upper Makefield Township, Pa., in May 1816. He married Margaret, daughter of Joseph and Margaret Lawrence Thomas, on July 29, 1777. Previous researchers have confused the father and son. It was the son Joseph who married Jane Bond.

In 1780, Joseph purchased a 100-acre farm near Dolington. From 1790 until her death in 1842, Margaret was an approved minister in the Society of Friends. After Joseph died, Margaret sold the farm in 1822 and moved to Philadelphia to live with her son.

In his *Memoirs*, Edward wrote of her, "My dear deceased aunt, Margaret T. Hicks, a minister, who stood high, not only with Friends of Makefield, but with Bucks Quarter. . . . she was a precious minister to me, and a very dear mother in our Israel, whom I loved much."

S. W. Hicks, Notebook, pp. 31–34, 36–37; Davis, *History of Bucks County*, p. 112; Hicks, *Memoirs*, p. 173.

11. Catharine Hicks

Catharine was born in New York on Nov. 4, 1745, and died in Burlington, N. J., on Oct. 19, 1781, after a five-week illness described by family as bilious fever. Edward wrote that his mother was buried in St. Mary's churchyard in Burlington, but he could not find her gravestone. Edward noted his mother requested "there should be no monument of any kind placed at her grave, which appears to have been complied with." Her death and burial are recorded in the Hicks family Bible, although Catharine does not appear in the extant church records.

Catharine's brother William was elected prothonotary of Bucks County from 1770 to 1772. Upon his decease, William's two boys, Richard Penn and Edward (often called "Ned" in the records), were sent to board with Isaac and Catharine. About 1779, when Isaac was being forced to find a new home for his family, he placed his nephews in new homes. Previous researchers have sometimes confused references to Edward Hicks, son of William, and Edward Hicks, son of Isaac and Catharine.

S. W. Hicks, Notebook, pp. 23–25; Hicks, *Memoirs*, pp. 17–21, 26; Hicks family Bible; Isaac Hicks to John Dickinson, Sept. 27, 1779, Friends Hist. Soc.

12. Isaac Hicks

Isaac was born to Samuel and Phebe Seaman Hicks on Apr. 19, 1767, in Westbury, Long Island, N. Y. He was an active member of the Society of Friends and accompanied Elias Hicks on several ministerial trips. Isaac married Sarah, daughter of John and Abigail Doughty, in 1790. Benjamin Doughty Hicks, their son, traced the family history. Benjamin's records were transcribed by Florence Youngs.

After receiving word from John Comly about the artist's debts, Isaac, a businessman, provided $500.00 in financial support to Edward Hicks. Isaac Hicks died on Jan. 10, 1820.

Robert A. Davison, *Isaac Hicks: New York Merchant and Quaker, 1767–1820* (Cambridge, Mass., 1964), pp. 11, 13, 24–26, 29, 149–150.

13. Samuel Hicks

Samuel Hicks, the brother of Isaac, was born to Samuel and Phebe Seaman Hicks of Westbury, Long Island, N. Y., on Oct. 20, 1778. Samuel married Sarah Haydock in 1801. They were both Quakers. Like his brothers Isaac and Valentine, Samuel was a New York businessman. Valentine married Elias Hicks's daughter Abigail.

In 1818, Samuel matched his brother Isaac's contribution of $500.00 to help pay off Edward's debts. Samuel died on Oct. 12, 1837.

Walter Barrett, *The Old Merchants of New York City* (New York, 1863), pp. 302–303; Davison, *Isaac Hicks*, p. 150.

14. Gilbert Edward Hicks

The eldest son of Isaac and Catharine, Gilbert Edward was born in Newtown on Mar. 11, 1773. He was baptized in Christ Church, Philadelphia, on June 21. After several years of schooling with James Boyd, Gilbert was placed with Dr. James De Normandie to study medicine.

Edward wrote in his *Memoirs* that "Gilbert took a religious turn, joined the Society of Friends, and became, what is a phenomenon in the faculty, a humble, practical Christian, an honor to his profession." On Apr. 23, 1796, Gilbert applied to the Catawissa Monthly Meeting to become a member of the Religious Society of Friends. He was approved, as was his application for marriage. Gilbert married Catherine, daughter of James Hibbs of Catawissa, on Aug. 4, 1801. He died in Catawissa on Sept. 14, 1836.

S. W. Hicks, Notebook, pp. 24–25; Baptisms 1773, XXXI, reel 8, Christ Church Recs.; Isaac Hicks, Is[aac] Hicks's Book of Accounts, pp. 53, 55, 60, 73, 75; Hicks, *Memoirs*, p. 26; Catawissa Monthly Meeting minutes, microfilm, Friends Hist. Lib.; *Bucks County Intelligencer and General Advertiser*, July 5, 1837; Hicks family Bible.

15. Eliza Violetta Hicks

Eliza Violetta was born in Attleborough, now Langhorne, Pa., on Mar. 17, 1778. She lived with Catherine Heaton during her youth. Her father's account book shows payments to Mrs. Heaton from May 1782 through May 1789.

Eliza Violetta married Thomas G. Kennedy on Oct. 4, 1807. Kennedy served as prothonotary of Bucks County in 1808, in the Pennsylvania Assembly in 1809, was sheriff from 1815 to 1817, and was a member of the legislature of Pennsylvania in 1818. He was the superintendent in charge of building the Delaware division of the Pennsylvania Canal and was a partner, builder, and projector in financing and constructing the Philadelphia and Trenton Railroad.

Eliza Violetta drowned at age 40 in Newtown Creek near Newtown on July 28, 1817. Edward had a premonition about her death while he was in meeting at Rahway, N. J. "I had an impression that something sorrowful had happened to me, but I think I recollect it was nearly a silent meeting, and I told the people that, for some reason or other, I had but little to communicate to them."

S. W. Hicks, Notebook, p. 25; Isaac Hicks's Book of Accounts, pp. 55, 72; Register of Marriages for the Year 1769, microfilm, Dept. of History, Presbyterian Church (USA), Philadelphia, Pa.; Thomas G. Kennedy Papers, microfilm, R929.374818 Ch 5004, A-H, Bucks Co. Hist. Soc.; *Pennsylvania Correspondent, and Farmers' Advertiser*, Aug. 5, 1817; Hicks family Bible; Hicks, *Memoirs*, pp. 26–27.

16. Edward Hicks

Edward Hicks, Quaker minister and painter, was born to Isaac and Catharine Hicks in Bucks County, Pa., on Apr. 4, 1780. He married Sarah Worstall, a Quaker, on Nov. 17, 1803.

Five children were born to Edward and Sarah: Mary, Oct. 12, 1804–Feb. 7, 1880; Susan, Nov. 9, 1806–Jan. 24, 1872; Isaac Worstall, Jan. 20, 1809–Mar. 28, 1898; Elizabeth, Aug. 24, 1811–Mar. 22, 1892; and Sarah, Dec. 24 or 26, 1816–Feb. 23, 1895.

Edward died in Newtown, Pa., on Aug. 23, 1849.

17. Joseph Hicks

Joseph, the son of Joseph Rodman and Margaret Thomas Hicks, was born on June 12, 1780. He married Jane, daughter of Levi Bond of Newtown, Pa., in 1804. He was the father of Thomas Hicks, who worked briefly in Edward Hicks's Newtown painting shop before pursuing a professional career in art. Previous researchers have mistakenly identified Joseph's parents as Gilbert and Mary Rodman Hicks, thus creating an incorrect relationship between Edward Hicks and Thomas Hicks, the artist.

Joseph died in Oct. 1827 in Philadelphia, Pa.

Youngs, Hicks Family of Long Island, III, pp. 509–516; S. W. Hicks, Notebook, p. 32.

18. Thomas Hicks

Thomas was born on Oct. 18, 1817, in Newtown, Pa. He was the seventh child of Joseph and Jane Bond Hicks. Several months before he turned thirteen, Thomas is recorded as working in Edward Hicks's Newtown shop. Thomas may have been apprenticed to learn the carriage painting trade, but he also spent time painting portraits of Newtown townspeople. An account book that belonged to Edward's son Isaac W. Hicks records that Thomas painted 50-some portraits while working with Edward from July 1836 through June 1837.

Thomas married Angeline King, eldest daughter of Theodore F. King of New York, N. Y., on May 26, 1853. The couple had no children. Thomas died in Oct. 1890 at his country home, Thornwood, in Trenton Falls, N. Y.

Youngs, Hicks Family of Long Island, III, p. 513; George A. Hicks, "Thomas Hicks, Artist, a Native of Newtown," *Bucks Co. Hist. Soc. Papers*, IV (1917), pp. 89–92; Isaac W. Hicks, Daybook of Isaac Hicks, Collection of Katherine K. Fabian, Newtown, Pa., pp. 32–37; Tatham, "Thomas Hicks at Trenton Falls," pp. 5–20.

Checklist of Works by Edward Hicks

The 133 entries in the checklist are divided into topical categories that include both shop work and easel pictures. The works are arranged in chronological sequence in each category. Numbering within the checklist, from category to category, is sequential. Where known, information about original frames is cited at the end of the text. Ownership history combines information in Mather and Miller, *Edward Hicks*, with that in the research files of the Abby Aldrich Rockefeller Folk Art Center (cited as AARFAC archives) and appears in chronological order. Other sources used in compiling the list are also cited. Current ownerships are largely institutional or private; many private owners requested anonymity.

Dimensions are cited in inches, height precedes width, and dimensions of three-dimensional objects appear in the order of height, width, and depth.

Assignment of works to Edward Hicks in the checklist is based on documented evidence provided by inscriptions on the works, surviving archival materials such as letters and receipts, histories of original ownership, or strong stylistic relationships with works that have such documentation.

Works illustrated in this book are noted by the figure number(s).

Peaceable Kingdom Paintings

1

The Peaceable Kingdom
Oil on canvas, 18¾" x 23½"
1816–1818

OWNERSHIP HISTORY: The history is not well documented in Mather and Miller. They stated that its provenance is probably of Lambertville, N. J., where Hicks visited in June 1820.[1] When the painting was borrowed for an exhibit at the AARFAC in 1960, only the following was known. Acquired by dealers Lewis Steinberg and David Y. Ellinger, Hatsboro, Pa.; John E. Abbott, New York, N. Y.; Edith Gregor Halper, The Downtown Gallery, New York, N. Y.; Valentine Galleries, New York, N. Y.; purchased for the Cleveland Museum of Art with a gift from the Hanna Fund in 1945. It was exhibited at the Friends Historical Association, Philadelphia, Pa., in 1944.

The painting has been attributed to both Edward Hicks and Thomas Hicks in the past, although assigning it to Edward seems more plausible. The manner in which the leaves on the trees were executed, the shapes of the leopard's, child's, and lion's faces, and the blasted tree trunk in the background are similar to those Edward painted in other works.

The birch-veneered frame is possibly original to the work, although birch was not commonly used for frames on Edward Hicks's paintings.

Illustrated as figs. 28, 79, 80, and 81.

1. Mather and Miller, *Edward Hicks*, p. 94.

2

"The peaceable KINGDOM of the branch"
Oil on wood, 37¼" x 44⅞"
1822–1825

OWNERSHIP HISTORY: According to Mather and Miller and 1967 correspondence in the AARFAC archives, the painting was probably painted for Dr. Joseph Parrish. A Hicksite Quaker, Parrish was Edward Hicks's personal physician and a noted surgeon at the Pennsylvania Hospital, Philadelphia, Pa. The picture descended to Miss Helen Parrish, a relative, also of Philadelphia. It was purchased in 1933 by Arthur Edwin Bye, Holicong, Pa.; acquired by Edward R. Barnsley, Newtown, Pa.; and subsequently sold to the painter's great-grandson Robert W. Carle, New York, N. Y., and South Salem, Conn. Carle, an alumnus of Yale University, gave the picture to the Yale University Art Gallery, New Haven, Conn., in 1958.[1]

"The wolf also shall dwell with/the lamb, & the leopard shall lie down with the/kid; & the young lion & the fatling/together: & and a little child shall lead them" is lettered in gold paint in the black-painted border.

The frame is original. It bears the lettered inscription "The peaceable KINGDOM of the branch" on its top member.

Illustrated as fig. 86.

1. Mather and Miller, Edward Hicks, p. 95; AARFAC archives.

3

"THE PEACEABLE KINGDOM OF THE BRANCH"
Oil on canvas, 32¼" x 37¾"
1822–1825

OWNERSHIP HISTORY: The early history is not known. Chester R. Smith, Indianapolis, Ind., purchased it from an un-

known source prior to its acquisition for the AARFAC in 1967.

The colors in this painting are especially rich and pleasing. The warm browns for many of the animals are balanced by similar tones in the fall foliage on the oak tree above the group. In this early version, the evergreen in the background and the oak can be identified easily. As Hicks advanced through the Kingdom series, he gradually developed a generic method for foliage, often making the types of trees indistinguishable.

There is no evidence that a frame was originally used. The modern frame was added to protect the edges of the canvas support.

Lettered in black paint across the top is "THE PEACEABLE KINGDOM OF THE BRANCH." Beginning at the lower left corner and running around the painted brown border are the gold letters: "The wolf also shall dwell with the/lamb & the leopard shall lie down with kid;/& the calf & the young lion & the fatling/together; and a little child shall lead them."

Illustrated as fig. 87.

4

"THE PEACEABLE *KINGDOM* OF THE BRANCH"
Oil on wood, 33⅜" x 49½"
1822–1825

OWNERSHIP HISTORY: Mather and Miller believed that the original owner probably was John H. Bunting, a Hicksite living in Darby, Pa. The earliest documented reference is in *The Practical Book of Early American Art and Crafts*, where authors Harold Donaldson Eberlein and Abbot McCline cited the current owner as Morgan Bunting, a descendant of John. The painting was inherited by Mrs. Morgan Bunting and subsequently sold to Eugene J. Sussel, both of Philadelphia, Pa. It was auctioned as part of the Sussel Estate at Sotheby's, New York, N. Y., to a private collector in 1993.[1]

The lower member of the original reed-molded, black-painted frame was replaced sometime before 1960 when it was exhibited at the AARFAC. The top member has the lettered title "THE PEACEABLE *KINGDOM* OF THE BRANCH." Beginning with the left border, "The wolf also shall dwell with/ the lamb & the leopard shall lie down with the/ kid: & the young lion & the fatling/together; & a little child shall lead them" is lettered in black and gold paint. Lettered in black on the flag at the stern of the ship is "Peace on Earth."[2]

Illustrated as fig. 90.

1. Mather and Miller, *Edward Hicks*, p. 99.
2. *Ibid.*

5

The Peaceable Kingdom
Oil on canvas, 30¼" x 36"
1822–1825

OWNERSHIP HISTORY: The painting was originally owned by Dr. Joseph Parrish, according to Mather and Miller.[1] It was passed down in the family to Miss Helen Parrish. Notes made by Arthur Edwin Bye indicate he purchased the painting about 1933.[2] Dealer Julius Weitzner, New York, N. Y., sold the picture in 1936 to the Garvan Collection, Yale University Art Gallery, New Haven, Conn. It was subsequently owned by Richard Loeb, Hampton, N. J. (1942); Maxim Karolik, Boston, Mass. (1943); Macbeth Gallery, New York, N. Y. (1946); and M. Knoedler & Co., New York, N. Y.; prior to its purchase by Stephen C. Clark, New York, N. Y., who gave it to the Mead Art Museum, Amherst College, Amherst, Mass.[3]

This is one of four early Peaceable Kingdoms that feature a prominent view of the Natural Bridge of Virginia in the background. Inspiration for the bridge device probably came from Edward's visit to the site, while the vignette from Henry S. Tanner's 1822 map of Virginia (fig. 85) served as the pictorial source.

The painting was signed by the artist "Edw Hicks Pinx^t" at lower right, below the small inner gold border and above the word "grace." Phrases lettered in gold and black in the borders read: *(left)* "The wolf shall with lambkin dwell in peace,/His grim, carniv'rous nature, then shall cease"; *(top)* "The leopard with the harmless kid lay down,/And not one savage beast be seen to frown"; *(right)* "The lion and the calf shall forward move,/A little child shall lead them on in love"; *(bottom)* "When *MAN* is moved and led by sov'reign grace,/To seek that state of everlasting *PEACE*." A dove with olive branch hovering over a recumbent white lamb and "INNOCENCE," "MEEKNESS," and "LIBERTY" appear in the four painted corner blocks. The inscriptions are in English at lower left, French at upper left, Latin at upper right, and Greek at lower right.

Illustrated as figs. 88 and 4.

1. Mather and Miller, *Edward Hicks*, p. 97.
2. Arthur Edwin Bye, notes, Bucks Co. Hist. Soc.
3. Mather and Miller, *Edward Hicks*, p. 97.

6

The Peaceable Kingdom
Oil on canvas, 23½" x 30¾"
1822–1825

OWNERSHIP HISTORY: Correspondence from the 1960s in the AARFAC archives confirms Mather and Miller's belief that the painting's original owner is unknown; the earliest owner who is identified was Judge Potter of Philadelphia, Pa. It was later owned by Leonard C. Ashton, Paris Hill, Me., who sold it to Feragil Galleries, New York, N. Y., between 1945 and 1951. Frederick Newlin Price, New Hope, Pa., owned the picture for an unknown time prior to 1960 when it was offered for sale at the Hartert Gallery, New York, N. Y. It was then acquired by Kennedy Galleries, Inc., New York, N. Y., and sold to Reynolda House, Museum of American Art, Winston-Salem, N. C.[1]

Beginning with the left member and continuing on the other three sides, the lettered inscription in the border reads: "His grim carniv'rous nature then shall cease,/And not one savage beast be seen to frown,/A little child shall lead them on in love,/When man is led and moved by sovereign grace."

Illustrated as fig. 89.

1. Mather and Miller, *Edward Hicks*, p. 98; AARFAC archives.

7

The Peaceable Kingdom
Oil on canvas, 21¹¹⁄₁₆" x 27"
1822–1825

OWNERSHIP HISTORY: According to the family's oral history as documented by Mather and Miller, this painting hung in Edward Hicks's house in Newtown, Pa. He gave it to his son Isaac Worstall Hicks, also of Newtown. It descended in the family to the present owner from Isaac Hicks to his daughter Sarah Worstall Hicks,[1] to her grandniece Eleanore Hicks Lee Swartz, to a private collector.[2]

Previous scholars have dated this painting to the 1830s. Recent examinations of the support reveal that its original border was removed at an unknown date. The placement and style of the animals and the assumption that the now missing border contained a lettered message suggest that a date of 1822–1826 is more appropriate.

Conservation of the picture provided insight into Edward's painting techniques. Hicks rendered the sky and horizon and then covered the complete background with the foliage. This method of layering differs from academic oil painting in which the work is composed and developed as a whole. Microscopic examination of the paint layers showed a minute layer of dust trapped between the sky and the components of the trees, suggesting enough time had passed between the completion of the background and the addition of the trees for dust to collect. The technique of layering and the use of glazes in this picture indicate Edward's training in ornamental painting associated with signboards and carriages.[3]

Careful examination of the canvas back revealed pencil sketches of a rooster and two human profiles, one of which may be George Washington. An inscription on the stretcher reads "assisted by Edward Trego," perhaps a reference to the man who is known to have made frames for Hicks.[4] The painting no longer retains its original frame. The current nineteenth-century gilded and molded frame presumably was added after the painting was cut down.

Illustrated as fig. 98.

1. Mather and Miller, *Edward Hicks*, p. 116.
2. Information courtesy, private collector, 1998.
3. Information courtesy, Scott Nolley, associate conservator, CWF, 1998.
4. Ibid.

8

The Peaceable Kingdom
Oil on canvas, 32⅞" x 41¾"
Dated August 26, 1826

OWNERSHIP HISTORY: According to Ford, this painting was owned in 1952 by Charles C. Willis, Newtown, Pa. Willis advised Ford that it was willed to him by Harrison Streeter, the original owner, who received it as a gift from the artist. Streeter was a member of Fallsington Meeting near Newtown and probably a Hicksite. The painting went to the Philadelphia Museum of Art by bequest of Willis in 1956.[1]

Edward inscribed the painting on the verso of the support: "Edw. Hicks painter/New-town Bucks County/Penna. 8 moᵗʰ 26th/1826." The lettered border verses are: *(left)* "The wolf did with the lambkin dwell in peace/His grim carnivorous nature there did cease"; *(top)* "The leopard with the harmless kid laid down/And not one savage beast was seen to frown"; *(right)* "The lion with the fatling on did move/A little child was leading them in love"; *(bottom)* "When the great PENN his famous treaty made/With indian chiefs beneath the Elm tree's shade."

Illustrated as fig. 93.

1. Ford, *Hicks: Painter of the Peaceable Kingdom*, p. 50; Mather and Miller, *Edward Hicks*, p. 104.

9

The Peaceable Kingdom
Oil on canvas, 32⅛" x 38⅛"
Dated 1826

OWNERSHIP HISTORY: This painting is undoubtedly the one created for Sarah Hicks (Mrs. Silas Hicks, New York, N. Y.) in 1826 as discovered by Ford in her research on the artist. After Edward completed the painting, he inscribed on the verso of the support that it was for "his Dear Cousin Sarah [H]icks/4 mo. 1st 1826 New York." A month later, Sarah's husband, Silas, wrote to Edward that they had received the painting and viewed it as a "Choice Memorial" of the artist's friendship. Silas added that other friends had seen it and agreed it was "executed in a masterly style, which must have taken a good deal of time and labor, which I, however, do not profess to be a judge of. I have enclosed for thee a check on the Schuylkill Bank of Philadelphia, made payable to thy order for one hundred dollars, which please accept."[1] Occasionally, recipients of Edward's pictures voluntarily remunerated him for his efforts; the artist rarely solicited such payments.

Mather and Miller and the AARFAC archives note the painting's subsequent history: Ariel B. Appleton, Elgin, Ariz.[2]; in 1983, to her four children and four grandchildren; currently on loan to the National Museum of American Art, Smithsonian Institution, Washington, D. C.[3]

Inscribed on the verso of the support is "Edward Hicks, Painter to/his Dear Cousin Sarah [illegible]/ 4. ᵐᵒ. 1ˢᵗ 1826 New York." The lettered borders read as follows: *(left)* "The wolf did with the lambkin dwell in peace/His grim carniv'rous nature there did cease"; *(top)* "The leopard with the harmless kid laid down/And not one savage beast was seen to frown"; *(right)* "The lion with the fatling on did move/A little child was leading them in love"; *(bottom)* "When the great Penn his famous treaty made/With indian chiefs beneath the elm tree's shade." The four corner blocks feature white recumbent lambs surrounded by a large olive branch and a banner held aloft by a dove. "INNOCENCE," "MEEKNESS," and "LIBERTY" are lettered on the banners in each block. As seen in previous corner blocks Hicks painted, the words were lettered in French, Latin, and Greek in three of the blocks.

Illustrated as fig. 96.

1. Ford, *Hicks: Painter of the Peaceable Kingdom*, p. 49.
2. Mather and Miller, *Edward Hicks*, p. 100.
3. Information courtesy, Linda Hartigan, National Museum of American Art, Washington, D. C.

10

The Peaceable Kingdom
Oil on canvas, 32⅜" x 42⅜"
1826–1828

OWNERSHIP HISTORY: Mather and Miller suggested the original owner was Amos Campbell, a friend and neighbor of Edward Hicks in Newtown, Pa. The painting apparently descended through the Campbell family to the original owner's great-granddaughter Henrietta C. Collins, Haddonfield, N. J. It then was sold successively to dealer Robert Carlen, Philadelphia, Pa., and Hirschl & Adler Galleries, New York, N. Y. Ima Hogg, Houston, Tex., purchased the painting, which subsequently was accessioned in 1954 as part of the Bayou Bend Collection, Museum of Fine Arts, Houston.[1]

The painting is the most unusual Kingdom picture with borders for several reasons: its colors are subdued, either intentionally or because of paint supplies available to Hicks, and the drawing and painting of the vegetation is similar to that in other works by the artist but is more twisted, gnarled, and decayed. The prominent stump in the foreground left and the dead and fallen trees behind the treaty group seem contrived and suggest a particular meaning. Increased tensions and the ultimate schism within the Society in 1826–1827 probably caused Hicks to emphasize these elements.

The artist's inscription "Edw Hicks Pinx[t]" appears in the lower right border beneath the word "shade." The gold-lettered phrases in the borders read: *(left)* "The wolf did with the lambkin dwell in peace,/His grim carniv'rous nature there did cease"; *(top)* "The leopard with the harmless kid laid down,/And not one savage beast was seen to frown"; *(right)* "The lion with the fatling on did move,/A little child was leading them in love"; *(bottom)* "When the great PENN his famous treaty made/With INDIAN chiefs beneath the elm tree's shade." The four corner blocks contain doves with olive branches hovering over recumbent white lambs with the words "INNOCENCE," "MEEKNESS," and "LIBERTY" surrounding them. These words appear in respective blocks in English, French, Latin, and Greek.

Illustrated as fig. 92.

1. Mather and Miller, *Edward Hicks*, p. 103.

11

The Peaceable Kingdom
Oil on canvas, 29¼" x 35¼"
1826–1828

OWNERSHIP HISTORY: Nothing is known about the original ownership of this early Kingdom. Mather and Miller discovered a photograph of it in the library at the Bucks County Historical Society, Doylestown, Pa., that had been annotated by Arthur Edwin Bye. Bye stated that he had owned the painting. It was subsequently sold to dealer Victor Sparks, New York, N. Y., and acquired by the Rhode Island School of Design, Providence, R. I. Abby Aldrich Rockefeller acquired the painting for her collection (now AARFAC) in 1933.[1]

The gold- and black-painted border verses read: *(left)* "The wolf did with the lambkin dwell in peace,/His grim carniv'rous nature there did cease"; *(top)* "The leopard with the harmless kid laid down,/And not one savage beast was seen to frown"; *(right)* "The lion with the fatling on did move,/A little child was leading them in love"; *(bottom)* "When the great PENN his famous treaty made/With indian chiefs beneath the elm tree's shade." The painting has the four traditional corner blocks with recumbent white lambs over which soars a dove with an olive branch. "INNOCENCE," "MEEKNESS," and "LIBERTY" surround the corner block figures respectively in English, French, Latin, and Greek.

The artist inscribed the painting at right in the lower border above the word "made" as "Edw Hicks Pinx[t]."

In the 1950s, a mid-nineteenth-century molded and gilded frame was added to protect the support's edges.

Illustrated as figs. 94 and 83.

1. AARFAC archives; Mather and Miller, *Edward Hicks*, p. 105.

12

The Peaceable Kingdom
Oil on canvas, 30" x 35½"
1826–1828

OWNERSHIP HISTORY: The inscription on the verso of the support indicates that Hicks painted this as a dedicatory piece for Mary Leedom, Newtown, Pa., and "her Daughters." Quaker records reveal that Mary (Twining) Leedom and her husband, Jesse, avowed disownment of Falls Monthly Meeting and joined the Hicksites in 1828.[1] Which of the Leedoms' daughters inherited the painting is not known. It later passed to a niece, Mary A. Cadwallader, and to Carl Lindborg, Newtown Square, Pa. It was subsequently sold by M. Knoedler & Co., New York, N. Y., to Howard and Jean Lipman, Wilton, Conn. The New York State Historical Association, Cooperstown, N. Y., acquired the picture in 1961.[2]

The artist's inscription is "Edw. Hicks To his adopped/Sister Mary Leedom/& her Daughters didecates/this humble peice of his art/of Painting." The border phrases in shaded black paint read: *(left)* "The wolf did with the lambkin dwell in peace,/His grim carniv'rous nature there did cease"; *(top)* "The leopard with the harmless kid laid down,/And not one savage beast was seen to frown"; *(right)* "The lion with the fatling on did move,/A little child was leading them in love"; *(bottom)* "When the great PENN his famous treaty made,/With indian chiefs beneath the elm-trees shade." The painting's corner blocks feature recumbent white lambs and hovering doves holding olive branches. The blocks do not have the usual inscriptions.

The mahogany-veneered frame is believed to be original. It

is the only one of its type known to have been used for the Kingdom pictures bearing lettered borders.

Illustrated as fig. 95.

1. William Wade Hinshaw, *Encyclopedia of American Quaker Genealogy.* Vol. II: *Containing Every Item of Genealogical Value Found in All Records and Minutes (Known To Be in Existence) of Four of the Oldest Monthly Meetings Which Ever Belonged to the Philadelphia Yearly Meeting of Friends* (Ann Arbor, Mich., 1938), p. 1054.
2. Mather and Miller, *Edward Hicks,* p. 106.

13
The Peaceable Kingdom
Oil on canvas, 30" x 36"
1826–1829

OWNERSHIP HISTORY: The picture was one of a pair presented by the artist to Hicksite Quaker Edward Lawrence of Lawrence, Long Island, N. Y., according to Mather and Miller.[1] The recipient may have been the Edward N. Lawrence, son of John B. and Hannah N. Lawrence, who died in 1839.[2] It descended to his great-granddaughter Hortense Howland Dixon (Mrs. Cortlandt P. Dixon), of Lawrence. The painting was advertised for sale by Marguerite Riordan, Stonington, Conn., in 1991, and subsequently was purchased by a private collector.[3]

This painting may date closer to 1826 because of its strong stylistic and compositional similarity to the Kingdom documented for that year (checklist no. 9). The children were posed almost identically and dressed alike. The two works also have similar corner blocks.

The lettered border verses read: *(left)* "The wolf did with the lambkin dwell in peace/His grim carniv'rous nature there did cease," *(top)* "The leopard with the harmless kid laid down/And not one savage beast was seen to frown," *(right)* "The lion with the fatling on did move/A little child was leading them in love," *(bottom)* "When the great Penn his famous treaty made/With indian chiefs beneath the elm trees shade." The four corner blocks depict doves hovering over recumbent lambs surrounded by banners with the words "INNOCENCE," "MEEKNESS," and "LIBERTY" These words appear in English, French, Latin, and Greek.

Probably original, the frame is painted black with reed molding similar to that of checklist no. 4.

Illustrated as fig. 97.

1. Mather and Miller, *Edward Hicks,* p. 101.
2. William Wade Hinshaw, *Encyclopedia of American Quaker Genealogy.* Vol. III: *Containing Every Item of Genealogical Value Found in All Records and Minutes (Known To Be in Existence) of All Meetings of All Grades Ever Organized in New York City and on Long Island* (Ann Arbor, Mich., 1940), p. 199.
3. Information courtesy, Marguerite Riordan, Stonington, Conn., AARFAC archives, 1997.

14
The Peaceable Kingdom
Oil on canvas, 29" x 36"
1826–1829

OWNERSHIP HISTORY: According to Mather and Miller, the earliest owner was Dr. Richard Hickman Harte, Rock Island, Ill., and Philadelphia, Pa.[1] The authors speculated that Harte may have had Hickman ancestors among Quakers living near Newtown, Pa. A branch of Hickmans from Philadelphia were Hicksites and were connected by marriage to the Hicks family; descendants from this branch moved to Illinois.[2] The painting was given to Dr. Edward Martin, Media, Pa., with the understanding that it "should come to Swarthmore College."[3] The college acquired it in 1912 by gift of alumnus Edward Martin.[4]

The artist signed the painting in the lower border at right beneath the word "shade" as "Edw Hicks, Pinxt." There are gold- and black-painted verses in the borders: *(left)* "The wolf did with the lambkin dwell in peace,/His grim carniv'rous nature there did cease"; *(top)* "The leopard with the harmless kid laid down,/And not one savage beast was seen to frown"; *(right)* "The lion with the fatling on did move,/A little child was leading them in love"; *(bottom)* "When the great PENN his famous treaty made/With indian chiefs beneath the elm tree's shade." The four corner blocks contain the white recumbent lamb below a hovering dove carrying an olive branch. "INNOCENCE," "MEEKNESS," and "LIBERTY" surround the figures in each block lettered respectively in English, French, Latin, and Greek.

Illustrated as fig. 91.

1. Mather and Miller, *Edward Hicks,* p. 102.
2. Hinshaw, *Encyclopedia,* II, p. 800.
3. Mather and Miller, *Edward Hicks,* p. 102.
4. Information courtesy, Constance Cain Hungerford, Swarthmore College, Swarthmore, Pa., 1998.

15
The Peaceable Kingdom
Oil on canvas, 21¼" x 28"
1827–1828

OWNERSHIP HISTORY: The original owner is unknown but probably was a member of Hicks's immediate family since Mather and Miller documented that Sarah Worstall Hicks, the granddaughter of the painter, inherited it. Later owners included the artist's great-grandson Robert W. Carle, South Salem, Conn., and New York, N. Y., who gave the picture to the Yale University Art Gallery, New Haven, Conn.[1] Peter H. Tillou, Litchfield, Conn., acquired it in 1975. Advertised for sale in *The Magazine Antiques* in June 1985, Mr. and Mrs. John L. Tucker subsequently purchased the painting.

Illustrated as figs. 100, 102, and 103.

1. Mather and Miller, *Edward Hicks,* p. 117.

16

The Peaceable Kingdom
Oil on canvas, 17⅜" x 23⅝"
1829–1830

OWNERSHIP HISTORY: The original owner has not been identified. Edith Gregor Halpert, American Folk Art Gallery, New York, N. Y., acquired the painting in 1933 from an unidentified source and sold it to an unknown Bucks County, Pa., dealer. It was then purchased by Holger Cahill, New York, N. Y., and remained on loan from his collection to Smith College, Northampton, Mass.,[1] until it was sold to Joan Washburn Gallery, New York, N. Y., in 1991. In 1993, the painting was sold through Christie's to Berry-Hill Galleries, and later that year sold to the Terra Foundation for the Arts, Daniel J. Terra Collection, Chicago, Ill.[2]

Although Mather and Miller stated that the painting retained its original cherry-veneered frame, the Terra Foundation archives note that the frame is made of mahogany veneer.[3] The frame has block corners and "PEACABLEKINGDOM" lettered in gold by Hicks on the lower member.

Illustrated as figs. 106, 3, and 111.

1. Mather and Miller, *Edward Hicks*, p. 107.
2. Information courtesy, Mary Ellen Goeke, Terra Museum of American Art, Chicago, Ill., 1998.
3. Mather and Miller, *Edward Hicks*, p. 107; information courtesy, Mary Ellen Goeke.

17

"PEACEABLE KINGDOM"
Oil on canvas, 17½" x 23½"
1829–1830

OWNERSHIP HISTORY: According to Mather and Miller, this painting descended in the Hicks family to Robert W. Carle, the artist's great-grandson, South Salem, Conn., and New York, N. Y. By Carle's bequest, it was acquired by the Yale University Art Gallery, New Haven, Conn., in 1965.[1]

This is one of the Kingdoms that includes the so-called "Thirteen Rays of Light" mentioned by Mather and Miller. A detail of the painting illustrated on p. 119 reveals that there are thirteen small human figures on the distant hill. Rays of light surround the head of the central image with uplifted arms which represents Jesus Christ. The remaining twelve figures, six on each side of Jesus, depict the apostles. Below are two clusters of curious small figures that undoubtedly symbolize a biblical event. One features a group of humans kneeling in a circle around a bright light; the other vignette portrays two figures with uplifted arms kneeling before what appears to be an altar or pyre from which a bright light emanates. The banner begins at the foot of the Christ figure, flows to the two groups below, and is held aloft by increasingly larger, unidentified figures before becoming entwined with the Quakers.

Lettered on the banner carried by the figures in the left background is "BEHOLD I BRING/YOU GLAD TIDINGS of GREAT JOY/PEACE ON EARTH AND GOOD-WILL to MEN."

The painting retains its original cherry-veneered frame with corner blocks. "PEACEABLE KINGDOM" is lettered in gold on the frame's lower member.

Illustrated as figs. 107 and 112.

1. Mather and Miller, *Edward Hicks*, p. 108.

18

The Peaceable Kingdom
Oil on canvas, 17¾" x 23¾"
1829–1830

OWNERSHIP HISTORY: No information on the provenance of this painting has been discovered since 1979 when Mather and Miller established the earliest known owner as William Sharpless, West Chester, Pa., or his wife, Frances Linton Sharpless, whose grandparents were Hicksites. They lived outside Newtown and were related to Dr. Morris Linton, the owner of a Hicks painting (checklist no. 106). William Sharpless gave the painting to Swarthmore College, Swarthmore, Pa., in 1928.[1]

The banner vignette elements in checklist no. 17—rays of light above a Christ figure surrounded by the apostles and standing on the small hill in the distant background at right; a kneeling group of figures below; and the banner emanating from Christ that flows down to the group, through the hands of other figures, and then is entwined with the larger dignitaries—also appear here.

The lettered inscription on the banner reads: "B[E]HOLD I BRING/YOU, GLAD TIDINGS OF GREAT JOY/PEACE ON EARTH and GOOD-WILL TO MEN."

The nineteenth-century mahogany frame is a replacement.

Illustrated as fig. 104.

1. Mather and Miller, *Edward Hicks*, p. 109.

19

"PEACEABLE KINGDOM"
Oil on canvas, 18" x 24"
1829–1830

OWNERSHIP HISTORY: Hicks family descendants claimed that this version of the Kingdom was originally owned by the artist's son Isaac Worstall Hicks, Newtown, Pa. Mather and Miller traced its history as follows: "to his [Isaac's] daughter, Sarah Worstall Hicks, Newtown; her cousin, Tacie Parry (Mrs. Robert R. Willets), New York; to her brother and his wife, Mr. and Mrs. John Carle Parry, Wyncote, Pa.; to their son, Edward Hicks Parry, Wyncote, Pa., who in joint ownership with his niece, Martha Parry Hankin, sold it to Hirschl & Adler Galleries, New York, N. Y.; to the Ewing Halsell Foundation, San Antonio, Tex.; presented to the San Antonio Museum Association in memory of Eva Halsell McCluskey."[1] Research in the AARFAC archives collected by curators in conversations with Edward Hicks Parry and Robert Abendroth in 1959–1960 corroborates this history.

The lettered inscription on the banner reads: "BEHOLD I

BRING/YOU GLAD TIDINGS of GREAT JOY/PEACE ON EARTH AND GOOD-WILL TO MEN."

The painting retains its original cherry-veneered frame with corner blocks and has the lettered title "PEACEABLE KINGDOM" on its bottom member.

Illustrated as fig. 105.

1. Mather and Miller, *Edward Hicks*, p. 110; A slightly different provenance was given in *Quality: An Experience in Collecting*, exhibit catalog, Hirschl & Adler Galleries (New York, 1974). The original owner was identified as "Sara" Hicks, daughter of Edward Hicks and wife of Isaac Parry.

20

"PEACEABLE KINGDOM"
Oil on canvas, 23½" x 30"
1829–1830

OWNERSHIP HISTORY: The current owner and location are unknown. When Mather and Miller published their book in 1979, the picture was owned by an unidentified private collector. Hirschl & Adler Galleries, New York, N. Y., purchased the work from Mrs. Edwin Lewis Read, Jr., Tucson, Ariz., and advertised it for sale in 1968. At that time, a modern label attached to the verso of the painting noted it was painted for Edward Hicks's (unidentified) brother-in-law who gave it to his niece in Ephrata, Pa.[1]

This is an important picture in the series of Kingdoms with Elias Hicks as a central figure among Quakers with banners. It is similar to the version owned by the Henry Francis du Pont Winterthur Museum, Winterthur, Del. (checklist no. 21). Like others from the 1829–1830 period, this unlocated Kingdom features a prominent cleft in the tree trunk behind the child, lion, and fatling calf. The limited existing photography indicates that the twelve apostles and the Christ figure are not included in the background above the principal Quaker group. It is difficult to distinguish other elements, although several small figures are visible on the strongly illuminated hill in the distant background.

The lettered banner inscription is from Mather and Miller: "MIND THE LIGHT of truth; PEACE ON EARTH GOOD WILL TO ALL MEN." The cherry-veneered frame with corner blocks, documented by Mather and Miller, is probably original and bears the lettered title "PEACEABLE KINGDOM" on its lower element.[2]

1. Mather and Miller, *Edward Hicks*, p. 112. The painting is illustrated and the typed modern note is quoted in full. Hicks's brothers-in-law included Thomas G. Kennedy, James Sleeper, Amos Phipps, Joseph Worstall, Jr., Amos T. Worstall, James Worstall, and John Worstall.

2. Ibid.

21

The Peaceable Kingdom
Oil on canvas, 17⅜" x 23⅜"
1829–1830

OWNERSHIP HISTORY: This painting, so close in detail to checklist no. 20, unfortunately has no early provenance history. According to records in the AARFAC archives, Henry Francis du Pont purchased it, but the source and date of acquisition are unknown. It was recorded as no. 37744 in the Frick Art Reference Library, New York, N. Y., prior to du Pont's purchase. Du Pont loaned the picture to the Walters Art Gallery, Baltimore, Md., in 1944. The painting is currently in the collection of the Henry Francis du Pont Winterthur Museum, Winterthur, Del.[1]

The picture retains its original cherry-veneered frame with corner blocks. The banner reads: "Mind the LIGHT/BEHOLD I BRING GLAD TIDINGS of GREAT JOY/PEACE ON EARTH/GOOD WILL TO MEN."[2]

Illustrated as figs. 108, 17, and 109.

1. AARFAC archives.
2. Mather and Miller, *Edward Hicks*, p. 111.

22

The Peaceable Kingdom
Oil on canvas, 16¾" x 20"
1829–1831

OWNERSHIP HISTORY: Mather and Miller noted that the artist presented this painting to his daughter Sarah Hicks Parry, Horsham, Pa., who gave it to her daughter Mrs. Susan Parry Harrar, Hatboro, Pa. Mary B. Atkinson, a dealer in Doylestown, Pa., purchased it at an undetermined date and subsequently sold it to Edith Gregor Halpert, American Folk Art Gallery, New York, N. Y. Halpert sold the painting to an unidentified source but later reacquired it. It was sold to Sidney Janis, New York, N. Y., at the November 14–15, 1963, Sotheby's sale of Halpert's folk art collection, then the property of Terry Dintenfass.[1] The current owner is Conrad Janis, New York, N. Y.[2]

The painting retains its original cherry-veneered frame with block corners.

Illustrated as figs. 113, 31, 35, and 101.

1. Mather and Miller, *Edward Hicks*, p. 118.
2. Information courtesy, Jeanie Deans, Sidney Janis Gallery, New York, N. Y., 1998.

23

The Peaceable Kingdom
Oil on canvas, 17½" x 23⅜"
1829–1831

OWNERSHIP HISTORY: Nothing is known about the original ownership. Mrs. John Law Robertson, Scranton and Montrose, Pa., owned the picture early in this century, along with the artist's impressive view of Leedom Farm (checklist no. 83). Robertson sold the picture to Sidney Janis, New York, N. Y. Mr. and Mrs. Martin B. Grossman, New York, N. Y., purchased it before or in 1960, according to correspondence in the AARFAC

archives. The Grossmans retained ownership until 1981 when the painting was placed on sale at Christie's, New York, N. Y. Curtis Galleries, Inc. (formerly Regis Collection), Minneapolis, Minn., acquired it in June 1981. The painting was sold in July 1983; the current owner is not known.[1]

The Kingdom bears an inscription in the center foreground beneath the clustered animals: "IS[A]IAH *11 Chap. 6.7.8*," denoting the source of the scene. Although inscriptions of this sort appear on other paintings by Hicks (checklist nos. 24 and 28), they are rare in comparison to the large number of other lettered titles and phrases.

> 1. Mather and Miller, *Edward Hicks*, p. 120; information courtesy, Curtis Galleries, Inc., Minneapolis, Minn., 1998.

24

The Peaceable Kingdom
Oil on wood panel, 17¼" x 23½"
1829–1832

OWNERSHIP HISTORY: The current location of this painting is unknown; it was reported missing from Scripps College, Claremont Calif., in May 1966, after having been on exhibit in Arizona. Mather and Miller recorded its history as follows in chronological sequence: Robert Carlen Gallery, Philadelphia, Pa.; Hirschl & Adler Galleries, New York, N. Y.; M. Knoedler & Co., New York, N. Y., in 1954; sold to Bill Pearson, Pasadena, Calif. Mr. and Mrs. Bill Pearson presented it to Scripps College in 1956.[1]

One of the earliest Kingdoms to feature a large seated lion, this painting was clearly important as Edward developed a sophisticated series during the early to mid-1830s. That it disappeared is a great loss to those who study Hicks's work.

"ISAIAH *11 Chap. 6 7 8*" is inscribed at lower left near the bottom.

Illustrated as fig. 115.

> 1. Mather and Miller, *Edward Hicks*, p. 121; information courtesy, Kirk Delman, Ruth Chandler Williamson Gallery, Scripps College, Claremont, Calif., 1998.

25

The Peaceable Kingdom
Oil on canvas, 18" x 24⅛"
1829–1832

OWNERSHIP HISTORY: The ownership history is not known prior to the twentieth century. It was acquired at an undetermined date for the Garvan Collection, Yale University Art Gallery, New Haven, Conn., and then by the Brooklyn Museum of Art, Brooklyn, N. Y., in 1940.[1]

Perhaps one of Hicks's earliest seated lion Kingdoms, this version features a magnificently painted leopard whose striking spotted coat becomes one of the focal points. The especially well-balanced composition is achieved by the strong downward diagonal of the steer's proper right shoulder that leads to Penn's group.

It is possible that the present veneered frame is the original. The staff of the Brooklyn Museum stated that the picture has the same frame it did when the Garvan Collection owned it.

Illustrated as fig. 116.

> 1. Mather and Miller, *Edward Hicks*, p. 122.

26

The Peaceable Kingdom
Oil on canvas, 17½" x 23½"
1829–1832

OWNERSHIP HISTORY: According to Mather and Miller, the painting descended in a New Jersey family, was purchased by dealer Lillian W. Boschen, Freehold, N. J., and sold to Phyllis Crawford, Santa Fe, N. Mex. Miss Crawford bequeathed it to the Maier Museum of Art, Randolph-Macon Woman's College, Lynchburg, Va.[1]

Maier Museum archives indicate the unadorned frame is believed to be the original. In the last ownership records, the frame is described as oak, but another wood might have been used.[2]

Illustrated as figs. 117 and 2.

> 1. Mather and Miller, *Edward Hicks*, p. 123; information courtesy, Ellen S. Agnew, Maier Museum of Art, Randolph-Macon Woman's College, Lynchburg, Va., 1998.
> 2. Maier Museum archives.

27

"PEACEABLE KINGDOM"
Oil on canvas, 18½" x 24"
1830–1831

OWNERSHIP HISTORY: No documentation about the first owner of the painting exists. Mather and Miller suggested that Ellen Stephens Davis, Norristown, Pa., acquired the picture and sold it to Arthur Edwin Bye, Holicong, Pa., early in this century. Subsequent owners included dealer Albert Duveen, New York, N. Y., and Mrs. B. A. Behrend, Aiken, S. C., who sold it to Hirschl & Adler Galleries, New York, N. Y. It was purchased by Thomas Laughlin, New York, N. Y., and Aiken, S. C., who sold it to Aquavella Gallery about 1976. Kennedy Galleries offered the painting in their December 6, 1978–January 6, 1979 catalog. Blount, Inc., Montgomery, Ala., purchased this Kingdom in 1985.[1] It was given to the Montgomery Museum of Fine Arts, Montgomery, Ala., in 1989.[2]

The painting retains its original cherry-veneered frame with corner blocks. The title, "PEACEABLE KINGDOM," is lettered on the lower frame member. The banner inscription reads: "I BRING YOU GLAD/TIDINGS OF GREAT JOY/PEACE ON EARTH AND GOOD-WILL TO MEN."[3]

> 1. Mather and Miller, *Edward Hicks*, p. 114.
> 2. Information courtesy, Pam Bransford, Montgomery Museum of Fine Arts, Montgomery, Ala., 1998.
> 3. Mather and Miller, *Edward Hicks*, p. 114.

28

The Peaceable Kingdom
Oil on canvas, 17⅞" x 28⅞"
1830–1832

OWNERSHIP HISTORY: Mather and Miller documented the early ownership of the painting to the Burton family of Edgely, Bucks County, Pa.[1] Anthony Burton, who disowned the Orthodox Falls Monthly Meeting and joined the Hicksites in 1828, may have been the first owner.[2] An unidentified member of the Burton family sold the picture to the Robert Carlen Gallery, Philadelphia, Pa. It subsequently was sold to Edith Gregor Halpert, American Folk Art Gallery, New York, N. Y. Valentine Galleries, New York, N. Y., acquired the picture and sold it to Edgar William and Bernice Chrysler Garbisch of New York, N. Y. In 1970, the Garbisches gave the painting to the Metropolitan Museum of Art, New York, N. Y.[3]

Of particular note are the stalks of grain in the central lion's mouth, which are intermingled with his whiskers. Hicks included this literal interpretation of the Isaiah prophecy in only a few Kingdoms, mainly those dating from the 1830s and late 1840s. The artist characterized lions as carnivorous animals whose natural diets consist of fresh meat. For the lion to relinquish his usual food in favor of grain symbolized self-denial, the surrender of self-will.

The painting retains its original mahogany-veneered and beveled frame with corner blocks.

Inscribed below the leopard's proper left leg is "ISAIAH *11 Chap. 6 7 8*."

Illustrated as figs. 114 and 37.

1. Mather and Miller, *Edward Hicks*, p. 119.
2. Hinshaw, *Encyclopedia*, II, p. 1047.
3. Mather and Miller, *Edward Hicks*, p. 119.

29

"PEACEABLE KINGDOM"
Oil on canvas, 17½" x 23½"
Possibly 1832

OWNERSHIP HISTORY: The dating of this Peaceable Kingdom is directly related to its uncertain ownership history. Eleanore Price Mather corresponded with AARFAC staff in 1977 regarding the painting. An old label affixed to the verso of the support reads "Edward Hicks Phipps/presented to him by his beloved uncle/Edward Hicks in the year of our/lord 1832[7?]."[1] The "2" in this date appears to have been overwritten to read "7." After the date and written in another hand is "1837." The date of the label is unknown but was likely added sometime before Phipps's death in 1849. While it is possible that the painting was created in 1837 when Phipps was eleven years old, no other Kingdom of this style or type seems to have been rendered that late in the artist's career. I believe the date probably was 1832. If so, at age six, Phipps was probably the youngest person to receive a painting from Edward.

At an unknown date early in the twentieth century, the painting was acquired by Moore Price, New Hope, Pa., who sold it in the 1930s to Mrs. William Greenough Thayer, Jr., New York, N. Y. It was then purchased by a private collector.[2]

The painting retains its original mahogany-veneered frame with corner blocks. Edward lettered the lower member of the frame "PEACEABLE KINGDOM." The banner reads, "I BRING YOU GLAD/TIDINGS OF GREAT JOY/PEACE ON EARTH AND GOOD-WILL TO MEN."

1. Edward Hicks Phipps, who was named after the artist, lived in Whitemarsh, Pa. Mather and Miller, *Edward Hicks*, p. 115.
2. *Ibid.*

30

"PEACEABLE KINGDOM"
Oil on canvas, 17½" x 23¾"
1832–1834

OWNERSHIP HISTORY: A letter from Mabel Willets Abendroth (Mrs. William P. Abendroth), Harrison, N. Y., to Abby Aldrich Rockefeller in 1938 contains what is known of the early ownership of this painting. Mrs. Abendroth, a great-granddaughter of the artist, owned two Kingdom paintings, this one and checklist no. 56, and two portraits by Thomas Hicks, one of which depicts Edward Hicks. While her letter does not reveal how she inherited this Kingdom, it likely was through the Willets and Parry branches of the family. Tacie Parry Willets (Mrs. Robert R. Willets) was Mrs. Abendroth's mother and a granddaughter of Edward Hicks. Mrs. Willets apparently owned several Peaceable Kingdom paintings, some of which had been acquired from Sarah Worstall Hicks, Isaac's daughter.[1] The painting was later inherited by Mrs. Abendroth's son William P. Abendroth, Jr., Berwyn, Pa. Kennedy Galleries, New York, N. Y., later sold it to a private collector.[2]

The painting retains its original cherry-veneered frame with corner blocks and was lettered by the artist on the lower member "PEACEABLE KINGDOM." The banner reads, "I BRING YOU GLAD/TIDINGS OF GREAT JOY/PEACE ON EARTH AND GOOD-WILL TO MEN."

1. Mather and Miller, *Edward Hicks*, p. 110. In documenting the history of checklist no. 19, the authors quoted a Nov. 2, 1974, letter from Edward Hicks Parry, the nephew of Tacie Parry Willets, to Mather: "A younger sister (Tacie) of my father John C. (grandson of EH) married Robert R. Willets of N. Y. and she and he on one of their visits in Newtown in the late 80's or very early 90's procured at least 3, and probably as many more, PK's from Cousin Sarah W. Hicks. One of these they gave my father and mother [Mr. and Mrs. John Carle Parry]."
2. *Ibid.*, p. 113.

31

The Peaceable Kingdom
Oil on canvas, 17¼" x 23¼"
1832–1834

OWNERSHIP HISTORY: The early provenance of this painting is unknown. Abby Aldrich Rockefeller acquired it in 1932 from

Edith Gregor Halpert, Downtown Gallery, New York, N. Y. Subsequently, it was given to the Museum of Modern Art, New York, N. Y., and was transferred to the Metropolitan Museum of Art, New York, N. Y., from which David Rockefeller acquired it. He reunited the painting with his mother's collection when the AARFAC opened to the public in 1957.[1]

An interesting detail seen in this painting informs the viewer about Edward's painting technique. Hicks combined his draftsmanlike ornamental style with other approaches more closely associated with easel or studio painting. The drop shadow outlining the calf is a direct result of his lettering and sign painting technique.[2]

The frame is a modern replacement modeled on existing original mahogany-veneered examples.

Illustrated as figs. 119, 32, and 36.

1. AARFAC Archives; Mather and Miller, *Edward Hicks*, p. 125.
2. Information courtesy, Scott Nolley, associate conservator, CWF, 1998.

32
The Peaceable Kingdom
Oil on canvas, 17⅞" x 25¹⁵⁄₁₆"
1832–1834

OWNERSHIP HISTORY: The early ownership remains unknown. Edith Gregor Halpert, American Folk Art Gallery, New York, N. Y., owned the painting in 1938. She sold it to modernist artist Elie Nadelman, Riverdale, N. Y., who retained it until 1943 when M. Knoedler & Co., New York, N. Y., purchased the picture and sold it to Joseph Katz Co., New York, N. Y., in 1944. It was purchased and then sold by M. Knoedler to William M. and Lisa Norris Elkins, Philadelphia, Pa., in 1945. Mrs. Elkins bequeathed the painting to the Philadelphia Museum of Art in 1950.[1] It was exchanged by the Philadelphia Museum of Art in 1985 and is now owned by the Pennsylvania Academy of the Fine Arts, Philadelphia, Pa. (John S. Phillips bequest).[2]

Illustrated as fig. 118.

1. Mather and Miller, *Edward Hicks*, p. 124.
2. Information courtesy, Museum of American Art, Pennsylvania Academy of the Fine Arts, Philadelphia, Pa., 1998.

33
The Peaceable Kingdom
Oil on canvas, 17½" x 23½"
1832–1834

OWNERSHIP HISTORY: In 1990, the State University of New York contacted the AARFAC staff about this painting which had been bequeathed to them. Curator Barbara Luck verified the attribution to Edward Hicks. No earlier information has been located. The painting was in the possession of Alice T. Miner, Plattsburgh, N. Y., from about 1929 until her death and the bequest to the State University of New York. Auctioned by

Sotheby's, New York, N. Y., in October 1991, it was acquired by the Warner Collection of the Gulf States Paper Corporation, Tuscaloosa, Ala.[1]

The black-painted frame with gilded insert is the original or a nineteenth-century replacement. A late nineteenth-century or early twentieth-century paper label on the verso reads: "Peaceable Kingdom/Taken from Isaiah:-/'The wolf shall dwell with the lamb, and the leopard shall lie/down with the kid and the calf and the young lion and the fatling/together and a little child shall lead them.'/'The illustrious Penn this heavenly/Kingdom felt,/When with Columbia's native sons he dealt;/Without an oath a lasting Treaty made/In Christian Faith beneath the elm tree's shade.'/Painting by Edward Hicks, nephew of Elias Hicks, founder of the Hicksite Friends."

Edward Hicks paraphrased the Isaiah prophecy in various ways for the lettered verses in the borders of his earlier Kingdoms. He did so in a more complete poem with rhyming couplets that was printed on cards. As the story goes, the cards were distributed to recipients of the Peaceable Kingdom paintings. The verses on the label of this painting are nearly identical to Edward's poem and probably were copied from an original card no longer extant.

1. AARFAC archives.

34
The Peaceable Kingdom
Oil on canvas, 17½" x 23¹¹⁄₁₆"
1832–1834

OWNERSHIP HISTORY: Nothing is known about the original ownership. It was purchased early in this century by Edith Gregor Halpert, American Folk Art Gallery, New York, N. Y., who sold it to the Worcester Art Museum, Worcester, Mass., in 1934.[1]

Illustrated as fig. 120.

1. Mather and Miller, *Edward Hicks*, p. 126.

35
The Peaceable Kingdom
Oil on canvas, 29⅜" x 35½"
Ca. 1834

OWNERSHIP HISTORY: In 1834, Hicks gave this painting to Joseph Foulke (probably Dr. Joseph Foulke who married Elizabeth Shoemaker), Three Tuns, Pa., according to Mather and Miller. It was later inherited by Foulke's great-grandson Thomas Foulke, Ambler, Pa. He sold it to the Robert Carlen Gallery, Philadelphia, Pa. Edgar William and Bernice Chrysler Garbisch, New York, N. Y., purchased the picture and presented it to the National Gallery of Art, Washington, D. C., in 1980.[1]

The painting retains its original 2 1/2-inch black-painted frame with gilded liner.[2]

Illustrated as fig. 121.

1. Mather and Miller, *Edward Hicks*, p. 127. For an in-depth discussion of this painting, see Deborah Chotner et al., *American Naive Paintings* (Washington, D. C., 1992).
2. Information courtesy, Anne Halpern, Department of Curatorial Records, National Gallery of Art, Washington, D. C., 1998.

36
The Peaceable Kingdom
Oil on canvas, 28" x 35"
1835–1837

OWNERSHIP HISTORY: The history of this painting is well documented at the Bucks County Historical Society, Doylestown, Pa., where it has been since 1910. The original owner was Abraham Chapman, the lawyer from whom Edward Hicks purchased his first house in Newtown. Chapman either purchased several other paintings or received them as gifts from the artist (checklist no. 94). A family member may have received the painting before it was inherited by Elizabeth Canby Jenks, Yardley, Pa. She presented the picture to Henry Chapman Mercer, Doylestown, Pa., a descendant of Abraham Chapman, in 1910. Mercer presented it to the Mercer Museum, Bucks County Historical Society, Doylestown, Pa.[1]

Mather and Miller assigned an 1837 date for this painting, presumably based on a letter from Edward Hicks to Samuel Hart (see checklist no. 37), but no other documentation supporting an 1837 date has been discovered. Stylistically, the painting falls within the broader period 1835–1844.

The painting retains its original black-painted frame with gilded liner.

Illustrated as figs. 135 and 5.

1. Mather and Miller, *Edward Hicks*, p. 132.

37
The Peaceable Kingdom
Oil on canvas, 29" x 36"
Ca. 1837

OWNERSHIP HISTORY: Alice Ford documented the original ownership of this painting to Samuel Hart, Doylestown, Pa.[1] Subsequent research about its descent to a relative, Florence Hart Wainwright (Mrs. T. F. Dixon), Villanova, Pa., corroborates this history.[2] Ford also quoted a letter written by Hicks on March 12, 1838, to Samuel Hart in which two[?] paintings were discussed. It is likely that Hicks was referring to the painting in checklist no. 36 and this entry: "if thee . . . should see my friend Abraham Chapman, ask him if anybody has taken any of them paintings I took the liberty to send to his care, and, if they are still there, apologize for the liberty I took of troubling him, and if he is willing to take them. I think there is two. One I presented to him as a small compensation for many favors, and if thou can dispose of them for any price from five dollars to twenty, do so, but keep them out of sight,

hung up in some upper room till some suitable person should be at thy house . . . The object of my painting them was to try to raise money to bear my expenses in my late journey."[3]

The painting passed from Mrs. Wainwright to her son Robert L. Montgomery II, Big Flats, N. Y. It was subsequently sold to R. H. Love Galleries, Chicago, Ill.; to Chris Stenger in the 1980s; Kennedy Galleries, New York N. Y., to a private collector; and finally to the present owners in the early 1990s.

Illustrated as fig. 123.

1. Ford, *Hicks: Painter of the Peaceable Kingdom*, p. 88.
2. Mather and Miller, *Edward Hicks*, p. 135.
3. Ford, *Hicks: Painter of the Peaceable Kingdom*, p. 88.

38
The Peaceable Kingdom
Oil on canvas, 29½" x 35¼"
1835–1840

OWNERSHIP HISTORY: Mather and Miller based their history of the painting on Ford's research.[1] The original owner was Thomas Janney, a Hicksite, longtime friend of Edward Hicks, and one of the administrators of the artist's will. Janney married Mary Kimber, the daughter of Emmor Kimber who owned the Kingdom in checklist no. 39. The Janneys' son Emmor Kimber Janney, Philadelphia, Pa., inherited the painting and left it to his son Walter C. Janney, Bryn Mawr, Pa. The Kingdom was sold to Arthur J. Sussell, Philadelphia, Pa., early in this century. M. Knoedler & Co., New York, N. Y., sold it to Clifford Smith, New York, N. Y. Knoedler also transacted the subsequent sale of the painting to Mr. and Mrs. Irwin Miller, Columbus, Ind.

The painting retains its original black-painted frame with inner gilded edge.

1. Ford, *Hicks: Painter of the Peaceable Kingdom*, pp. 68, 113, discussed in Mather and Miller, *Edward Hicks*, p. 126.

39
The Peaceable Kingdom
Oil on wood panel, 29" x 35¼"
1835–1840

OWNERSHIP HISTORY: Mather and Miller traced the early history of this painting to Emmor Kimber, Kimberton, Pa. They described Kimber as a minister in the Society who was involved in the "Underground Railroad," and as the founder of a girls' school.[1] The Kimbers were closely associated with Newtown Quakers and were related to the Janneys through the marriage of their daughter Mary to Thomas Janney (checklist no. 38). Emmor Kimber and his son Emmor Kimber, Jr., were both Hicksites. Emmor Kimber, Jr., named his son Edward Hicks Kimber.[2]

The painting then passed through a family with the surname Massey, whose relationship to the Kimbers is unknown, to Norris Barratt and subsequently his wife, Polly Barratt, both

of Philadelphia, Pa. M. Knoedler & Co., New York, N. Y., sold it to the Everson Museum of Art, Syracuse, N. Y., in 1978.[3]

Illustrated as fig. 122.

1. Mather and Miller, *Edward Hicks*, p. 129.
2. William W. H. Davis, *A Genealogical and Personal History of Bucks County, Pennsylvania*, ed. Warren S. Ely and John W. Jordan, 1905 (reprint, Baltimore, Md., 1975), p. 58.
3. Mather and Miller, *Edward Hicks*, p. 129; information courtesy, Thomas E. Piche, Jr., Everson Museum of Art, Syracuse, N. Y., 1997.

40
The Peaceable Kingdom
Oil on canvas, 30⅛" x 34½"
1835–1840

OWNERSHIP HISTORY: The earliest owner is not known. Mather and Miller stated that Hicks painted this Kingdom for a farmer in the area of Newtown, Pa.; it subsequently passed to the farmer's great-grandson. Wilbur T. Gracey, Bucks County, Pa., and Richard A. Loeb, Hampton, N. J., were other owners. It was then sold to dealer Albert Duveen, New York, N. Y., and purchased from him by Howard and Jean Lipman, Wilton, Conn. The New York State Historical Association, Cooperstown, N. Y., acquired the painting in 1961.[1]

The painting retains its original black-painted frame with gilded liner.

Illustrated as figs. 137 and 133.

1. Mather and Miller, *Edward Hicks*, p. 130.

41
The Peaceable Kingdom
Oil on canvas, 30" x 35¾"
1835–1840

OWNERSHIP HISTORY: An early twentieth-century label attached to the verso of the painting indicates it was originally owned by Benjamin Hallowell, onetime president of the state college now known as the University of Maryland. The label also states that Hallowell purchased the picture to assist Hicks financially.[1]

According to Mather and Miller, the painting descended to Hallowell's son Henry C. Hallowell, Sandy Spring, Md., who presented it to his cousin Charles F. Kirk. The picture then descended through the Kirk family to Charles Kirk's son Rudolph Kirk and his wife, Clara, New Brunswick, N. J., and later Ohio. M. Knoedler & Co., New York, N. Y., sold it in 1966 to Mr. and Mrs. Thomas M. Evans, New York, N. Y., and Gainesville, Va.[2] The painting was given to Carnegie Mellon University, Pittsburgh, Pa., in 1994.[3]

The painting retains an old, possibly original, black-painted frame with gilded liner. According to Thomas M. Evans, the frame was enlarged at an unspecified date.

1. Mather and Miller, *Edward Hicks*, p. 131. This may not be the

correct Hallowell. There were also Benjamin and Margaret Hallowell, clerks of the Alexandria Monthly Meeting, friends of Edward Stabler who associated with the artist. A Dr. William Hallowell and his wife, Mary, of Philadelphia and Norristown, Pa., were connected in some way with Edward Hicks. The J. Stanley Lees, descendants of the artist, owned in 1960 a photograph of a small drawing of Edward Hicks inscribed "E. Hicks/drawn by Dr. Hallowell/ with a pen." AARFAC archives. This may have been drawn by Dr. William Hallowell. Surviving pictures by him include a Peaceable Kingdom. Jean Lipman, "The Peaceable Kingdom by three Pennsylvania primitives," *Art in America*, XL (1957), pp. 28–29. It is also known that a Dr. William Hallowell owned a fireboard by Edward Hicks, probably the item described in his will as "a painting by Edward Hicks." Information courtesy, Robert F. Trent, AARFAC archives, Oct. 17, 1996. The fireboard remains unidentified. There is a reference to a "Hollowell" on p. 52 in Edward Hicks's account book, but the entry pertains to painting a vehicle.

2. *Ibid.*
3. Information courtesy, Thomas M. Evans, AARFAC archives, Apr. 14, 1997.

42
The Peaceable Kingdom
Oil on canvas, 29" x 35¾"
1835–1840

OWNERSHIP HISTORY: The earliest documented owner was cited by Mather and Miller as the Honorable Henry W. Watson, Langhorne, Pa., probably Henry Winfield Watson, born in 1856, the son of Mitchel and Anna Bacon Watson and the grandson of Joseph and Mary White Watson. The painting was one of several Kingdoms acquired by Arthur Edwin Bye, Holicong, Pa. It was subsequently sold to Charles J. Rosenbloom, Pittsburgh, Pa., who left it by bequest to the Carnegie Museum of Art, Pittsburgh, Pa., in 1974.[1]

The painting retains its original black-painted frame with gilded liner.

Illustrated as fig. 136.

1. Mather and Miller, *Edward Hicks*, p. 133; information courtesy, B. Monika Tomko, Carnegie Museum of Art, Pittsburgh, Pa., 1998.

43
The Peaceable Kingdom
Oil on canvas 17½" x 23½"
1835–1844

OWNERSHIP HISTORY: Mather and Miller noted the uncertainty about the original owner. Mrs. Edwa Osborne Wise, owner of the painting by 1976, purchased it from a Hicks family descendant who stated that Hicks gave the picture to the family doctor who delivered his babies. After the physician's death, his widow returned it to the Hicks family. Mrs. Wise

and Mather and Miller speculated that the doctor was either George T. Heston or A. H. Trego.[1] Heston was born in Newtown in 1826 and thus was too young to have delivered Edward Hicks's children. Nothing has been found about Trego, although families with that name lived in Doylestown, Philadelphia, Newtown, and Wrightstown, Pa.[2]

William Penrose Hicks, the artist's grandson, Newtown, Pa., eventually inherited the painting and left it to his daughter Hannah (Mrs. J. Stanley Lee), Newtown, Pa. Edwa Osborn Wise bought the Kingdom[3] and subsequently sold it to New York, N. Y., collector Barry Cohen. The Cohen Collection was auctioned in 1990 by America Hurrah and David A. Schorsch, Inc.[4] A private collector purchased the painting on April 8, 1990.[5]

The painting retains its original black-painted frame with corner blocks. The inner edges of the frame and the edges of the corner blocks were outlined in gold paint by Hicks or the unidentified frame maker.

1. Mather and Miller, *Edward Hicks*, p. 137.
2. Edward Hicks occasionally employed Edward Trego from Newtown for carpentry work and making frames. The artist's connection with other Tregos cited here is undetermined. Jonathan K. Trego, Philadelphia, Pa., and his relative, Edward A. Trego of Doylestown, Pa., were both artists of some reputation. Cory Amsler, *3 Artists Named Trego: An Exhibition at the Mercer Museum through April 30, 1993*, exhibit catalog (Doylestown, Pa., 1993).
3. Mather and Miller, *Edward Hicks*, p. 137.
4. Lita Solis-Cohen, "Barry Cohen Collection Sold," *Maine Antiques Digest* (June 1990), p. 1-D.
5. AARFAC archives.

44
The Peaceable Kingdom
Oil on canvas, 17½" x 23¾"
1835–1844

OWNERSHIP HISTORY: Information Mather and Miller acquired from dealer Robert Carlen's records led them to believe that John Lovett, Penn's Manor, Pa., first owned this painting. Lovett's relationship to Edward Hicks is unknown. The Robert Carlen Gallery, Philadelphia, Pa., acquired the painting from a Lovett descendant and sold it to a private collector.[1]

The painting retains its original black-painted frame with corner blocks and a gilded liner.

1. Mather and Miller, *Edward Hicks*, p. 134.

45
The Peaceable Kingdom
Oil on canvas, 17¾" x 23¾"
1835–1844

OWNERSHIP HISTORY: According to Mather and Miller and AARFAC archives, the painting's early provenance can be traced to Elmhurst, Long Island, N. Y., where it was owned by someone named Schlosser. Edith Gregor Halpert, American Folk Art Gallery, New York, N. Y., purchased it in December 1931. Holger Cahill acquired the painting in 1945 during a disbursement of the inventory of the American Folk Art Gallery. In 1960, Dorothy C. Miller inherited the work.[1] From 1988 to 1996, the painting was on extended loan to the Museum of Fine Arts, Boston, Mass. It was sold to a private collector in 1996.[2]

This painting has always been a favorite. Its appeal lies in the languid expressions of the lion with prominent sagging eyes, the sensual leopard, the second lion in the middle ground, and a lion cub that looks like a large domestic tabby. Hicks intended some of these features to reflect fatigue and resignation, not the humorous reaction they evoke from modern viewers.

Illustrated as fig. 124.

1. Mather and Miller, *Edward Hicks*, p. 138.
2. Information courtesy, Wendy Jeffers, New York, N. Y., 1997.

46
The Peaceable Kingdom
Oil on canvas, 29½" x 35¾"
1835–1844

OWNERSHIP HISTORY: Mather and Miller and research notes in the AARFAC archives identify this painting's earliest known owner as Mrs. T. Charlton Henry, Chestnut Hill, Pa. Her daughter Mrs. Philip D. Armour, Coral Gables, Fla., inherited it post-1920. Samuel T. Freeman & Co., Philadelphia, Pa., auctioned the painting in 1980. It was purchased by Robert Lee, Philadelphia, Pa.[1] The painting came up for auction at Christie's, New York, N. Y., in the Robert S. Lee, Sr., estate sale held January 15, 1999.

1. Mather and Miller, *Edward Hicks*, p. 136.

47
The Peaceable Kingdom
Oil on canvas, 24" x 31¼"
1844

OWNERSHIP HISTORY: Joseph Watson, Langhorne, Pa., attended Middletown Monthly Meeting, which went over to the Hicksite faction in 1828–1829. His ownership of the painting is documented by a letter from Hicks to Watson, September 23, 1844, in which Edward claimed it to be "one of the best painting I ever done." Edward Trego was identified as the frame maker in the letter.[1] Watson apparently commissioned the painting, the only transaction of this sort known for a Peaceable Kingdom.

Watson left the painting to his daughter Mary Elizabeth Watson. It then passed to her sister Susanna Watson Hancock, and from her to her great-niece Jane Watson Taylor Brey. It was subsequently acquired by Mabel Zahn of Charles Sessler, Inc., Philadelphia, Pa., in 1960. It was acquired that same year by the AARFAC.[2]

This painting illustrates Hicks's advanced familiarity with his subject. Examination of the work during conservation revealed that the picture was completed with minimal underdrawings in graphite. It is direct and spontaneous with little or no reliance on academic models. This Kingdom is one of the most painterly in its execution.[3]

The painting retains its original chamfered walnut frame with outer bead made by Edward Trego.

Illustrated as figs. 125 and 33.

1. Hicks to Joseph Watson, Sept. 23, 1844, AARFAC archives.
2. AARFAC archives; Mather and Miller, *Edward Hicks*, p. 140.
3. Information courtesy, Scott Nolley, associate conservator, CWF, 1998.

48
The Peaceable Kingdom
Oil on canvas, 24" x 31¼"
1844–1846

OWNERSHIP HISTORY: The current owner and location of this Kingdom are unknown. In 1957, it was owned by John and Lillian Harney, Trenton, N. J.[1] It was purchased by Leonardo L. Beans, Trenton, N. J., about that time and subsequently was auctioned by Sotheby's, New York, N. Y., in 1980.[2]

According to Mather and Miller, the picture retains its original walnut frame.

1. AARFAC archives.
2. Mather and Miller, *Edward Hicks*, p. 139.

49
The Peaceable Kingdom
Oil on canvas, 23⅞" x 31¼"
1844–1846

OWNERSHIP HISTORY: The early history is unknown, although Mather and Miller reported the oral tradition that the painting was found in the Germantown area of Philadelphia, Pa. It was subsequently acquired by Hirschl & Adler Galleries, New York, N. Y., and sold to dealer David David, Philadelphia, Pa. David Bakalar, Boston, Mass., the next owner, sold it to Hirschl & Adler Galleries, New York, N. Y. The Dallas Museum of Fine Arts, Dallas, Tex., acquired the painting through the Art Museum League Fund in 1973.[1]

Illustrated as fig. 146.

1. Mather and Miller, *Edward Hicks*, p. 141; information courtesy, Kay Johnson, Dallas Museum of Art, Dallas, Tex., 1998.

50
The Peaceable Kingdom
Oil on canvas, 24¼" x 31"
1845

OWNERSHIP HISTORY: This Kingdom has a history of ownership by Isaac Worstall Hicks, the artist's son, according to Mather and Miller. Isaac gave the painting to his son, also named Edward, Newtown, Pa. Robert W. Carle, the artist's great-grandson, subsequently acquired the painting and bequeathed it to the Yale University Art Gallery, New Haven, Conn., in 1965.[1]

This is one of the most interesting and curious of Hicks's late Peaceable Kingdoms for two reasons. The lion's face seems almost human in the drawing of the eyes, eyebrows, and forehead. The background includes a view of the Natural Bridge of Virginia, a device Edward used in the earlier Kingdoms and greatly simplified in this late version.

The artist inscribed the following on the verso of the strainer, "Painted by Edward Hicks in the 65th year of his age, 1845."

Illustrated as figs. 126 and 127.

1. Mather and Miller, *Edward Hicks*, p. 144.

51
The Peaceable Kingdom
Oil on canvas, 25" x 28½"
1845–1846

OWNERSHIP HISTORY: Curatorial staff at the Fine Arts Museums of San Francisco, Calif., have recently traced the original ownership of this painting to Dr. Daniel Janney, Loudon County, Va., a member of the Goose Creek Meeting.[1] Janney's relationship—if any—to the descendants of Amos Janney, Newtown, Pa., who relocated to Opequon, Va., early in the eighteenth century, or to Amos's relative, Mary Janney, who moved to Goose Creek before Hicks's visit in 1837, is unknown. Ford claimed that an unidentified member of the Janney family hosted the artist during his visit.[2]

The painting descended to Daniel Janney's great-great-granddaughter Mrs. Leonard C. Bowman (Ruth Gregg), Lucketts, Loudon Co., Va. Subsequent owners included Edith Gregor Halpert, American Folk Art Gallery, New York, N. Y.; Joseph Katz, New York, N. Y.; M. Knoedler & Co., New York, N. Y.; Martin Grossman, New York, N. Y.; and Hirschl & Adler Galleries, New York, N. Y. In 1976, Mr. and Mrs. John D. Rockefeller 3rd acquired the picture and bequeathed it to the Fine Arts Museums of San Francisco in 1993.

The unpainted wooden frame with gold liner has not been changed since the painting was acquired from the Rockefellers. However, curatorial staff at the Fine Arts Museums of San Francisco suspect that the frame may have been altered or switched in the 1930s.[3]

Illustrated as fig. 138.

1. Patricia Junker, "Edward Hicks and His Peaceable Kingdom," *Triptych* (1994), pp. 13–18.
2. Ford, *Hicks: Painter of the Peaceable Kingdom*, p. 136.
3. Information courtesy, Patricia Junker, Fine Arts Museums of San Francisco, San Francisco, Calif., 1998.

52

The Peaceable Kingdom
Oil on canvas, 24½" x 30½"
1845–1847

OWNERSHIP HISTORY: According to AARFAC archives and Mather and Miller, the earliest known owner of this Kingdom was Mary S. Paxson, Newtown, Pa. Several prominent Hicksite Quaker families of that name lived in Bucks County during the 1840s; Edward Hicks had business and religious dealings with some of them. The painting undoubtedly was created for one of them. Mary Paxson presented it to Dr. Charles B. Smith, Newtown, Pa., who bequeathed it to the Friends Boarding Home, Newtown, Pa. This Kingdom was later purchased by Hirschl & Adler Galleries, New York, N. Y., and sold to Leslie Miller and Richard Worley.

Illustrated as fig. 128.

1. Mather and Miller, *Edward Hicks*, p. 143.

53

The Peaceable Kingdom
Oil on canvas, 23⅞" x 31⅞"
1845–1847

OWNERSHIP HISTORY: Mather and Miller recorded that the painting was created for a "Dr. Thompson," Richboro, Pa., and was give to his daughter Martha Vanegrift, Wycombe, Pa. It was then purchased as follows: Harry C. Worthington, Doylestown, Pa.; Col. Henry D. Paxson, Lahaska, Pa.; Arthur Edwin Bye, Holicong, Pa.; Joseph Downs, New York, N. Y.; Arthur Edwin Bye; Julius Weitzner, New York, N. Y.; George Keller, Bignou Gallery, New York, N. Y. The Albright-Knox Art Gallery, Buffalo, N. Y., purchased the painting via the James G. Forsyth Fund in 1940.[1]

Illustrated as fig. 145.

1. Mather and Miller, *Edward Hicks*, p. 146; information courtesy, Albright-Knox Art Gallery, Buffalo, N. Y., 1998.

54

The Peaceable Kingdom
Oil on canvas, 23½" x 31"
1845–1847

OWNERSHIP HISTORY: The painting has a history of first ownership in a Pickering family near Bristol, Pa., according to Mather and Miller. It was inherited by Henry Pickering, Woodbourne, Bucks County, Pa. Mather and Miller chronicled subsequent owners: dealer Robert Carlen, Philadelphia, Pa.; Mrs. Theobald Clarke, Chestnut Hill, Pa.; to her son Anthony M. Clarke, Philadelphia, Pa.; sold again to Robert Carlen. Current ownership and location are unknown.[1]

Mather and Miller noted that the painting retains its original frame, but gave no details of its design.[2]

1. Mather and Miller, *Edward Hicks*, p. 145.
2. *Ibid.*

55

The Peaceable Kingdom
Oil on canvas, 24⅛" x 32⅛"
1846

OWNERSHIP HISTORY: The earliest known owner was Edith Gregor Halpert, Downtown Gallery, New York, N. Y. This painting was acquired by the Phillips Collection, Washington, D. C., in 1939.[1]

The painting is inscribed by the artist on the stretcher "Painted by Edward Hicks in the 66th year of his age."

Illustrated as fig. 129.

1. Mather and Miller, *Edward Hicks*, p. 148.

56

The Peaceable Kingdom
Oil on canvas, 26" x 29½"
1846–1848

OWNERSHIP HISTORY: Mather and Miller stated that wealthy New York Hicksite Quaker merchant Amos Willets commissioned this painting.[1] He was related to the Hicks family through marriage. Correspondence with Mabel Willets Abendroth, Harrison, N. Y., in the AARFAC archives also indicated that Amos Willets was the first owner. Documentation for "commissioning" the work from the artist is unknown, however. It is more likely that the painting was a gift for which Willets may voluntarily have sent money to Hicks.

This Kingdom was subsequently given to Amos's nephew Robert R. Willets, who married Edward Hicks's granddaughter Tacie Parry, daughter of Isaac C. and Sarah Hicks Parry. Robert and Tacie's daughter Mabel Willets Abendroth inherited the painting and gave it to her son William P. Abendroth Jr., Berwyn, Pa. Later sold to Kennedy Galleries, New York, N. Y., it was acquired by a private collector.

Mabel Willets Abendroth described the painting: "One of the Peaceable kingdoms is quite large and to my way of thinking, it is the most beautiful thing of Grandfather's I have ever seen. . . . It was given to my father and mother about the time they were married in 1869, by the children of great Uncle Amos Willets (maybe Great-Uncle promised it to my mother before he died)."[2]

This painting and checklist no. 57 are among Hicks's finest late Kingdom pictures. The artist arranged the animals, dispersed and spread over more than half of the canvas, in new and interesting ways. Many stand alone or are positioned apart from one another, an approach that is distinctively different from Hicks's Kingdoms of the 1830s and early 1840s. The artist used squarer canvases to provide the additional space he needed for the new organization. Edward did not often repeat this format in the late Kingdoms. His separation of the animals may have symbolized the further divided Orthodox and

Hicksite groups which Hicks believed would be difficult to re-unite into one cohesive Society of Friends.

Illustrated as figs. 144 and 142.

1. Mather and Miller, *Edward Hicks*, p. 147.
2. AARFAC archives.

57
The Peaceable Kingdom
Oil on canvas, 26⅜" x 30"
1846–1848

OWNERSHIP HISTORY: This painting has an oral tradition of being a payment from Hicks to a member of the Janney family (probably Thomas Janney, Newtown, Pa.) against a debt, according to Mather and Miller. Unfortunately, no documentation supports this assertion. Mrs. Beverly C. Compton, Baltimore, Md., inherited the painting; her relationship to the Janneys is unknown. It was subsequently sold to dealer Marguerite Riordan, Stonington, Conn., and purchased by a private collector.[1]

At the lower right is a curious animal that Hicks used only in this version of the Peaceable Kingdom. It has a bovine body, but the shapes of the head and ears seem to be those of an unidentified species. The ewe and lamb at center left are nearly identical to those Edward included in several views of William Penn's gravesite.

Illustrated as figs. 139, 140, and 143.

1. Mather and Miller, *Edward Hicks*, p. 211.

58
The Peaceable Kingdom
Oil on canvas, 25" x 32½"
1847

OWNERSHIP HISTORY: Nothing is known about the original owner or early history of this painting. Dealer Robert Carlen, Philadelphia, Pa., found the painting in Montgomery County, Pa., according to Mather and Miller.[1] Mrs. Robert Carlen subsequently owned this picture and loaned it to the Diplomatic Reception Rooms, United States Department of State, Washington, D. C.[2]

The frame is a modern replacement. Inscribed by the artist on the strainer is "Painted by Edward Hicks in the 67th Year of His Age."

1. Mather and Miller, *Edward Hicks*, p. 151.
2. AARFAC archives.

59
The Peaceable Kingdom
Oil on canvas, 23¾" x 31⅛"
1847

OWNERSHIP HISTORY: Nothing is known about the original owner. According to AARFAC archives and Mather and Miller, the painting was owned jointly by New York dealers M. Knoedler & Co. and Harry Shaw Newman before it was purchased by Charles Bayly, Jr., for the Denver Art Museum, Denver, Colo.[1]

This is one of the most curious of Hicks's late Kingdoms because he reintroduced a view of the Natural Bridge in Virginia in the background. The other Kingdoms that feature this prominent natural wonder, checklist nos. 2, 3, 5, and 6, date from the 1820s. Perhaps this device can be interpreted as "a doorway opening upon another world," as Mather and Miller observed.[2] At this stage in his life, Hicks was aware of his weakening physical condition and impending mortality; he was also aware that these conditions would apply to all earthly beings. It is worth noting that entering the "doorway" was also a matter of choice and depended upon the way in which individuals conducted their mortal life. The element thus functioned not only as a passage but also as a literal bridge between mortal and immortal life.

The expressions of the animals have changed yet again, and some have assumed new positions. The wolf now looks more like a large domestic dog; the lion lunges forward, yet appears to be an old feline; the shape of the bear's mouth and nose have become misformed and fierce; and the leopards, one reclining in a languid daze and the other arched above it snarling, are at odds. The little child is nearly buried among the creatures at right. Hicks's advancing age and declining abilities might explain the obvious disunity of the animals in this Kingdom were it not that he painted other well-integrated, crisply developed pictures dating from this period. Instead, it seems likely that the peculiar mood of this Kingdom was intentional and reveals the artist's perception of religious life among Quakers during the years after the separation in 1827. It was a time of disparate opinions and many factions.

The painting retains its original walnut-veneered frame. On the verso of the stretcher the artist inscribed "The Peaceable Kingdom/Painted by Edward Hicks in his 67 year."[3]

Illustrated as fig. 132.

1. Mather and Miller, p. 150.
2. *Ibid.*
3. Information courtesy, Denver Art Museum, Denver, Colo., 1998.

60
"The Peaceable Kingdom"
Oil on canvas, 24" x 32"
1847

OWNERSHIP HISTORY: AARFAC archives and Mather and Miller trace the history of this painting as follows: presented to the Vineland Historical Society, Vineland, N. J., by T. W. Scull; sold by Sotheby's, New York, N. Y., in 1977 to James Maroney, New York, N. Y.; purchased by Sidney Janis, New York, N. Y.[1] The painting is currently owned by Carroll Janis, New York, N. Y.[2]

Of particular interest are the leopard's new pose and posi-

tion. The artist placed him at far right, looking calmly to the left, a demeanor that suggests ease and comfort. On the other hand, the lion appears haggard and spent.

The painting retains its original black-painted frame with gilded liner. The artist inscribed (top) "THE PEACEABLE KINGDOM, ISA[H]. 11.6.7.8," (bottom) "PAINTED BY EDWARD HICKS IN THE 67 YEAR OF HIS AGE" on the stretcher.

Illustrated as figs. 130, 34, and 131.

1. Mather and Miller, *Edward Hicks*, p. 149.
2. Information courtesy, Sidney Janis Gallery, New York, N. Y., 1998.

61

The Peaceable Kingdom
Oil on canvas, 24" x 30¼"
1848–1849

OWNERSHIP HISTORY: According to Mather and Miller, this Kingdom was created for Eliza Hough Jackson Bell (Mrs. Thomas C. Bell), Bayside, Long Island, N. Y.[1] She was the daughter of Hicksite Quaker Halliday Jackson and Jane Hough Jackson, Darby, Pa. Both Eliza and her husband were Hicksites.[2] The authors outlined later ownership. The painting descended to a Miss Bell, Bayside, Long Island, N. Y., who sold it to dealer Robert Carlen, Phildelphia, Pa. It was purchased by Mrs. William Elkins, Philadelphia, Pa., and sold by her to M. Knoedler & Co., New York, N. Y.[3] It was subsequently purchased by Dr. Otto Kallir and is currently owned by a private collector, courtesy of the Galerie St. Etienne, New York, N. Y.

The two final Kingdoms that Edward Hicks created before his death in 1849 (checklist nos. 61 and 62) are remarkably different from those that preceded them. The artist never tired of experimenting with his interpretation of Isaiah's prophecy. At the left, one child leads a young lion by its yoke to an imaginary world beyond the canvas. Most of the creatures are positioned near the bottom, but they do not seem to be actively following the child and the cub. For instance, the wolf is facing the other direction, the leopard, reclining in the center next to the kid, is more preoccupied with the viewer than with the child, and the bear and steer in the middle ground are focused on eating together. This Kingdom and checklist no. 62 captured a group of animals whose calm expressions and movements suggest peaceable coexistence amid disparate activities. The landscape elements consume more of this canvas than the animals do, while Hicks reduced the Penn treaty group to a much smaller vignette in the left middle ground. Although not entirely clear, these changes and reasons for them seem to relate to those in checklist nos. 59 and 60.

Illustrated as figs. 147 and 149.

1. Mather and Miller, *Edward Hicks*, p. 152.
2. Hinshaw, *Encyclopedia*, III, pp. 31, 377; Davis, *History of Bucks County*, pp. 612, 699; Robert W. Doherty, *The Hicksite Separation: A Sociological Analysis of Religious Schism in Early Nineteenth Century America* (New Brunswick, N. J., 1967), p. 134.
3. Mather and Miller, *Edward Hicks*, p. 152.

62

The Peaceable Kingdom
Oil on canvas, 24³⁄₃₂" x 30⅜"
1849

OWNERSHIP HISTORY: This is believed to be the Kingdom Edward Hicks completed just before his death in 1849. Tradition holds that it was intended for Elizabeth Hicks (Mrs. Richard Plummer), Edward's daughter. Mather and Miller stated, "Apparently Elizabeth Hicks did not take this with her when she went to Baltimore as the wife of Richard Plummer."[1] In a 1938 letter to Abby Aldrich Rockefeller, Mabel Willets Abendroth wrote that "the Plummers live in Baltimore . . . I think Bob's father is going to leave the better Peaceable Kingdom to Bob in his will." Mrs. Abendroth knew the Plummers and indicated that the family had at least two Kingdom pictures in 1938.[2] Which ones were they?

The composition of this painting and its association with Hicks's children make it a strong candidate for the artist's last Kingdom. Its history of descent is based on Mather and Miller and AARFAC archives: presumably kept in the house of Edward's son Isaac and subsequently given to his daughter Sarah Worstall Hicks; to Hannah Brown Hicks Lee (Mrs. J. Stanley Lee); to a descendant.[3] The painting is currently on loan at the Nelson-Atkins Museum of Art, Kansas City, Mo. It is possible that Elizabeth Hicks Plummer gave the painting to her niece Sarah Worstall Hicks.

Nothing is known of the second Plummer Kingdom; presumably it survives and is one of the paintings with an incomplete history in the checklist.

Illustrated as fig. 148.

1. Mather and Miller, *Edward Hicks*, p. 153. The source of this information is unknown and may be partially incorrect.
2. AARFAC archives.
3. Mather and Miller, *Edward Hicks*, p. 153.

Landscape, Farmscape, and Pastoral Paintings

63

"The Falls of Niagara"
Oil on canvas, 31½" x 38"
1825

OWNERSHIP HISTORY: Mather and Miller recorded that the painting was purchased by the Argosy Gallery, New York, N. Y., and subsequently sold to Edgar William and Bernice Chrysler Garbisch, New York, N. Y. The Chryslers gave it to the Metropolitan Museum of Art, New York, N. Y., in 1962.[1] An early work, Hicks probably painted it for a close friend or family member. It cannot be one of the landscapes recorded in the artist's account book for 1818 because the Tanner map, the print source, was not published until 1822. The only other information on a possible owner came from Ford and the artist's account book. Ford stated that the artist sold Elizabeth Twining a "landscape" in 1825 for $25.[2] The book listed a "chim-

ney board" purchased by Beulah Twining in 1823, but no landscape.[3]

Derived from the poem "The Foresters" by the noted ornithologist Alexander Wilson, Hicks lettered the painting's border verses in gold paint: *(left)* "With uproar hideous' first the *Falls* appear,/The stunning tumult thundering on the ear."; *(top)* "Above, below, where'er the astonished eye/Turns to behold, new opening wonders lie,"; *(right)* "This great o'erwhelming work of awful Time/In all its dread magnificence sublime,"; *(bottom)* "Rises on our view, amid a crashing roar/That bids us kneel, and Time's great God adore."[4] The lettered title of the painting appears in the top corner blocks: *(upper left)* "The Falls" *(upper right)* "of Niagara." The date is painted in the two lower corner blocks: *(left)* "18" *(right)* "25."

Illustrated as fig. 20.

1. Mather and Miller, *Edward Hicks*, p. 202.
2. Ford, *Hicks: Painter of the Peaceable Kingdom*, p. 48. I have not located the source of this quote.
3. Hicks, account book, p. 162. The cost of the "landscape" is given as $20.
4. The Wilson poem was published in the *Port Folio*, III (1809–1810), p. 183. S. Siegfried and J. Wilson republished it in Newtown, Pa., in 1818. Mather and Miller, *Edward Hicks*, p. 25, n. 5.

64
"FALLS OF NIAGARA"
Oil on wood, 22¾" x 30⅛"
1825–1826

OWNERSHIP HISTORY: According to AARFAC archives, this version was painted for Dr. Joseph Parrish, Philadelphia, Pa., who also owned checklist nos. 2 and 5. Dr. Parrish gave the picture to a relative, Miss Helen Parrish, Philadelphia, Pa., who sold it to Arthur Edwin Bye, Holicong, Pa. It was purchased next by Edward R. Barnsley, Newtown, Pa., and sold by him to the AARFAC in 1959.[1]

The gold-painted lettering in the borders reads: *(left)* "With uproar hideous, first the *Falls* appear, The stunning tumult thundering on the ear."; *(top)* "Above, below, where'er the astonished eye/Turns to behold, new opening wonders lie." *(right)* "There the broad river, like a lake outspread,/The islands, rapids, falls, in grandeur dread,"; *(bottom)* "This great, o'erwhelming work of awful Time,/In all its dread magnificence, sublime." The painting retains its original frame painted green, brown, and black with "FALLS OF NIAGARA" in gold letters.

Illustrated as fig. 21.

1. AARFAC archives; Mather and Miller, *Edward Hicks*, pp. 203–204.

65
Lamb
Lead pencil on paper, 5" x 5½"
Ca. 1831

OWNERSHIP HISTORY: Descended through the artist's family to Mrs. J. Stanley Lee, great-granddaughter of the painter, Newtown, Pa., who owned it in 1960. The drawing was given to her daughter Mrs. Eleanore Lee Swartz, and then to a private collector.[1]

Although technically not a painting, the little sketch is an important document because it provides evidence that Hicks practiced his art in preparation for rendering more complex works. It also suggests that the artist may have assembled a reference collection of such sketches made from life or from paintings and print sources he had seen.

The drawing, framed in the twentieth century, carries a label affixed to the back which reads: "This drawing was made by Edward Hicks. The envelope that it was drawn on was labelled in pencil by Miss Sarah Hicks (d. Newtown 1946): 'Found in one of Edward Hicks old Letters dated 1831.' The envelope's address is missing except for this: 'd Hicks/own/ucks County/Penn[a].'"

Illustrated as fig. 141.

1. Information courtesy, the owner.

66
Pole Screen with Landscape
Mahogany; oil on yellow poplar panel, brass and iron; 57¼" x 23³⁄₁₆";
painting: 20" x 23³⁄₁₆"
1825–1835

OWNERSHIP HISTORY: The original owner is unknown. The painting was purchased from Tom Renn Arts and Antiques, Boston, Mass., in 1986 by the AARFAC.

Hicks probably was commissioned by a Bucks County cabinetmaker to paint this panel. The image, possibly derived from an unidentified print source, departs from traditional ornamental work and is more closely related to Hicks's landscape paintings and to landscape elements in the Peaceable Kingdoms. This small panel picture was constructed like another pastoral scene owned by the AARFAC (checklist no. 74) that was never attached to a pole.

The painting retains its original mahogany frame affixed to a mahogany pole with metal rings. Whether or not the pole and picture were originally used together is not known, although they are contemporary. "Pole screen" and "banner screen" refer specifically to a freestanding tripod base supporting a panel decorated with needlework, a painting, a drawing, or a pane of glass that blocked fireplace heat yet allowed light to pass.[1]

Illustrated as figs. 166 and 16.

1. The AARFAC has recorded another pole screen that incorporates a folk painting, a theorem on velvet illustrated in an advertisement for David A. Schorsch, Inc., *The Magazine Antiques*, CXXXI (1987), p. 774.

67
The Residence of Thomas Hillborn
Oil on canvas, 23⅝" x 31⅞"
1845–1847

OWNERSHIP HISTORY: Owned originally by Cyrus Hillborn, the painting descended to his brother Samuel Hillborn. It was inherited by Samuel's son Isaac Hillborn, who gave it to his daughter Martha Hillborn Tomlinson. Mrs. Tomlinson left it to her children Ruth, Caroline, Ella, Anna, and Harvey Hillborn Tomlinson. It was acquired by the AARFAC in 1961.[1]

The painting retains its original walnut frame. The inscription "Purchased by his son Cyrus Hillborn in 1845, when/this Picture was painted, by Edward Hicks in his 66th year" on the top member of the original strainer was removed from the painting during restoration but has been retained by the AARFAC. Inscribed on the bottom member of the strainer is "The Residence of Thomas Hillborn in Newtown/Bucks County Pennsylvania, in the Year 1821." The inscriptions are not in Edward Hicks's hand and probably were added later by someone in the Hillborn family.

Illustrated as fig. 161.

1. Mather and Miller, *Edward Hicks*, p. 190; AARFAC archives.

68

The Residence of David Twining
Oil on canvas, 22¼" x 26⅛"
1845–1847

OWNERSHIP HISTORY: Mather and Miller cite the provenance as: "Painted for Thomas and Sarah Twining Hutchinson [eldest of the four daughters of David and Elizabeth Twining], Newtown, Pa., who bought Twining farm in 1826 after the death of Beulah Twining Torbert; to their son, Dr. David Hutchinson, Newtown, Pa.; to his son, Edward Stanley Hutchinson; to his daughter, Rachel Hutchinson Lincoln, Elkhorn, W. Va.; to a private collector."[1] Since the publication of this history, the painting passed to John J. Lincoln, Jr., son of Rachel Hutchinson Lincoln, to his son Dr. Thomas Lincoln, Los Angeles, Calif., in 1967.[2] The painting appeared at auction in Christie's, New York, N. Y., sale on January 16, 1999.

Mather and Miller believed the frame to be original, wood unknown, and without a lettered title.[3]

1. Mather and Miller, *Edward Hicks*, p. 191. It is not known if Edward Hicks had a close relationship with Sarah Twining Hutchinson, whom he barely knew during his childhood. The Hutchinsons may have owned the painting at one time, but it is doubtful that the first version of Twining Farm, as this entry has been credited, would have been painted for her.
2. Information courtesy, Dr. Thomas Lincoln, Los Angeles, Calif., 1998.
3. Mather and Miller, *Edward Hicks*, p. 191.

69

"The Residence of David Twining in 1785"
Oil on canvas, 26" x 29½"
1845–1847

OWNERSHIP HISTORY: Genealogical research undertaken by Mather and Miller suggested that this painting was owned first by Sarah Hopkins Liones, New York, N. Y., who left it to her daughter Elizabeth Hopkins (Mrs. William Carpenter). The picture descended through the Carpenter family of North Greenwich, Conn., specifically from Francis W. Carpenter, son of William, to one or more of his children Mary, Evelyn, and Grace. It was then loaned or given to the North Greenwich Congregational Church, North Greenwich, Conn. Mather and Miller stated that it passed "through Dorothy C. Miller" to M. Knoedler & Co., New York, N. Y., which sold it in 1962 to the Howard N. Eavenson Memorial Fund for the Howard N. Eavenson Americana Collection, Carnegie Museum of Art, Pittsburgh, Pa.[1]

Inscribed on the picture at the bottom center is "The Residence of David Twining in 1785/when the painter was five years old." The hardwood frame with gilded liner is believed to be original to the painting.

Illustrated as fig. 162.

1. Mather and Miller, *Edward Hicks*, p. 192. Sarah's mother, Elizabeth Twining Hopkins, died in 1832, before the painting was created. Hicks mentioned Elizabeth Twining's marriage to Hopkins on p. 22 of his *Memoirs*.

70

"THE RESIDENCE OF DAVID TWINING 1787"
Oil on canvas, 26½" x 51³⁄₁₆"
1845–1847

OWNERSHIP HISTORY: This picture probably was painted for Charles Leedom (son of Jesse and Mary Twining Leedom), Newtown, Pa., and descended to his granddaughter Lydia L. Knight. The next owner was Carl Lindborg, Newtown Square, Pa. Abby Aldrich Rockefeller purchased the painting in 1933 and gave it to the Museum of Modern Art, New York, N. Y., in 1939. The painting was transferred to the Metropolitan Museum of Art, New York, N. Y., in 1949, and turned over to Colonial Williamsburg in 1955.[1]

This version of Twining Farm is the most elaborate known. There are more people, animals, and fowl in the center ground between the house and outbuildings. The squabbling dog and cat in front of the farmhouse form a new and humorous vignette.

The painting retains its original oak frame with outer bead and gold lettering, "THE RESIDENCE OF DAVID TWINING 1787," on its lower member. Hicks used the date 1785 in the other inscribed or lettered versions of the view. Why "1787" appears on this version is unknown.

Illustrated as figs. 8 and 9.

1. Mather and Miller, *Edward Hicks*, p. 194; AARFAC archives.

71
"THE RESIDENCE OF DAVID TWINING 1785"
Oil on canvas, 26" x 29¾"
1846

OWNERSHIP HISTORY: Leonardo L. Beans, Trenton, N. J., was the earliest documented owner. The painting was auctioned at Sotheby's, New York, N. Y., in 1980 and acquired by Andy Williams, Los Angeles, Calif.[1] In October 1997, the painting came up at auction at Sotheby's, New York, N. Y.

The 1846 date is based on a photograph in the AARFAC archives accompanied by a 1957 letter from curator Mary C. Black in which she stated, "Long ago you asked me for a photograph of your Twining Farm and the inscription on the reverse. I am sending you it herewith, with my compliments."[2] The inscription reads: "PAINTED BY EDW. HICKS IN HIS 67 Yr."

The painting retains its original frame, probably oak, with the lettering in gold: "THE RESIDENCE OF DAVID TWINING 1785."

1. Mather and Miller, *Edward Hicks*, p. 193.
2. AARFAC archives.

72
Landscape with Stream
Oil on academy board, 7½" x 9½"
1845–1848

OWNERSHIP HISTORY: Inscribed for its original owner, Mary Roberts, presumably of Bucks County, Pa., a relative of the Tomlinsons of Langhorne, Pa. It descended to dealer Bill Woolsey, Lumberville, Bucks County, Pa., who sold it to the current owners, Martha and Malcolm Cade, Atlanta, Ga., in the early 1970s.[1]

No other works by Hicks of this small size are known. The painting retains its unusual original tiger maple frame.[2] Inscribed by the artist on a paper label affixed to the verso of the canvas is "Edw. Hicks to his beloved/friend Mary Roberts sendeth/Greeting."

Illustrated as fig. 164.

1. Mather and Miller, *Edward Hicks*, p. 201. The authors documented a family tradition that the view represented Roberts's pasture.
2. Curly maple was more commonly used by the artist.

73
Landscape
Oil on canvas, 17⅜" x 20⅜"
1845–1849

OWNERSHIP HISTORY: AARFAC staff have been unable to locate this painting, but its attribution to Edward Hicks appears to be accurate. Mather and Miller stated that Samuel Hart, the original owner, also acquired a Peaceable Kingdom from Hicks in the 1830s (checklist no. 37). The painting passed from Hart to Miss Natalie Hart, Villanova, Pa., a relative, who gave it to her sister Mrs. J. H. Ward Hinkson, Haverford, Pa. Mrs. Hinkson subsequently sold the painting to the Robert Carlen Gallery, Philadelphia, Pa., who then sold it to a private collector.[1]

1. Mather and Miller, *Edward Hicks*, p. 199.

74
Landscape
Oil on wood panel, 16¾" x 20"
1845–1849

OWNERSHIP HISTORY: Charles Leedom, Newtown, Pa., the son of Jesse and Mary Leedom, was the first owner. It was given to his granddaughter Mrs. Lydia L. Knight, and then owned by Carl Lindborg, Newtown Square, Pa. Edith Gregor Halpert, Downtown Gallery, New York, N. Y., purchased the painting and sold it to John D. Rockefeller, Jr., for his wife, Abby Aldrich Rockefeller. The picture became part of her collection that was given to Colonial Williamsburg in 1939. It was later loaned to, and then purchased by, the Rockefellers for use in their Williamsburg home, Bassett Hall. In 1956, the Rockefeller family gave it to Colonial Williamsburg for display in the new AARFAC that opened in 1957.[1]

The painting's walnut splayed frame is probably the original.

Illustrated as fig. 165.

1. Mather and Miller, *Edward Hicks*, p. 200; AARFAC archives.

75
James Cornell's Prize Bull
Oil on wood, 12" x 16⅛"
1846

OWNERSHIP HISTORY: The receipt of payment to Edward Hicks for this painting was pasted to the reverse of the support, probably by the original owner, James C. Cornell, Bucks County, Pa. Cornell also commissioned the artist to paint a large view of his farm in 1848 (checklist no. 82). The painting passed through the family and was subsequently sold to dealer Lillian Harney, Trenton, N. J. It was purchased for the AARFAC in 1958.[1]

Hicks's rendering of the animals is impressive by comparison with the linear, sometimes flat, creatures in the Kingdom pictures. He undoubtedly had the ability to render lifelike animals, using this skill most often toward the end of his career in Cornell's bull, the small landscape for Roberts (checklist no. 72), and a few other paintings. His reluctance to paint in this fashion probably resulted from the criticism he received from fellow Quakers early in his career.

Eleanore Price Mather discovered several early nineteenth-century prints in papers collected by her grandfather James M. Price, West Chester, Pa. Among them were two featuring sheep labeled with the artist's or engraver's name, "Gustave Canton." Hicks used

these prints when planning the composition of this work.[2] Examination and X-rays of the painting reveal underdrawings that correspond directly to the sheep and rams in the Canton prints. Edward likely made a direct tracing of the desired print source elements on thin paper using a soft pencil or similar medium. The paper was then placed, drawing faced down, on the panel. The reverse of the paper was rubbed to transfer the soft graphite to the panel surface. The resulting transferred images, although faint, were further refined by Edward with the printed versions as his guide. The paint was applied up to but not beyond the line that defines the outline and detail of the transferred figures.[3]

The molded frame of unidentified wood is probably the original. The original label was removed from the painting for conservation purposes about 1959. It reads: "James Cornell/To Edward Hicks Do/To painting his prize bull. $15.00/Rec 5th mo 16th 1846 the above in full/of all demands by me/Edward Hicks."[4] "Prize Bull/Edw. Hicks/1846" is inscribed on the reverse of the panel.

Illustrated as fig. 167.

1. Mather and Miller, *Edward Hicks*, p. 198; AARFAC archives.
2. Mather and Miller, *Edward Hicks*, pp. 82–83.
3. Information courtesy, Scott Nolley, associate conservator, CWF, 1998.
4. AARFAC archives.

76
"GRAVE OF WILLIAM PENN . . ."
Oil on canvas, 25¾" x 29⅞"
1847

OWNERSHIP HISTORY: According to Mather and Miller, this version was painted for Job Roberts, Whitpain, Pa., and probably inherited from him by Mary Beans, Jenkintown, Pa. It then passed through the Robert Carlen Gallery, Philadelphia, Pa., and Hirschl & Adler Galleries, New York, N. Y. Robert W. Carle, South Salem, Conn., Hicks's great-grandson, purchased the painting and gave it to the Yale University Art Gallery, New Haven, Conn., in 1958.[1]

Inscribed on the strainer is: *(top member)* "Painted by Edward Hicks in the 68th year of his age/for his old friend Job Roberts Esq. the practical," *(bottom member)* "farmer of Montgomery County, Pennsylvania aged 91/Painted A.D. 1847." Lettered at the bottom of the canvas is "GRAVE OF WILLIAM PENN IN THE FRIENDS BURI/AL GROUND AT JORDANS IN THE BUCKINGHAMSHIRE EL[D]." The painting's wooden frame is probably original.[2]

Illustrated as fig. 160.

1. Mather and Miller, *Edward Hicks*, p. 186.
2. *Ibid.*

77
"The Grave of W[M] PENN at Jordans in England"
Oil on canvas, 24" x 30"
1847

OWNERSHIP HISTORY: Information in the AARFAC archives indicates that Ann Drake, Newtown, Pa., originally owned this version. It then passed to an unidentified descendant before being sold to Edith Gregor Halpert, Downtown Gallery, New York, N. Y. In 1932, Abby Aldrich Rockefeller acquired the painting, which became part of her gift to Colonial Williamsburg in 1939.[1]

The painting bears the inscription in brown paint at the bottom: "The Grave of W[M] PENN at Jordans in England." "Painted by E. Hicks in his 68th year,/For his friend Ann Drake" is painted in black on the top member of the original strainer. The painting retains its original splayed mahogany-veneered frame with a quarter-round molding at the outer edge.

Illustrated as fig. 159.

1. Mather and Miller, *Edward Hicks*, p. 184.

78
"Grave of W[M] PENN at Jordans in England . . ."
Oil on canvas, 24" x 30"
1847

OWNERSHIP HISTORY: The William H. Macy identified in the inscription as the original owner was probably William Hicks Macy, a distant relative of the artist. Macy was a Hicksite member of the New York Monthly Meeting, as were other members of his family.[1] The painting passed from Macy to his wife, Eliza L. Jenkins Macy, to her grandson George Macy. It was sold about 1954 to dealer Mary Allis, Southport, Conn., and purchased by Mr. and Mrs. Bernard M. Douglas, Stockton, N. J., who gave the painting to the Newark Museum, Newark, N. J., in 1956.[2]

The painting bears the artist's inscription at the bottom of the canvas. Beginning at left, it reads, "Grave of W[M] PENN at Jordans in England with the old Meeting House/& Burial. ground and J. J. Gurney & Friends looking at the Grave." An old paper label affixed to the strainer is inscribed "Presented to/George Macy/from/his grandmother/E. L. Macy."[3]

The gilt molded frame may be the original.

1. Hinshaw, *Encyclopedia*, III, pp. 216–217.
2. Mather and Miller, *Edward Hicks*, p. 188; Elinor Robinson Bradshaw, "American Folk Art in the Collection of The Newark Museum," *The Museum*, XIX (1967), pp. 46–47.
3. Mather and Miller, p. 188.

79
"Grave of W[M] PENN at Jordans . . ."
Oil on canvas, 24" x 30"
1847

OWNERSHIP HISTORY: According to Ford, the painting was originally owned by Elizabeth Cary, Newtown, Pa.[1] It may have been given to Ann Cary, a descendant, by Sarah Worstall Hicks, granddaughter of the artist. Miss Cornelia Carle Hicks,

the painter's great-granddaughter, was the next owner. In 1968, the picture descended in the family to a private collector.

Beginning at lower left, "The Grave of W^M PENN at Jordans, Buckinghamshire England" is inscribed by the artist on the canvas. The verso of the canvas bears the inscription "Painted by E. Hicks in the 68th year of his age For his friend Elizabeth Cary, 1847." An old paper label affixed to the verso is inscribed "From Ann Cary to Sallie Hicks." According to Mather and Miller, the painting retains its original stained wood frame.[2]

1. Ford, *Hicks: Painter of the Peaceable Kingdom*, p. 153. Elizabeth Cary and her husband, Joseph Cary, were members of Makefield Meeting, which became exclusively Hicksite after 1827.
2. Mather and Miller, *Edward Hicks*, p. 185.

80

The Grave of William Penn
Oil on canvas, 23½" x 31¼"
1847

OWNERSHIP HISTORY: AARFAC archives correspondence with a previous owner and the lettering on the strainer indicate the painting was created for Joshua Longstreth, Philadelphia, Pa. Several people in Philadelphia named Longstreth were acquainted with the artist. The painting was later acquired by Edward Hicks Carle, great-grandson of the artist, for Owen Winston of New York, N. Y. It then passed to Winston's wife and by her to their son John Winston, Gladstone, N. J. The picture subsequently was inherited by John Winston's daughter Mrs. David Callard, Bethesda, Md., who auctioned it through Christie's, New York, N. Y. In 1981, Eleanore Price Mather informed the AARFAC that the painting was owned by the Andrew Crispo Gallery, New York, N. Y.[1] In 1997, Sotheby's offered the painting at auction, listing it as from the Andrew Crispo Collection.

Lettered in black across the top element of the strainer is "PAINTED BY EDW. HICKS IN THE 68TH YEAR OF HIS AGE," and across the bottom element continues "FOR HIS FRIEND JOSHUA LONGSTRETH OF PHILADA." The painting originally had an inscription on the canvas, beginning at lower left, that is no longer legible.

The picture retains its original curly maple frame with gilded liner.

1. AARFAC archives; Mather and Miller, *Edward Hicks*, p. 187.

81

"Grave of William Penn at Jordans in England . . ."
Oil on canvas, 23⅝" x 29¾"
1847–1848

OWNERSHIP HISTORY: According to Mather and Miller, the original owner is unknown. It was purchased by dealer Robert Carlen, Philadelphia, Pa., who sold the picture to Edith Gregor Halpert, Downtown Gallery, New York, N. Y., and then passed through the following dealers: M. Knoedler & Co., New York, N. Y.; Joseph Katz Co., New York, N. Y.; and M. Knoedler & Co., New York, N. Y. Edgar William and Bernice Chrysler Garbisch purchased the painting, which they gave to the National Gallery of Art, Washington, D. C., in 1980.[1]

The inscription on the canvas begins at lower left and reads: "Grave of William Penn at Jordans in England with a view of the old/Meeting House & Grave-Yard, & J. J. Gurney with some Friends looking at the Grave." The National Gallery of Art believes the curly maple frame is original.

Illustrated as figs. 158, 14, and 18.

1. Mather and Miller, *Edward Hicks*, p. 189.

82

"An Indian summer view of the Farm & Stock of JAMES C. CORNELL . . ."
Oil on canvas, 36¾" x 49"
1848

OWNERSHIP HISTORY: James C. Cornell undoubtedly commissioned this painting from the artist. Two years earlier, Cornell had engaged Hicks to do a portrait of his prize bull (checklist no. 75). This painting passed to Cornell's descendants and then was purchased by Mr. and Mrs. J. Stanley Lee, Newtown, Pa. Mrs. Lee, née Hannah Brown, was the great-granddaughter of the artist. She sold the picture to Edgar William and Bernice Chrysler Garbisch, New York, N. Y., who presented it to the National Gallery of Art, Washington, D. C., in 1964.[1]

The painting bears the artist's inscription along the lower edge of the canvas beginning at left: "An Indian summer view of the Farm & Stock of JAMES C. CORNELL of Northampton, Bucks County, Pennsylvania, That took the Premium in the Agricultural Society: October the 12, 1848/Painted by E. Hicks in the 69th year of his age."

The painting retains its original 5 1/8-inch beveled chestnut-veneered pine frame.[2]

Illustrated as figs. 171 and 173.

1. Mather and Miller, *Edward Hicks*, p. 195.
2. Information courtesy, Steve Wilcox, National Gallery of Art, Washington, D. C., 1998.

83

"A May morning view of the Farm and Stock of David Leedom . . ."
Oil on canvas, 40⅛" x 49¹⁄₁₆"
1849

OWNERSHIP HISTORY: The first owner was David Leedom, the son of Jesse and Mary Twining Leedom, Newtown, Pa., members of Makefield Meeting, which was exclusively Hicksite after 1827. Unidentified Leedom descendants subsequently sold the painting to Mrs. John Law Robertson, Scranton, Pa. In

1957, the AARFAC acquired it from the Robertson Collection through M. Knoedler & Co., New York, N. Y.[1]

At lower left in yellow paint is the artist's inscription, "A May morning view of the Farm and Stock of DAVID LEEDOM of Newtown Bucks County—Pennsylvania/with a representation of Himself. Wife. Father. Mother. Brothers. Sisters and nephew." In yellow paint on the right-hand side is "Painted by Edw. Hicks in the 70th year of his age." This painting was probably one of two that Hicks completed shortly before his death (see checklist no. 62).

During conservation, graphite underdrawings were found on the canvas. The composition of the painting is complex and required that Hicks lay out the vista as he knew it from life before painting it. By composing the picture in this sequence, Edward was able to organize the animals, farmland, and buildings to his satisfaction as well as the patron's. A number of changes made in the underdrawing are now visible through the paint that has become transparent with age. These refinements indicate that Edward gave considerable care to the arrangements, linear perspective, and other details of his pictures.[2]

Illustrated as figs. 172 and 163.

1. AARFAC archives; Mather and Miller, *Edward Hicks*, p. 197.
2. Information courtesy, Scott Nolley, associate conservator, CWF, 1998.

Historical and Patriotic Paintings

84
Liberty, Meekness, and Innocence
Oil on wood, 14" x 9¾"
1830–1835

OWNERSHIP HISTORY: Nothing is known about the early history of this small panel picture. Mather and Miller stated that it was owned by dealer Marian Conrad Beans, Newtown, Pa., prior to its sale to the Museum of Modern Art, New York, N. Y. It was later purchased by Robert W. Carle, South Salem, Conn., and New York, N. Y., a descendant of Edward Hicks. AARFAC archives indicate that it was owned by Carle's nephew in the 1960s.[1]

Lettered in the banner held by the youthful female are "LIBERTY," "MEEKNESS," and "INNOCENCE." Mather and Miller noted that the frame is possibly original. The current owner believes that the veneered frame is of the period.[2]

Illustrated as fig. 134.

1. Mather and Miller, *Edward Hicks*, p. 169.
2. Ibid.; information courtesy, current owner, 1998.

85
"PENN'S TREATY"
Oil on canvas, 17⅝" x 22¾"
1830–1835

OWNERSHIP HISTORY: The original owner is unknown. The painting was acquired early in this century by dealer Charles F. Montgomery and then sold to J. Stuart Halladay and Herrel George Thomas, Sheffield, Mass. It came to the AARFAC in 1958 as part of the Halladay-Thomas Collection.[1]

In black paint on the scroll within the painting at the right foreground is "Charter of/Pennsylvania/in North Ame[rica]/Treaty with/the Indians in—/1681 with out an/oath & never bro[ken]/Wm. Penn/Thos.Lloyd/James Logan/Thos Story/Thos. Janney/Wm. Markham."

The painting retains its original mahogany-veneered flat frame with corner blocks and "PENN'S *TREATY*" lettered in yellow paint across the bottom member. Edward Trego may have made the frame.[2]

Illustrated as fig. 153.

1. AARFAC archives; Mather and Miller, *Edward Hicks*, p. 171.
2. Mather and Miller, *Edward Hicks*, p. 171.

86
"PENNS TREATY"
Oil on canvas, 17¼" x 23¼"
1830–1835

OWNERSHIP HISTORY: According to Mather and Miller, the original owner may have been Dr. David Hutchinson, the grandson of David and Elizabeth Twining and a Hicksite member of Makefield Meeting, Bucks County, Pa. They indicated that the first recorded owner was Hutchinson's son James Pemberton Hutchinson, Newtown, Pa. Subsequent owners were Thomas Ross, Doylestown, Pa., and the Robert Carlen Gallery, Philadelphia, Pa. The painting has been owned by Mr. and Mrs. Meyer P. Potamkin, Philadelphia, Pa., since 1979.[1]

The painting retains its original mahogany-veneered flat frame with corner blocks and the title "PENN'S *TREATY*" on the lower member. Edward Trego may have made the frame. The inscription on the scroll, which is difficult to read, contains a message similar to that on the others in the series, including the names of William Penn, Thomas Lloyd, James Logan, Thomas Story, Thomas Janney, and William Markham.

1. Mather and Miller, *Edward Hicks*, p. 172.

87
"PENN'S TREATY"
Oil on canvas, 17¾" x 24"
1830–1835

OWNERSHIP HISTORY: Edith Gregor Halpert, American Folk Art Gallery, New York, N. Y., was the earliest recorded owner. Mather and Miller noted that Thomas Gilcrease, Claremore, Okla., purchased the painting from Halpert and later gave it to the Thomas Gilcrease Institute of American History and Art, Tulsa, Okla.[1]

The inscription on the scroll in Penn's hand includes "Charter of/ Pennsylvania/North America." The names William Penn, Thomas Lloyd, Thomas Story, James Logan, Thomas Janney, and William Markham are inscribed on the lower portion of the scroll. The painting retains its original mahogany-veneered frame with corner blocks and the lettered title "PENN'S TREATY" painted in gold on its lower member.[2]

1. Mather and Miller, *Edward Hicks,* p. 173.
2. Information courtesy, Thomas Gilcrease Institute of American History and Art, Tulsa, Okla., 1998.

88
"PENN'S TREATY"
Oil on canvas, 17½" x 23½"
1830–1835

OWNERSHIP HISTORY: The painting descended in the Ruddle family of Pennsylvania, according to Mather and Miller. John Ruddle, Bucks County, Pa., may have been the original owner. It passed to his son George Ruddle, and then to his daughter Eliza Ruddle, Mauch Chunk, Pa., and her husband, Lawrence Ruddle. Other owners were Mrs. Roger Ruddle, W. Kent Haydock, Peter Tillou, and Kennedy Galleries, Inc., New York, N. Y. The painting was acquired by a private collector and was placed on extended loan to the White House, Washington, D. C.[1] In the early 1990s, the painting was returned to the owners.

Although only partly legible, the inscription on the scroll is similar to that on other versions. The painting retains its original Edward Trego-type mahogany- or cherry-veneered frame with corner blocks. Lettered in gold paint on the lower member of the frame is the painting's title, "PENN'S TREATY."

1. Mather and Miller, *Edward Hicks,* p. 174.

89
"PENN'S TREATY"
Oil on canvas, 17¾" x 23¾"
1830–1835

OWNERSHIP HISTORY: Hirschl & Adler Galleries, New York, N. Y., stated that the painting descended through an unidentified branch of the Hicks family to the artist's great-grandson Robert W. Carle, South Salem, Conn., and New York, N. Y. Carle gave the painting to the Yale University Art Gallery, New Haven, Conn. Hirschl & Adler Galleries, New York, N. Y., subsequently sold it to a private collector before October 1980.[1] The current owner and location are unknown.

The inscription on the scroll is an abbreviated version of those on the other pictures in this group. The painting retains its original cherry-veneered frame with corner blocks of the type made by Edward Trego. "PENN'S TREATY" is lettered in gold paint on the lower member of the frame.

1. *American Art from the Gallery's Collection,* exhibit catalog, Hirschl & Adler Galleries (New York, 1980); Hirschl & Adler

Galleries advertisement, *The Magazine Antiques,* CXII (1977), p. 786; Mather and Miller, *Edward Hicks,* p. 175.

90
"Washington Crossing Delaware"
Oil on wood, 17" x 21½"
1833–1835

OWNERSHIP HISTORY: The original owner and much of this painting's early history are unknown. The first recorded owner, according to Mather and Miller and the AARFAC archives, was Leonardo L. Beans, Trenton, N. J. It was subsequently sold and is currently owned by a private collector.

The most unusual aspect of this painting is its frame. Ford noted that two of its many carved elements, the oak leaves and acorns, resemble a sketch on the back of a letter from the artist's mother to his father.[2] The frame is thought to be original, although this is difficult to confirm without information about original ownership and descent.

The inscription on the back of the panel, presumably added by an owner, reads "Washington Crossing Delaware/E. H. 1817 Phila. Pa." It differs in wording and construction from most other inscriptions by Hicks. For that reason and because of its strong stylistic relationship to later versions, "1817" probably does not relate to the painting's date of execution.

Illustrated as fig. 150.

1. Mather and Miller, *Edward Hicks,* p. 154.
2. Ford, *Hicks: Painter of the Peaceable Kingdom,* pp. 28, 117.

91
"PENN'S TREATY."
Oil on canvas, 20⅞" x 27⅞"
1835–1840

OWNERSHIP HISTORY: Mather and Miller noted that this painting was given by the artist to Abraham Chapman's daughter Wilhelmina, Doylestown, Pa. It passed to her daughter Mary Ann Lyman, Boston, Mass., and then to her daughter Marian Lyman. Henry Chapman Mercer, the next owner, gave it to the Bucks County Historical Society, Doylestown, Pa.[1] The Bucks County Historical Society files cannot confirm this history, but state that the painting was presented to them by Miss Lyman prior to 1920.[2]

The inscription on the scroll reads "PENN's Treaty/With the/INDIANS/FOR/PENNSYVAN." Most of the scroll is filled with scribbles rather than actual words. The "S" in Indians is painted backward. Since the word "Pennsylvania" trails off near a curve in the scroll, the last two letters are presumably under the fold.[3]

The veneered frame with raised corner blocks is believed to be original. "Penn's Treaty" is lettered on the frame.[4]

Illustrated as figs. 154 and 66.

1. Mather and Miller, *Edward Hicks,* p. 178.
2. Information courtesy, Mary Catherine Bluder, Bucks Co. Hist.

2. Information courtesy, Mary Catherine Bluder, Bucks Co. Hist.
 Soc., 1998.
3. *Ibid.*
4. *Ibid.*

92
"PENN'S TREATY"
Oil on canvas, 17¾" x 23¾"
1835–1840

OWNERSHIP HISTORY: Nothing is known about the history or
location of this painting, which was not included in Mather
and Miller's 1983 catalog of works. The only source of infor-
mation is the 1953 *Portfolio* illustration and commentary.[1]

In 1953, the painting retained its original mahogany-ve-
neered frame with corner blocks of the type made by Edward
Trego. The lower member of the frame featured the title
"PENN'S TREATY" in gold paint.

1. *Portfolio*, XIII (1953), p. 48.

93
Penn's Treaty
Oil on canvas, 17¾" x 23⅝"
1853–1840

OWNERSHIP HISTORY: Nothing is known about the nine-
teenth-century history of this painting. Miss Ima Hogg pur-
chased it in 1922 from the Jacob Paxson Temple sale at Ander-
son Galleries, New York, N. Y., for her brother and
sister-in-law, Mike and Alice Hogg, New York, N. Y. Following
Mike's death, Alice married Harry Hanszen, Houston, Tex.
The painting was given to her niece Alice C. Simkins, Hous-
ton, Tex., who presented it to the Museum of Fine Arts, Bayou
Bend Collection, Houston, Tex., in memory of Alice Hanszen
in 1977.[1]
Inscribed and lettered on the scroll behind Penn's left hand
is "CHARTER/of/PENNSYLVA[NIA]/Treaty with the/IN-
DIAN'S/ [illeg.]."

1. Mather and Miller, *Edward Hicks*, p. 176; information courtesy,
 Katharine S. Howe, Museum of Fine Arts, Houston, Tex.,
 AARFAC archives, Feb. 20, 1978.

94
Washington at the Delaware
Oil on canvas, 17¼" x 23¼"
1835–1840

OWNERSHIP HISTORY: This painting was given to Abraham
Chapman, a close friend of the artist, according to Mather and
Miller. It then descended in Chapman's family to his son the
Hon. Henry Chapman of Doylestown, Pa.; to his son Arthur
Chapman; and to Arthur Chapman's nephew Henry Chapman

Mercer. Mercer gave it to the Mercer Museum, Bucks County
Historical Society, Doylestown, Pa.[1]
The veneered frame with raised corner blocks appears to be
original.
Illustrated as fig. 61.

1. Mather and Miller, *Edward Hicks*, p. 157; The Bucks Co. Hist.
 Soc. files cannot confirm this history because the picture was
 not accessioned at the time it was donated and thus no informa-
 tion was recorded.

95
"Washington Passing the Delaware . . ."
Oil on wood, 14¾" x 20"
1835–1840

OWNERSHIP HISTORY: This painting, like several others in the
checklist, was owned early in the twentieth century by
Leonardo L. Beans, Trenton, N. J. It subsequently was sold to
an unidentified collector before being purchased by dealer
Clarence Prickett, Yardley, Pa. H. Richard Dietrich, Jr.,
Philadelphia, Pa., acquired the picture in 1981.[1]
Mather and Miller qualified the attribution of this work to
Edward Hicks as "somewhat uncertain." Although the inscrip-
tion varies from Hicks's usual wording and perhaps is not in
his hand, the style of the painting is very similar to other sur-
viving documented versions.[2] The small size is unique.
The painting is inscribed on the verso of the panel "Wash-
ington Passing the Delaware/Evening Previous to the Battle
of Trenton Dec 25 1776/E. H." It retains the original black
walnut frame with crotched-grain and black-painted corner
blocks.[3]
Illustrated as fig. 152.

1. Mather and Miller, *Edward Hicks*, p. 158.
2. *Ibid.*
3. *Ibid.;* information courtesy, Jacqueline DeGroft for H. Richard
 Dietrich, Jr., Philadelphia, Pa., 1998.

96
Washington at the Delaware
Oil on canvas, 36" x 49"
1835–1840

OWNERSHIP HISTORY: According to Mather and Miller, the
earliest documented owner was Bihler and Coger Antiques,
Ashley Falls, Mass. H. Richard Dietrich, Jr., Philadelphia, Pa.,
acquired the painting in 1966.[1]
The frame is a period reproduction.[2]

1. Mather and Miller, *Edward Hicks*, p. 159.
2. Information courtesy, Jacqueline DeGroft, Dietrich American
 Foundation, Philadelphia, Pa., 1998.

97
Washington at the Delaware
Oil on canvas, 37½" x 47⅝"
1835–1840

OWNERSHIP HISTORY: The nineteenth-century history is unknown. The painting was purchased by auctioneers Stalker and Boos, Birmingham, Mich., and sold in 1972 to the Henry Ford Museum, Dearborn, Mich.[1]

1. Mather and Miller, *Edward Hicks*, p. 160.

98
"COLUMBUS"
Oil on canvas, 17½" x 23½"
1836–1840

OWNERSHIP HISTORY: Painted for a member of the William Janney family, Newtown, Pa., the picture was taken with Mary Janney to Loudon County, Va., when she moved there after her marriage. It was apparently presented by her or a member of her family to Goose Creek Meeting, Loudon County. The meeting is said to have given it to an unidentified family in Silver Spring, Md. Dealer Robert Carlen, Philadelphia, Pa., acquired the painting early in this century, and sold it to Edith Gregor Halpert, Downtown Gallery, New York, N. Y., after which it passed through M. Knoedler & Co., New York, N. Y.; Joseph Katz Co., New York, N. Y.; M. Knoedler & Co., New York, N. Y. Edgar William and Bernice Chrysler Garbisch, New York, N. Y., purchased the picture in 1947. In 1980, it was given to the National Gallery of Art, Washington, D. C.[1]

The title "COLUMBUS" is lettered in black paint at the center bottom of the canvas.[2]

1. Mather and Miller, *Edward Hicks*, p. 205; Chotner et al., *American Naive Paintings*, p. 187.
2. Chotner et al., *American Naive Paintings*, p. 187.

99
"THE DECLARATION OF INDEPENDENCE, 1776"
Oil on canvas, 26¼" x 29¾"
1840–1845

OWNERSHIP HISTORY: The only reference to the early ownership history of this painting is in the files of the version owned by the AARFAC (checklist no. 100). Early in the twentieth century, Col. Henry D. Paxson annotated a note then owned by a grandson of the artist, stating that "another version" of the painting was owned by Horace Burton. Presumably, he was the Horace Burton Mather and Miller identified as living in Edgely, Bucks County, Pa. Horace Burton was descended from the Burton family, who have been associated with the Peaceable Kingdom painting in checklist no. 28. The painting was sold to the Robert Carlen Gallery, Philadelphia, Pa., and then to Edith Gregor Halpert, Downtown Gallery, New York, N. Y. It subsequently passed through dealers M. Knoedler & Co.,

New York, N. Y.; Joseph Katz Co., New York, N. Y.; and M. Knoedler & Co., New York, N. Y. Edgar William and Bernice Chrysler Garbisch, New York, N. Y., acquired the picture and gave it to the Chrysler Museum, Norfolk, Va., in 1976.[1]

The painting retains what is probably its original bird's-eye maple frame. Hicks lettered the title, "THE DECLARATION OF INDEPENDENCE, 1776," at the top of the canvas.[2]

1. Mather and Miller, *Edward Hicks*, p. 166.
2. *Ibid.*

100
"THE DECLARATION OF INDEPENDENCE Ju,ʸ 4, 1776"
Oil on canvas, 24" x 34¾"
1840–1845

OWNERSHIP HISTORY: According to documentation acquired by the AARFAC with the painting, it was presented by Edward Hicks to his son Isaac W. Hicks, Newtown, Pa. It passed to Isaac's son Edward Hicks, Newtown, Pa., and then to his daughter Mary Barnsley Hicks Richardson, Sweet Briar, Va. It was owned by Capt. Richard A. Loeb, Hampton, N. J., prior to being purchased by Howard and Jean Lipman, Wilton, Conn. Dealer Mary Allis, Southport, Conn., bought the picture and subsequently sold it to M. Knoedler & Co., New York, N. Y. The AARFAC purchased it in 1957.[1]

The eagle at the cornice holds a banner with the lettered phrase "E PLURIBUS UNUM. IN UNITY, THERE IS STRENGTH." The title of the picture, "THE DECLARATION OF INDEPENDENCE Ju,ʸ 4 1776," is lettered on the wall below. The mahogany-veneered cove-molded frame with corner blocks may be original.

Illustrated as fig. 63.

1. AARFAC archives; Mather and Miller, *Edward Hicks*, p. 167.

101
"THE ILLUSTRIOUS PATRIOTS OF 1776 AND AUTHORS OF THE DECLARATION OF INDEPENDENCE. 1844."
Oil on canvas, 26" x 30"
1844

OWNERSHIP HISTORY: Nothing is known about ownership in the nineteenth century. Leonardo L. Beans, Trenton, N. J., purchased the picture prior to 1951. It was auctioned as part of his estate at Sotheby's, New York, N. Y., in 1980. Hirschl & Adler Galleries, New York, N. Y., owned the painting in 1981.[1] Subsequently sold at auction, it is currently owned by a private collector.

The painting's title, "THE ILLUSTRIOUS PATRIOTS OF 1776 AND AUTHORS OF THE/DECLARATION OF INDEPENDENCE. 1844." is lettered in a separate border at the top of the canvas. Within the banner held by the eagle below is "E PLURIBUS UNUM." "In UNITY there is STRENGTH" lettered below arches from the cornice of the left window to that of the right.

The curly maple-veneered frame with corner blocks is probably the original.[2]

1. Mather and Miller, *Edward Hicks*, p. 168.
2. *Ibid.*

102
"PENNS TREATY with the INDIANS"
Oil on canvas, 25" x 30¼"
1840–1845

OWNERSHIP HISTORY: This is one of two versions of Penn's Treaty that Mather and Miller believed was probably owned by Dr. David Hutchinson, son of Sarah Twining Hutchinson and grandson of David and Elizabeth Twining. This example's history is better documented. It was inherited by David Hutchinson's son Edward Stanley Hutchinson, Newtown, Pa., whose daughter Helen Caples, Princeton, N. J., was the next owner. From her, the painting passed to three children, one of whom was Mrs. M. W. Barrett, Norfolk, Va. It was subsequently sold to Arthur E. Bye, Holicong, Pa., and purchased by Edith Gregor Halpert, Downtown Gallery, New York, N. Y. The Shelburne Museum, Shelburne, Vt., acquired the picture in 1953.[1]

The extensive lettered inscription within a painted border at the bottom of the canvas reads: "PENNS TREATY with the INDIANS, made 1681 with/out an Oath, and never broken. The foundation of Religious and Civil LIBERTY, in the U. S. of AMERICA." "PENNSYLVANIA" is lettered on the scroll.

Illustrated as fig. 155.

1. Mather and Miller, *Edward Hicks*, p. 180. See also checklist no. 86.

103
"PENNS TREATY with the INDIANS . . ."
Oil on canvas, 24¼" x 30⅛"
1840–1845

OWNERSHIP HISTORY: Nothing is known about the early history of this painting. Elie Nadelman, the first known owner, retained it until 1943. M. Knoedler & Co., New York, N. Y., owned the work from 1943 to 1944. It was sold to Joseph Katz, New York, N. Y., and remained in his ownership until 1947. That year it was acquired by M. Knoedler & Co., New York, N. Y., and sold to Edgar William and Bernice Chrysler Garbisch. The Garbisches gave it to the National Gallery of Art, Washington, D. C., in 1980.[1]

The painting retains its original molded and brown-painted frame. Lettering within the border at the bottom of the painting reads: "PENNS TREATY with the INDIANS, made 1681 with/out an Oath, and never broken. The foundation of/Religious and civil LIBERTY, in the U. S. of AMERICA." "PENNSYLVANIA" is lettered on the scroll.[2]

1. Chotner et al., *American Naive Paintings*, p. 189.
2. Mather and Miller, *Edward Hicks*, p. 181.

104
"PENNS TREATY with the INDIANS . . ."
Oil on canvas, 24" x 30"
1840–1845

OWNERSHIP HISTORY: The original owner is unknown. It was purchased by David David, Inc., Philadelphia, Pa. Hirschl & Adler Galleries, New York, N. Y., acquired the painting and subsequently sold it to the Dietrich American Foundation (formerly Dietrich Brothers Americana Corporation), Philadelphia, Pa.[1] In 1993, the painting was sold through Christie's to a private collector.[2]

Lettered in the border at the bottom of the canvas is "PENNS TREATY with the INDIANS, made 1681 with/out an Oath, and never broken. The foundation of/Religious and Civil LIBERTY in the U. S. of AMERICA." The inscription on the scroll is illegible; Hicks painted nondescript lines in place of words. The only two legible words are "CHARTER" and "PENNSYLVA[NIA]." "Charter" is thought to refer to Penn's Charter of Privileges, which granted liberty to Pennsylvanians in 1701.[3]

1. Mather and Miller, *Edward Hicks*, p. 182.
2. Information courtesy, Dietrich American Foundation, Philadelphia, Pa., 1998.
3. Mather and Miller, *Edward Hicks*, p. 182.

105
"Wᴹ PENNS TREATY with the INDIAN'S 1681"
Oil on canvas, 24¾" x 29¾"
1847

OWNERSHIP HISTORY: Mather and Miller listed the original owner as Edward Leedom, Bristol and Newtown, Pa. He was a son of Mary Twining and Jesse Leedom and died in 1871. The painting was inherited by his great-granddaughter Mrs. Dora Leedom Cadwallader, and then purchased by dealer Robert Carlen, Philadelphia, Pa. It was purchased by a private collector who placed it on loan to the State Department, Washington, D. C.[1] In 1990, the picture was sold through Sotheby's, New York, N. Y., to a private collector.

The canvas is lettered at the base with the title, "Wᵐ PENNS *TREATY* with the *INDIAN'S 1681*." The only word on the scroll that can be deciphered is "PENNSYLVANIA." The frame is not original to the painting.[2]

1. Mather and Miller, *Edward Hicks*, p. 183.
2. *Ibid.*

106

"George Washington with his army crosing the Delaware . . ."
Oil on canvas, 36⅛" x 47⅜"
1848

OWNERSHIP HISTORY: The AARFAC archives and the painting's inscription indicate that it was originally owned by Dr. Morris Linton, a dentist in Newtown, Pa. His nephew Henry Ridge, the next owner, wrote in 1957: "Both my sister and I distinctly remember this painting without a frame before it was sent to our attic fifty odd years ago. . . . It is very likely that Hicks did this work for my great uncle . . . in payment for a medical bill and did not include a frame."[1] The painting was sold to M. Knoedler & Co., New York, N. Y., and purchased for the AARFAC in 1957.

The artist's inscription, beginning at lower left, reads: "Painted by Edw. Hicks in the 69th year of his age/for Doctor M. Linton of Newtown, son of his/old Friend & fellow Soldier, James Linton," (continuing at lower center) "George Washington with his army crosing the Delaware/at McConkey Ferry the night before he took the Hessians, Dec. 25, 1776."

Illustrated as fig. 151.

1. Henry Ridge to Mitch Wilder, AARFAC archives, 1957.

107

Washington at the Delaware
Oil on canvas, 28" x 35¾"
1849

OWNERSHIP HISTORY: Nothing has been discovered about the early history of this painting. It was purchased by Edgar William and Bernice Chrysler Garbisch, who gave it to the Chrysler Museum, Norfolk, Va., in 1977.[1]

The date "1849" is inscribed on the verso of the stretcher. According to the museum's files, the canvas is inscribed on the reverse, "Painted by Edw. Hicks in his 70th year." The painting has since been lined and therefore the inscription is no longer visible. Although this painting does not retain its original frame, it has an old pine frame from a maker named Heyderyk.[2]

1. Information courtesy, Chrysler Museum, Norfolk, Va., 1998.
2. Ibid.

Religious and Related Paintings

108

Noah's Ark
Oil on canvas, 26" x 30"
1846

OWNERSHIP HISTORY: According to the Philadelphia Museum of Art and Mather and Miller, this important painting was created for Dr. Joseph Parrish, Burlington, N. J. He was the son of Dr. Joseph Parrish, Philadelphia, Pa., longtime friend of the artist and one of his patrons. An unidentified New Jersey family sold it to Harry Shaw Newman, New York, N. Y., early in the twentieth century. It subsequently was sold to M. Knoedler & Co., New York, N. Y., and acquired by Mr. and Mrs. William M. Elkins, Philadelphia, Pa. Mrs. Elkins bequeathed it to the Philadelphia Museum of Art.[1]

The painting is small by comparison with the impression it makes as a book illustration. Hicks placed the biblical event in an expansive landscape. The source for this composition was Nathaniel Currier's 1844 lithograph, as Ford and Mather and Miller noted.[2] Hicks added a few elements, including a lion that is much like those seen in his Peaceable Kingdoms.

Inscribed by the artist on the verso of the stretcher is "Painted by E. Hicks in the 67th year of his age," "And they went in unto Noah in the ark, two and two of all flesh, wherein is the breath of life Se. Gen. VII 15." The stretcher is finished and painted dark green.[3]

Illustrated as fig. 82.

1. Mather and Miller, Edward Hicks, p. 206.
2. Ford, Hicks: Painter of the Peaceable Kingdom, p. 85; Mather and Miller, Edward Hicks, p. 206.
3. Information courtesy, Darrel Sewell and Mark Tucker, Philadelphia Museum of Art, Philadelphia, Pa., 1998.

109

"David & Jonathan at the Stone Ezel"
Oil on canvas, 24" x 32"
1846–1847

OWNERSHIP HISTORY: The early history is unknown. It was purchased by Leonardo L. Beans, Trenton, N. J., and auctioned as part of his estate at Sotheby's, New York, N. Y., in 1980. The John Gordon Gallery purchased the painting.[1] The picture came up for auction in the Jan. 15, 1999 sale at Christie's, New York, N. Y.

The biblical story illustrated here is from 1 Sam. 20:13–42. The painting is inscribed at the bottom beneath the figures "David & Jonathan at the Stone Ezel." Inscribed by the artist on the strainer is "Painted by Edw. Hicks in his 67 Yr."[2]

1. Mather and Miller, Edward Hicks, p. 207.
2. Ibid.

Signboards, Banners, and Decorated Objects

110

Vanhorn Signboard
Oil on wood, 17⅛" x 54³⁄₁₆"
1800–1805

OWNERSHIP HISTORY: The sign descended in the Vanhorn family in the following manner: Henry Vanhorn, Bucks County, Pa.; to his son John R. Vanhorn (b. 1820), Bucks County, Pa.; to his son Joseph Feaster Vanhorn (1854–1924), Bucks County, Pa.; to his son Joseph Watson Vanhorn (b. 1890), Bucks County, Pa.; to his son Joseph Feaster Vanhorn (b. 1917), Bay Head, N. J. The AARFAC purchased the sign from the last Vanhorn in 1986.[1]

Henry Vanhorn opened his cabinet shop in Newtown, Pa., in 1796. At that time, Edward Hicks was sixteen years old and working as an apprentice. Probably created around 1800, the signboard may be the artist's earliest surviving work. Vanhorn moved to Lower Makefield Township, Bucks County, around 1800 and was listed in the tax records as a carpenter. He may have ended his woodworking career and taken up farming around 1812.

The sign shows Vanhorn was capable of satisfying his customers' carpentry needs "from cradle to grave." Interestingly, Hicks reversed the progression by painting the coffin to the left, a chest of drawers in the center, and a cradle at right. Vanhorn may have corrected an error on the sign since an "e" at the end of "HORN" was scraped off.

The execution of the sign differs from easel painting in its linear, draftsmanlike style exemplified by the clearly defined letters and bold linework around the pictorial images. It could be read easily at a distance, and its visual impact as well as its message were eye-catching. Two nail holes, one above the image of the coffin and the other within the image of the cradle, indicate the sign was originally nailed to the facade of Vanhorn's shop. The sign bears the words "HENRY VAN HORN/Carpenter & Joiner." Carved into the back panel is "1790," which may have been added at a later date. Its significance is unknown.

Illustrated as fig. 58.

1. AARFAC archives. The signboard first came to the attention of the AARFAC staff in 1960 when publicity about the Edward Hicks exhibit at the museum appeared in Tidewater Virginia newspapers. The last Vanhorn owner was living in Newport News, Va., at the time. He was aware through family tradition that the sign had been painted by a "famous Quaker minister" but did not know his name. The owner contacted the AARFAC and, after examination of the sign, it was attributed to Edward Hicks.

 Current family members write their surname as "Van Horn." "Vanhorn" has been used in this text as it appears in nineteenth-century records.

111

Jacob Christ Signboard
Oil on wood, 36" x 98"
1810–1840

OWNERSHIP HISTORY: It is believed that the sign was painted for Christ's hat shop, Nazareth, Pa. The first John Jacob Christ began the manufacture of "stovepipe" hats in 1771. By 1803, his son-in-law Christian Henry Miller had also entered the hatmaking business. The sign was probably painted for a second-generation Christ. It descended through three generations of the Christ family and then was acquired by dealer H. K. Deisher, Kutztown, Pa., who sold it to Dr. Henry Chapman Mercer. Dr. Mercer presented the signboard to the Bucks County Historical Society, Doylestown, Pa., in 1918.[1]

The sign is laid out in three sections on one wide wooden board. The left has a dog chasing a fox with other animals, the center features two shelves on which hats are displayed, and the right depicts a dark-skinned native American with a bow and arrow. "Jacob Christ, Hatter" is lettered in gold on the bottom margin.

The wooden panel has a narrow painted molding attached to three sides (originally around all four sides).[2]

Illustrated as fig. 68.

1. Information courtesy, Mary Catherine Bluder, Bucks Co. Hist. Soc., 1998.
2. *Ibid.*

112

Jacob Christ Signboard
Oil on wood, 20½" x 33"
1810–1840

OWNERSHIP HISTORY: The origin is unknown. The panel apparently was painted for hatter C. H. Miller, the son-in-law of the first Jacob Christ, over which Jacob Christ's name was later painted. He owned the Christ hat shop, Nazareth, Pa. Dealer H. K. Deisher, Kutztown, Pa., acquired the signboard and sold it to Dr. Henry Chapman Mercer, Doylestown, Pa., in 1918. Mercer presented it to the Bucks County Historical Society, Doylestown, Pa.[1]

The panel features six stovepipe hats with side brims and different buckles and bands against a white background. The colors of the hats vary. The bottom five inches of the panel is inscribed "Jacob Christ: Hatter."

The wooden panel is mounted in a frame which consists of a broad apron 1½" wide by ¼" deep with an outer molding 1" wide and 2" deep. It is believed to be original.[2]

Illustrated as fig. 69.

1. Information courtesy, Mary Catherine Bluder, Bucks Co. Hist. Soc., 1998.
2. *Ibid.*

113

Holland Sabbath School Banner
Oil and gold-leaf paint on silk; silk backed on canvas; gold (metal) fringe, 31½" x 32¼", fringe along bottom, 1½"
Ca. 1821

OWNERSHIP HISTORY: The banner is believed to have been painted for Christopher Vanartsdalen, who was responsible for starting the Holland Sabbath School of Churchville Dutch Reformed Church, Churchville, Pa., in 1821. The next recorded owner, Vanartsdalen's great-granddaughter Mrs. William B. Koehler, Frankford, Pa., presented the banner to the Bucks County Historical Society, Doylestown, Pa., in 1927.[1]

Lettered in gold paint, the banner reads "Holland Sabbath School/Remember now thy creator in the days of thy youth." On the opposite side is "Instituted 1821./Come with us." It features a small building, probably the schoolhouse, which is surrounded by trees and three people.

Illustrated as fig. 157.

1. Object files, Mercer Museum, Bucks Co. Hist. Soc.

114

Newtown Library Signboard
Oil on wood, 17¾" x 37½"
1825

OWNERSHIP HISTORY: In 1825, the Newtown Library Company, Newtown, Pa., commissioned Edward Hicks to paint this sign for their new building. For his work, Edward was paid $1.00. Hicks may have been recommended for the task by the library's treasurer, Asa Cary, for whom Edward had painted a tavern sign. The chairman of the library's building committee, Dr. Phineas Jenks, may also have suggested the artist since Hicks had painted a fireboard for him.[1] The Newtown Library Company continues to own the sign.

The two ribbon banners surrounding the portrait of Franklin are lettered in Latin (left) "BIBLIOTHECA EST UTILE" and (right) "JUVENIBUS SENIBUS JUCUNDA," loosely translated as "Books are useful to young and old." The sign has its original molded frame.[2]

Illustrated as figs. 55 and 56.

1. Pullinger, *Newtown's First Library Building*, p. 6; Mather and Miller, *Edward Hicks*, pp. 164–165.
2. Mather and Miller, *Edward Hicks*, p. 165.

115

"WASHINGTON crossed here . . ."
Oil on canvas originally mounted on wood panel, 31½" x 31½"
1833

OWNERSHIP HISTORY: This sign is one of two that were placed at the entrance to the bridge spanning the Delaware River from the New Jersey side to Taylorsville in Bucks County (checklist no. 116). A nineteenth-century account recorded that Huston Thompson rescued the sign in 1841. He ran onto the bridge during a flood and retrieved the sign just as the bridge was ready to fall. The sign was later discovered in the loft of the Taylorsville store located only a short distance from the original bridge. Mather and Miller cite the owner as James B. Jamison, who gave the sign to Henry Chapman Mercer, Doylestown, Pa. Mercer in turn donated it to the Mercer Museum, Bucks County Historical Society, Doylestown, Pa., in 1897.[1]

In the border at the bottom is lettered "WASHINGTON crossed here/ Christmas-eve 1776, aided by Genl's/*Sullivan, Greene, lord Sterling Mercer & C.*" A peculiar feature is the way the last lettered line ends: there appears to be a "c" after the ampersand. The last line on the companion signboard (checklist no. 116) ends with the name "St. Clair." Perhaps Hicks simply miscalculated the space for the inscription on this version, or it may have been altered. Unlike the companion signboard, this example is on canvas mounted on a pressed wood panel. The painting was conserved in 1975.[2]

The bridge opened on January 1, 1834, so the sign was completed in 1833, not 1834 as previously published.

Illustrated as fig. 59.

1. Information courtesy, Mary Catherine Bluder, Bucks Co. Hist. Soc., 1998; Mather and Miller, *Edward Hicks*, p. 157.
2. Information courtesy, Mary Catherine Bluder.

116

"WASHINGTON Crossed here . . ."
Oil on wood, 32" x 31½"
1833

OWNERSHIP HISTORY: This is one of two signs Hicks created for the bridge that spanned the Delaware River from Taylorsville, Pa., to New Jersey (checklist no. 115). It was originally located at the New Jersey entrance to the bridge. According to Mather and Miller, this sign was also rescued from the flood that destroyed the bridge in 1841. It then hung in the bar of Alexander Nelson's tavern in New Jersey, and later was located at Macy's department store in New York, N. Y. An unidentified owner sold it to William Secord, New York, N. Y. Dealer Robert Friedenberg, New York, N. Y., purchased the sign and sold it to dealer Harry Shaw Newman, New York, N. Y. in 1946. Subsequent owners included George G. Frelinghysen, Morristown, N. J.; Bertram K. and Nina Little, Brookline, Mass.; and Childs Gallery, Boston, Mass. In 1997, it was auctioned at Sotheby's, New York, N. Y.[1]

The lettered inscription in the border at the bottom reads "WASHINGTON Crossed here/Christmas-eve 1776, aided by Genl/ Sullivan, Greene, lord Sterling Mercer & St. Clair."

1. Mather and Miller, *Edward Hicks*, p. 155; *American Paintings, Drawings and Sculpture*, auction catalog, Sotheby's (New York, Dec. 3, 1997).

117
Andrew Jackson
Oil on carriage cloth, 21½" x 19¹³⁄₁₆"
Ca. 1835

OWNERSHIP HISTORY: According to Mather and Miller, Isaac Worstall Hicks, Newtown, Pa., the artist's son, owned this picture. Isaac gave it to his daughter Sarah Worstall Hicks, Newtown, Pa. It then passed to Mr. and Mrs. J. Stanley Lee (Hannah Brown Hicks Lee, great-granddaughter of Edward Hicks), to their daughter Mrs. Eleanore Lee Swartz, and to a private collector who has placed the painting on loan at the Nelson-Atkins Museum of Art, Kansas City, Mo.[1]

The Lees stated that the picture was found rolled up in Hicks's workshop after his death and subsequently was mounted on a board so that it could be hung. However, it is unlikely that "Andrew Jackson" was intended as an easel painting to hang. Hastily painted, the picture is not typical of Hicks's usual crisp, precise brushwork. The picture's unusual support, which is heavier than normal painting canvas, the fact that it was rolled up when found, and its rather sketchy execution suggest use as a parade banner or sign for a special occasion.

Illustrated as fig. 156.

1. Mather and Miller, *Edward Hicks*, p. 165.

118
Penn's Treaty Signboard
Oil on wood, 57" x 57"
1844

OWNERSHIP HISTORY: Mather and Miller derived the ownership history from an 1884 publication by Henry Ashmead. The signboard was painted by Edward Hicks in 1844 for Samuel West, who presented it to Edward E. Flavill, owner of the Washington House, a temperance hotel in Chester, Pa.[1] Later ownership is not clear. William Band gave it to the Delaware County Historical Society in 1920. As of 1983, the society's collection was housed in the Wolfgram Memorial Library, Widener College, Chester, Pa.[2] The signboard was sold in 1986 to the Newtown Historic Association, Newtown, Pa.[3]

Illustrated as fig. 65.

1. Henry Graham Ashmead, *History of Delaware County*, 1884, p. 368, in Mather and Miller, *Edward Hicks*, p. 179.
2. *Ibid.*
3. Information courtesy, Newtown Hist. Assn., 1998.

119
William Wood Tavern Signboard
Oil on wood, 43½" x 29½"
1844–1847

OWNERSHIP HISTORY: The signboard was originally painted for tavern owner William Wood, New Jersey. Subsequent owner Leonardo L. Beans, Trenton, N. J., described it as a farmscape showing "various birds and a squirrel in and around a large tree." It may also have included a view of the tavern. It was on loan to, and then donated to, Historic Fallsington, Inc., Fallsington, Pa., in 1980.[1]

This signboard has traditionally been attributed to Edward Hicks on the basis of the stylistic similarity of its lettering to that on related works by the artist. Without a more extensive analysis, including identification of the paints and paint layers, the attribution remains strong but inconclusive because of the poor condition of the side that once had a landscape scene.

Lettered below the spread eagle with shield is "WM WOOD's/Tavern." The signboard retains its original simple frame and hanging hooks with chains.

1. L. L. Beans, *The Life and Work of Edward Hicks* (Trenton, N. J., 1951), p. 30; Mather and Miller, *Edward Hicks*, p. 170.

120
Still Life
Oil on panel, 10" x 21"
1846–1847

OWNERSHIP HISTORY: Mather and Miller noted that the following history was written on the back of the top member of the frame: "This panel is from the dining room of the/P. Oliver Hough House on S. State St. Newtown."[1] Hough, a Quaker printer, agreed to work with Hicks on Edward's memoirs for publication. As part of the house, the painting presumably descended in the family. Early in the twentieth century, the house was turned into offices, at which time the painting was removed and acquired by C. B. Sloan & Co., Washington, D. C. It was subsequently owned by Arthur R. Rupley, Alexandria, Va., and the John Gordon Gallery, New York, N. Y.[2] The painting came up for auction at Christie's, New York, N. Y., in early 1999.

On the reverse of the painting is the inscription "Painted by Edw. Hicks in the 67th year of his age." The frame with the information quoted above was probably added when the painting was removed from the house around 1916.[3]

1. Mather and Miller, *Edward Hicks*, p. 210.
2. *Ibid.*
3. *Ibid.*

Decorated Objects

121
Ornamented Tin Tray
Oil on tin, 19" x 26"
1815–1830

OWNERSHIP HISTORY: The tray is believed to have passed down through the Hicks family to J. Stanley Lee. Katherine K. Fabian, Newtown, Pa., acquired it in 1971 from the Lee estate.

122
Ornamented Rocking Chair
Oil on wood, 43½" x 23¾" x 33⅜"
1830–1845

OWNERSHIP HISTORY: It is believed that the rocking chair descended in the Hicks family to J. Stanley Lee. Beatrice Stump, Newtown, Pa., purchased the chair in 1971 and gave it to the Newtown Historic Association, Newtown, Pa., in 1994.
 Illustrated as fig. 52.

123
Ornamented Tin Box
Oil on tin, 1⅜" x 3" x 3"
Ca. 1835

OWNERSHIP HISTORY: It is believed that the box remained in the Hicks family and was passed down to J. Stanley Lee. In 1971, it was purchased by Beatrice Stump, Newtown, Pa. Mrs. Stump gave the box to the Newtown Historic Association, Newtown, Pa., in 1994.
 Illustrated as fig. 53.

124
Ornamented Miniature Chest
Oil on wood, 5⅜" x 8" x 4"
Ca. 1835

OWNERSHIP HISTORY: It is believed that the chest remained in the Hicks family and was passed down to J. Stanley Lee. In 1971, Beatrice Stump, Newtown, Pa., purchased the chest and gave it to the Newtown Historic Association, Newtown, Pa., in 1994.
 Illustrated as fig. 54.

125
Ornamented Child's Side Chair
Oil on wood, 31⅛" x 11¾" x 10¼"
Ca. 1840

OWNERSHIP HISTORY: Passed down through the Hicks family, presumably in this descent: Isaac Worstall Hicks to Sarah W. Hicks, to Nellie Brown Hicks, to Hannah Brown Hicks Lee, to a private collector.

Works with Uncertain Attribution to Edward Hicks

126
Robert Morris Signboard
Oil on wood, 48" x 36"; lettered pendant 10" x 36"
Ca. 1825

OWNERSHIP HISTORY: The signboard hung for many years outside the Carlisle Hotel, Morrisville, Bucks County, Pa. Early in the twentieth century, it was acquired by William F. Diener, Philadelphia, Pa., and eventually came into the collection of the Mercer Museum, Bucks County Historical Society, Doylestown, Pa.[1]
 Although the attribution has been questioned, some evidence suggests the signboard is by Hicks. Staff at the Mercer Museum discovered an 1875 notice in the local paper that described the sign clearly and stated it was painted by Edward Hicks. The subject matter, which relates to Washington, and the plain language are reasons for attributing this work to Hicks.[2]
 The sign is made up of two two-sided boards. The top board depicts a bust of Robert Morris with a banner reading "THY WORD IS THY BOND." On the reverse is a picture of Morris receiving a bag labeled "10,000" from another gentleman, a reference to Morris trying to raise much needed money for Washington's army. On the lower left is "Pictorial Sign Co./ 206 North 8th St. Phila." This name is one reason for the questionable attribution. The two-sided pendant board bears no stylistic relationship to other lettering by Hicks. One side reads "ROBERT MORRIS/A Distinguished Member of the Illustrious Congress of 1776 for/whose financial labors, next to Washington, America is indebted/for turning the tide of success in the American Revolution, in taking/the Hessians at Trenton on Christmas Morning 1776, reviving/the desponding cause of Liberty and Independence." The other reads "Washington needs $10,000-/You must let me have this money./My note and my honor will be your only security/Robert: Thee Shall Have It."
 Illustrated as fig. 70.

 1. Mather and Miller, *Edward Hicks*, pp. 163–164.
 2. *Doylestown Democrat* (Doylestown, Pa.), June 8, 1875, quoted *ibid.*, p. 164.

127
Portrait of a Child
Oil on wood, 17⅜" x 14⅜"
Ca. 1835

OWNERSHIP HISTORY: Mather and Miller gave the history as follows: "Robert Carlen recalls purchasing this from the Burton family of Edgely, Bucks Co., Pa.; to Edith Gregor Halpert (American Folk Art Gallery), New York; to M. Knoedler & Co., New York; to Joseph Katz Co., New York; returned to M. Knoedler and Co., New York; to Edgar William and Bernice Chrysler Garbisch, New York who bequeathed it to the National Gallery of Art, Washington, D. C."[1]

If the painting is by Edward Hicks, it is the only portrait known by his hand. Only one reference alluding to portrait work by the artist has been found. John Comly, writing to Isaac Hicks, a cousin of Edward's, in 1817 about the artist's debts, described Edward's "chimerical scheme of extricating himself by ornamental or portrait painting, in violation of the scruples in his own mind."[2]

1. Mather and Miller, *Edward Hicks*, p. 204.
2. John Comly to Isaac Hicks, Oct. 23, 1817, Ford files, Newtown Hist. Assn.

128
St. John and the Lamb
Oil on canvas, 25" x 25½"
1840–1849

OWNERSHIP HISTORY: The early history is unknown. The first recorded owner was Harry Stone, New York, N. Y. In 1982, the painting was purchased by its present owners, Anita and Irwin G. Schorsch, Jr., Bucks County, Pa.[1]

The painting retains its original veneered frame with beaded edging on both the inner and outer edges.[2]

1. Information courtesy, Anita Schorsch, Philadelphia, Pa., 1998.
2. *Ibid.*

129
Eagle Chimney Panel
Oil on wood, 6¾" x 20¾"
Ca. 1840

OWNERSHIP HISTORY: The early history is not known. The first recorded owner was Leonardo L. Beans, Trenton, N. J., in the early 1960s. In 1964, a private collector from Trenton, N. J., bought the painting.[1] It went to Sotheby's in 1996 for auction.

The panel illustrates an American eagle, shield, and flags on the front and bears the inscription "E. Hicks, 1847" on the back. How the panel was used is confusing; it may have been a carriage plaque or a fire truck panel.

1. Information courtesy, Joseph Barrett, Darby Barrett Antiques, Lahaska, Pa., 1995.

130
The Signing of the Declaration of Independence
Oil on canvas, 47½" x 74"
Ca. 1840

OWNERSHIP HISTORY: This painting descended in a family from Princeton, N. J., until 1994. It was purchased for the Warner Collection of the Gulf States Paper Corporation, Tuscaloosa, Ala., in 1998.[1]

According to the records of the current owner, this version of Hicks's Declaration is most closely related to the print source based on the Trumbull painting. Features such as the overall composition and details such as the decorated back wall and other emblems of war and patriotism are derived directly from the print.[2]

The large size of this painting is unusual among the known group of Declaration of Independence pictures by Hicks. The canvas consists of two large lengths sewn together in a center vertical seam. Whether the size indicates anything about its original use and ownership is unknown. The painting retains its original pine stretchers. The present frame is a copy of an original Hicks frame.[3]

1. Information courtesy, Leigh Keno, American Antiques, New York, N. Y., from the files of the Gulf States Paper Corporation, Tuscaloosa, Ala., 1994.
2. *Ibid.*
3. *Ibid.*

131
Pastoral Landscape
Oil on wood, 16" x 21"
Ca. 1846

OWNERSHIP HISTORY: The early history is unknown. In 1978, it was owned by a private collector, Santa Fe, N. Mex. The painting went to the Hirschl & Adler Galleries, New York, N. Y., and then to the Coe Kerr Gallery, New York, N. Y.[1] The current owner and location are unknown.

The landscape and animals are reminiscent of works by Hicks. Mather and Miller noted that the diagonal-growing tree is much like Hicks's drawing of similar features in several of his Peaceable Kingdoms.[2] However, the large steer with its massive proportions is more reminiscent of English farm animal portraiture that was popular throughout the nineteenth century.

1. Mather and Miller, *Edward Hicks*, p. 198.
2. *Ibid.*

132
Indians Shooting Jaguar in a Tree
Oil on canvas, 17" x 24½"
1846–1847

OWNERSHIP HISTORY: The earliest owners are unknown, according to Mather and Miller. The first recorded owner, Mrs. Brooks Shepard, Saxtons River, Vt., acquired the painting in 1958 and presented it to the Shelburne Museum, Shelburne, Vt.[1]

"Painted by Edw. Hicks/ in the 67 year of his age" is inscribed on the back of the stretcher. Despite the inscription, the work cannot be attributed firmly to Hicks. As Mather and Miller suggested, the subject matter was unusual for Hicks, and the size and coloring of the painting are also atypical.[2] The composition and details such as the jaguar's expression are reminiscent of Hicks's work, however.

1. Mather and Miller, *Edward Hicks*, p. 208.
2. *Ibid.*

133
The Tempest
Oil on canvas, 25" x 30"
1846–1847

OWNERSHIP HISTORY: According to Mather and Miller, the early history is unknown. The first recorded owner was Edith Gregor Halpert, New York, N. Y., from whom it went "to M. Knoedler & Co., N. Y.; to Joseph Katz, N. Y.; returned to Knoedler, who sold it to Edgar William and Bernice Chrysler Garbisch, who bequeathed it in 1980 to the Chrysler Museum, Norfolk, Va."[1]

The unlikely subject matter, a scene from one of Shakespeare's plays, and the theatrical figures raise the question whether Hicks painted this picture.[2] Some of the details are strikingly similar to ones in Edward's known works.

1. Mather and Miller, *Edward Hicks*, p. 209; information courtesy, Chrysler Museum, Norfolk, Va., 1998.
2. Mather and Miller, *Edward Hicks*, p. 209.

Addendum

"Grave of Wm. Penn in Friend Grave Yard . . ."
Oil on canvas, 23⅝" x 30⅝"
1848

OWNERSHIP HISTORY: This painting was given to the Historical Society of Pennsylvania, Philadelphia, Pa., through the bequest of Emily W. Williams in 1997. The provenance for the picture prior to Williams is unknown. The inscription on the back indicates that Edward painted it for his friend Israel Hallowell.[1]

Beginning at lower left, "The Grave of Wm. Penn in Friend Grave Yard at Jordans in England, with the old/Meeting House and J. J. Gurney & some Friend looking at the Grave" is inscribed by the artist on the canvas. On the back top stretcher is lettered "Painted by Ew. Hicks in the 68th year of his age," and on the bottom stretcher "For his old Friend ISRAEL HALLOWELL of *Abington*."[2] The frame is probably a replacement.

This version of Penn's Grave was brought to my attention after this book went to press. It has not been examined but was assigned to Hicks based on photographs and the inscription.

1. Information courtesy, Kristen Froehlich, Historical Society of Pennsylvania, Philadelphia, Pa., 1998.
2. *Ibid.*

Excerpts from Edward Hicks's Goose Creek Sermon

DISCOURSE.

(See Math. chap. xvi. 24; and Isaiah, xi. 6, 7.)

Since I took my seat in this meeting, my mind has been arrested by the unchangeable terms of salvation laid down by the Divine Saviour: "If any man will come after me, let him deny *himself*, take up his daily cross, and follow me;" and as the subject has spread before the view of my mind, it has opened into a wide field of instruction, and whether I shall be able to lay it fully before this large and interesting assembly, depends much upon Divine assistance, and the Christian sympathy and feeling of others. As I feel very poor and weak, and as the fervent and effectual prayer of the righteous availeth much, I feelingly desire the prayers of all that can feel for and with me, to enable me to fulfil the important trust of a gospel minister, to the honor of my Creator, the edification of my fellow pilgrims, and the peace of my own mind. It was in a view similar to this great testimony of Christ that the divinely inspired prophet Isaiah held forth this language when alluding to the fulness of the glorious gospel dispensation: "The wolf also shall dwell with the lamb, and the leopard shall lie down with the kid;" "The cow and the bear shall feed; their young shall lie down together; and the lion shall eat straw like the ox." Now the prophet was not only a righteous man, but a true philosopher, and understood the astonishing variety embraced in the wonderful creature called man, viewing him, no doubt, as he ought to be viewed, as the

> "Connection exquisite of distant worlds!
> Distinguish'd link in being's endless chain!
> Midway from nothing to the Deity."

"In the beginning GOD created the heavens and the earth —and *he* said, let there be light, and there was light." "In the beginning was the *Word*, and the *Word* was with GOD, and the *Word* was GOD: all things were made by *him*, and without *him* was nothing made that was made: In *him* was *life*, and the *life* was the *light* of men." In these last days GOD hath spoken by his *Son* (Jesus Christ), whom *he* hath appointed heir of all things, and by whom *he* made the worlds. Thus the testimony of the Holy Scriptures, which contain the most important history, the purest morality, and the finest strains of poetry and eloquence, that can be found in any book, in whatever age or language it may have been composed, tells us that this wonderful phenomenon of the material universe was created by the eternal WORD in six days, and pronounced by Infinite Wisdom to be good.

> "Look nature through, 'tis neat gradation all;
> By what minute degrees her scale ascends!
> Each middle nature joined at each extreme,
> To that above it joined, to that beneath!
> Parts into parts, reciprocally shot,
> Abhor divorce: what love of union reigns:
> Here dormant matter waits a call to life:
> Half life, half death, joined there;"—

As in the egg and some of the lower orders of animal existence, particularly a species of shellfish, called the polypus—

> —"here life and sense;
> There sense from reason steals a glimmering ray;"—

As in the fox, and the dog and some other animals subservient to man, whose actions, at times, evidently appear to partake of something like reason; but

> "Reason shines out in man. O how preserved
> The chain unbroken, upward to the realms
> Of incorporeal life; those realms of bliss,
> Where death has no dominion. Grant an earthly part
> And an etherial; grant the soul of man
> Eternal; or in man the series ends."

The animal body of man was the finishing work of all animated nature, and consequently the highest order of terrestrial creation; being compounded of the four principal elements— Earth, Air, Water and Fire. As either of these predominated in the animal economy, it gave rise to the constitutional character or complexion, called by the physician and philosopher— melancholy, sanguine, phlegmatic and choleric. Hence arises that astonishing variety in the appearances and actions of men and women, as creatures of this world. As the animal man possessed the nature and propensities of all other animals, being superior to them all,—so that strong law of animated nature, called self or self-will, was commensurate with or equal to his standing in the scale of beings; that is, his self-will was as much stronger as he was superior to other animals; being the spirit of the animal so essentially necessary to its perfection,

and in man was to be governed by his superior rational, immortal soul, which was created in the image of God, who said—Let us create man in our own image: God being an all-powerful, incomprehensible, eternal mind or spirit, that pervades immensity of space; a being whose centre is every where, and whose circumference is no where; the God and father of all, that is above all, through all, and in all; in whom we live, and move, and have our being. If the soul of man is made in the image or likeness of such a being as this, it must be spiritual, infinite in its nature, everlasting in its duration. Hence the correctness of the conclusion that the soul of man is the lowest order of celestial, and his body is the highest order of terrestrial creation; which is confirmed by the testimony of the inspired psalmist, "Thou madest him a little lower than the angels, and hast crowned him with honor and glory; thou madest him to have dominion over the work of thy hands; thou hast put all things under his feet." Thus man is placed before us a superior being, composed of two natures, material and immaterial: the first, being a part of the material universe, was designed by its author for change and decay, as it is written, "Dust thou art, and unto dust thou shalt return." The second is an immaterial being, possessing an immortal life that can never be annihilated. It was into this spiritual, or, as the apostle calls it, the inner man of the heart, that God breathed the breath of life, and it became a living soul—not a living body, for the body had been completed in all its organic structure in the finishing of animated nature, and, breathing the atmospheric air that surrounds this globe, it became a living creature; which life continued several hundred years after Adam ate of the forbidden fruit, and therefore could not have been the life involved in the solemn declaration of JEHOVAH, when he said, the day thou eatest thereof thou shalt surely die. But the life that was lost by transgression was that precious life of God that was breathed into man's immortal soul; that not only made him a pure, free, intelligent being, but endowed him with a capacity for the everlasting contemplation of infinite goodness and perfection, placing him amongst the constellations of heaven, where he might shine with new accessions of glory, and brighten to all eternity, where the morning stars sing together, and all the sons of God forever shout for joy.

I now feel a freedom in the ability I may be endowed with, to apply the subject more particularly to the several states in this large company of men and women, who, notwithstanding they may be composed principally of Friends, and friendly people, are before me as an epitome of the great family of mankind, whose animal bodies being compounded of the four principal elements—earth, air, water and fire—I shall divide them into four classes, and denominate them melancholy, sanguine, phlegmatic and choleric.

The man or woman in whom the element of earth predominates, so as to produce that peculiar constitutional trait of character called melancholy, in their unregenerate state have all the characteristics of the wolf; and the Lord's prophet could not have been more happy in his choice of a figure, had he searched the whole chain of animated nature. The skulking solitary habits of the wolf, who generally retires in the day-time to the inmost recesses of the swamp, or the gloomiest glens of the forest, only coming forth to prowl and devour innocent and helpless animals under cover of the darkness of night,—he whose carnivorous appetite can never be satiated, presents the strong law of nature called self, in one of its most incorrigible attitudes; and the reasonable beings whom it represents, that will not submit to the terms of salvation laid down by the blessed Saviour, to deny this cursed self, and take up the cross, are undoubtedly the most unhappy of mankind. This gloomy, hidden, reserved disposition enables them to keep their sorrows to themselves, till in the accumulation of imaginary troubles, their animal spirits, and indeed their whole system, become so affected as to produce that dreadful disease called complexional melancholy, which is as hereditary, and almost as incurable as the pulmonary consumption; and all the cases of suicide, from Judas down to the present day, have sprung from this source. I know of no state more to be pitied, or one that has stronger claims on the sympathies of the true Christian disciple; and it seems as if the beloved Paul might have been led to describe this state, when he so emphatically exclaimed, "Oh wretched man that I am! who shall deliver me from the body of this death?" and oh that they could see like this precious saint, that it is Jesus Christ our Lord, who, when suffering in the flesh without the gates of Jerusalem, the just for the unjust, and baptized into this dreadful state, cried out, "My God! my God! why hast thou forsaken me?" When these make profession of religion without being regenerated and born again, they are wolves in sheep's clothing, and hence the origin of hypocrisy and deception in the religious world; for this complexion being naturally disposed to be religious, there is more of them than all the other three put together. Their steady, solid deportment, and very serious, solemn countenances, enable them to pass, as religious men and women, for more than they are worth; and they are put forward in religious communities, as the leaders of the people. This was, I apprehend, the state of Israel in the apostasy, when the Lord, through his prophet, solemnly reproved them; and our Saviour advises his disciples against carrying their religion in their faces, saying: "When ye fast, be not as the hypocrites, of a sad countenance; for they disfigure their faces, that they may appear to men to fast." Nothing is so obnoxious to this infinitely pure Being, as a hypocritical state; and indeed it may be said at this door the enemy entered and made great devastation in the Christian church, and none have suffered more according to their relative numbers, than the Society of Friends.

And here permit me to declare the sentiments of my heart. Independent of all sectarian prejudices, I verily believe the people called Quakers, or Society of Friends, as they stood a distinct organized body of Christians, in the days of Fox, Penn and Barclay, were nearer the primitive standard than any others, both as respects doctrine and discipline. I loved them in my

infancy, and although not born a member, I received my earliest and best impressions among them; and during my juvenile infatuation, when marching in the ranks as a soldier, my heart elated with the sound of the martial music, and the feathered foppery of the regimentaled warrior, the very sight of a plain, steady, consistent Friend, either young or old, filled me with respect and awe. And when I arrived at maturer age, and more serious consideration, I was united with them in religious fellowship, and few that have ever come among them have less cause to speak of their failings, or uncover their weaknesses, than I have; because few have ever been treated with more brotherly kindness and affection; and however diversified with affliction the remainder of my life may prove, I shall ever consider it one of the greatest blessings that my lot was cast among them; nor can I conceive of any greater trouble in this world, than to be separated from the Society, and lose the unity of the spirit and the bond of peace. Nevertheless I dare not omit the discharge of a duty that appears to be required of me—to endeavor to point out some of the causes that have led to the present weak state of Society. Therefore, bear with me, beloved Friends, for flattery and smooth tales may feed fools, but it will not be acceptable to intelligent, honest people; much less will it please Him whom I would wish to please in the gospel of his dear Son.

I have already said that there were more men and women of a melancholy complexion professors of religion, and I may add especially in the Society of Friends: their quiet, steady, unobtrusive habits—their silent retirement—exemplary industry and frugality—all unite in forming an asylum peculiarly fitted to a melancholy complexion, where its first nature may remain unsubdued; or, as our Saviour says, the strong man armed may keep the palace, and his goods be at ease; where men and women that have never denied self, never witnessed the wolf to dwell with the lamb, may fill the most important stations in Society, if they are only steady in their attendance of meetings, exemplary as to plainness of speech, behaviour and apparel; and more especially if they are of respectable connections, and are in the way of making money, and can lend their poorer brethren a few hundred dollars every year on usury—notwithstanding lending money to a brother on usury or interest is condemned and positively forbidden by the infinitely wise Jehovah, through his faithful servants, Moses, Nehemiah, David, Proverbs, Isaiah, Jeremiah, Ezekiel, and in these last days by his beloved son Jesus Christ. Friends not having recognised it as an evil, it by no means disqualifies them from being appointed clerks, overseers, elders and even preachers; and the apostle's excellent advice to his son Timothy, when making such appointments, not being attended to, in many meetings, the dreadful consequences that Paul alluded to have been realized; they have been puffed up with pride and too many have fallen into the condemnation of the devil, ending, a disgrace to the cause of Christ, and a burthen on Society. In the small circle in which I have moved, I have, alas, known too many Friends, and among them three ministers, two of

which crossed the Atlantic ocean, come to this most wretched and melancholy end. I am aware I may lay myself open to censure by publishing such things; but the time has come that the hidden things of Esau must be brought to light, and effects traced to causes: for I have no doubt but that one of the principal causes of the weak state of Society is the injudicious appointment or promotion of Friends, both young and old, to important stations, that are what the apostle Paul called *Novices*, that is, men and women without heartfelt religious experience; having never denied self, or witnessed the wolf to dwell with the lamb. Hence the spiritual pride, religious consequence and malignant enthusiasm that characterized the belligerent party among Friends, in the late unhappy and disgraceful controversy.

And here I will meet the sceptical cavillers, and more orthodox enemies of Friends—one of which, a neighboring physician, informed me that it was the opinion of the faculty that there were more cases of suicide occurred in the Society of Friends than in any other society. Since which I have been informed, by respectable authority, that it was the prevailing opinion among the same class in England. Admitting it to be the fact, there being so many more melancholy people belonging to the Society, for reasons already given, rationally accounts for it, without leaving a stigma on the principles of the Christian religion as professed by Friends. Indeed, I have no doubt but the greater part of the Friends of the first convincement were of this constitutional make; but as the great doctine of regeneration and the new birth was the burthen of their ministry, they had experimental knowledge of it within themselves, and knew Christ, the Lamb of God, that taketh away the sins of the world, to bring into subjection all their wolfish nature, and establish the kingdom of heaven, which Jesus emphatically declared was within. Hence their nonresistance, their love for each other, their unexampled patience under suffering, and steady perseverance in well-doing to a peaceable and happy conclusion. But such as did not witness this change of heart, but retained a part of their first nature, not having the same swamp of worldly-mindedness, or comfortable glen of money-making, to retire to, like the Quakers of the present day, in consequence of an unjust and cruel law then existing in England,—by which they were dragged from their religious meetings, arraigned before a despotic tribunal, where the oath of allegiance being tendered, which they could not take for conscience sake, their real estate was confiscated for life, and their personal estate for ever, and their bodies imprisoned during the king's pleasure: I say, such of the primitive Quakers as remained in the mixture, and were like Ephraim, a cake not turned, showed their wolfish nature by the same wild, fanatical howlings and eccentric wanderings that have hung upon the rear of the Christian church in all ages, from the hateful Nicolaitans alluded to by John in his Revelations, down to the wrong-headed enthusiasts of the present day. Witness John Parrott's insignificant quibble about rising in the time of public prayer, which ended in his decided opposition to Fox, Penn

and Barclay, and becoming one of the most subtle and bitter persecutors of our early Friends; witness, too, the fanatical ranterism of Story and Wilkinson, opposing the established order and discipline of Society, which ended in a similar manner.

I come now to a class so entirely different, that they may be considered almost like antipodes to those I have been addressing; men and women in whose animal economy the element of air predominates, producing that constitutional character called sanguine. To describe these, in their unredeemed and unregenerated state, the Lord's prophet has been equally happy in the selecting of his figure from the animal creation, "The leopard shall lie down with the kid." The leopard is the most subtle, cruel, restless creature, and at the same time the most beautiful of all the carnivorous animals of the cat kind; but wo be to the unsuspecting admirers of its beauty, should they attempt to manifest any personal familiarity or kindness, because it will destroy the very hand that feeds it. Men and women of this class, in their sinful state, are not to be depended upon, and when young are impatient of the restraints of virtuous discipline; and even in their minority, break through the enclosure of parental care and commence that terrible career in vanity that must end in vexation of spirit. Excessively fond of company, more especially where there is gaiety, music and dancing, they frequent taverns and places of diversion, where young men too often become an easy prey to the demon of intemperance and sensuality; and the poor negatively innocent female is too often seduced by these beautiful monsters, more cruel than the leopard, who rob them of their virtue, and destroying their innocence and reputation, leave them in a state of desperation or despair, where, afraid to meet the tears of their parents, the chidings of their relations, or the scoffs and sneers of their youthful companions, they too often fly to those sinks of pollution in our towns and cities, where being further debased, even below brutality, they blot out of their very nature every thing that was once agreeable and beautiful, and, at last, come to an untimely and most miserable end.

> "Where groaning hospitals eject their dead,
> While many groan for sad admission there;
> While many, once in fortune's lap high fed,
> Solicit the cold hand of charity."

Oh! that such libertines would solemnly reflect upon the dreadful account that they must finally settle before the judgment seat of quick and dead; and oh that they could be persuaded, before it is too late, that there still remains an everlasting friend and blessed Saviour of sinners, that seeks to save that that is lost; the same that cast out of one formerly the whole number of evil spirits: *licentiousness—ignorance—intemperance—wrathfulness—devilishness—covetousness—pride;—*and filled the empty soul with seven heavenly and angelic spirits—*virtue—knowledge—temperance—*

patience—godliness—brotherly kindness and *charity;* but alas! for these when they reject this darling attribute of mercy and call into their aid that abominable abomination of all abominations, unbelief, and a persuasion that death is an eternal sleep. To such, the writings of the sophistical Paine are the most relieving and edifying, because they are peculiarly calculated to work on their narrow and debauched understandings. Should such men and women marry, the act certainly would be highly honorable; but the sacred covenant would be likely to be broken, if not trampled under foot with impunity; for there is no confidence to be placed in such, particularly men, who too often leave their poor wives to suffer for the want of the comforts, if not the very necessaries of life, while the careless, shackling, unmanly husband is found spending his time and money at taverns, tippling houses, gambling tables, or houses of ill-fame, participating in the most tremendous quarrellings and fightings, attended with blasphemous expressions and the most vulgar and bitter imprecations, with a confused noise that could scarcely be equalled by the howling of the wolf—the screaming of the leopard—the growling of the bear, or the roaring of the lion—thus debased below the very brute creation, with all the manly feelings totally extinguished. Such poor creatures are too often seen in our country, staggering along the high way, with their black jug and corncob stopper, containing the remains of a quart of whiskey, purchased of some Judas that would sell his Saviour for money. Should the sanguine wife of such a man as this be, what they too often are, prodigious scolds, the scene that would be likely to take place, when he arrived at his uncomfortable home, I have no language that possesses force sufficient adequately to describe. I shall, therefore, leave it for the temperance lecturer, who, perhaps, has ransacked the scriptures from Genesis to Revelations for appropriate texts, and committed to memory the novel incidents so awfully painted in the temperance tracts; telling the same story so often, that by this time he has it so pat that his eloquence may be irresistible; notwithstanding it may be among the possible circumstances that he has never denied self, or taken up the cross of Christ, but is pursuing that echo of folly and shadow of renown, called popularity, or the more common and, if possible, more selfish object of a good salary. If so, he is an hireling, to all intents and purposes, and careth not for the sheep, and, therefore, may be compared to one of the seven sons of Sceva, a Jew and chief of the priests that we read of in the days of the apostles, who undertook to make a mercenary concern of casting out evil spirits, saying, "We adjure you by Jesus that Paul preaches;" and the evil spirit answered and said, "Jesus I know, and Paul I know, but who are ye;" and the man in whom the evil spirit was, leaped upon them, and overcame them, and prevailed against them, so that they fled out of the house naked and wounded; but the man who seems to have gained the victory remained possessed of the devil.

Such appears to me most likely to be the end of all these popular advocates for moral reform, that has neither the pure

religion of Jesus, nor the noble patriotism of Paul.—The drunkard will leap upon them and overcome them, while the demon of intemperance will keep possession of his unhappy victim. I know of no class of American citizens more truly to be pitied and felt for than the poor, habitual drunkard, deprived of almost every acquisition that can procure the comforts of life; deprived of the social and relative enjoyments of their own families—scolded by their wives—hated by their children—despised by the proud and looked down on with contempt by the rich; shunned by the moral and pitied by the pious, without reputation, without property, compelled from necessity to undergo the most unpleasant and laborious employments, by land and by sea, by night and by day, in summer's heat and winter's cold; and after thus ploughing the waves of the deepest affliction, they at last may reap despair. Oh! that the Shepherd of Israel, that sleeps not by day nor slumbers by night, would extend the crook of his love and mercy and snatch these poor dear creatures from the horrible pit. Oh! that he would now, in his spiritual appearance cast out the legion of evil spirits, and bring these poor bruised and naked souls to his blessed feet, where, clothed in their right mind, they will know Jesus Christ to be a propitiation for their sins. And oh! that these poor, discouraged, peevish, fretful wives, and all cross, scolding women, especially such as have been so long afflicted with this direful disease, so as to become crookedly deformed, (that is) entirely different from what they were when they constituted the beloved object of their husband's youthful affections,—I say, could these believe in an omnipresent Saviour, and press through the crowd of difficulties till they could touch, in a spiritual sense, the hem of his garment, his heavenly virtue would cure their sin-sick souls, as certainly as he cured the woman we read of in the New Testament; and that selfish, catlike nature, that was the source of their misery, would be denied, and taking up the cross of Christ, they would witness the leopard to lie down with the kid; and when they had experienced this great change of heart, they could no more hide themselves amongst the gay, the light, and chaffy spirits of the world, than the woman that was cured by touching the Saviour's garment could hide herself in the crowd; but like her, they would be constrained to come forward, and in the presence of Christ, declare publicly what great things he had done for their souls. Blessed are such among women, and blessed is the fruit of their lips. I have heard the everlasting gospel preached in the demonstration of the Spirit, and with more feeling power, from such a woman, than I ever heard from the lips of man.

I will now take a view of sanguine men and women. As members of civil society, while under the influence of their first nature, they are so light and chaffy in their spirits, and moreover as changeable as the element and animal that rules them, that there is very little confidence to be placed in their promises or engagements. Having more imagination than mind, they too often spend their little stock of energy in thinking and telling what they intend to do, so that they have noth-ing left to carry out their plans, or meet their contracts. Hence the cause of the almost total loss of private and public confidence, by a series of failures and bankruptcies, that are not only unchristian, but unmanly and dishonorable, a disgrace to religion, and a serious injury to the commonwealth. Speculation being so fashionable, attended with a gambling spirit so fascinating, that sanguine people I fear are approaching a vortex of greater ruin, as respects the risk of credit, the war of interest, and the crush of property, than this country has ever experienced; when the wolf, the leopard, the bear and the lion, while biting, scratching, squeezing, and tearing each other, will cause many a poor lamb, kid, cow, and ox to suffer severely.

But it is under a profession of religion without a change of heart, that sanguine men and women do the most injury to the cause of Christ; for they are quite disposed to be religious, provided they can have it on their own terms; but it must be spotted, like the beautiful animal that rules in them, and full of excitement and activity. They are more especially at home in their favorite element, under the influence of a popular mania, called religious revivals and moral reforms. Every kind of business must give way to religious meetings, night meetings, camp meetings, class meetings, prayer meetings, singing meetings, temperance lectures, abolition and colonization lectures, and many others that I cannot mention, where they are the most active and the most happy creatures; but being naturally disposed to shackle, they too soon fall into the sin that the primitive saints considered worse than infidelity; that is, neglecting to make a proper provision for their own families. For the sons of that glorious morning were so very tenacious of the example that God had placed before them in the person of his dear Son, walking in the path of humble industry, that they required of every member of the church, that they should maintain or support themselves and families by the labor of their own hands, (not their heads): and hence the commandment in their pure but simple discipline, "if any would not work, neither should they eat: a commandment that would be very unpopular amongst the sanguine members in the present day, who not only neglect to work with their hands, that they may walk honestly towards them that are without, and that they may lack nothing; but are content to live on the industry of others, by getting a salary as preachers, or their expenses borne out of the funds of Society, or some profession or office of profit and honor, by which they can live without working with their own hands; and such as cannot gain this point too often run in debt and borrow money: then the melancholy and phlegmatic brother must be applied to for money or credit, with all the sanctimonious, long-faced innocence of a very pretty spotted kid; their feelings and interest being excited, the money is forthcoming, and a promise is made to pay at a certain time, with legal interest from the date thereof. But when the kind usurer calls for his money, the poor sanguine debtor is neither able nor willing to pay; and should the honest creditor appeal to the laws of his country for redress in such a griev-

ance, he will soon find himself in contact with something like a cruel leopard, that would now destroy the hand that was stretched forth for relief; tearing the reputation of their friend to pieces and having the eye of the cat, that is peculiarly calculated to see best in the dark, with a restless impetuosity they will try to destroy every good trait in the character of the object of their resentment.

I believe there are fewer sanguine people among Friends, in proportion to their numbers, than any others, (for reasons which I think I have already given,) and what there is are mostly birth-right members, who are too often finding fault with the order of Society—particularly plainness of dress, behaviour and apparel; and animadverting with great severity on the bigoted notion of keeping to their own meetings, and not mixing with other societies; and appear so liberal that I am afraid they would turn Christian liberty into licentiousness. These kind of Friends remind me of a set of restless, discontented Jews, that we read of in the days of the outward advent of the Saviour, called Gadarenes, who opposed the order and economy of the Israelitish church, and seemed so particularly offended at Moses prohibiting the use of swine's flesh, (in consequence of its predisposing the human body to putrid diseases in that warm climate,) that they would, in their perverse selfishness, keep whole herds of hungry hogs on their barren mountains, to the great annoyance of their more orthodox neighbors. These sanguine Gadarenes, being in a state of mind in such perfect accordance with their favorite animal, it is no marvel that our Saviour found a legion of devils among them; which, when dispossessed of their more comfortable quarters, would naturally wish to go into what they would think the next best place for them, notwithstanding the rational supposition that such a superabundance of obstinate selfishness might drive the poor swine headlong to destruction; and being disappointed in their hoggish speculation, it is no wonder these Gadarenes wished to get rid of so unprofitable a visiter as the Divine Saviour.

I now come to a third class of mankind, called Phlegmatic, in whose animal body the element of water predominates. This element is cold and unfeeling, but powerful by its great weight and influence upon the other elements; and when put in motion by the laws of gravitation, or agitated by air or fire, its strength is irresistible. Hence the Lord's prophet, in describing these in their unregenerate state, brings forward in poetical figure two of the larger and more powerful animals: "And the cow and the bear shall feed, their young shall lie down together." Men and women of this class, while under the influence of their beastly natures, are not only cold and unfeeling, but dull and inert; but when agitated by some of the stronger passions, they are too often powerful, cruel and voracious, and therefore more like the bear than any other animal. For the bear is a dull, sluggish, inert creature, and appears more peaceable and contented than most of the carnivorous

tribe, and will seldom if ever prey upon other animals, if they can find plenty of nuts, fruit, grain, or even roots; they will then, especially in autumn, become very fat, and retire to their den, curl themselves up in their bed of leaves, and live by sleeping and sucking their paws. In this quiet retreat, they may appear inoffensive and entirely harmless; but wo unto the man or beast that would presume to take away one of the leaves that compose their bed, or even disturb their repose; they would soon show their carnivorous teeth, and if within their reach, they might feel the weight of their tremendous paws, or be crushed in their powerful hug.

Could the prophet have found in the whole chain of carnivorous animals, one link that would so completely describe a phlegmatic worldly-minded man, wholly intent on the acquisition of wealth? One who adopts for his motto the Dutch proverb, "My son, get money; get it honestly if you can, but be sure to get it." One that pursues this object with an eye that never winks, and a wing that never tires; if he can get money fast enough, and by the regular routine of business and a legal six per cent., may be apparently satisfied; but if trade should be dull, and the regular course of business obstructed, attended with some loss of property, he will have recourse to shaving some poor, weak, straitened brother's notes or paper, and then adding their shavings to his bonds and mortgages, he will have a comfortable dry bed to retire to; and having grown fat like the bear, he can sleep securely, and while sucking the paws that have done such great things, can adopt the language of one formerly: "Soul, thou hast much goods laid up in store for many years; take thy ease, eat, drink, and be merry." But if God should say to such a man as this, as he did in the parable, "Thou fool, this night shall thy soul be required of thee," then whose would all these shavings and dry leaves be? what relief could they afford?

"The frantic soul
Raves round the walls of her clay tenement;
Runs to each avenue, and shrieks for help;
But shrieks in vain. How wishfully she looks
On all she's leaving, now no longer her's!
A little longer, yet a little longer,
Oh! might she stay to wash away her stains,
And fit her for her passage! Mournful sight!
Her very eyes weep blood; and every groan
She heaves, is big with horror. But the foe,
Like a stanch murderer, steady to his purpose,
Pursues her close through every lane of life,
Nor misses once the track; but presses on,
Till, forced at last to the tremendous verge,
At once she sinks to everlasting ruin."

For the rich man also died, and was buried; and in hell he lifted up his eyes, being in torment, and seeth Abraham afar off, and Lazarus in his bosom; and he cried, "Father Abraham, have mercy on me, and send Lazarus, that he may dip the tip of his finger in water, and cool my tongue, for I am tormented

in this flame." Ah, my dear friends, what will be the difference in the eternal world between such rich men and their poor debtors, that have been brought, Lazarus-like, to their gates, full of sores, occasioned perhaps by being squeezed too hard in dealing with something like a grizzly bear, while their only crime may have been they could not add sufficiently to the superabundance of his dry bed, by paying up their interest or rent. In vain did the poor Lazarus desire a crumb of mercy; the dogs were only permitted to lick his sores. But it came to pass that the beggar died, and was carried by angels into Abraham's bosom. Oh! that I could persuade professing Christians to return to those first, glorious, and heavenly principles, that so adorned the infant and innocent state of the primitive church—sympathy and feeling for suffering humanity—which laid the foundation for true Christian discipline; which made provision for the poor saints;—when ministers of the gospel were conscientiously concerned to maintain themselves and families by the labour of their own hands, and could appeal to the elders of the church in a language like this: "I have coveted no man's silver or gold, or apparel; yea, ye yourselves know that these hands have ministered to my necessities, and to them that were with me: and I have shown you, that so labouring ye ought to support the weak, remembering that it is more blessed to give than to receive." Such was the precept and example of the first Christian ministers, and such was their sympathy for suffering humanity in the household of faith, that they begged the crumbs that fell from the rich man's table, not to clothe themselves in purple and fine linen, and fare sumptuously every day, but to relieve the poor Lazarus that lay within their own gates, full of sores. Oh! that I could persuade the Society of Friends to return to their first principles, that Christian benevolence that shone so conspicuously among them for the first half century, when poor Friends' necessities were duly inspected, and they relieved, and assisted in such business as they were capable of. They would then cease their running in the ways of the Gentiles, and joining those extraneous speculations, so popular in the cities of the Samaritans, for they would then find the lost sheep of the house of Israel; or, to speak in plainer terms, they would no longer spend that time and money on Indians, a people that do not even profess to be Christians, that ought to be appropriated to save their own poor members from sinking into the quicksands of despair. How many Friends that might have been ornaments to Society have sunk and are sinking for the want of that relief that our early Friends were the most prompt in affording. How many have had to give up to their creditors, and are either disowned or under dealing for partial assignments, when it was occasioned perhaps by a cold unfeeling creditor, that had let in the suspicion that he would lose his money if it were not immediately secured, and therefore had presented himself before his poor debtor in all the terrific appearance of a grizzly bear, demanding security by judgment bond or partial assignment; the poor man, who has now become like a striken deer, or a poor chased and starved heifer, without strength or spirit to re-sist, complies with the unjust demand, by which other creditors are excluded, and he must be excommunicated at a time when of all other times he stands most in need of friends and assistance; while the triumphant creditor, like the fat bear, retires quietly to his den, with the commendations of society for being wiser in his generation than the children of light. My soul feels for these poor Lazaruses that are full of sores and discouragements, too many of whom I fear are attempting to drown their sorrows in the gulf of intemperance. Others, under a consideration of hard treatment from those they once thought their Christian friends, have let in hardness of heart and difficulty of understanding, and are descending the dark turbulent stream of doubt which too often ends in the ocean of scepticism and infidelity. Many of these might be saved to sing the praises of redeeming love on the banks of deliverance, had they only a little timely advice and assistance. But, alas, alas! that Christian sympathy and tenderness, that was once the crown and diadem of the religious Society of Friends, the radiance of whose glorious light caused even their enemies to exclaim—See these Quakers, how they love one another—seems now rapidly transforming into the speculative popular mania that characterizes the deluded votaries of Anti-christ, in compassing sea and land to make proselytes. This philanthropic gambling has been placed before the public in rather a ludicrous point of view by an ingenious American writer, one of whose figures, if I recollect right, was something like this:

"I was sitting in my study, when my reverie was broken by a confident rap at the door, and the entrance of a respectable looking elderly woman, with a book in her hand, who thus addressed me: 'I have come, sir, to request you to subscribe to a mission to the Hottentots.' I answered—'Why do you go so far from home to exercise your charity? Can't you bestow it upon the poor colored people in this city, who, in many places, are as ignorant and wretched as the Hottentots can be: and if you must go from home, why go further than the poor slaves at the south?'—when she gave me this conclusive answer: '*La, sir; nobody thinks of things so near home, and besides, the Missionary Magazine never mentions them;*' so I subscribed and paid my money, in hopes of getting my name in the Missionary Magazine."

Would it not be a sorrowful consideration if this ingenious satire should apply to the Society of Friends in their Indian and African concerns? Oh! that I could persuade them that while they profess to be the Israel of God, or the Lord's chosen people under the gospel dispensation, that they would obey that imperative and positive commandment given by the infinitely wise Jehovah to his people Israel—"If thy brother be waxen poor, and fallen into decay with thee, *then thou shalt relieve him*; take thou no usury of him, nor increase, but fear thy God, that thy brother may live with thee. Thou shalt not give him thy money upon usury, nor lend him thy victuals for increase. If thou lend money to any of my people that are poor by thee, thou shalt not be unto him as an usurer, neither shalt thou lay upon him usury; thou shalt not lend upon usury to thy

brother, usury of money; for he that by usury and unjust gain increases his substance, shall gather it for them that will pity the poor. Lord, who shall abide in thy tabernacle? who shall dwell in thy holy hill? He that putteth not out his money to usury—he that hath not given forth upon usury, nor taken reward against the innocent. He that turneth away his ear from hearing this law, even his prayers shall be an abomination. Thou hast taken usury and increase, and thou hast greedily gained of thy neighbors by extortion, and hath forgotten me, saith the Lord God." These are the words of the Lord through the mouths of his prophets and faithful servants, embracing the great commandment to Israel, touching the subject of usury—a commandment that contained a political as well as a moral good to his people; and although it was only expressly given to the Jews, the light thereof appears to have dawned on the Roman republic; for when a proposition was made to the Roman senate for laying a one per cent. usury, it was opposed by the most illustrious senators, particularly by the elder Cato, or Cato the Censor, who considered the deleterious effect of usury on the social happiness of the people to be equal to taking their lives. And had those illustrious American senators, that organized the federal compact, taken the same view of usury, and recognized that great commandment given by Jehovah himself, "Thou shalt not lend thy money upon usury to thy brother," our money matters would have been preserved from a vortex of confusion to which I fear they are rapidly approaching, and thousands of our citizens saved from ruin; for it appears to me that usury is the bane of a republic, and the lever of the power of aristocracy. How those professors of religion that tell us that the Bible is the word of God, can ever reconcile lending their money to their brethren on usury, is a matter of difficulty and astonishment to me; and the difficulty is increased from the matter of fact recorded in the New Testament; the dear Son and Sent of God, instead of abrogating this commandment or word of the Lord, recorded in the Bible, has gloriously asserted and corroborated it in the following clear and powerful testimony: "Give to him that asketh thee, and from him that would borrow of thee turn not thou away; and if ye lend to them of whom ye hope to receive, what thanks have ye? For sinners lend to sinners to receive as much again. But do good and lend, hoping for nothing again, and your reward shall be great; and ye shall be the children of the Highest, for he is kind to the thankful and the evil. Be ye therefore merciful as your Father is merciful; ye are my friends, if *ye do whatsoever I command you.*" How the people called Quakers can assume the name of the Friends of Christ upon the unchangeable terms He has laid down, is paradoxical to me, while they continue to act in direct opposition to one of his positive commandments, and instead of doing good and lending their money without usury, they are, in too many instances, taking an illegal interest from a poor brother, that is falling into decay.

Oh this love of money, if it has not been the root of all, it has been and still is the root of much evil in the religious Society of Friends, and the cause thereof appears to me to be that evil seed of usury that lay snugly preserved in the bosom of the landed aristocracy of England, but never vegetated in the Society till after the Toleration Act; then the warming influence of the sunshine of worldly prosperity, and the great influx of wealth flowing, as a natural consequence, from that inexhaustible source—*humility, faithfulness,* and *industry*—acted as the summer's showers on the spontaneous productions of the earth, causing this evil seed of usury to put forth its branches, resplendent with evil fruit; amongst which, covetousness and pride shone the most conspicuous, and was highly esteemed amongst men, but an abomination in the sight of Christ, because they were the greatest enemies to his church militant on earth. About this time, that is, the latter end of the seventeenth and the beginning of the eighteenth century, if I am not mistaken, Friends had near seven hundred meetings in England, Ireland and Scotland; but the love of money and the love of the world, the inseparable friends of usury, were now insidiously drawing them away from their first great principles; and I think I am safe in saying, their meetings declined at the ratio of two meetings a year for the last hundred and thirty years; and what appears to have added to the rapidity of this retrograde movement, they were losing their faith in Christ as an omnipresent Saviour, and putting their dependence in the arm of flesh; hence, their attachment to those beautiful idols of a fallen world—*wealth, power* and *scholastic education*—the wonderful machinery by which the deluded votaries of anti-Christ vainly expect to establish the kingdom of heaven throughout the whole earth. I am aware that some of my best friends may be ready to conclude, that on the subject of usury I have certainly got wrong, and my enemies will be disposed to laugh me to scorn as a fanatic; but I shall comfort myself with the fact, that I have the unity of some of the brightest stars that ever shone in the old and new world of mind, with the testimony of God, who is judge of all, before whose righteous tribunal I may now leave the subject of usury to be settled.

As members of civil society, phlegmatic people, even in their unregenerate state, have the advantage of the other three; for they may, with some degree of propriety, be called the very sinews of the state. Their steady, persevering, plodding industry, in the pursuit of wealth, almost invariably puts them in possession of the object of their pursuit, and then their superior systematic judgment and pre-science enables them to make the best of their money and property; hence, they stand pre-eminent as farmers, merchants, and business men; and even in the arts and sciences they certainly may claim some degree of superiority, for the most of the useful discoveries and inventions were first found out by phlegmatic men; and hence Germany has been considered the most fertile in useful works. But in no case do they become substantially useful till they experience something of the change embraced in the prophet's figure; for the cow and the bear must feed, their young ones must lie down together; the wild carnivorous nature of the bear must be

changed and become like the tame, ruminating nature of the cow; and although self may not be entirely denied, and they may be too much like the dry, fat cow that keeps her substance within herself, yet with more than the strength and power of the bear, they chew the cud and divide the hoof; this is often the source of stupendous works as well as great and useful inventions. But it is when self is entirely denied, and the daily cross taken up, that phlegmatic men, that are rich, witness a thorough change from a state like that of the cold, cruel, selfish bear, to that like the noble, generous cow, with her distended udder quietly soliciting the hand of the lovely milk-maid to draw forth the rich nutritious stream that is to feed the helpless, hungry children of men. Such men, wherever their lot may be cast, or whatever their profession to religion may be, are a blessing to the city or country where they live, and an honor to the society to which they belong. Permit me to corroborate this position by the strongest of evidence, matters of fact, two of which I am a living witness of. I knew a poor minister, near twenty years ago, that, by imprudence and want of capacity, was brought into serious difficulties, for he had quit a business that he understood, and for which the Author of Nature had peculiarly qualified him, because he then thought it was inconsistent with his profession, and undertook a business he did not understand, by which he was brought to the eve of bankruptcy. Aware of his embarrassment, he exerted himself by working with his own hands, day and night, till his health was broken, and the symptoms of a pulmonary consumption caused him to look with sorrow and discouragement on a beloved wife and little family of children that in all probability must soon be left destitute, to be fed by the hand of charity, or coldly provided for by friends. Winter was fast approaching, and many things were wanting to make his little family comfortable, for which he had not the means. In this street called Strait, after spending some sleepless nights and discouraging days, like one formerly, in the depth of humility, he prayed to his blessed Saviour, who stilled the rolling of the tempestuous billows, and there was a calm, where heavenly hope became an anchor to the soul. A few days after this exercise, his neighbor, the postmaster, told him there was a letter for him in the post-office. When he got the letter, he directly discovered that the superscription and post-mark were entirely new; but what was his surprise on opening it, to find two fifty dollar bank notes, from a wealthy merchant with whom he had but little acquaintance, who stated in his letter that he had been led recently to feel sympathy and tenderness for the poor man, and in contrasting his superabundance with a Christian brother's real wants, he felt it his duty to send that little present, and to inform him further not to suffer himself to be improperly discouraged for the want of any little pecuniary assistance—that he was at liberty, at any such time to draw on him.

This was one of those noble, benevolent men, that, like the generous cow, is a supporter and nourisher of the weak and helpless part of the human family; of such a man, a member of your own Quarter, I could relate something similar, were it not for reasons ingeniously expressed by the poet, that—

> *"Praise from a friend, or censure from a foe,*
> *Is lost on hearers who their merits know."*

I come now to the fourth and last class of mankind, in whose material system, or animal body, the element of fire predominates, and hence are called Choleric. Now these, like the phlegmatic, being stronger in intellect, the Lord's prophet makes use of the most powerful and courageous animal as an emblem of their unredeemed and wicked state—"And the lion shall eat straw like the ox." Now the lion is not only the most powerful and courageous, but the most destructive among inferior animals; consequently the fear or dread of him is so universal through all animated nature, that he is styled the king of beasts. The besetting sin of men and women of this constitutional make is pride and arrogance; proneness to anger; impatient of contradiction, fierce, cruel. They are best described in the language of the patriarch Jacob: "Oh my soul, come not into their secrets—unto their assemblies, mine honor, be not thou united: for in their anger they slew a man, and in their self-will they digged down a wall: cursed be their anger, for it was fierce, and their wrath for it was cruel. I will divide them in Jacob, and scatter them in Israel."

This beautiful prophetic declara[t]ion was not only verified in the scattering of the Jews as captives in all nations, but the same cause is producing the same effects, from the domestic circle through all the social compacts, in all nations, kindreds, tongues, and people: for wherever such men and women are found, even in private families, they will be head, or contend, quarrel or fight for it. Hence the direful altercations that too often take place between husbands and wives, parents and children, brothers and sisters, friends and neighbors; and hence too the litigations that occupy our courts of justice, and the bloody and destructive wars, where the lives and property of men are destroyed by the insatiable ambition of such men as Alexander and Bonaparte. But it is under the profession of religion, that a greater cause than the cause of empires and kingdoms is sorrowfully injured; for men and women of this class, when they profess to be religious, and have never denied self, or witnessed the lion to eat straw like the ox, become leaders of the people, (for leaders they will be,) that the cause of truth suffers; which is abundantly proved by the page of history, from the orthodox priests and their satellites in the Jewish church, at the advent of the Messiah, down to the present day. For such choleric professors of religion are predisposed to be orthodox. And here I wish distinctly to be understood as not casting any reflections upon my Friends that differ from me in opinion. What I mean by orthodoxy is, that malignant, persecuting spirit, that has shed more blood, and been guilty of blacker crimes, than any other spirit in Christendom. A spirit that I have detected in my own breast, that would lead me, through jealousy and envy, to hate a Christian brother or sister, for differing from me in mere matter of opinion, and which I am ashamed almost to think of.

When such choleric men and women get to be leaders in the church, and are not daily concerned to deny self and take up the cross, they are some of the greatest stumbling blocks in the way of keen-sighted, intelligent inquirers. The self-will of such choleric people is the most beautifully described in the book of Job. In its primeval state, it is said to eat grass like the ox, and its increasing strength, while negatively innocent, is called behemoth; or, as the poetical language has it—"Seest thou not behemoth, that I have created with thee? lo! he eateth the grass as an ox." It is then described as gradually leaving the Divine harmony, in the figure of leviathan, and growing into a monster, that causes the sea to boil as a pot; and as a proof that it is the man of sin, or son of perdition, it expressly says, "he is king over all the children of pride," which cannot with propriety be applied to any animal creature. Thus it appears plain to me, that this self-will, or strong law of animal spirit in men and women of superior talents, when brought back to its original state, by submitting to the conditions contained in the text, is clearly embraced in the figure of the ox—strong and powerful, but perfectly docile and submissive. Such have ever been the most distinguished instruments in the cause of Christ. Oh, my dear friends, that you could be persuaded to obey your Saviour's command—"Take my yoke upon you, and learn of me; for I am meek and lowly of mind, and ye shall find rest for your souls:" and of all the souls of the children of men, such as inhabit an animal body where the element of fire is predominant, are the furthest at times from this rest; for unless their spirits are daily qualified with the waters of life, they are ever liable to be set on fire of hell.

Notes

Pages xiv–xv
Notes on the Memoirs of Edward Hicks

1 Richard Price to Hicks, Sept. 12, 1845, Friends Hist. Lib.
2 Price to Hicks, Sept. 8, 1848, *ibid.*
3 Amos Willets to Benjamin Ferris, Sept. 24, 1849, *ibid.*
4 Isaac Parry to Ferris, Oct. 6, 1849, *ibid.*
5 Susan Hicks Carle to Mary Hicks, Jan. 29, 1850, *ibid.*

Pages 2–11
Introduction

1 Edward Hicks, *Memoirs of the Life and Religious Labors of Edward Hicks, Late of Newtown, Bucks County, Pennsylvania. Written by Himself* (Philadelphia, Pa., 1851), p. 149.
2 Alice Ford, *Edward Hicks: Painter of the Peaceable Kingdom* (Philadelphia, Pa., 1952); Alice Ford, *Edward Hicks: His Life and Art* (New York, 1985); Eleanore Price Mather and Dorothy Canning Miller, *Edward Hicks: His Peaceable Kingdoms and Other Paintings* (Newark, N. J., 1983).
3 Mrs. Rockefeller purchased 4 of the 16 works owned by the Abby Aldrich Rockefeller Folk Art Center in the 1930s. The remaining 12 pictures have been acquired since the museum opened to the public in 1957. All 16 are illustrated in this volume.
4 The exhibit and accompanying catalog were titled "Edward Hicks, 1780–1849: A Special Exhibition Devoted to His Life and Work." The show was held at the AARFAC from Sept. 30 to Oct. 30, 1960. The only previous showing of Hicks's works was at the debut of Mrs. Rockefeller's important collection in New York City. "American Folk Art—The Art of the Common Man in America, 1750–1900," organized by Holger Cahill, opened at the Museum of Modern Art in 1932. This landmark exhibit helped establish folk art as a component of American art history. It brought attention and renewed interest to Hicks the canvas painter, rather than to Hicks the Quaker preacher.
5 Works by Edna S. Pullinger consulted include: *A Dream of Peace: Edward Hicks of Newtown* (Philadelphia, Pa., 1973); the manuscript version, A Vision of Peace: Edward Hicks of Bucks County, 1983, Newtown Historic Association, Newtown, Pa.; and a slide lecture, "Edward Hicks of Bucks County," n.d., *ibid.* Pullinger wrote many articles for the Newtown newspaper, *The Advance of Bucks County*: "Edward Hicks and neighbors—Part one: How Edward Hicks came to leave Attleborough," Dec. 11, 1975; "Edward Hicks and neighbors—

Part two: A Friends meeting formed at Newtown," Dec. 18, 1975; "Edward Hicks and neighbors—Part three: Hicks defends his moral character," Dec. 25, 1975; "Edward Hicks and neighbors—Part four: Hatter was a close associate of Hicks," Jan. 1, 1976; "Hicks and the Cornell connection," Apr. 17, 1980; "The house that Hicks built," Sept. 25, 1980; "No more need of war," Dec. 24, 1981; "Edward Hicks, farmer," Feb. 17, 1983; "A Vision of Peace," Dec. 22, 1983; "Edward Hicks on Bellevue Avenue," Feb. 16, 1984; "Tree of brotherhood," Feb. 14, 1985. Pullinger also published articles in other publications: "The art of peaceable living," *Panorama—The Magazine of Bucks County* (Nov. 1972), pp. 8–9, 38; "Panic and panacea: Edward Hicks Deplores Overspeculation in the 1830's—And the Silkworm Mania That Followed," *George School Bulletin* (Mar. 1978), pp. 1–3; "Where Hicks Lived in Bucks," *Bucks County Courier Times (Pa.)*, Feb. 24, 1980; "The Penn Treaty Swinging Sign," *Mercer Mosaic: The Journal of the Bucks County Historical Society* (1988), pp. 75–78.
6 David Tatham, "Edward Hicks, Elias Hicks and John Comly: Perspectives on the Peaceable Kingdom Theme," *American Art Journal*, XIII (1981), pp. 36–50.
7 Account Book of Edward Hicks, Bucks County Historical Society, Doylestown, Pa., photostat, AARFAC. Daybook of Isaac W. Hicks, collection of Katherine K. Fabian, photostat, AARFAC. There has been confusion in the past about the extant Hicks business records. Edward's account book, damaged in a fire early in the twentieth century, survives in large part. The earliest dated entry in the account book is for 1800, the year when he concluded his apprenticeship with the Tomlinsons. The last is for 1846, suggesting that the account book served Edward for most of his professional life. The daybook retains its original marbleized cover with "ISAAC HICKS" lettered at the top. Edward's son Isaac kept it when he worked in the shop and later used it for personal accounts. The daybook includes shop transactions during a significant portion of the time when Edward Hicks & Son was in operation. The handwriting throughout the 1830s and 1840s is strikingly similar to that in the latter portion of Edward's account book, supporting the belief that Isaac was keeping the shop records.
8 For a nineteenth-century description of the organization of the Society, see Samuel M. Janney, *An Examination of the Causes Which Led to the Separation of the Religious Society of Friends in America, in 1827–28* (Philadelphia, Pa., 1868), pp. 190–209.
9 John F. A. Sawyer, *The Fifth Gospel: Isaiah in the History of Christianity* (Cambridge, 1996), pp. 234–239.
10 Steven C. Rockefeller, "The Wisdom of Reverence for Life," in John E. Carroli, Paul Brockelman, and Mary Westfall, eds., *The Greening of Faith: God, the Environment, and the Good Life* (Hanover, N. H., 1997).

1 Hicks, *Memoirs*, p. 13. During his lifetime, Edward actively corresponded with many of his relatives, most of whom lived in New York and Pennsylvania. With the exception of a few genealogical errors and rather sketchy information on more distant forebears, his account of the Hicks family is reasonably accurate. The artist described his parents as "both regularly descended from Thomas Hicks, . . . Our progenitor . . . a native of Long Island." *Ibid.*, p. 15.

2 Edward wrote, "My grandfather, Gilbert Hicks, (my father's father) married the daughter of Joseph Rodman, of Long Island, a consistent, active member of the Society of Friends, and the young man, not being a member, the marriage, of course, was clandestine." *Ibid.*, p. 16.

3 Sarah W. Hicks, "The Life and Expatriation of Judge Gilbert Hicks," *Bucks County Historical Society: Papers Read Before the Society and Other Historical Papers*, VII (1937), p. 247–249.

4 Bucks County tax records for Bensalem show that Gilbert's estate was taxed at £40 in 1754, the fourth highest in the county, the average being £10. Terry A. McNealy and Frances Wise Waite, comps., *Bucks County Tax Records, 1693–1778* (Doylestown, Pa., n.d.).

5 S. W. Hicks, "Life and Expatriation of Judge Gilbert Hicks," pp. 247–249.

6 Ford, *Hicks: Painter of the Peaceable Kingdom*, pp. 2–3. Edward later wrote, "My mother father and particular family where [were] Episcopalians and of the high church party her eldest sister having married the Bishop of New York and she [my mother] being the youngest of corse was brought up according to the straightest sect of that religion." Edward Hicks, Memoirs, undated papers of Edward Hicks, Friends Historical Library, Swarthmore College, Swarthmore, Pa.

7 Ford, *Hicks: Painter of the Peaceable Kingdom*, p. 3.

8 Hicks, *Memoirs*, p. 20.

9 Hicks, Memoirs, undated papers of Hicks.

10 Hicks, *Memoirs*, p. 20.

11 Hicks, Memoirs, undated papers of Hicks.

12 S. W. Hicks, "Life and Expatriation of Judge Gilbert Hicks," pp. 252–253; Ford, *Hicks: His Life and Art*, pp. 166–167.

13 Gilbert Hicks to Isaac Hicks, July 1784, Ford files, Friends Hist. Lib. Writing from "Digby in New Scotland" [Nova Scotia], Gilbert gave the dates of his departure from New York, arrival on Martha's Vineyard, and departure from the island, stating that he was now among "a Set of people known by the Names of Refugees Torrys Royalists." *Ibid.*

14 S. W. Hicks, "Life and Expatriation of Judge Gilbert Hicks," p. 255.

15 J. Pemberton Hutchinson, "Newtown Prior to 1800," *Bucks Co. Hist. Soc. Papers*, II (1909), p. 401. Presumably, these were records kept by Isaac, although many may have been official documents prepared years before by Gilbert acting in his judicial role. In 1772, Isaac was elected prothonotary and clerk of several courts in Bucks County, and was appointed to the office of recorder of deeds. In 1774, he became justice of the peace for the county. *Minutes of the Supreme Executive Council of Pennsylvania, From Its Organization to the Termination of the Revolution*, XI (Harrisburg, Pa., 1853), pp. 128, 178.

16 *Ibid.*

17 Isaac Hicks to John Dickinson, Sept. 27, 1779, Ford, *Hicks: Painter of the Peaceable Kingdom*, p. 9.

18 Isaac Hicks to Dickinson, Nov. 2, 1779, *ibid.*

19 *Ibid.*

20 In 1780, Gilbert, exiled in New York, wrote Isaac about the son's familial responsibilities "as thou art the head of the family in Pennsylvania." Gilbert Hicks to Isaac Hicks, Apr. 5, 1780, Ford files, Friends Hist. Lib. The question of whether Isaac left for New York in 1781 is discussed in Pullinger, Vision of Peace, manuscript, p. 4, and Ford, *Hicks: Painter of the Peaceable Kingdom*, pp. 9–10, 12. Even if Isaac went to New York, he was not there in 1782 when his father wrote him requesting money. Earlier in the same year, Isaac recorded in his account book that he had boarded out his daughter.

21 Hicks, Memoirs, undated papers of Hicks. In his will, Gilbert left his son Isaac "My Negro Wench named Jane, and my Library of Books, Book Case, and Scrutoire."

22 Hutchinson, "Newtown Prior to 1800," p. 401.

23 Two other children born to Catharine and Isaac—William Richard, Nov. 17, 1774–Feb. 5, 1777, and Edward Henry, June 1775–Aug. 20, 1776—were dead by 1780. Isaac's two nephews had also been living with the family, but because of circumstances, Isaac had placed them in other homes by the end of 1779.

24 Hicks, *Memoirs*, p. 21.

25 Isaac Hicks, Is[aac] Hicks's Book of Accounts, American Philosophical Society, Philadelphia, Pa., p. 53. Isaac recorded both business and family transactions in two volumes titled Isaac Hicks Book of Accounts, which is older than Edward's account book and Isaac W. Hicks's daybook. Edward's older brother Gilbert was boarding with and being schooled by Josiah M. Davenport in 1781.

26 Hicks, *Memoirs*, p. 25.

27 *Ibid.*, p. 26; Isaac Hicks's Book of Accounts, pp. 55–56, 60, 72–73. See also Ford, *Hicks: His Life and Art*, p. 18.

28 Isaac Hicks's Book of Accounts, p. 55.

29 Isaac Hicks to Thomas Riché, May 15, 1791, Ford, *Hicks: Painter of the Peaceable Kingdom*, p. 14. In 1791, Isaac was listed as deputy surveyor of Bucks County. Two years later, he was appointed notary public for the county. William Henry Egle, ed., *Minutes of the Board of Property and Other References to Lands in Pennsylvania* (Harrisburg, Pa., 1894); Bond Isaac Hicks Notary Public and His Sureties . . . , Jan. 23, 1793, Newtown Historic Association, Newtown, Pa.

30 Hicks, *Memoirs*, p. 21.

31 *Ibid.*, p. 22.

32 *Ibid.*

33 *Ibid.*, p. 23.

34 Hicks, Memoirs, undated papers of Hicks.

35 Edna S. Pullinger, *Newtown's First Library Building* (Newtown, Pa., 1976), pp. 1–2. Pullinger provided an interesting history of the library as it pertained to Hicks and his family. For more information, see George A. Jenks, "The Newtown Library," *Bucks Co. Hist. Soc. Papers*, III (1909), pp. 316–329, and Edward R. Barnsley, *Newtown Library Under Two Kings*

(Bristol, Pa., 1938), pp. 7–15. The library moved to Newtown in 1818 and was temporarily housed in the courthouse until a new building was constructed on property donated by Edward's father. For this generous gift of land, Isaac Hicks was granted life membership, the only such grant made by the Newtown Library Company. Joseph Worstall, Jr., Hicks's brother-in-law, and Thomas Goslin oversaw the building project, which was funded by subscription. Edward contributed $1.00 to the project. Sometime in 1825, Edward was asked to paint the sign for the library for which it is possible he was paid $1.00. In 1826, the committee hired Thomas Goslin to paint the building for $3.00. It took Goslin almost a year to complete the job. Charles Swain repainted and rewhitewashed the building in 1833. Isaac W. Hicks, Edward's son, became an active member in 1827. Edward was a member only for one year. Other Hicks relations involved in the company were Thomas Kennedy, Jesse Leedom (husband of Mary Twining), and Charles Leedom (son of Jesse). Pullinger, *Newtown's First Library Building*, pp. 1–8.

36 Hicks, *Memoirs*, p. 24.

37 *Ibid.*, p. 22; Pullinger, *Newtown's First Library Building*, p. 2.

38 Pullinger, *Newtown's First Library Building*, p. 8. A few years later, Eliza Violetta attended the Newton Female Seminary.

39 Hicks, *Memoirs*, pp. 25–26.

40 *Ibid.*, p. 34; Pullinger, "Edward Hicks on Bellevue Avenue," p. 11.

41 Hicks, *Memoirs*, p. 34.

42 Pullinger, *A Dream of Peace*, pp. 4–6. War seemed imminent by 1798 because American ships were being seized by French privateers.

43 Pullinger, "Edward Hicks on Bellevue Avenue," p. 11.

44 The first entry, for payment received, in Hicks's account book is dated Dec. 22, 1800, although the transaction between Comly and Hicks occurred prior to that date. The nature of the transaction is unknown.

45 Hicks, *Memoirs*, p. 37.

46 *Ibid.*, p. 38.

47 *Ibid.*, p. 39.

48 *Ibid.*

49 James Walton was a Quaker from the Byberry, Pa., meeting. He and John Comly first met Edward through a debating society in Attleborough. Walton and Comly were great friends of Edward, assisting him in various ways.

50 Hicks, *Memoirs*, p. 38.

51 Hugh Barbour and J. William Frost, *The Quakers* (New York, 1988), pp. 307–308.

52 John Comly, *Journal of the Life and Religious Labours of John Comly, Late of Byberry, Pennsylvania* (Philadelphia, Pa., 1853), p. 138.

53 Hicks, *Memoirs*, p. 50.

54 *Ibid.*

Pages 24–33
Artist and Minister

1 Hicks, *Memoirs*, p. 50.

2 Richard C. Pullinger and Edna S. Pullinger, "The House That Edward Hicks Built, Hulmeville, Pennsylvania," *Bucks County Historical Society Journal*, II (1978), pp. 106–107. Both Canby and Hulme figured prominently in Edward's career as a decorative painter. The coach-making shop was large, and Canby was an important source of work for Edward in later years. Joseph, Isaac, and Rebecca Hulme, John Hulme's children, were great friends with Edward Hicks.

3 Hicks, *Memoirs*, pp. 50–51.

4 *Ibid.*, p. 56; Pullinger, *Dream of Peace*, p. 8.

5 Pullinger and Pullinger, "House That Edward Hicks Built," p. 110.

6 Hicks, *Memoirs*, p. 51. Edward characterized himself as an "uncommonly dogmatical disputant," p. 53. See also Edna S. Pullinger, "Edward Hicks: Committee Worker," *Mercer Mosaic*, I (1984), p. 3.

7 Hicks, *Memoirs*, p. 54.

8 *Ibid.*, p. 56.

9 *Ibid.*, p. 58.

10 *Ibid.*, p. 62; Ford, *Hicks: His Life and Art*, p. 29.

11 Edwin B. Bronner, *"The Other Branch": London Yearly Meeting and the Hicksites 1827–1912* (London, 1975), pp. 1–7; Elbert Russell, *The Separation After a Century*, reprinted from *The Intelligencer* (n.p., 1928), pp. 21–22, 28; George W. Burnap, *Review of the Life, Character, and Writings of Elias Hicks* (Cambridge, Mass., 1851), pp. 17–20.

12 Burnap, *Review of the Life*, p. 18.

13 Hicks, *Memoirs*, p. 59.

14 *Ibid.*, pp. 59, 61.

15 Burnap, *Review of the Life*, pp. 18–19.

16 *Ibid.*, p. 19.

17 Hicks, *Memoirs*, p. 69.

18 *Ibid.*, p. 70. Edward noted that Wrightstown Meeting was a larger, more impressive meeting, whose members were "fanning" his "native vanity into a flame," p. 69.

19 Pullinger, "Edward Hicks of Bucks County," n.p.

20 Comly, *Journal*, pp. 153–154.

21 Elias Hicks, *Journal*, p. 228.

22 Pullinger, *Dream of Peace*, p. 12.

23 Hicks, *Memoirs*, p. 12.

24 *Ibid.*, p. 71. The sale at a reduced price was probably necessary to pay off some of Edward's debts.

25 *Ibid.*

26 *Ibid.*

27 *Ibid.*, pp. 71–72.

28 *Star of Freedom* (Newtown, Pa.), May 21, June 4, 11, 18, 25, 1817.

29 Thomas Goslin was a painter in Newtown. It appears that he applied base and varnish coats on vehicles and other articles and painted houses. There is no evidence that Goslin did ornamental painting.

30 Comly to Isaac Hicks, June 15, 1817, Friends Hist. Lib. Isaac was a relative of Edward's who lived in Westbury, Long Island, N. Y. In his long, highly detailed letter, Comly explained Edward Hicks's landholdings in great detail, noting that Edward's crops were doing well with the help of hired hands.

31 *Ibid.*

32 Comly to Isaac Hicks, Oct. 23, 1817, Ford files, Newtown Hist. Assn.

33 Comly to Isaac Hicks, Nov. 17, 1817, Friends Hist. Lib.

34 *Ibid.*

35 *Ibid.*

36 Comly to Isaac Hicks, Feb. 11, 1818, *ibid.*; Mar. 10, Aug. 20, 1818, Ford files, Newtown Hist. Assn.; May 23, July 7, 1818, Friends Hist. Lib. Comly described Beulah Twining as "a warm friend in the case of Edward has done much for him." Apr. 29, 1818, Ford files, Newtown Hist. Assn.

37 Hicks, *Memoirs*, pp. 7–8.

Pages 34–40
Voices of Discord

1 Hicks, *Memoirs*, p. 72.

2 Pat M. Ryan, "Mathias Hutchinson's *Notes of a Journey* (1819–20)," *Quaker History*, LXVIII (1979), pp. 92–114; Pat M. Ryan, "Mathias Hutchinson's *Notes of a Journey* (1819–20)," *ibid.*, LXIX (1980), pp. 36–57; Pat M. Ryan, ed., "Rochester Recollected: A Miscellany of Eighteenth- and Nineteenth-Century Descriptions," *Rochester History*, XLI (1979), pp. 8–12. At the time of the 1827 separation, Hutchinson chose to follow the Orthodox Quakers, yet he and Edward remained friends.

3 Hicks, *Memoirs*, pp. 72–89. The map pictured on page 95 reflects information found in both Hutchinson's *Notes* and Edward's *Memoirs*. Hutchinson's notes are very complete, having been written during the journey as opposed to Hicks's account set down from memory many years later.

4 *Ibid.*, p. 74.

5 *Ibid.*, p. 89; Elias Hicks, *Journal of the Life and Religious Labours of Elias Hicks*, 5th ed., 1832, reprint, ed. by Edwin S. Gaustad (New York, 1969), p. 389.

6 Elias Hicks to Hicks, Feb. 23, 1821, Friends Hist. Lib.

7 Hicks, *Memoirs*, pp. 90–91.

8 *Ibid.*, p. 89.

9 *Ibid.*, pp. 89, 91–92, 252.

10 *Ibid.*, p. 98. These issues became so important that Edward eventually expressed them on canvas in the Peaceable Kingdom pictures.

11 Russell, *Separation After a Century*, pp. 24–26.

12 See Hicks, *Memoirs*, pp. 251–252, for Edward's discussion of "Hicksites" and "Orthodox." Also see Janney, *An Examination*, pp. 180–181.

13 Russell, *Separation After a Century*, pp. 17, 29. Edward also shared this opinion: "Neither Elias Hicks nor his doctrine had any thing to do with our Quaker revolution in Pennsylvania, which originated in a contest between the republicanism of William Penn, planted in America and watered and cherished by the free institutions of our country, and the aristocracy of the Yearly Meeting of London, under the influence of the British hierarchy. This being the fact, and that Elias Hicks never united with John Comly's excellent Christian plan of re-organizing our Yearly Meeting, through its constituent branches, nor came into it, till after it was effected, and the Genius of Pennsylvania had offered its protection to Friends; this of itself, certainly shows the inconsistency of calling us Hicksites. If we must have a nick-name there would be much more propriety in calling us Comlyites." Hicks, *Memoirs*, p. 252.

14 Russell, *Separation After a Century*, pp. 13–15. For additional information on the causes of the separation and the principal people involved, see Burnap, *Review of the Life*, pp. 16–25, and Bronner, *"The Other Branch,"* pp. 1–10.

15 Hicks painted Washington at the crossing of the Delaware several times. In *A Word of Exhortation to Young Friends*, published with the *Memoirs*, he wrote a lengthy paragraph that began "Who was George Washington?" Edward briefly summarized Washington's humble beginnings, concluding, "In a word, a series of offices and appointments, involving the greatest responsibility, from his youth up, which he filled with perfect propriety and faithfulness, prepared him to stand at the head of a band of the most illustrious patriots the world ever saw." Washington was credited with establishing an American government that espoused liberty and virtue. Although Edward did not recommend that Quakers follow all of Washington's examples, "I produce him as a conspicuous matter of fact argument in favor of my important concern, that our American youth, if brought up in the path of humble industry, and thrown more on their own responsibility, even if they should not attain to the perfection of the Christian, would be most likely to make the greatest gentile benefactors, or in other words, the strongest sinews of civil government." Pp. 357–358.

16 Russell, *Separation After A Century*, p. 15.

17 *Ibid.*, pp. 15–16. The French Revolution was, in part, a revolt against arbitrary authority of both church and state. The Catholic hierarchy and the Bourbon dynasty were considered to be enemies of liberty and chief perpetrators of dogma. English Deists were instrumental in promulgating the idea that man should be allowed the right to pursue what was reasonable in the quest for rational religious beliefs. Their work, which influenced Voltaire, Rousseau, and other French intellectuals, spread to Germany and back to England. Thomas Paine's *Age of Reason*, heavily shaped by Voltaire's writings, circulated widely in America. Paine was of Quaker ancestry. Elias Hicks noted that an entire Quaker community in Virginia had come under the influence of the *Age of Reason*.

18 *Ibid.*, pp. 27, 17.

19 *Ibid.*, pp. 17–18. Burnap, *Review of the Life*, p. 14.

20 Russell, *Separation After a Century*, p. 17.

21 See chap. 6 for a general discussion of the Quaker aesthetic as it evolved in eighteenth- and nineteenth-century America.

22 Bronner, *"The Other Branch,"* p. 1; Russell, *Separation After a Century*, pp. 19–22.

23 Russell, *Separation After a Century*, p. 21.

24 *Ibid.*

Pages 41–50
Elias and the Elders

1 Information on the leaders of the separation was derived in

large part from the chapter titled "Four Saints of the Separation," Russell, *Separation After a Century*, pp. 25–44.

2 Elias Hicks, *Journal*, pp. 7–8.

3 *Ibid.*, pp. 9–15.

4 *Ibid.*, pp. 16–17.

5 *Ibid.*, p. 57.

6 *Ibid.*, p. 102.

7 *Ibid.*

8 *Ibid.*, pp. 438, 448.

9 Russell, *Separation After a Century*, p. 27.

10 Elias Hicks, "Letter to Hugh Judge, of Ohio," *Journal*, p. 440.

11 *Ibid.*, pp. 440–441.

12 *Ibid.*, p. 442.

13 On Mar. 1, 1830, soon after his death, the New York *Evening Post* published a poem entitled "A Farewell to Elias Hicks."

14 Comly, *Journal*, p. 309; Russell, *Separation After a Century*, pp. 38–39. By 1827, Comly's impression of the situation was changing. He wrote that "many tender spirits were pained with this arbitrary stretch of orthodox power, to see the once beautiful order and unity of the society thus prostrated and trampled upon to gratify a false and fiery zeal, and an engine thus formed by a party, in order to establish its authority over the consciences and gifts of all who might be obnoxious to their creed, or standard of doctrines." Comly, *Journal*, p. 318.

15 Russell, *Separation After a Century*, pp. 29–30.

16 *Ibid.*, pp. 31–32.

17 *Ibid.*, p. 41.

18 *Ibid.*, pp. 42–43.

19 Quoted in Bronner, *"The Other Branch,"* p. 5, n. 1.

20 *Ibid.*, pp. 4–5.

21 Hicks, *Memoirs*, p. 106.

22 *Ibid.*, p. 108.

23 *Ibid.*, pp. 108–109.

24 *Ibid.*, pp. 109–110. Such verbal exchanges were remembered, reported on, and collected as evidence of each faction's opinion of and opposition to the other. Edward kept abreast of both parties' positions.

25 *Ibid.*, p. 99. Edward was referring to Ezekial 8:6–12. He equated the wickedness of the ancient Israelites who carried out their actions in the dark behind the wall to the Orthodox Friends who met secretly to plan "abominations" against the Hicksites.

26 Hicks to David Seaman, undated, Friends Hist. Lib. Although undated, the various issues discussed in the letter indicate that it likely was written in 1822.

27 *Ibid.*

28 Janney, *An Examination*, p. 214.

29 *The Cabinet; or, Works of Darkness Brought to Light*, 2nd ed. (Philadelphia, Pa., 1825), p. 5. An early opponent of Elias, Evans condemned his teachings. In 1819, Elias attended the Pine Street Monthly Meeting of which Evans was an elder. In an unprecedented move, Evans convinced the members to adjourn the meeting. Janney, *An Examination*, pp. 211–213. In his *Memoirs*, Edward wrote of Evans, "I certainly have no unkind feeling towards those whose names I have mentioned, especially dear old Jonathan Evans, for whom I have ever felt, and still continue to feel, a decided partiality. But I believe what I have said of him was true; that he was a violent, choleric man, and too much like myself, malignant and bitter against his enemies, which he supposed we were, and called us Hicksites, separatists, infidels, &c." Edward envisioned "the angelic spirit of dear Jonathan Evans and Elias Hicks, clothed in white raiment," united in heaven together indicating a better time when "the Society of Friends might once more flow together." P. 158.

30 *Ibid.*

31 Janney, *An Examination*, p. 215.

32 *Ibid.*; Bliss Forbush, *Elias Hicks: Quaker Liberal* (New York, 1956), p. 216.

33 *The Cabinet*, p. 26.

34 *Ibid.*, pp. 26–29; Russell, *Separation After a Century*, pp. 31–32. "The conduct of [elders] Ezra Comfort and Isaiah Bell, in relation to the charges against Elias Hicks, being brought before the monthly Meeting to which they belonged, they were dealt with as the discipline requires, and being unwilling to acknowledge their error, were disowned. They appealed to Abington Quarterly Meeting, and the judgment of the Monthly Meeting was confirmed. They then appealed to the Yearly Meeting, and were reinstated." Janney, *An Examination*, p. 226.

35 Janney, *An Examination*, p. 226; *The Cabinet*, pp. 21–32.

36 Janney, *An Examination*, p. 181.

37 Forbush, *Elias Hicks*, pp. 218–219.

38 *Ibid.*, pp. 218–220.

39 Hicks, *Memoirs*, p. 107.

40 Comly, *Journal*, p. 309.

41 Janney, *An Examination*, pp. 260–263.

42 Mather and Miller, *Edward Hicks*, p. 36.

43 Janney, *An Examination*, pp. 260–263.

44 Comly, *Journal*, pp. 322–325, quote on p. 325.

45 Hicks, *Memoirs*, pp. 124–125.

46 Janney, *An Examination*, pp. 271–279.

47 *Ibid.*, pp. 45–47; Mather and Miller, *Edward Hicks*, p. 36; Bronner, *"The Other Branch,"* p. 7; Hicks, *Memoirs*, pp. 126–127.

48 *The Cabinet; A Chapter of Modern Chronicles, In Which Certain Events Which Lately Took Place in the City of Gotham Are Truly Set Forth* (New York, 1826); [Benjamin Ferris and Rebecca B. Comly], *An Epistle from the Yearly Meeting of Friends, Held in Philadelphia, By adjournments from the fifteenth day of the Tenth Month, to the nineteenth of the same, inclusive, 1827, To the Quarterly, Monthly, and Particular Meetings of Friends, Within the Compass of the Said Yearly Meeting* (Philadelphia, Pa., 1827); James Cockburn, *A Review of the General and Particular Causes Which Have Produced the Late Disorders and Divisions in the Yearly Meeting of Friends, held in Philadelphia: with introductory remarks on the state of the Primitive Churches, their gradual declension, and subsequent advancement in reformation, to the rise of the Society of Friends* (Philadelphia, Pa., 1829); William Gibbons, *A Review and Refutation of Some of the Opprobious Charges Against the Society of Friends, as Exhibited in a Pamphlet Called 'A Declaration, &c.' Published by the Yearly Meeting of Orthodox Friends (So Called) Which Was Held in Philadelphia in the Year 1828. To Which is Added, Remarks on What is*

Called the Hypostatical Union, and on the Trinity (Philadelphia, Pa., 1847).

49 *Hole in the Wall: or, A Peep at the Creed-Worshippers* (n.p., 1828). This creed was adopted by the yearly meeting at Arch Street meetinghouse in Apr. 1828. The man with the cane in fig. 27 is probably Samuel Bettle.

50 Robert Smith, ed., *The Friend: A Religious and Literary Journal.* The Oct. 17, 1829, issue is especially helpful in understanding the debates about the divinity of Christ and the often sarcastic tone of the rebuttals that flew back and forth between the two groups. Of Edward Hicks's discourses, the author wrote: "To give those who may never have read these famous discourses, a further insight of Edward Hicks' ingenuity in explaining away the pre-existence of our Lord, we shall quote a little further. He says, 'he [Christ] was a very superior child.'" P. 6.

51 *Ibid.*

52 *Ibid.*, Oct. 24, 1829, p. 15. The article is titled "Primitive Doctrines of Hicksism." "Edward Hicks took occasion recently to congratulate himself with never having spoken of the blood of Christ as being of no more value than that of a bullock." The writer also pointed out the close association between Edward and the ministry of Elias: "The principles of Edward Hicks' doctrine are much the same with those of his friend and patron Elias."

53 *Ibid.*, May 1, 1830, p. 232.

54 Hicks, *Memoirs*, pp. 103, 107, 127, 136, 158, 238–239.

55 *Ibid.*, pp. 133, 128.

56 Benjamin Davis to Thomas McClintock, Sept. 17, 1828, Friends Hist. Lib.

57 Ford, *Hicks: His Life and Art*, p. 67.

58 Russell, *Separation After a Century*, pp. 52–53.

Pages 51–64
The Nature of the Beasts

1 Hicks, *Memoirs*, p. 72.

2 Susan wrote several months later to her father that "it is a trial to be so long seperated from thee." She worried about his "heavy cold, . . . fearing lest thee does not take sufficient care of thyself—we know my dear father that thee never is very mindful of endangering thy own health." Susan Hicks to Hicks, Feb. 16, 1820, Ford files, Friends Hist. Lib. In late 1829, Edward commenced a second long ministry trip to Ohio. Mary, concerned about her father's health, wrote, "Do not dear father take two meetings in a day, thee knows the delicate state of they [thy] health—and I have always observed that after thee has attended two meetings in a day, thee has been much exhausted." Mary Hicks to Hicks, Jan. 7, 1830, *ibid.*

3 Hicks, *Memoirs*, pp. 100–101.

4 Elias Hicks to Hicks, Apr. 9, 1822, Friends Hist. Lib.

5 Beulah Twining's note to Edward of Oct. 16, 1819, reveals much about her role in caring for the Hicks family: "Cousin Edward I have obtained the privilege of adding . . . that the domestick concerns of thy family are carefully attended to, the winter grain well and seasonably put in. The Corn is gathered and . . . there is about 40 bushels. . . . [I] will furnish thy family with wood untill thy return. This, Edward, I consider a duty." In a letter from Mary Hicks to Hicks, Oct. 16, 1819, Ford files, Friends Hist. Lib.

6 Sarah Hicks seems to have relied on her daughters to handle most of the correspondence with their father. The letters reveal the depth of love and devotion the family shared. Writing to Sarah from New York in 1819, Edward observed, "I sometimes see children that look like ours at the sight of which I can scarsly restran my tears . . . I saw a little boy that so much resembled my dear little Isaac that I had to go out and take a crying spell. . . . I have no language to express how dear you all feel to me and particularly my dear wife. I have seen nobody that looks like her." In this same letter he added a note to daughter Susan with whom Edward shared an especially close relationship. The reasons may have been her gregarious nature and that Edward believed she "possesses so much the disposition of her Father." He described her as "a little vollitile girl." Hicks to Sarah Hicks, Dec. 8, 1819, *ibid.*

7 Dr. Joseph Parrish was one of Edward's most loyal clients and purchased a number of easel pictures from him.

8 During the period 1816–1818, Edward's account book, p. 74, indicates that he had also completed two "Landscape paintings" for Dr. Abraham Chapman. The book also lists a "Landscape fire board" for Dr. Phineas Jenks. P. 82. None of these paintings has been identified among Hicks's extant works. Perhaps they were similar to the pastoral scenes in figs. 164–166. Ford proposed that "landscape" applied to the Kingdom pictures, but this seems unlikely. Edward had more than a cursory knowledge of fine arts terminology and would not have considered the Kingdom pictures in that category. The Kingdoms were special paintings, religious in nature, and represented more than pastoral views. Unlike the first easel paintings recorded for Parrish and Streeter and those mentioned above, few that followed were documented in the account book. Edward's easel paintings were rarely commissioned. Most were presented to family members and close friends. In this sense, they had personal value for the artist and the recipient and were rarely works for hire.

9 Mather and Miller, *Edward Hicks*, p. 19.

10 Ford, Mather and Miller, and Pullinger identified a relationship between the paintings and the Hicksite-Orthodox schism in several of their publications, principally by the coincidence of the creation of the paintings during the troubled period of the schism. In *Hicks: Painter of the Peaceable Kingdom*, Ford discussed the symbolism of the animals extensively. In 1981, David Tatham offered the most sensitive analysis of the impact of the Quaker controversy on Edward's art. He wrote that Edward's "life was one of central involvement in complex and unremitting religious controversy on a national scale, of which many of his paintings are . . . significant records." Tatham also outlined the symbolic meanings of the animals which he believed alluded to "the animal nature of mankind and they characterize the beastly qualities Elias and Edward saw in those Quaker—the Orthodox—who openly opposed them." Tatham, "Edward Hicks, Elias Hicks and John Comly," p. 43.

11 Isaiah 11:6–9. Stories in the book of Isaiah echoed the warlike encounters and debates of the Quaker schism.

12 Tatham, "Edward Hicks, Elias Hicks and John Comly," pp. 46–47; Ford, *Hicks: His Life and Art*, pp. 76–82.

13 Hicks, Goose Creek sermon, *Memoirs*, p. 325.

14 See Jean Lipman, "The Peaceable Kingdom by three Pennsylvania Primitives," *Art in America*, XL (1957), pp. 28–29.

15 Of Hicks's known works, 62 of a total of 108 easel pictures are Kingdoms.

16 Hicks, Goose Creek sermon, *Memoirs*, p. 268.

17 Herbert Leventhal, *In the Shadow of the Enlightenment: Occultism and Renaissance Science in Eighteenth-Century America* (New York, 1976), pp. 4–5.

18 *Ibid.*, pp. 5–6.

19 *Ibid.*, pp. 6–7, 192–205. See also W. F. Bynum and Roy Porter, eds., *Companion Encyclopedia of the History of Medicine*, I (London, 1993), pp. 143–144, 287–288.

20 Bynum and Porter, eds., *Companion Encyclopedia*, pp. 143–144, 287–288; Leventhal, *In the Shadow of the Enlightenment*, pp. 223, 231–242, 258.

21 Leventhal, *In the Shadow of the Enlightenment*, pp. 181–191, 267.

22 Hicks, Goose Creek sermon, *Memoirs*, pp. 268–269.

23 *Ibid.*, p. 269.

24 *Ibid.*, p. 270.

25 *Ibid.*, pp. 270–271. The concept of relinquishing self-will is mentioned repeatedly throughout the sermon in association with the characteristic behaviors of the carnivorous animals. Edward associated the wolf, the leopard, the bear, and the lions as embodiments of hatred, envy, jealousy, etc., "where cursed self reigns."

26 *Ibid.*, p. 276.

27 *Ibid.*, pp. 276–277.

28 *Ibid.*, p. 277.

29 *Ibid.*, p. 278.

30 *Ibid.*, pp. 278–279.

31 *Ibid.*, p. 287.

32 *Ibid.*, p. 291.

33 *Ibid.*, pp. 291–292.

34 *Ibid.*, p. 294.

35 *Ibid.*, pp. 294–295.

36 *Ibid.*, p. 307.

37 *Ibid.*

38 *Ibid.*, p. 312.

39 *Ibid.*, pp. 312–313, 317.

40 *Ibid.*, p. 314.

41 Ibid., p. 315.

42 *Ibid.*, pp. 321–322.

43 Howard H. Brinton, "Quakers and Animals," in *Then and Now: Quaker Essays: Historical and Contemporary*, ed. Anna Cox Brinton (Philadelphia, Pa., 1960), pp. 188–190. As early as 1643, George Fox wrote that "Wolves, Dogs, Dragons, Bears, Lions, Tigers, Wild Beasts and Birds of Prey make a Roaring and a Screeching Noise against the Lambs, Sheep, Doves and Children of Christ." P. 188.

44 *Ibid.*, pp. 191–193.

Pages 65–89
Ornamental Painter

1 Frederick B. Tolles, "'Of the Best Sort but Plain': The Quaker Esthetic," *American Quarterly*, XI (1959), pp. 487–488.

2 *Ibid.*, p. 485. Writing about Philadelphia's well-heeled seventeenth-century Quakers, Tolles observed: "If they deviated from plainness by a jot or a tittle— . . . they stood under the judgment of their meeting, and had to face the disapproval, spoken and unspoken, of the simpler country Friends who, . . . preserved the primitive Quaker ideal of simplicity more faithfully." P. 495.

3 *Ibid.*, pp. 495–500. Some Quakers among "the rich" were characterized in 1806 as using "as plain and frugal furniture, as those in moderate circumstances. Others again step beyond the practice of the middle classes, and buy what is more costly, not with a view of shew so much as to accommodate their furniture to the size and goodness of their houses. In the houses of others again, . . . we now and then see what is elegant, but seldom what would be considered to be extravagant furniture. We see no chairs with satin bottoms and gilded frames, no magnificent pier-glasses, no superb chandeliers, no curtains with extravagant trimmings." P. 501. Tolles explained, "Of course, the surviving evidence is inevitably incomplete and therefore may be deceptive. After all, the examples of Philadelphia craftsmanship which have caught the connoisseur's eye and been preserved in museums naturally tend to be the more spectacular pieces. Many of the more typical products fashioned by Quaker craftsmen for their Quaker clients may have disappeared." P. 498.

4 Lillian B. Miller, ed., *The Selected Papers of Charles Willson Peale and His family*, I (New Haven, Conn., 1983), p. 97.

5 *Ibid.*, p. 124.

6 Charles Coleman Sellers, *Portraits and Miniatures by Charles Willson Peale* (Philadelphia, Pa., 1952), p. 28.

7 Mather and Miller, *Edward Hicks*, pp. 36–37. In fact, Ferris seems to have been as enamored with art as Hicks was. In 1801, he wrote to his sister, "Dame nature . . . has bestowed on me, that smattering talent . . . just to arrive at that degree of skill in the fine arts which brings to its possessors trouble without honor or profit. Thou knows that I have attempted at some branches of the painting business. This was one of the unlucky turns of my life." Jonathan L. Fairbanks, "Benjamin Ferris: A Friend of Many Talents," *Delaware Antiques Show*, catalog (Wilmington, Del., 1966), p. 81.

8 Mather and Miller, *Edward Hicks*, p. 51.

9 *Ibid.*, p. 53. The authors discussed points made in Frederick J. Nicholson, *Quakers and the Arts: A survey of attitudes of British Friends to the Creative Arts from the Seventeenth to the Twentieth Century* (London, 1968).

10 Mather and Miller, *Edward Hicks*, p. 53.

11 Although painters were important to the completion of a carriage, they were only one group among a hierarchy of employees. Bodymakers, trimmers, smiths, springmakers, wheelwrights, platers, and bracemakers were some of the other specialists who worked on carriages.

12 William Bridges Adams, *English Pleasure Carriages; Their Origin, History, Varieties, Materials, Construction, Defects,*

Improvements, and Capabilities: with an Analysis Of the Construction Of Common Roads and Railroads, and The Public Vehicles Used On Them (London, 1837), pp. 180–188.

13 *Ibid.*, p. 205.

14 *Ibid.*, pp. 205–210.

15 Entries throughout the account book show that several types of vehicles were painted in Edward's shop. Some were given special embellishments with the addition of ciphers, letters, and other ornamentation. There are several references to details such as lettering stages and painting ciphers on chair bodies. One entry noted, "to putting on six gold letters and his coat of arms to a coachee." P. 52. Each of these elements was an additional cost to the client. A cipher or letter could cost as little as 50 cents, whereas the work quoted above cost $6.00. The cost of simply painting a chair body averaged about $10.00, a coachee $15.00 to $20.00.

16 *Ibid.*, p. 212. Entries in the account book refer to painting vehicles. Specific colors and types of finishes used were mentioned occasionally. Workers in the shop silvered a chair body, streaked a carriage, and worked with silver leaf. Although noted rarely, the colors cited were yellow rassees and gigs, cream-colored berushes, a light-colored gig body, and brown bodies. In 1831, Edward charged $10.00 "to painting a new Sulky for one Cook of Philadelphia in the best manner." P. 198. The price indicated that Edward took special care with this vehicle, since painting a sulky usually cost $5.00 to $7.00. Paints were mentioned throughout the accounts—vermilion, Prussian blue, yellow ocher, Spanish brown, green, sand ocher. Supplies included white lead, letherage, putty, varnish, and oil used to prime and prepare paints. Occasional references to grinding paint hint at the time it took to prepare them. Other paints and techniques were needed to coat the metal components of carriage wheels and supports.

17 Jennifer D. Baker, "Understanding Antique Carriage Finishes," *Driving Digest Magazine*, XC (1995), p. 9. This article is one of only a few modern sources that offer information on finish analysis of antique carriages and related vehicles.

18 Many sources describe the types of vehicles manufactured and used in America during the eighteenth and nineteenth centuries. *The Coach-Makers' Illustrated Hand-Book*, 2nd ed. 1875 (reprint, Mendham, N. J., 1995) was especially helpful in sorting out the various types Edward painted. It contains instructions for and descriptions of the trades involved in carriage building.

19. Ford files, Newtown Hist. Assn. The first recorded coach maker in Newtown was Alexander Vanhorn, who advertised in 1815 and 1821. James Philips sold his coach-making business, including tools and vehicles, in 1829. Silas Philips advertised in 1832, as did Charles Craven in 1835. Philips's business was taken over by John Cornell in 1840. The firm of Yardley and Buckman was well established by 1831; soon after, Benjamin Yardley advertised as being on his own. The account book verifies that Edward had dealings with several of these coach makers.

20 *Herald of Liberty* (Newtown, Pa.), June 21, 1815.

21 *Star of Freedom* (Newtown, Pa.), May 21, June 4, 11, 18, 25, 1817. During that period, Hicks's shop painted vehicles, houses, furniture, and signs. An analysis of the account book showed that in 1809, the shop worked on approximately 60 different vehicles, the mainstay of the business. Shop workers painted both the interiors and exteriors of houses and applied faux finishes on room cornices, doors, and fireplaces. This branch of the business declined after the 1820s. Because of damage to the original book, entries near the end lack dates. The year 1809 was chosen because entries near the front of the book are better preserved.

22 Hicks, account book, p. 130.

23 Richard Price to Hicks, Jan. 16, 1845, Friends Hist. Lib.

24 Hicks, account book, pp. 14, 28, 56, 90, 112, 186, 192.

25 Joseph Jackson, "John A. Woodside, Philadelphia's Glorified Sign-Painter," *Pennsylvania Magazine of History and Biography*, LVII (1933), p. 63. Jackson quoted a notice in the Feb. 28, 1852, *Public Ledger* (Philadelphia, Pa.) after his death in Feb. 1852. Scholars have alleged that Woodside studied with Matthew Pratt and his associates who painted much-admired signboards in Philadelphia. About 1817, Woodside relocated near Ann Parrish, sister of Dr. Joseph Parrish, one of Edward's greatest patrons.

26 Holger Cahill, "Artisan and Amateur In American Folk Art," *Folk Art in America: Painting and Sculpture*, ed. Jack T. Ericson (New York, 1979), p. 22.

27 Mather and Miller, *Edward Hicks*, pp. 58–59.

28 *Ibid.*, p. 154.

29 Ford, *Hicks: His Life and Art*, p. 122. Hicks's account book showed that he had painted a tavern sign for Archambault in 1828, for which he charged $6.00. Ford suggested that it was of Niagara Falls. The sign, now lost, was for an earlier tavern owned by Archambault. P. 56.

30 *Ibid.*, pp. 122, 182; Mather and Miller, *Edward Hicks*, pp. 60–61. At an auction in Newtown in 1976, Alice Ford made a list of books signed by Edward Hicks or members of his family. Among them were two copies of Goodrich's book. The frontispiece depicting the *Declaration* scene was missing in the one she said was signed by Edward. He may have removed the engraving in order to refer to it while painting. The other copy was signed by Isaac Worstall Hicks, the artist's son.

31 Ford, *Hicks: His Life and Art*, p. 122. Mather and Miller wrote that Samuel West ordered the sign and presented it to the landlord of the hotel. *Edward Hicks*, p. 179.

32 Cahill, "Artisan and Amateur," p. 22; Ford, *Hicks: His Life and Art*, pp. 118–121.

33 Mather and Miller, *Edward Hicks*, pp. 60, 179.

34 Information from the previous owner, J. F. Van Horn, AARFAC archives.

35 Mather and Miller, *Edward Hicks*, pp. 163–164.

36 *Doylestown Democrat*, May 31, 1848, Ford files, Friends Hist. Lib.

37 In 1843, Edward resumed his advertisements for painting highway signs: "Edward Hicks wishes to inform the Supervisors and all others interested in putting up the Directors, on our public highways, according to law, that if they will paint the boards white, to suit themselves, and bring them to his shop in Newtown, he will letter them and ornament them with Hands &c. on both sides, completely, for forty-five cents per board. Or should he receive orders for forty or fifty in a place, he will deliver the boards, finished, ready to put up, at any distance not exceeding fifty miles, for sixty-five cents per

board." Ford, *Hicks: Painter of the Peaceable Kingdom*, p. 92.

38 The 1820 U. S. census records suggest that Goslin was between the ages of 26 and 30. Whether or not he ever apprenticed with Hicks is unknown, although he paid the artist for two years of board in 1815. Goslin's name appeared often in the Hicks account book until the mid-1820s, after which he was listed infrequently.

39 Ford, *Hicks: Painter of the Peaceable Kingdom*, p. 31; Pullinger, *Vision of Peace*, p. 59. Hubbord is mentioned several times in Edward's accounts, but his relationship is unclear. It appears that Edward hired him to provide work that the shop did not perform.

40 Hicks, account book, s.v. "Evans," pp. 2, 12, 30, 48–49, 88–89, 100, 188; "Shoemaker," pp. 40, 116, 118, 122, 132, 140–141, 148; "Twining," pp. 70–71, 118, 120. Shoemaker was credited $133.00 for a year's work in 1818 and $160.00 each for the years 1819 and 1820. P. 141.

41 Isaac W. Hicks, daybook, pp. 32–37. Between July and Dec. 1836, 37 portraits are listed individually by the client's name. Thomas Hicks charged an average of $6.00 per portrait. The 1836 portraits were painted for Linton Tolbert, Charles W. Swain, Charles W. Lee, John Ely, Harvy Blaker, Jonathan Schofield, Thomas Canby, Edward Kenenday, Joshua Woolston, Joseph Taylor, Peter Quinnen, Adrianna Craven, Doctor Clagett, Joseph Schofield, John Tucker, Adrian Cornell, Jr. "and sister," Mahlon Janney, Smith Trego, Fenne's (three portraits), Anna Tolbert, Francis Vanartsdellen, Charles W. Swain (his wife's portrait), Joshua Woolston (his wife's portrait), Elizabeth Feaster (Fester), John Vanartsdellen (his and his wife's portraits), William H. Hart, Miss Fenne, John Laeur, Edward Trego (his and his wife's portraits), Mahlon Trego (his and his wife's portraits), and Charles W. Lee (his wife's portrait). An entry for 1837 noted "16 Portraits (painted in Philadelphia)" by Thomas with a total value of $100.00.

42 Ford, *Hicks: His Life and Art*, pp. 130, 132. Edward's great-granddaughter recounted the family legend that surrounds the painting of the portrait: "My father told many times of this incident (which his father Isaac had told him)—Thomas purposely entered into a religious discussion with Edward, determined to disagree with him on a point, which he did, in order to stir Edward to anger, and thus caught the delightfully stern expression which you see.... This is of that original portrait." AARFAC archives. Two other versions of the portrait are at the National Portrait Gallery and the James A. Michener Museum, Doylestown, Pa. Thomas painted portraits of other family members including Edward's son Isaac and his daughter Elizabeth. Ford, *Hicks: His Life and Art*, pp. 124, 154–155. None of these portraits is recorded in Isaac W. Hicks's daybook. A reference in an exchange of letters between Edward Hicks and Richard Price, a merchant in Philadelphia, sheds some light on Thomas Hicks's early efforts at portraiture. Price wrote to Edward on Dec. 3, 1836, that he had received a portrait of Edward Stabler's father "to be sent to thee.... to have the use of it for a while." Edward wanted the portrait for Thomas Hicks to study, for he responded to Price about a week later that the portrait would remain with his cousin Thomas until further notice. Price to Hicks, Dec. 3, 1836, Hicks to Price, Dec. [12], 1836, Ford files, Friends Hist. Lib.

43 *Dictionary of American Biography*, s.v. "Hicks, Thomas." For more information on Thomas Hicks, see David Tatham,

"Thomas Hicks at Trenton Falls," *American Art Journal*, XV (1983), pp. 5–20. Tatham noted that he became one "of the most fashionable and prosperous of American portrait painters."

44 Robert G. McIntyre, *Martin Johnson Heade, 1819–1904* (New York, 1948), p. 7. Heade, the son of Joseph Cowell and Sarah Johnson Heed, was from Lumberville, Bucks County. P. 5. Theodore E. Stebbins, Jr., *The Life and Works of Martin Johnson Heade* (New Haven, Conn., 1975), pp. 3–4. The earliest reference to his association with Edward Hicks's shop is in an 1876 history of Bucks County: "Mr. Head is the son of Joseph Head, of Lumberville, and born August 11th, 1819. He . . . was a pupil of Edward Hicks, at Newtown." W. W. H. Davis, *The History of Bucks County, Pennsylvania, from the Discovery of the Delaware to the Present Time* (Doylestown, Pa., 1876), p. 768, n. 14.

45 Stebbins, *Life and Works of Martin Johnson Heade*, pp. 4, 6. Thomas Hicks painted Heade's portrait ca. 1841. Pp. 4, 7.

46 Hicks, account book, s.v. "Tomlinson," pp. 4, 58–59, 102, 108, 110, 136, 146, 148, 190; "Vanhorn," pp. 115, 134, 166–167, 176; "Canby," pp. 32, 48–50, 52, 54–56, 84, 88, 92.

47 "Blaker," pp. 153, 217, 220, 230; "Craven," pp. 207 and possibly 176; "Croasdale," p. 10, and "Croadsdale [*sic*] and Griggs," p. 4; "Phillips," pp. 173–175, 213; "Yardley," p. 195; "Yardley & Buckman," p. 258, *ibid.*

48 Some of those listed who can be associated with trades were Levi Bond, carpenter; John Brown (probably John F. Brown), carpenter; Brown, Eyre & Co., foundry; N. Burrows, blacksmith; Joseph Dirrickson (Derekson, Derickson), painter; Joseph Hicks, carpenter; Asher Miner, painter; Aaron Phillips, blacksmith; J. Phillips (probably James Phillips), blacksmith; Samuel Phillips, wheelwright; I. Reader, harness maker; Joseph Shaw (possibly Aaron Shaw), painter; James and Joseph Worstall, tanners; Enos Yardley, carpenter; J. (probably Joshua) Yardley, carpenter; and other Yardleys who may have been carpenters or lumberyard owners. *Ibid.*

49 *Ibid.*, pp. 130, 138, 168.

50 Hicks to Joseph Watson, Sept. 3, 1844, AARFAC archives.

51 I am grateful to Jonathan Prown, curator of furniture, CWF, for examining the original frames and providing an analysis based on constructional evidence. A complete study of all original frames on extant Hicks paintings was not possible. However, the variety observed among those on the AARFAC pictures suggests multiple frame makers, probably some of the same woodworking tradesmen Hicks mentions in his account book. An inscription made by an early owner of the painting illustrated in fig. 98 states that Edward Hicks was "assisted by Edward Trego," which probably refers to making a frame for it.

52 Hicks, *Memoirs*, p. 149.

53 *Ibid.*, p. 63.

Pages 90–130
The Early and Middle Kingdoms

1 Mather and Miller stated that fig. 28 was probably Edward's

earliest Peaceable Kingdom. They suggested a date ca. 1820, noting it could have been painted as early as 1815 when the artist's financial situation was at its worst and he was indecisive about which aspects of his painting trade to pursue. *Edward Hicks*, p. 94. But 1820 seems an unlikely date for Hicks to have created an entirely new easel genre. It is more likely that he painted the first Kingdom pictures about the time he decided to return to painting, certainly no earlier than 1816–1817.

2 Ford, *Hicks: His Life and Art*, p. 91.

3 Mather and Miller, *Edward Hicks*, p. 94; Ford, *Hicks: Painter of the Peaceable Kingdom*, pp. 41–43. Ford is credited with discovering the connection between Richard Westall's Bible print and Edward's early versions of the Peaceable Kingdom. The artist's direct source was probably the engraving after Westall by Charles Heath in *The Holy Bible* published by White, Cochrane and Co., London, 1815. Ford, *Hicks: His Life and Art*, p. 46. The Peaceable Kingdom image was popular in England during the early nineteenth century, and the Westall version or a yet-to-be-identified source inspired a number of other images. Perhaps the theme proliferated most widely through ceramics, many examples of which were produced for British markets, including the United States. Most were fabricated by Ralph Stevenson and Co., Staffordshire, Eng. See Mather and Miller, *Edward Hicks*, p. 19, for a brief discussion of the Westall version and its relationship to late eighteenth-century Romanticism.

4 Mather and Miller, *Edward Hicks*, p. 19.

5 This does appear to have been the case after 1820.

6 Two of the 5 pictures—the Yale University example (fig. 86) and the AARFAC one (fig. 87)—were titled on their frames by the artist. One of the paintings in this group of 13 (fig. 98) is missing the original border. Its removal may have occurred in the nineteenth century as a result of damage. No images of the painting showing the border are known, and thus the border message remains speculative.

7 Mather and Miller, *Edward Hicks*, pp. 95–106. The authors assigned the dates 1822–1825 to the earliest example and 1826–1827 to the latest.

8 The connection between the Henry S. Tanner Map and Edward's use of elements from it for the Branch Kingdoms and for the two fireboards was discovered by James Ayres and discussed in "Edward Hicks and his sources," *The Magazine Antiques*, CIX (1976), pp. 366–368. Edward's derivations were confined to the scenery and animals in the vignette beneath the title "A Map of North America." The map (fig. 84) was published in Philadelphia in 1822.

9 Mather and Miller, *Edward Hicks*, p. 95.

10 "And there shall come forth a rod out of the stem of Jesse, and a Branch shall grow out of his roots." Isaiah 11:1.

11 Although they cannot be specifically identified, these emblematic elements were based on popular print sources, several of which were suggested by Mather and Miller, *Edward Hicks*, pp. 58–60.

12 *Ibid.*, pp. 116–121.

13 Ford, *Hicks: His Life and Art*, pp. 98, 100.

14 Jonathan Fisher, *Scripture Animals: A Natural History of the Living Creatures Named in the Bible*, 1834 (reprint with a foreword by Mary Ellen Chase, Princeton, N. J., 1972), p. 153.

This little book is an interesting parallel to Edward's work that is helpful in understanding the popularity of Isaiah's prophecy. See pp. 33 and 70. Fisher derived his information from a number of publications.

15 Since pictures of lions and other creatures were widely available in printed material, engravers often referred to these sources for their work.

16 Mather and Miller, *Edward Hicks*, pp. 39–41; Frederick B. Tolles, "The Primitive Painter as Poet," *Bulletin of the Friends Historical Association*, L (1961), pp. 12–30.

17 Mather and Miller, *Edward Hicks*, p. 42, n. 7.

18 Ford, *Hicks: His Life and Art*, p. 82.

19 "Edward Hicks, Elias Hicks and John Comly," pp. 46–47.

20 Ford, *Hicks: His Life and Art*, pp. 76, 78–79; Mather and Miller, *Edward Hicks*, p. 39.

21 Mather and Miller, *Edward Hicks*, p. 113.

22 It would have been typical for Edward's friends or the artist himself to collect the numerous silhouettes of Elias. Traditionally, these small cut images were mounted in albums along with other notables and family members. One such album originally contained a profile of Elias that subsequently was removed, leaving a space and his name below. Another album contains a copy of an original profile (fig. 110). Helen and Nel Laughon, *August Edouart: A Quaker Album, American and English Duplicate Silhouettes 1827–1845* (Richmond, Va., 1987). The profiles illustrated here are from albums owned by American Quakers in the nineteenth century.

23 Tolles, "Primitive Painter as Poet," p. 27–29. See Mather and Miller, *Edward Hicks*, pp. 39–41, for a discussion of people in the banner Kingdoms.

24 Elias Hicks, "Letter to Hugh Judge," *Journal*, p. 442.

25 Mather and Miller, *Edward Hicks*, p. 111.

26 Hicks, *Memoirs*, p. 91.

27 Ford, *Hicks: Painter of the Peaceable Kingdom*, p. xii, note to pl. 3; Tolles, "Primitive Painter as Poet," p. 27. Mary C. Black offered a related Christian interpretation in "& a little child shall lead them," *Arts in Virginia*, I (1960), pp. 24, 27.

28 Tolles, "Primitive Painter as Poet," p. 27.

29 Hicks, Goose Creek sermon, *Memoirs*, p. 291.

30 Mather and Miller, *Edward Hicks*, pp. 44–47, were the first to point this out.

Pages 131–155
The Late Kingdoms

1 In referring to the last Kingdom, Mather and Miller pointed out that the leopard's "eyes already contemplate another world." The lion and the leopard had battled their inner wills for many years, and now the strain of self-denial showed on their faces. The authors also observed that the facial details of the lions in the late Kingdoms, particularly their eyes, appear to be more human. *Edward Hicks*, pp. 90, 89. They may depict the artist, or perhaps they represent Elias Hicks, whom Edward said was "in his first nature like a lion." Hicks, Goose Creek sermon, *Memoirs*, p. 325. Either theory is difficult to

prove. It is clear that the aging bodies and depleted energies of these creatures paralleled the declining health and interests of the artist who painted them.

2 Mather and Miller, *Edward Hicks*, p. 169.

3 *Ibid.*, pp. 72–75.

4 *Ibid.*, p. 74. The authors provided an elaborate interpretation, describing the leopard as the "beast of the vine god, Dionysus, known as Bacchus to the Romans." The animal's popularity decreased with the introduction of Christianity as the leopard became a symbol of the Antichrist. Mather and Miller pointed out that scholars studying other types of art also commented on the symbolism of the leopard. They suggested that an engraving by Wenceslas Hollar after Peter Paul Rubens's *Leopards* may have been Hicks's source.

5 Hicks, Goose Creek sermon, *Memoirs*, pp. 287, 291.

6 Mather and Miller, *Edward Hicks*, pp. 87–91.

7 *Ibid.*, p. 87.

8 *Ibid.*, p. 88.

9 Hicks to Price, Dec. [12], 1836, Ford files, Friends Hist. Lib.

10 Hicks, *Memoirs*, pp. 240–261.

11 *Ibid.*, p. 251.

12 *Ibid.*, pp. 251–252. "Scattered" and "divided" also describe the last of the Kingdom pictures where the dense unity of the animals in previous versions was replaced by looser, more independent clusters.

13 *Ibid.*, p. 259.

14 *Ibid.*, p. 261.

15 *Ibid.* To be sure, a few would remember him this way.

16 *Ibid.* This is the closing phrase of the *Memoirs*.

Pages 156–180
Painter at Peace

1 Many existing family letters suggest Edward's interest in fine painting. The artist's nephew Edward Hicks Kennedy, who appears to have had a passion for art, often wrote to Edward and his cousin Elizabeth about art matters and visits to galleries. In one letter, the younger man described family portraits being taken by "Mr. Moon from Easton," noting that he had seen various great paintings in Philadelphia in the company of Mr. Moon. Among the highlights of these visits was the nephew's opportunity to see John James Audubon's "great book of Birds." Edward Hicks Kennedy to Elizabeth Hicks, June 6, 1833, Ford files, Friends Hist. Lib. In Nov., Edward Hicks Kennedy visited the Academy of Fine Arts, Philadelphia, where he was much taken with the "splendid paintings. . . . by the Old painters," such as Rembrandt, Rubens, and Reynolds. Edward Hicks Kennedy to Elizabeth Hicks, Nov. 7, 1833, *ibid.* Writing to Elizabeth while on a trip to St. Louis, Mo., the young man reported that Edward's extraordinary reputation as a minister was known beyond the Mississippi River! Edward Hicks Kennedy to Elizabeth Hicks, June 20, 1832, *ibid.*

2 Hicks family Bible, privately owned.

3 Edward received the news on Mar. 9, 1846. Mather and Miller, *Edward Hicks*, p. 77. Edward was ill with grief over her death. "Indeed I never wanted to see thee worse than at this sorrowful season tho my sorrow respecting the loss of my precious little Phebe has almost been turned into joy from a prospect opened before me that I cannot find language possesing forse sufficient adequately to describe surfise [suffice] it to say there has been taken out of our limmited garden one of the most perfect plants that ever was planted." Hicks to Elizabeth Hicks, Mar. 31, 1846, Ford files, Friends Hist. Lib.

4 Mather and Miller, *Edward Hicks*, pp. 154–155.

5 *Ibid.*, p. 165.

6 Edward often asked a relative in New York, N. Y., to purchase painting canvas and ship it to him. For instance, on Jan. 15, 1846, Cyrus Hillborn in Philadelphia wrote to Edward, "I received thy letter of 30th ults. some days ago and I have waited in expectation of receiving the Canvas referred to in it from thy friends in New York but have as yet recd none—When it reaches me I will forward it by C. Higgs as requested." Cyrus Hillborn to Hicks, Jan. 15, 1846, Misc. letters 1811–1849, fol. 4, Bucks Co. Hist. Soc.

7 See checklist nos. 113 and 117.

8 Ford, *Edward Hicks: His Life and Art*, p. 184; *The American Earls: Ralph Earl, James Earl, R. E. W. Earl*, exhibit catalog, William Benton Museum of Art, University of Connecticut (Meriden, Conn., 1972), pp. 56–57.

9 Mather and Miller, *Edward Hicks*, p. 165.

10 *Ibid.*, p. 184.

11 *Ibid.*, pp. 184–189. The original owner of the sixth Grave of Penn is unknown.

12 Ford, *Edward Hicks: His Life and Art*, p. 186.

13 *Doylestown Democrat*, Oct. 12, 1845, in Ford, *Hicks: Painter of the Peaceable Kingdom*, p. 97.

14 Edna Pullinger, "The Residence of Thomas Hillborn by Edward Hicks," *The Magazine Antiques*, CXXX (1986), pp. 474–475.

15 Hillborn to Hicks, Jan. 15, 1846, Bucks Co. Hist. Soc.

16 Pullinger, "*Residence of Thomas Hillborn*," p. 475.

17 Mather and Miller, *Edward Hicks*, pp. 191–194.

18 *Ibid.*, p. 191.

19 *Ibid.*, p. 192.

20 *Ibid.*, p. 193.

21 AARFAC archives. James C. Cornell was a vice president of the Bucks County Agricultural Society. He commissioned Edward to paint his prize bull.

22 Julius S. Held, "Edward Hicks and the Tradition," *Art Quarterly*, XIV (1951), pp. 127, 132.

23 Mather and Miller, *Edward Hicks*, pp. 82–83. Each of the elements Edward selected from the Canton prints corresponds exactly to its representation in the painting. The two sheep from one print, when reversed, match up perfectly with their painted counterparts. The Canton ram is identical to Edward's ram. Details such as folds and creases in the wool and the linework that defines the hooves and features of the heads correspond to the linework in the print mark for mark. I am grateful to Scott Nolley, associate conservator, CWF, for his thorough examination of Hicks's paintings and the analysis of his findings.

24 *Ibid.*, p. 197.

25 *Ibid.*

26 Robert Melville, "American Museum in Britain," *Architectural Review*, XXIX (1961), p. 422.

27 Mather and Miller, *Edward Hicks*, pp. 81, 84.

28 Hicks, *Memoirs*, p. 9.

29 *Ibid.*, p. 10.

Bibliography

Adams, William Bridges. *English Pleasure Carriages, Their Origin, History, Varieties, Materials, Construction, Defects, Improvements, and Capabilities: with an Analysis Of the Construction Of Common Roads and Railroads, and The Public Vehicles Used On Them; Together With Descriptions Of New Inventions.* London: Charles Knight & Co., 1837.

American Art from the Gallery's Collection. Exhibit catalog. New York: Hirschl & Adler Galleries, 1980.

The American Earls: Ralph Earl, James Earl, R. E. W. Earl. Exhibit catalog. William Benton Museum of Art, University of Connecticut. Meriden, Conn.: Meriden Gravure, 1972.

American Paintings, Drawings and Sculpture. Auction catalog. New York: Sotheby's, Dec. 3, 1997.

Amsler, Cory. *3 Artists Named Trego: An exhibition at the Mercer Museum Through April 30, 1993.* Exhibit catalog. Mercer Museum, Bucks County Historical Society, Doylestown, Pa., 1993.

The Animal Kingdom in American Art. Exhibit catalog. Syracuse, N. Y.: Everson Museum of Art, 1978.

Ashmead, Henry Graham. *History of Delaware County.* Philadelphia, Pa.: L. H. Everts & Co., 1884.

Ayres, James. "Edward Hicks and his sources." *The Magazine Antiques,* CIX (1976), pp. 366–368.

Baker, Jennifer D. "Understanding Antique Carriage Finishes." *Driving Digest Magazine,* XC (1995).

Barbour, Hugh, and J. William Frost. *The Quakers.* Denominations in America, No. 3. Westport, Conn.: Greenwood Press, 1988.

Barnsley, Edward R. *Newtown Library Under Two Kings.* Bristol, Pa.: Bristol Printing Co., 1938.

Barrett, Walter. *The Old Merchants of New York City.* New York: Carleton, 1863.

Bauman, Richard. *For the Reputation of Truth: Politics, Religion, and Conflict among the Pennsylvania Quakers, 1750–1800.* Baltimore, Md.: Johns Hopkins Press, 1971.

Beans, L. L. *The Life and Work of Edward Hicks.* Trenton, N. J.: privately printed, 1951.

Black, Mary C. "& a little child shall lead them." *Arts in Virginia,* I (1960), pp. 23–29.

Bowden, James. *The History of the Society of Friends in America.* Vol. II: *Pennsylvania and New Jersey.* London: W & F. G. Cash, 1854.

Bradshaw, Elinor Robinson. "American Folk Art in the Collection of The Newark Museum." *The Museum,* XIX (1967), pp. 46–47.

Braithwaite, William C. *The Second Period of Quakerism.* 1961. Edited by Henry J. Cadbury. Reprint. York, Eng.: William Sessions, 1979.

Brinton, Anna Cox. *Quaker Profiles: Pictorial and Biographical, 1750–1850.* Wallingford, Pa.: Pendle Hill Publications, 1964.

Brinton, Ellen Starr. "Benjamin West's painting of Penn's Treaty with the Indians." *Bulletin of the Friends Historical Association,* XXX (1941), pp. 99–189.

Brinton, Howard H. "Quakers and Animals." In *Then and Now: Quaker Essays: Historical and Contemporary.* Edited by Anna Cox Brinton. Philadelphia, Pa.: University of Pennsylvania Press, 1960.

Bronner, Edwin B. "The Other Branch": London Yearly Meeting and the Hicksites, 1827–1912. London: Friends Historical Society, 1975.

Burgess, James W. *A Practical Treatise on Coach-Building: Historical and Descriptive Containing Full Information of the Various Trades and Processes Involved, with Hints on the Proper Keeping of Carriages, &c.* London: Crosby, Lockwood and Son, 1910.

Burnap, George W. *Review of the Life, Character, and Writings of Elias Hicks.* Cambridge, Mass.: N.p., 1851.

Bynum, W. F., and Roy Porter, eds. *Companion Encyclopedia of the History of Medicine.* Vol. I. London: Routledge, 1993.

The Cabinet; or, Works of Darkness Brought to Light . . . 2nd ed. Philadelphia, Pa.: John Mortimer, 1825.

Cahill, Holger. *American Folk Art: The Art of the Common Man in America, 1750–1900.* New York: Museum of Modern Art, 1932.

———. "Artisan and Amateur In American Folk Art." In *Folk Art in America: Painting and Sculpture.* New York: Museum of Modern Art, 1932.

Catalog of Books in the Newtown Library. 1791. Newtown, Pa.: Newtown Library Company, 1791.

Catalog of Books in the Newtown Library. 1808. Newtown, Pa.: Newtown Library Company, 1808.

A Chapter of Modern Chronicles, In Which Certain Events Which Lately Took Place in the City of Gotham Are Truly Set Forth. New York: N.p., 1826.

Chotner, Deborah, et al. *American Naive Paintings.* Washington, D. C.: National Gallery of Art, 1992.

Christ Church, Philadelphia, Records. Vols. XXIX, XXXI, XXXVI, XXXVII. Microfilm. Historical Society of Pennsylvania, Philadelphia, Pa.

Christoph, Peter R., and Florence A. Christoph, eds. *New York Historical Manuscripts: English. Books of General Entries of the Colony of New York, 1674–1688.* Baltimore, Md.: Genealogical Publishing Co., 1982.

The Coach-Makers' Illustrated Hand-Book. 2nd ed. 1875. Reprint. Mendham, N. J.: Astragal Press, 1995.

Cockburn, James. *A Review of the General and Particular Causes Which Have Produced the Late Disorders and Divisions in the Yearly Meeting of Friends, Held in Philadelphia: with Introductory Remarks on the State of the Primitive Churches, Their Gradual Declension, and Subsequent Advancement in Reformation, to the Rise of the Society of Friends.* Philadelphia, Pa.: Philip Price, Jr., 1829.

Collections of the New-York Historical Society for the Year 1895. Abstracts of Wills, 1730–1744. New York: New-York Historical Society, 1896.

Comly, John. *Journal of the Life and Religious Labours of John Comly, Late of Byberry, Pennsylvania.* Philadelphia, Pa.: T. Ellwood Chapman, 1853.

Davis, William W. H. *History of Bucks County, Pennsylvania, from the Discovery of the Delaware to the Present Time.* 1876. 2nd ed. 1905. Edited by Warren S. Ely and John W. Jordan. Reprint. Baltimore, Md.: Genealogical Publishing Co., 1975.

Davison, Robert A. *Isaac Hicks: New York Merchant and Quaker, 1767–1820.* Cambridge, Mass.: Harvard University Press, 1964.

A Declaration of the Yearly Meeting of Friends, Held in Philadelphia, Respecting the Proceedings of Those Who Have Lately Separated from the Society: and also, Showing the Contrast between Their Doctrines and Those Held by Friends. New York: Samuel Wood and Sons, 1828.

Doherty, Robert W. *The Hicksite Separation: A Sociological Analysis of Religious Schism in Early Nineteenth Century America.* New Brunswick, N. J.: Rutgers University Press, 1967.

Edward Hicks, 1780–1849: A Special Exhibition Devoted to His Life and Work. Introduction by Alice Ford. Exhibit catalog. Abby Aldrich Rockefeller Folk Art Center, Williamsburg, Va., 1960.

Egle, William Henry, ed. *Minutes of the Board of Property and Other References to Lands in Pennsylvania. Pennsylvania Archives.* 3rd Ser. Vol. I. Harrisburg, Pa.: Clarence M. Burch, 1894.

Epistles and Testimonies issued by the Yearly Meetings of Friends, in North America; Setting Forth Their Faith Respecting The Holy Scriptures, and in the Divinity and Offices of Our Lord and Saviour Jesus Christ; Shewing That the Antichristian Doctrines of Those Who Have Lately Separated from the Society, Are Repugnant Thereto. Philadelphia, Pa.: Thomas Kite, 1828.

Evans, William Bacon. *Jonathan Evans and His Time, 1759–1839. Bi-centennial Biography.* Boston: The Christopher Publishing House, 1959.

An Examination of a Pamphlet, Entitled the Misrepresentations of Anna Braithwaite, in Relation to the Doctrines Preached by Elias Hicks. New York: N.p. [1825].

Extracts from the Writings of Primitive Friends, Concerning the Divinity of Our Lord and Saviour, Jesus Christ. Philadelphia, Pa.: Solomon W. Conrad, 1823.

Fairbanks, Jonathan L. "Benjamin Ferris: A Friend of Many Talents." *Delaware Antiques Show.* Exhibit catalog. Wilmington, Del., 1966.

Fay, Loren V., ed. *Quaker Census of 1828: Members of the New York Yearly Meeting, The Religious Society of Friends (In New York, Ontario, Vermont, Connecticut, Massachussetts, and Quebec), At the Time of the Separation of 1828.* Rhinebeck, N. Y.: Kinship, 1989.

Felton, William. *A Treatise on Carriages; Comprehending Coaches, Chariots, Phaetons, Curricles, Whiskies, &c.* 2 vols. 1794, 1796. Reprint. Mendham, N. J.: Astragal Press, 1996.

[Ferris, Benjamin, and Rebecca B. Comly.] *An Epistle from the Yearly Meeting of Friends, Held in Philadelphia, By adjournments from the fifteenth day of the Tenth Month, to the nineteenth of the same, inclusive, 1827, to the Quarterly, Monthly, and Particular Meetings of Friends, within the compass of the said Yearly Meeting.* Philadelphia, Pa.: 1827.

Fisher, Jonathan. *Scripture Animals: A Natural History of the Living Creatures Named in the Bible.* 1834. Reprint. Princeton, N. J.: Pyne Press, 1972.

Forbush, Bliss. *Elias Hicks: Quaker Liberal.* New York: Columbia University Press, 1956.

Ford, Alice. *Edward Hicks: His Life and Art.* New York: Abbeville Press, 1985.

———. *Edward Hicks: Painter of the Peaceable Kingdom.* Philadelphia, Pa.: University of Pennsylvania Press, 1952.

Frost, Josephine C. "John and Harwood Hicks." *New York Genealogical and Biographical Record,* LXX (1939).

Gibbons, William. *A Review and Refutation of Some of the Opprobrious Charges Against the Society of Friends, as Exhibited in a Pamphlet Called "A Declaration," &c.* Philadelphia, Pa.: T. E. Chapman, 1847.

Griffith, Lee Ellen. "John Archibald Woodside, Sr." *The Magazine Antiques,* CXL (1991), pp. 816–825.

Hamm, Thomas D. *The Transformation of American Quakerism: Orthodox Friends, 1800–1907.* Bloomington, Ind.: Indiana University Press, 1988.

Hay, Edith Carman, and Sidney Wilson. "John Carman." *New York Genealogical and Biographical Record,* LXX (1939).

Haynes, George Emerson. *Edward Hicks, Friends' Minister.* Doylestown, Pa.: Quixott Press, 1974.

Held, Julius S. "Edward Hicks and the Tradition." *Art Quarterly,* XIV (1951), pp. 121–136.

Hicks, Edward. Account Book. Bucks County Historical Society, Doylestown, Pa. Photostat, AARFAC.

———. *Memoirs of the Life and Religious Labors of Edward Hicks, Late of Newtown, Bucks County, Pennsylvania. Written by Himself.* Philadelphia, Pa.: Merrihew & Thompson, 1851.

———. Memoirs. Undated papers of Edward Hicks. Friends Historical Library, Swarthmore College, Swarthmore, Pa.

———. Memoirs (partial). Transcription by Alice Ford. Ford files. Friends Historical Library, Swarthmore College, Swarthmore, Pa.

———. *A Sermon, by Edward Hicks, Delivered at Friends' Meeting, Green Street, Philadelphia, on the Evening of the 18th, of 4th Month, 1834, after the Conclusion of the Yearly Meeting.* Darby,

Pa.: Y. S. Walter, 1834.

———. *Sermon delivered at Friends' Meeting, Rose Street, on First Day Morning, 11th month, 21st, 1830.* New York: Isaac T. Hopper, 1830.

Hicks, Edward, and Elias Hicks. *Sermons delivered by Elias Hicks & Edward Hicks; in Friends' Meetings; New-York; In 5th Month, 1825.* New York: J. V. Seaman, 1825.

Hicks, Elias. *A Doctrinal Epistle, Written by Elias Hicks, of Jericho, on Long Island, in the Year 1820; Purporting to Be an Exposition of Christian Doctrine, Respecting the Nature and Office of Jesus Christ.* Philadelphia, Pa.: S. Potter & Co., 1824.

———. *Extracts from Two Letters Written by Elias Hicks, to a Friend Who had Joined an "Association for the Suppression of Vice and Immorality."* New York: Baker, Crane, & Co., 1841.

———. *Journal of the Life and Religious Labours of Elias Hicks.* 5th ed. 1832. Reprint. Edited by Edwin S. Gaustad. New York: Arno Press, 1969.

———. *Observations on the Slavery of the Africans and Their Descendants. Recommended to the Serious Perusal, and Impartial Consideration of the Citizens of the United States of America, and Others Concerned.* New York: Samuel Wood, 1811.

———. *A Review of the Principal Doctrines of Elias Hicks, as Exhibited in His Own Language.* Philadelphia, Pa.: N.p., 1825.

———. *Sermons, by Elias Hicks, Ann Jones, and Others, Of the Society of Friends, at the Quarterly Meetings of Nine Partners, and Stanford, and First Day Preceding, in Fifth Month, 1828.* New York: Piercy & Burling, 1828.

Hicks, George A. "Thomas Hicks, Artist, a Native of Newtown." *Collection of Papers Read Before the Bucks County Historical Society,* IV (1917).

Hicks, Isaac. Is[aac] Hicks's Book of Accounts. American Philosophical Society, Philadelphia, Pa.

Hicks, Isaac W. Daybook of Isaac Hicks. Collection of Katherine K. Fabian. Photostat, AARFAC.

Hicks, Sarah W. "The Life and Expatriation of Judge Gilbert Hicks." *Collection of Papers Read Before the Bucks County Historical Society,* VII (1937).

———. Notebook of S. W. Hicks. Newtown Historic Association, Newtown, Pa.

Hinshaw, William Wade. *Encyclopedia of American Quaker Genealogy.* Vol. II: *Containing Every Item of Genealogical Value Found in All Records and Minutes (Known To Be in Existence) of Four of the Oldest Monthly Meetings Which Ever Belonged to the Philadelphia Yearly Meeting of Friends.* Vol. III: *Containing Every Item of Genealogical Value Found in All Records and Minutes (Known To Be in Existence) of All Meetings of All Grades Ever Organized in New York City and on Long Island.* Ann Arbor, Mich.: Edwards Brothers, 1938, 1940.

Hodge, Harriet Woodbury. *Hicks (Hix) Families of Rehoboth and Swansea, Massachusetts: Some Descendants of Thomas Hicks of Scituate and his son, Daniel Hicks of Scituate and Swansea.* Winnetka, Ill.: privately printed, 1976.

Hole in the Wall; or A Peep at the Creed-Worshippers. N.p. [Philadelphia, Pa.], 1828.

Hutchinson, J. Pemberton. "Newtown Prior to 1800." *Collection of Papers Read Before the Bucks County Historical Society,* II (1909), pp. 386–405.

Jackson, Joseph. "John A. Woodside, Philadelpia's Glorified Sign-Painter." *Pennsylvania Magazine of History and Biography,* LVII (1933), pp. 58–65.

Janney, Samuel M. *An Examination of the Causes Which Led to the Separation of the Religious Society of Friends in America, in 1827–28.* Philadelphia, Pa.: T. Ellwood Zell, 1868.

Jenks, George A. "The Newtown Library." *Collection of Papers Read Before the Bucks County Historical Society,* III (1909), pp. 316–331.

Johnson, Samuel. *Poems on Various Subjects.* Philadelphia, Pa.: W. P. Gibbons, 1835.

Jones, Charles Henry. *Genealogy of the Rodman Family, 1620 to 1886.* Philadelphia, Pa.: Allen, Lane & Scott, 1886.

Jones, Rufus M. *The Later Periods of Quakerism.* 2 vols. 1921. Reprint. Westport, Conn.: Greenwood Press, 1970.

Junker, Patricia. "Edward Hicks and His Peaceable Kingdom." *Triptych* (1994), pp. 13–18.

Kennedy, Thomas G. Papers. Microfilm R929.374818 Ch 5004, A–H. Bucks County Historical Society, Doylestown, Pa.

Laughon, Helen, and Nel Laughon. *August Edouart: A Quaker Album, American and English Duplicate Silhouettes 1827–1845.* Richmond, Va.: Cheswick Press, 1987.

Leventhal, Herbert. *In the Shadow of the Enlightenment: Occultism and Renaissance Science in Eighteenth-Century America.* New York: New York University Press, 1976.

Lipman, Jean. "The Peaceable Kingdom by three Pennsylvania primitives." *Art in America,* XL (1957), pp. 28–29.

Lovejoy, Arthur O. *The Great Chain of Being: A Study of the History of an Idea.* Cambridge, Mass.: Harvard University Press, 1957.

MacReynolds, George, comp. *Place Names in Bucks County, Pennsylvania.* Doylestown, Pa.: Bucks County Historical Society, 1942.

Makefield Monthly Meeting records. Microfilm MR-ph292. Friends Historical Library, Swarthmore College, Swarthmore, Pa.

Mather, Eleanore Price. *Edward Hicks Primitive Quaker: His Religion in Relation to His Art.* Wallingford, Pa.: Pendle Hill Publications, 1970.

———. "In Detail: Edward Hicks's *Peaceable Kingdom.*" *Portfolio,* II (1980), pp. 34–39.

———. "The Inward Kingdom of Edward Hicks: A Study in Quaker Iconography." *Quaker History,* LXII (1973), pp. 3–13.

———. "A Quaker Icon: The Inner Kingdom of Edward Hicks." *Art Quarterly,* XXXVI (1973), pp 84–99.

Mather, Eleanore Price, and Dorothy Canning Miller. *Edward Hicks: His Peaceable Kingdoms and Other Paintings.* East Brunswick, N. J.: Associated University Presses, 1983.

McCoubrey, John W. "Three Paintings by Edward Hicks." *Yale University Art Gallery Bulletin*, XXV (1959), pp. 16–21.

McIntyre, Robert G. *Martin Johnson Heade, 1819–1904*. New York: Pantheon Press, 1948.

McNealy, Terry, and Frances Wise Waite, comps. *Bucks County Tax Records: 1693–1778*. Doylestown, Pa.: Bucks County Genealogical Society, n.d.

Melville, Robert. "American Museum in Britain." *Architectural Review*, XXIX (1961).

Michener, Ezra. *A Retrospect of Early Quakerism; Being Extracts from the Records of Philadelphia Yearly Meeting and the Meetings Composing It*. Philadelphia, Pa.: T. Ellwood Zell, 1860.

Miller, Lillian B., ed. *The Selected Papers of Charles Willson Peale and His Family*. Vol. I. New Haven, Conn.: Yale University Press, 1983.

Minutes of the Supreme Executive Council of Pennsylvania, From Its Organization to the Termination of the Revolution. Pennsylvania Archives. Vol. II. Harrisonburg, Pa.: Theo Finn and Co., 1853.

Montgomery, Thomas Lynch, ed. *Pennsylvania Archives*. 6th Ser. Vol. XII. Harrisburg, Pa.: Harrisburg Publishing Co., 1907.

Moore, James W., comp. *Rev. John Moore of Newtown, Long Island, and Some of His Descendants*. Easton, Pa.: Chemical Publishing Co., 1903.

Moriarity, G. Andrews. "The Parentage of George Gardiner of Newport, R. I." In *The American Genealogist, Volumes 21–23*. Edited by Donald Lines Jacobus. Camden, Me.: Picton Press, 1989.

Nicholson, Frederick J. *Quakers and the Arts: A Survey of Attitudes of British Friends to the Creative Arts from the Seventeenth to the Twentieth Century*. London: Friends Home Service Committee, 1968.

Price, Frederic Newlin. *Edward Hicks, 1780–1849*. Swarthmore, Pa.: Benjamin West Society [1945].

Pullinger, Edna S. "The Art of Peaceable Living." *Panorama—The Magazine of Bucks County* (1972).

———. *A Dream of Peace: Edward Hicks of Newtown*. Philadelphia, Pa.: Dorrance & Co., 1973.

———. "Edward Hicks: Committee Worker." *Mercer Mosaic: The Journal of the Bucks County Historical Society*, I (1984).

———. "Edward Hicks, farmer." *Advance of Bucks County*, Feb. 17, 1983.

———. "Edward Hicks and neighbors—part one: How Edward Hicks came to leave Attleborough." *Advance of Bucks County*, Dec. 11, 1975.

———. "Edward Hicks and neighbors—part two: A Friends Meeting formed at Newtown." *Advance of Bucks County*, Dec. 18, 1975.

———. "Edward Hicks and neighbors—part three: Hicks defends his moral character." *Advance of Bucks County*, Dec. 25, 1975.

———. "Edward Hicks and neighbors—part four: Hatter was a close associate of Hicks." *Advance of Bucks County*, Jan. 1, 1976.

———. "Edward Hicks, Newtown Coach Painter, Among Friends." *Bucks County Historical Society Journal*, II (1979), pp. 202–224.

———. "Edward Hicks of Bucks County." Slide lecture. Newtown Historic Association, Newtown, Pa.

———. "Edward Hicks on Bellevue Avenue." *Advance of Bucks County*, Feb. 16, 1984.

———. "Hicks and the Cornell connection." *Advance of Bucks County*, Apr. 17, 1980.

———. "The house that Hicks built." *Advance of Bucks County*, Sept. 25, 1980.

———. *Newtown's First Library Building*. Newtown, Pa.: Newtown Library Company, 1976.

———. "No more need of war." *Advance of Bucks County*, Dec. 24, 1981.

———. "Panic and Panacea: Edward Hicks Deplores Overspeculation in the 1830's—And the Silkworm Mania That Followed." *George School Bulletin* (1978), pp. 1–3.

———. "The Penn Treaty Swinging Sign." *Mercer Mosaic: The Journal of the Bucks County Historical Society* (1980).

———. "The Residence of Thomas Hillborn by Edward Hicks." *The Magazine Antiques*, CXXX (1986), pp. 474–475.

———. "The Tomlinson-Huddleston House: Where Edward Hicks Once lived." *Bucks County Historical Society Journal*, II (1977), pp. 5–15.

———. "Tree of brotherhood." *Advance of Bucks County*, Feb. 14, 1985.

———. *A Vision of Peace: Edward Hicks of Bucks County*. Manuscript. Newtown Historic Association, Newtown, Pa., 1983.

———. "Where Hicks Lived in Bucks." *Bucks County Courier Times*, Feb. 24, 1980.

Pullinger, Edna S., and Richard C. Pullinger. "The House That Edward Hicks Built, Hulmeville, Pennsylvania." *Bucks County Historical Society Journal*, II (1978), pp. 106–107.

The Quaker, Being a Series of Sermons by Members of the Society of Friends. Vols. I, II, IV. Philadelphia, Pa.: Society of Friends, 1830, 1827, 1828.

Quality: An Experience in Collecting. Exhibit catalog. New York: Hirschl & Adler Galleries, 1974.

Ranlet, Philip. *The New York Loyalists*. Knoxville, Tenn.: University of Tennessee Press, 1986.

Register of Marriages for the Year 1769. Microfilm. Department of History, Presbyterian Church (USA), Philadelphia, Pa.

Renunciation of Edward Hicks. Oct. 25, 1836. #7010. Microfilm. Bucks County Courthouse, Doylestown, Pa.

Rockefeller, Steven C. "The Wisdom of Reverence for Life." In John E. Carroli, Paul Brockelman, and Mary Westfall, eds. *The Greening of Faith: God, the Environment, and the Good Life*. Hanover, N. H.: University Press of New England, 1997.

Russell, Elbert. *The History of Quakerism*. New York: Macmillan Co., 1943.

————. *The Separation After a Century*. Reprinted from *Friends' Intelligencer*. N.p., 1928.

Ryan, Pat M. "Mathias Hutchinson's *Notes of a Journey* (1819–20)." *Quaker History*, LXVIII (1979), pp. 92–114.

————. "Mathias Hutchinson's *Notes of a Journey* (1819–20)." *Quaker History*, LXIX (1980), pp. 36–57.

————, ed. *Rochester Recollected: A Miscellany of Eighteenth- and Nineteenth-Century Descriptions. Rochester History*, XLI (1979), pp. 8–12.

Sawyer, John F. A. *The Fifth Gospel: Isaiah in the History of Christianity*. Cambridge: Cambridge University Press, 1996.

Sellers, Charles Coleman. *Portraits and Miniatures by Charles Willson Peale*. Philadelphia, Pa.: American Philosophical Society, 1952.

Settlement of the Estate of Isaac Hicks, Esq., Late of Newtown, deceased. 1837. #1010. Microfilm. Bucks County Courthouse, Doylestown, Pa.

Smith, Josiah B. Historical Collections of Persons, Land, Business and Events in Newtown and Other Places in the Middle and Lower Parts of Bucks County. Book I. 1941. Bucks County Historical Society, Doylestown, Pa.

Smith, Robert, ed. *The Friend: A Religious and Literary Journal*. Vols. III–VIII, 1829–1834.

Soderlund, Jean R., ed. *William Penn and the Founding of Pennsylvania, 1680–1684: A Documentary History*. Philadelphia, Pa.: University of Pennsylvania Press, 1983.

Solis-Cohen, Lita. "Barry Cohen Collection Sold." *Maine Antiques Digest* (June 1990).

A Statement of Facts, Exhibiting the Causes That Have Led to the Dissolution of the Connexion Which Existed Between Philadelphia Quarterly Meeting and the Monthly Meeting of Friends, Held at Green Street, Philadelphia. Philadelphia, Pa.: D. & S. Neall, 1827.

Stebbins, Theodore E., Jr. *The Life and Works of Martin Johnson Heade*. New Haven, Conn.: Yale University Press, 1975.

Swift, David E. *Joseph John Gurney: Banker, Reformer, and Quaker*. Middletown, Conn.: Wesleyan University Press, 1962.

Symbols of Peace: William Penn's Treaty with the Indians. Exhibit catalog. Philadelphia, Pa.: Pennsylvania Academy of the Fine Arts, 1976.

Tatham, David. "Edward Hicks, Elias Hicks, and John Comly: Perspectives on the Peaceable Kingdom Theme." *American Art Journal*, XIII (1981), pp. 36–50.

————. "Thomas Hicks at Trenton Falls." *American Art Journal*, XV (1983), pp. 5–20.

Tingry, P. F. *The Painter and Varnisher's Guide*. London: G. Kearsley, 1804.

Tolles, Frederick B. *Meeting House and Counting House: The Quaker Merchants of Colonial Philadelphia, 1682–1763*. Chapel Hill, N. C.: University of North Carolina Press, 1948.

————. "'Of the Best Sort but Plain': The Quaker Esthetic." *American Quarterly*, XI (1959), pp. 484–502.

————. "The Primitive Quaker as Poet." *Bulletin of the Friends Historical Association*, L (1961), pp. 12–30.

Wetherald, Thomas. *Sermons by Thomas Wetherald and Elias Hicks, delivered during the yearly meeting of Friends, in the city of New York, June 1826: together with a sermon by Elizabeth Robson, and a prayer, by Anna Braithwaite: also, sermons delivered in Philadelphia, and Wilmington, (Del.) by Thomas Wetherald, on his way to, and from the yearly meeting*. Philadelphia, Pa.: Marcus T. C. Gould, 1826.

Will of Elias Hicks. May 4, 1829. Surrogate's Court, Queens County, N. Y. Transcription. Hicks Manuscript Collection, Friends Historical Library, Swarthmore College, Swarthmore, Pa.

Wilson, Robert H. *Philadelphia Quakers, 1681–1981*. Philadelphia, Pa.: Philadelphia Yearly Meeting of the Religious Society of Friends, 1981.

Youngs, Florence E. The Hicks Family of Long Island, Copied from the Records of the Late Benjamin Doughty Hicks. 1924. 8 vols. Brooklyn Historical Society, Brooklyn, N. Y.

Index

Boldface numbers indicate illustrations.

THE KINGDOMS OF EDWARD HICKS

Designed by Greer Allen
Composed in Walbaum type by Highwood Typographic Services
Printed on KNP Leykam Matte Paper and bound in Brillianta cloth by CS Graphics